DRAWING AND PAINTING

Schmertzti\tel.

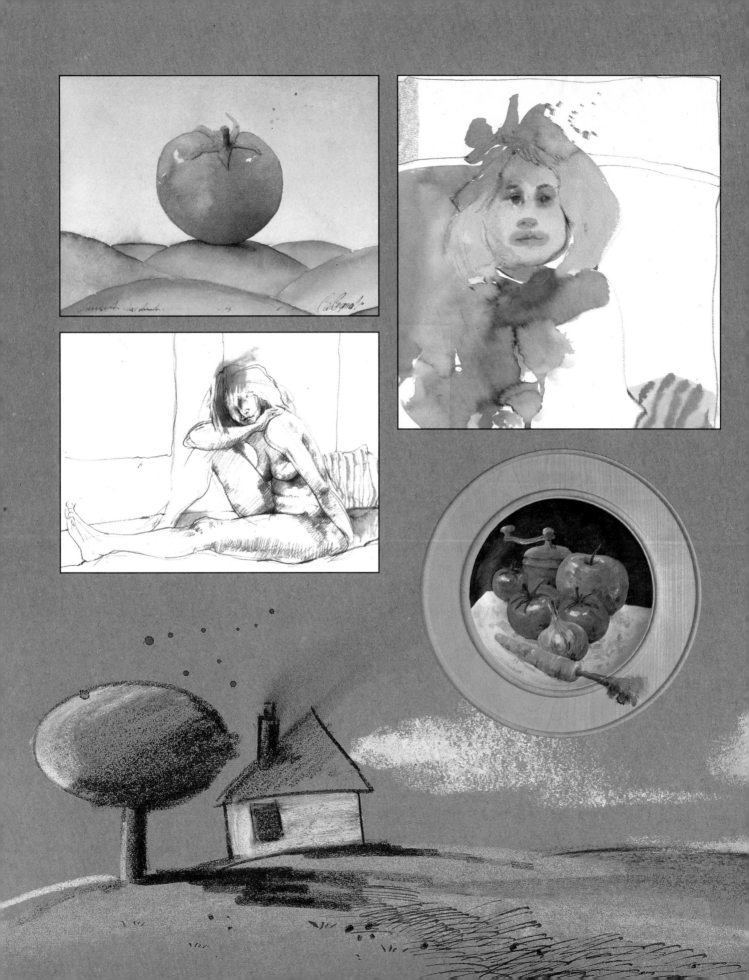

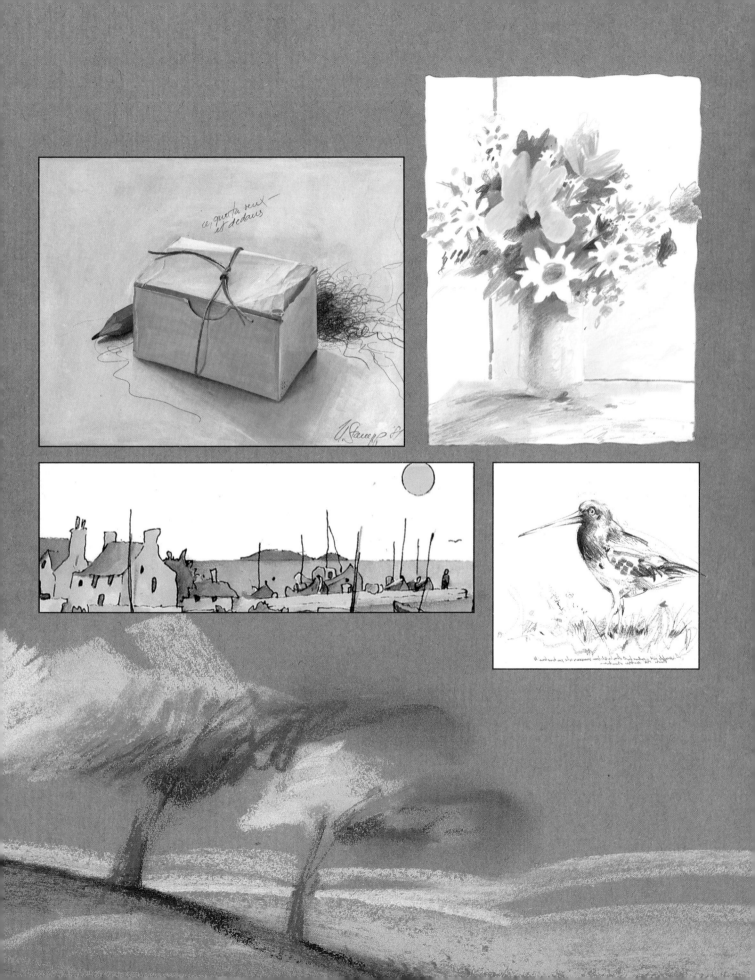

I should like to thank my wife, Uschi, without whose support this book would never have got off the ground; Professor Rudolf Krahwinkel; Frank Reger; Tom Rummonds; and all the people from the publishing company who worked with me on the book and helped me in so many ways.

Brian Bagnall

Brian Bagnall

CREATIVE

DRAWING AND PAINTING

NORTH LIGHT

Cincinnati, Ohio

Contents

LEARNING TO SEE

Who would like to be able to draw and paint? Almost everybody. But the problem is that this tends to be associated with such awe-inspiring names that most people feel intimidated before they even start. We have been indoctrinated with the concept that art is something special, something to stand in front of and admire in museums and galleries, thinking, "I could never do anything like that."

False assumptions—drawing and painting are skills that everyone can learn, and, more important, afford to use. You don't need to invest in any expensive equipment or facilities, as in tennis, for example, where you even have to pay for the court. A picture can be the size of a postcard or can cover a whole wall. You can draw anywhere—in a bar, on a trip, or at home in your living room.

Of course there are certain techniques that have to be learned. But these often look more difficult than they actually are. The artist who can use these various techniques and his imagination has a strong advantage over all others.

Everyone has a deep sense of the aesthetic and an appreciation of beauty. The first objective of this book is to remove any reservations you may have and encourage you to start. It should erase any fears of spoiling a clean sheet of paper or doing "something wrong." There ,is no right or wrong in art. Long before humans started writing, they painted on the walls of caves using primitive tools and materials. These cave paintings were an important means of communication, thanks to which we can today conjure up a picture of the spiritual life of our primitive ancestors.

Similarly, young children often scribble before they can speak properly. Simple, symbolic drawings can also help us find our way around in countries where we cannot communicate verbally. An artist, in turn, aims at portraying his impressions and feelings in a pictorial manner. The paintings and etchings of Goya (Spanish painter, etcher, and lithographer, 1746-1828), for example, provide a clear picture of the political atmosphere and life in Spain long before the age of photography or film.

Another important aspect is the simple joy to be experienced in experimenting and trying out new methods. Since art is not only an exercise of the mind but also demands certain manual skills, the artist will soon find out that he cannot rely merely on good ideas. The physical application is of equal importance—whether he presses hard or gently with his pencil or whether he uses sharp or soft brush strokes can produce a great variation in effects. A single line can be dramatic or totally boring. It is in the hands of the artist whether he provokes an atmosphere of joy or melancholy. Even a still life can be seen as something cheerful or somber.

In order to paint or draw you also need the ability to see. A rock doesn't have to be just a piece of stone. In conjunction with its surroundings it might seem threatening; each of its faces has a different form and character; light and shade alter its appearance. In short, if you contemplate a rock you will discover that it is much more than a stone.

Just look around and study the world about you; observe how things are related to one another, how some colors are dominant or how one object can cast a shadow on another. You will discover beauty in objects that seem quite insignificant to others. This "sight" is of unimaginable value when you want to produce a picture.

There are usually two rea-sons behind an unsatisfactory result with your first attempt at painting a landscape. The first is insufficient observation—a fleeting look at your subject will lead to a fleetingly painted picture. The second reason is probably the wrong choice of materials, rendering it difficult to transfer the landscape onto paper. This is once again a matter of sight. If you really observe nature, you will soon discover which materials are suitable for the various subjects—how thick, black charcoal, for example, can ruin any attempt to portray a delicate sunset.

All good artists in history had to learn how to interpret the real world. Take a look at how the great artists saw, observed, discovered, and transposed the world around them.

Let's take Vincent van Gogh (Dutch painter, 1853-1890) and his cypress tree (page 289) as an example.

This perfectly simple tree, set in a normal landscape, probably would not look very impressive as a photograph. It's the way that van Gogh saw this tree that makes it unique. He lends an atmosphere of strength to this peaceful scene; the picture is full of harmony and rhythm. The simple cypress tree, which might have appeared motionless and insignificant to anyone else, becomes something vivacious—something aspiring to reach the sky.

"Looking" is not nearly the same as "seeing." You will be surprised how many things you will become aware of for the first time once you begin to paint and draw. Perhaps you will realize that you are only really seeing some things for the first time. I hope that this book will help you with all this. It should not only teach you something about the different techniques, but also inspire you to play with the various materials and to try them out for yourself. No book can ever be comprehensive enough to cover all the various possibilities offered by the different mediums, but hopefully this book will stimulate you into experimenting. Another aim is to provide some ideas for discovering subjects to draw or paint. All too often people tend to sit with a box of watercolors in front of them, completely lacking in any inspiration as to what they can paint.

But my main objective is to convey the idea that painting and drawing can be great fun. It's not only the picture that turns out the way you wanted that can satisfy the budding artist, but also the fact that you have used your time meaningfully. Let yourself be stimulated by the experiments that I show on the last pages, in which I mix techniques and utilize unorthodox materials. Really let yourself go and forget any restrictive "you-can't-do-thats"!

Drawing and painting mean unrestricted enjoyment—a letting loose of the imagination. What can happen? At the worst, you might have to throw away a piece of paper.

Georges Braque (French painter and graphic artist, 1882-1963) once said on this subject: "I never know when I start a picture how it will turn out. It's an adventure every time. There's the initial idea, but this only serves as a starting point. As little as possible should remain of this. It is only semi-alive. But I am not actually a revolutionary painter. Fervor is enough for me." Whoever has mastered the various techniques experiences a new dimension through which he can communicate to others. This book aims at conveying how to enjoy this new dimension.

Basic Forms

You might ask yourself why you have to first learn to see. Of course you can "see," but everybody sees something very different. Seeing is of very special importance if you want to draw. One person will discover shapes in a tree that another person may not notice. If you want to draw a tree—to keep to this example—you cannot just start at the top left and then copy it branch for branch and leaf for leaf. First you have to recognize the basic form of the tree and transfer this to paper. With a little bit of practice, and, I hope, with the help of this book, you will soon develop a feeling for this.

The first task is to discover all the different ways that you can use your eyes. You'll be surprised how your surroundings will start to take on a different appearance.

We'll start with the simple shapes: the circle, triangle, rectangle, and oval. Keep your eyes open! Wherever you go, shopping, at the dentist, on the sports field, or while driving—you will meet up with these shapes. No matter how complicated an object might seem at first glance, it can be broken down into these basic forms, as this drawing by Paul Klee appropriately illustrates.

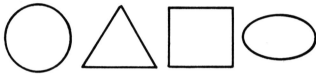

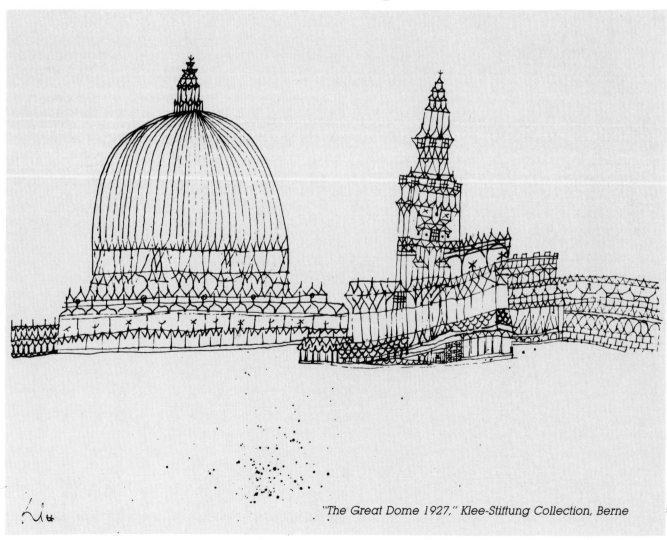

"The Great Dome 1927," Klee-Stiftung Collection, Berne

Children in particular have no problems recognizing basic forms. They freely turn a tree into a circle *with an elongated rectangle for a trunk or their mother into a triangle with a circle as a head.*

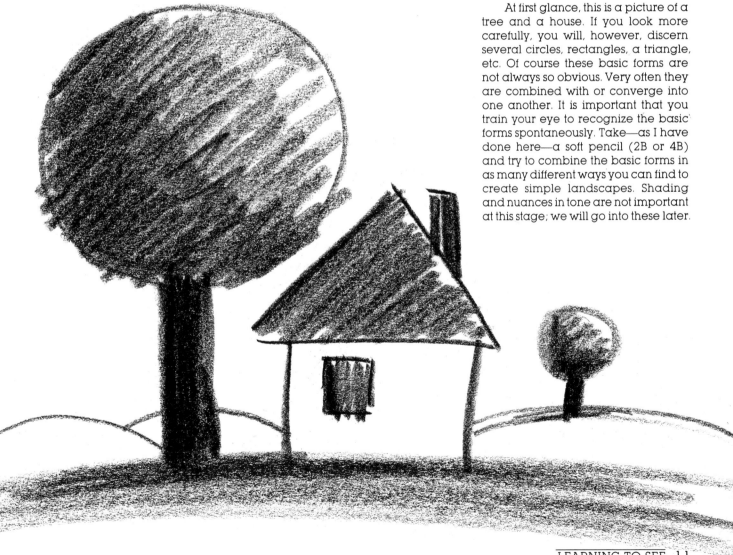

At first glance, this is a picture of a tree and a house. If you look more carefully, you will, however, discern several circles, rectangles, a triangle, etc. Of course these basic forms are not always so obvious. Very often they are combined with or converge into one another. It is important that you train your eye to recognize the basic forms spontaneously. Take—as I have done here—a soft pencil (2B or 4B) and try to combine the basic forms in as many different ways you can find to create simple landscapes. Shading and nuances in tone are not important at this stage; we will go into these later.

Circle

Oval

Rectangle

Triangle

You will find these basic forms in almost all objects as soon as you envisage them as flat surfaces.

The circle is to be found in the sphere, the oval in the cylinder, the rectangle in a cube, and the triangle in

a cone. Look around you and see where you can find these forms. Take a good look at fruit, cup-

boards, crockery, houses, and things like mountains, plants, and lakes.

Every object has a basic form, but the form is not always immediately recognizable. A cone might not have a point, or a circle might be dented, but as soon as you continue the form in your mind's eye

you will discover the initial form. It is much easier to draw an object once it has been reduced to its basic form.

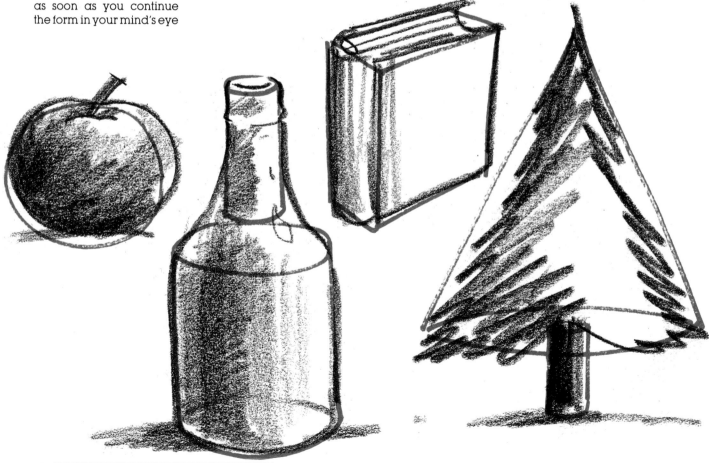

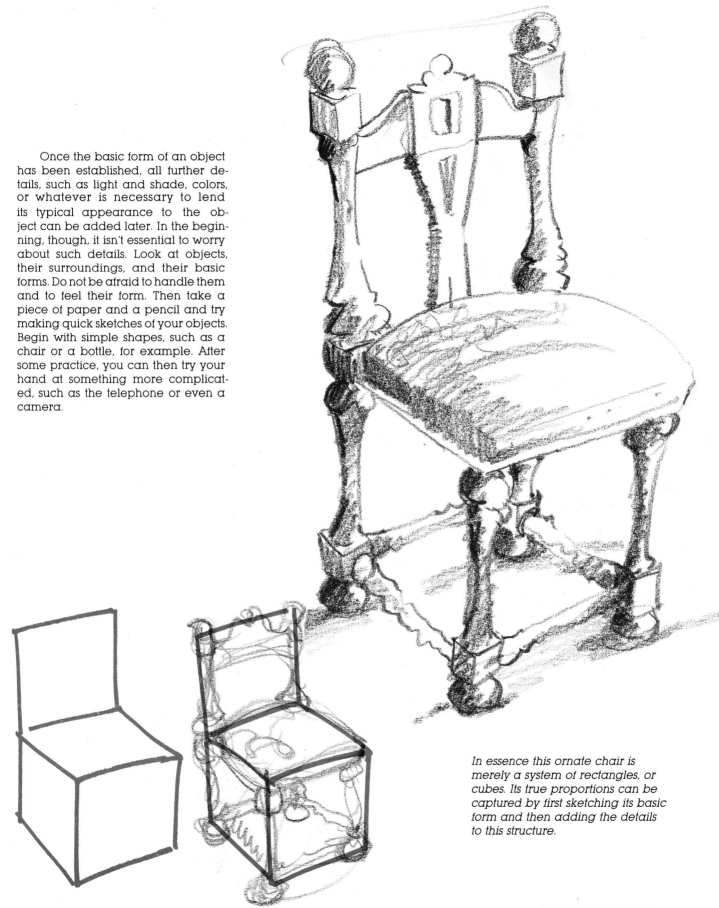

Once the basic form of an object has been established, all further details, such as light and shade, colors, or whatever is necessary to lend its typical appearance to the object can be added later. In the beginning, though, it isn't essential to worry about such details. Look at objects, their surroundings, and their basic forms. Do not be afraid to handle them and to feel their form. Then take a piece of paper and a pencil and try making quick sketches of your objects. Begin with simple shapes, such as a chair or a bottle, for example. After some practice, you can then try your hand at something more complicated, such as the telephone or even a camera.

In essence this ornate chair is merely a system of rectangles, or cubes. Its true proportions can be captured by first sketching its basic form and then adding the details to this structure.

Should you want to draw something more complicated, such as a landscape, it's difficult to break it down into basic forms. You have to first decide on a section of the landscape that appeals to you. Once you have made this decision, do not be afraid of omitting any disturbing details, such as a telephone pole. The only thing that matters is what you yourself want to put in your picture. Now break down your section into basic forms around which you can build up your picture.

Simplification is especially helpful in the case of complicated motifs. When I saw this village, I was particularly fascinated by the roofs. I included the lamp in the foreground to give more depth to the whole picture. It's quite easy to work from this basis, whether you decide to work in oils or crayon.

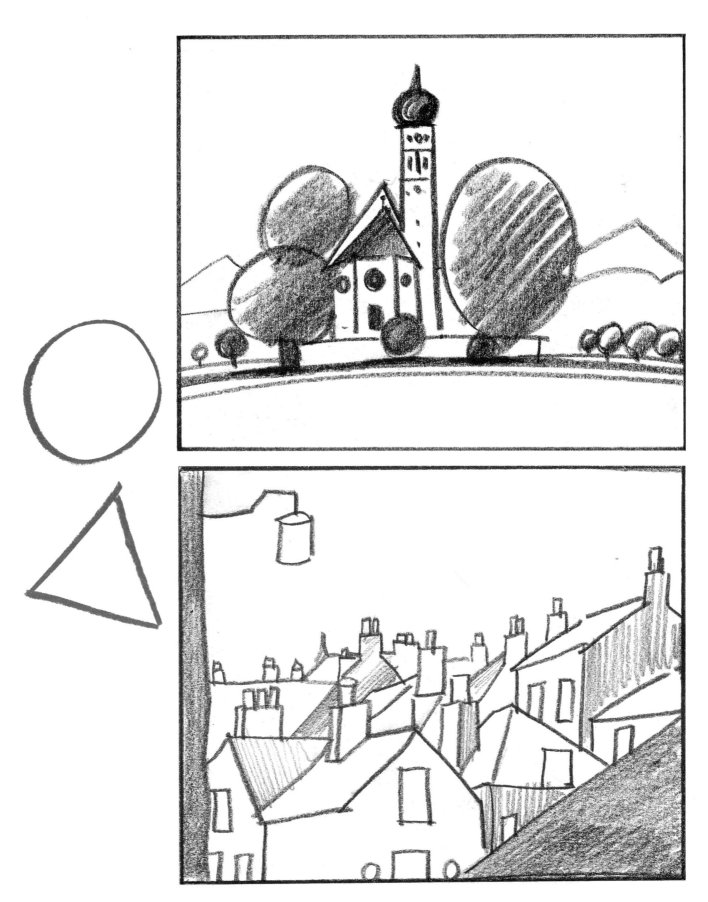

Composition

This is a pen-and-ink drawing taken from my sketchbook. In this sketch I laid down the composition for a later picture. The diagram shows, in a simplified form, how the picture can be divided into three parts. The emphasis in section two is on the houses. Although one's attention is actually led out of the picture in this central section, it is recaptured by the houses and diverted back into the picture, as shown by the arrows.

When creating a picture, special emphasis must be laid on arrangement—the composition of the separate elements.

Let us first of all consider the arrangement of shapes and objects within a limited space. If you are given the task of placing a chair, a table, and a cupboard in an empty room—to take a simple example—you will intuitively decide on certain groupings, because these arrangements fill you with a feeling of harmony. You feel at ease when the chair, the table, the cupboard, and the empty parts of the room fit together.

One of the most important aspects of the examples shown here is the relationship between the areas of white and the areas of black.

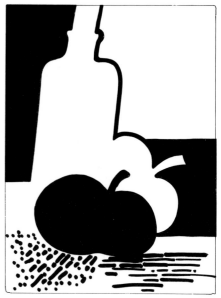

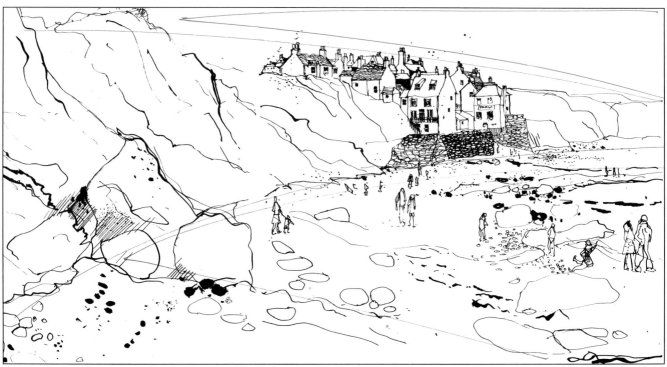

On the left, a black-and-white composition by Ursula Bagnall. The contrast between the black and the white areas was carefully planned to balance the importance of the negative and positive.

The Boris Sajtinacs composition, below, is divided into two almost equal halves. Balance is achieved through a progression in toning. A feeling of depth is created by using diminishing numbers and a dark foreground contrasting against a light background.

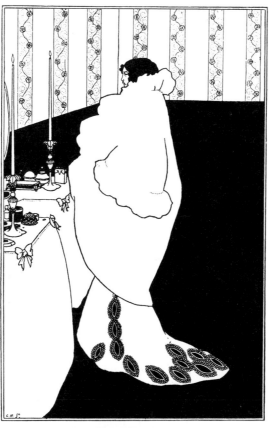

Aubrey Beardsley (English artist and illustrator, 1872-1898) was an extreme eccentric. His best known drawings are characterized by strongly contrasting areas of black and white and by his sweeping lines and structures. The balance between negative and positive is carefully planned and thought out with precision; an accentuated border combines with a strong area of black to form the main component of the composition. He used these lines, shapes, and surfaces to create an abstract piece of decorative art.

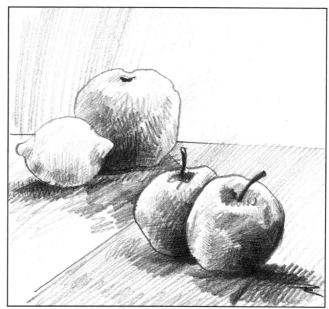

This drawing of pieces of fruit shows how toning can produce the basic pattern of a composition. Later in this chapter I'll deal with the importance of nuances in tone to lend depth to a picture.

A simple composition begins with the positioning of the positive and negative factors in a given space. You will always be working in some kind of space limitation, be it your piece of paper, sketchbook, a canvas, or even a framework that you have drawn yourself. All the elements that you want in your picture have to be contained in this space in such a way that they elucidate the idea you have in mind. The mere layout can make a picture seem either aggressive or calm, boring or lively. An object can become completely lost or it can, when its size is exaggerated, become threatening. The technique you decide to use is irrelevant if the composition itself is not right. Whether you are using oils or pencil, you still need to create harmony in the relationship between the various elements. Of course, it takes a bit of practice to master this. Let's look at some simple examples that illustrate the different effects that can be achieved and how the surrounding empty space is just as important as the positive shape—the object that you are portraying.

This motif is not confined only to the apple, but also includes an empty space.

 + =

Look at these three pictures. What effect do they have on you? This picture does not somehow feel right. With the apple stuck in the corner, the picture lacks harmony.

Here the apple has slipped to the bottom and one really sees only an empty space, which then becomes the most important part of the picture.

Now there is a balanced relationship between the apple and the surrounding space. Shape and space seem to be in harmony.

If we now play with the sizes, the little apple seems to be floating in a disproportionate space.

If we make the apple too big and fat, however, it seems to be squeezed into the framework and overdominant, an effect that is created not only by the size and texture of the apple but also by the spaces around it.

Reverse the colors, and you will clearly see how the areas surrounding the apple take on a shape of their own.

If we line up identical shapes in a row, we create the impression of a pattern. Here, once again, the positive shapes also form negatives.

By altering the sizes, we also alter the entire message; the negative shapes become considerably more complicated. The shapes influence one another. The large apple seems closer than the smaller ones.

Cut shapes 1, 2, and 3 out of paper and arrange them in various ways to create several different compositions.

A feeling for the composition of a picture, for its pictorial structure, for the relationship between surfaces and shapes, for the resulting movements and countermovements, is something that cannot be learned from one day to the next.

This takes much practice and experimenting. After a while you will instinctively feel troubled by "bad" compositions, even if you might not be able to pin this down to any concrete reason. You will sometimes notice that the composition of one of your finished pictures is somehow right without your ever having given much thought to this.

These two pages aim at helping you practice, using the apple once again, together with a napkin. In these four pictures I have merely played around with the negative and positive areas. If you also vary the sizes, you will find a lot more possibilities. Take a piece of paper and try it out yourself! With the help of these simple shapes—without altering any sizes—you should be able to see how the message of a picture can be changed by other means than altering positions and arrangement.

When is the apple farther away? When is it in the foreground?

When is the background more important than the foreground?

Does the apple look like a hole to you maybe? Is it floating or on a surface? Take time and let these illustrations speak to you.

Which compositions do you like or dislike? Think about why!

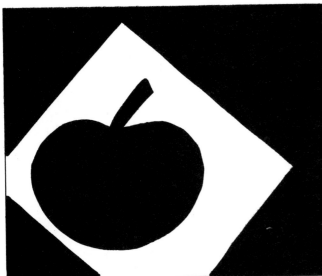

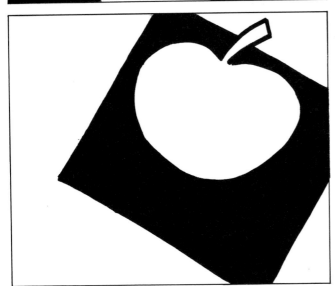

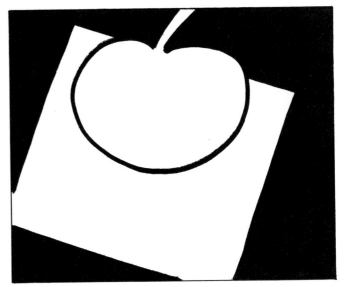

Play around with these objects first of all, then take some others. But start with a simple subject. A house with two trees, for example, is quite sufficient. By merely altering dimensions, you can also alter the message. You will see that an enormous tree can have a threatening effect on a house; a smaller tree seems distant. One tree can be right beside the house and the other way back in the background. Round objects appear softer than angular objects, jagged lines more aggressive than wavy lines. Do not set to work with a firm concept of a finished picture. Sketch the various possible sizes and shapes, the different positive and negative areas to test out all the effects.

Once you have read the following pages dealing with the various tones of gray, try the exercise again, this time using variations of gray. You will be surprised how the composition will express something entirely different.

We are often confronted with problems of composition in our daily lives. When furnishing a room or arranging a garden, for example, we use an inbred sense of layout. We all have this. All we have to do is learn to use it.

Try to combine these simple shapes with one another. It is completely irrelevant if the cup is, in reality, much smaller than the tree. If it is in the foreground it will simply make the tree seem farther away. What can you make out of them?

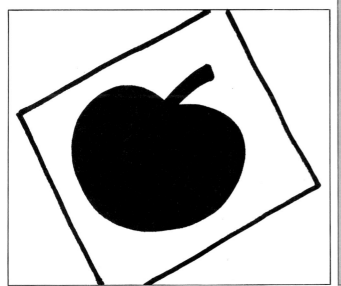

et's take a look at the different effects that can be achieved using simple lines in a space. The simple spiral has a calming symmetrical effect. In the diagram on the right, the lines have been pushed off center, giving a feeling of disquiet and tension.

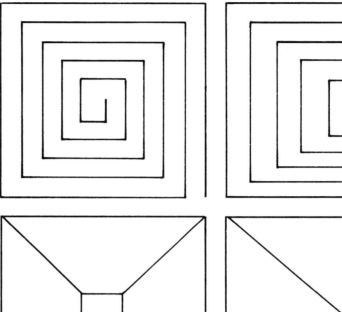

Here again the first diagram is calm and balanced. There is no tension between the individual shapes. By altering the proportions, tension and depth are created. The central section has, by the way, only been shifted; the size has not been altered.

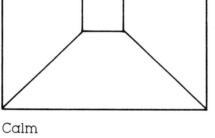

Calm Tension

This procedure also can be easily used in a picture of a landscape. Here I have simply placed a tree in a landscape. On the left, the positioning of the tree and the horizon creates an atmosphere of calm; you feel you can relax and breathe. The picture on the right creates an impression of depth; the calm has given way to tension.

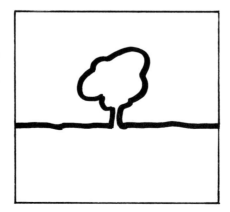

We now come to the subject of differentiation of subject matter using various shades of gray to create depth and atmosphere. Many people only see light and dark tones and do not register the many in-between tones. It is useful, therefore, to make a tone chart which will train your eyes to recognize the various nuances of gray from very dark to very light.

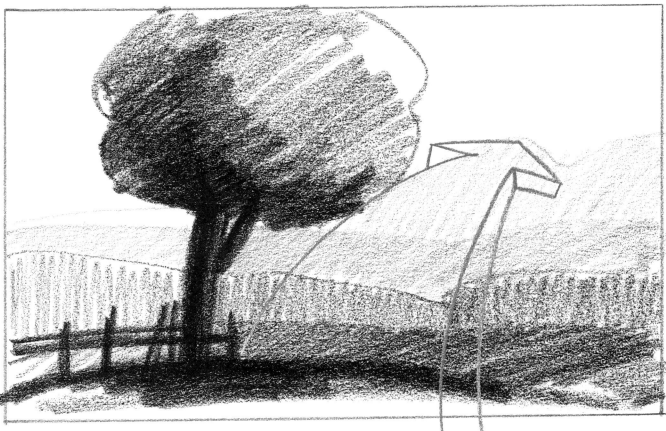

Try to produce the gray tones using different materials (pen, pencil, charcoal, etc.). You can take any color, not just black, to produce these toning effects, which are so important for bringing depth into a picture. Objects seen from a distance not only seem smaller but also grayer, hazier, and less detailed than objects seen close up. They become blurred and lighter as a result of the atmosphere and distance. In the above example I've used only the six tones of gray. Notice how dark the tree in the foreground is compared to the hills, which become gradually lighter the farther they disappear into the distance.

Can you find all the gray tones of the tone chart in this picture? This diagram should help you find them.

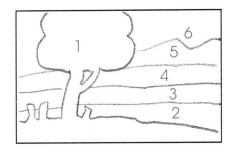

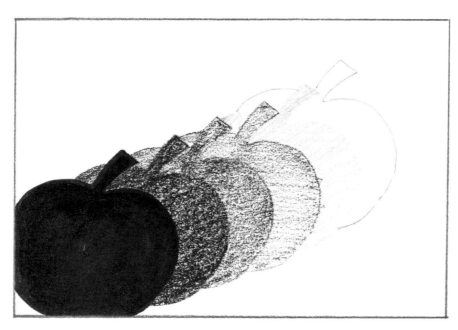

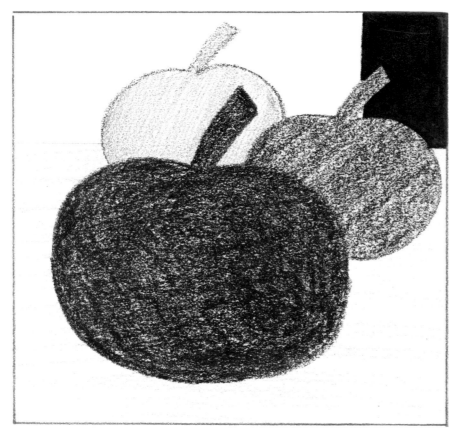

If we take our apple as an example once again, you will see clearly how just by using different tones of gray, the front apple seems closer and the others farther away.

Whenever we speak of tone values we are referring to the lightness or darkness of a tone. White is the lightest value and black the darkest. You will see that everything has its own tonal value. Train your eyes to recognize the various nuances in color. Take a look at your surroundings and compare the tonal values you can see. Decide whether an object is darker or lighter than the things around it. Is the glittering sea lighter or darker than the sunlit sky? Is a white seagull lighter than the sky, or darker? Objects differentiate themselves from their surroundings through this diversification in values; moods can also be expressed by fine nuances in tone. For these reasons it is very important to be familiar with the various values of gray. Think of the apples mentioned on pages 18 and 19. If we now apply the six tones of gray to these and at the same time alter the size relationships, the picture immediately takes on a feeling of tension and depth.

Before you read on, play around and experiment with these tones of gray and the apples. Make several sketches showing different combinations and sizes. Small tasks such as this will not only train your sight but also help you become familiar with the tone values around you.

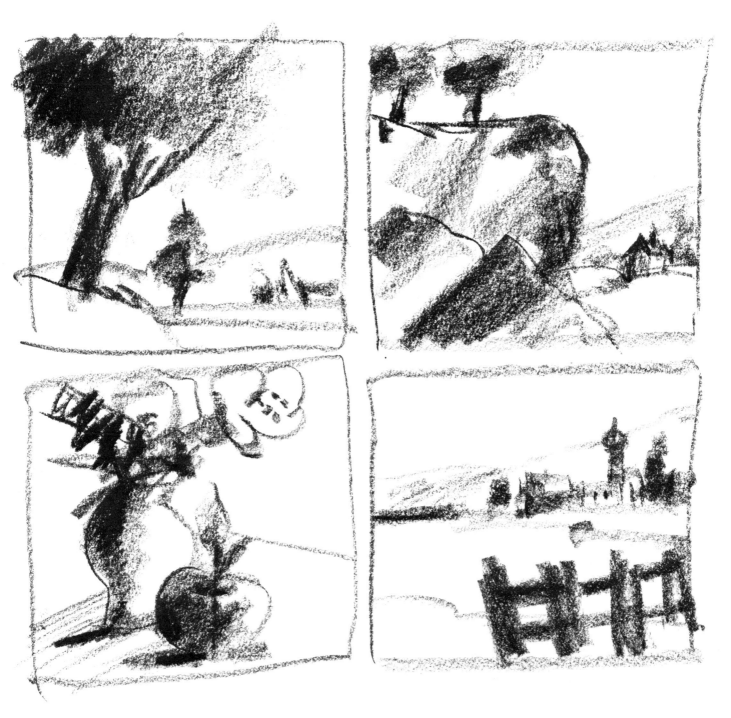

An interesting composition is no simple matter. It takes quite a bit of experimenting and trying out the various possible arrangements. Practice using the basic shapes, arranging them in different combinations and adding the gray tones. You will soon begin to feel whether a composition expresses harmony or not. I would like to mention here the importance of making sketches before beginning the final picture. They only have to be small sketches showing the elements of the picture in different arrangements and roughly determining the tones. If you proceed in this fashion, it will help you considerably when you come to finally deciding on the form of your picture. The examples shown above should give you an idea as to what such quick, simple sketches, capturing merely shapes and tones, can look like. Rough sketches of this nature will help you decide on the best composition and the best way to set about your final picture. Once you have learned to first think in terms of such sketches, you will certainly feel more confident when you begin a picture.

The Golden Section

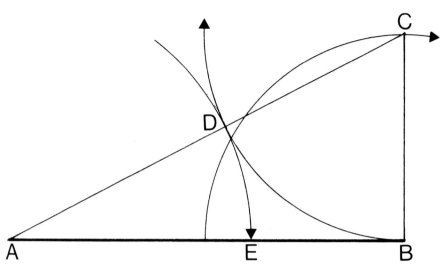

The Golden Section refers to a proportion which was, and still is, believed to possess a hidden harmonic quality in tune with the universe. It is used either consciously or unconsciously by most artists to render balance and aesthetic harmony to their works.

The Golden Section (also called the Golden Mean) is based on a mathematical theory advanced by the Greek geometrist Euclid. It is one way to place a picture's center of interest, and is based on the harmonious division of a straight line, where the ratio of the shorter section to the longer section is the same as the ratio of the longer section to the whole line. An area divided by means of the Golden Section will supply the artist with Golden Lines (in the example at right, lines *ad*, *bc*, *ge*, and *hf*), which are used for the proportionate subdivision of the area of a picture, and with "Golden Points," the points where these lines intersect.

Blotches of color placed on the Golden Points can influence the expression of a picture.

Here you can see how this geometric theory can be put to use in a watercolor picture. The lines indicate exactly where the Golden Section is to be found. The center of interest falls within the Golden Section.

The diagram above shows how the line AB can be harmoniously divided according to the Golden Section. First, a perpendicular line that is half the length of AB is drawn from point B. The end of this line is point C. Join C and A. On this new line determine point D by using a compass with a radius equal to BC and drawing an arc from C to cut line AC. Then with radius AD draw an arc from A through line AB, creating E. The harmonious proportion, EB is to AE as AE is to AB, has thus been found.

This construction was used to

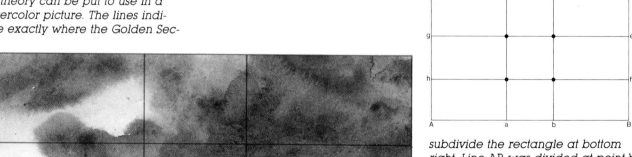

subdivide the rectangle at bottom right. Line AB was divided at point b using the procedure shown at the top of the page. It was also divided at point a (segments Aa and Bb are equal). Then the sides of the rectangle, AD and BC, were drawn equal to the length of Ab. The sides were then divided into thirds to give points e, f, g, and h.

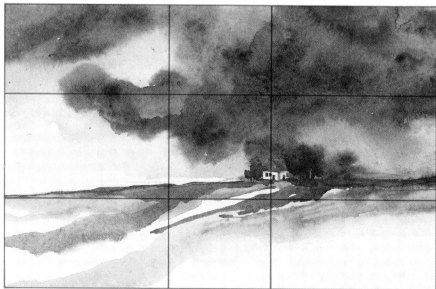

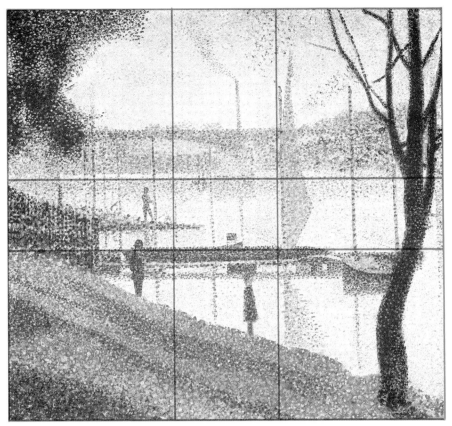

"Le Port de Courevoir"—a picture painted in the Pointillistic manner— uses vertical and horizontal divisions plotted according to the Golden Section. Original size: 457 × 546 mm (17¾ × 21¼ inches).

Georges Seurat (French painter, 1859-1891) was an artist who built up his paintings geometrically. After making numerous field sketches merely as a source of stimulation and information, he would then evaluate these in his studio for his pictures. Many of his compositions are exemplary models for the classical use of the Golden Section as the two pictures on this page show particularly clearly.

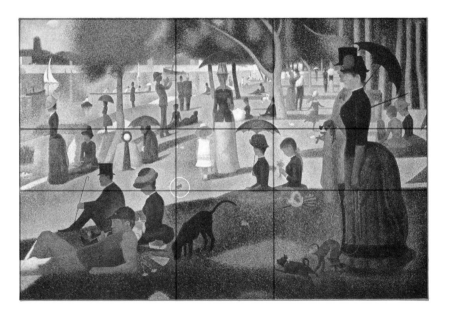

Seurat produced approximately 62 sketches and color compositions for "Une Dimanche d' Eté à l'Ile de la Grande Jatte." The positioning of the butterfly above the black dog is a good example of the punctiliousness and exactitude of the composition. It is fluttering right over one of the Golden Points. Original size: 210 × 288 mm (8¼ × 11¼ inches).

Perspective

It is necessary to spend a bit of time studying perspective in order to get figure and forms "right" in drawings as well as in paintings.

A perspective construction is an aid to promoting the illusion of three-dimensional depth in a picture. There are two types of perspective, parallel and vanishing-point perspective. While this can be a very detailed subject, you should not allow yourself to be carried away with the mechanical application. It's so easy to spoil the spontaneity of a picture by becoming engrossed in "getting it right."

Parallel Perspective

Parallel perspective is the simplest form of three-dimensional representation. We observe the object obliquely from above, so that, in the case of a rectangular object, three sides can be seen at the same time. All lines run parallel to each other. The surface on which the object is standing is at an angle to the observer's line of sight. There is a whole series of methods for drawing something in parallel perspective, each with its own rules. The most common methods are:

1. The isometric system

2. Cavalier's perspective

3. Military perspective

The isometric system, shown in diagram 1 at right, uses the dimensions of the main axes. The sides are drawn at a 30-degree angle to the horizontal plane on which the object is standing. The cavalier's perspective, figure 2, is a commonly used frontal perspective. In this case the most interesting face of an object is drawn facing the observer in its original dimensions. The length of the two remaining sides is cut by half and the lines are drawn at an angle of 45 degrees to the horizontal. In the military perspective, figure 3, the unchanged outline is rotated at the desired angle to the horizontal. The perpendiculars are drawn parallel to each other at a 90-degree angle to the horizontal and reduced in length by one third.

Vanishing-Point Perspective

In parallel perspective, you saw that the lines of a rectangular object ran parallel to each other—they never met. Vanishing point perspective is based on the idea that parallel lines, if continued, will meet somewhere on the horizon. This phenomenon is easily apparent on flat surfaces where you can see the horizon (the dividing line between earth and sky), such as on the open sea or in a desert. In such cases you can observe how lines running parallel to one another appear to meet at a point—how, to our eyes, widths and heights diminish and shrink to a single point, called a vanishing point. (See the illustration at top right.) This is referred to as a central perspective.

Should the horizon not be visible to us, because of hills or tall buildings, perhaps, the horizon line can be imaginary. It is always on a level with the eye level of the artist or of the observer featured in the picture, no matter whether he is sitting, standing, or lying down. In cases like these, we use auxiliary lines (vanishing lines) to help draw our pictures. The vanishing lines are established by extending the parallel lines of a drawing until they meet. They can help create an illusion of three-dimensionality on the two-dimensional surface of the paper.

In some cases, it might be necessary to work with more than one vanishing point. (See the drawing at bottom right.) This depends on the relative position of the objects or buildings we want to draw to our eye.

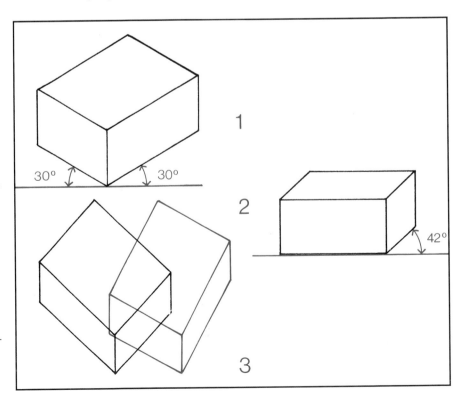

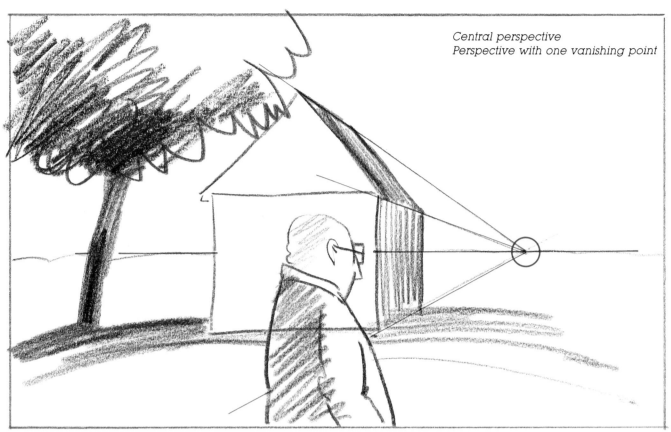

Central perspective
Perspective with one vanishing point

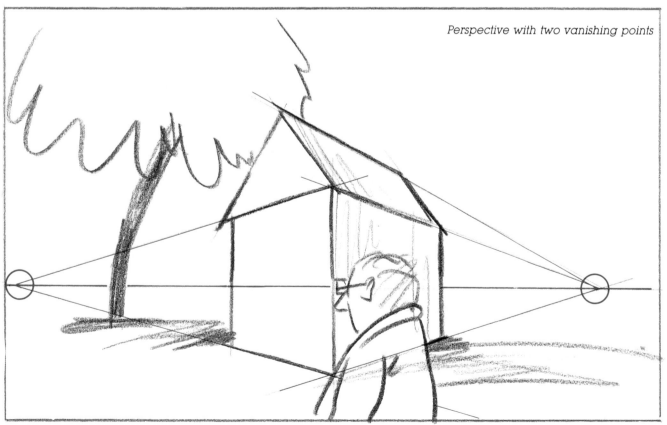

Perspective with two vanishing points

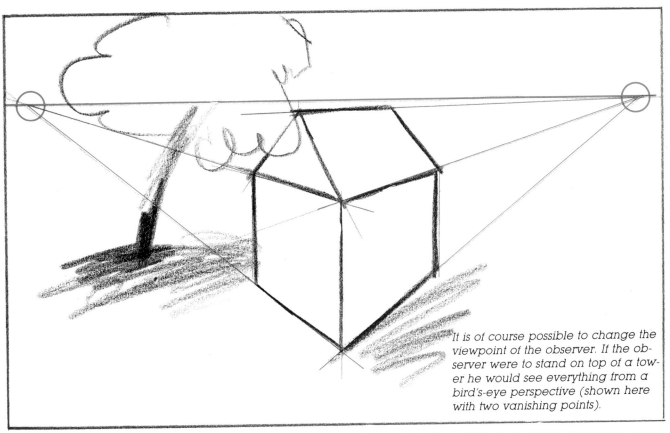

It is of course possible to change the viewpoint of the observer. If the observer were to stand on top of a tower he would see everything from a bird's-eye perspective (shown here with two vanishing points).

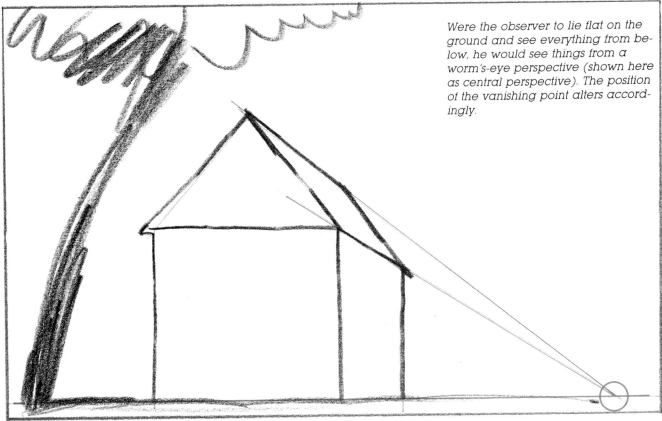

Were the observer to lie flat on the ground and see everything from below, he would see things from a worm's-eye perspective (shown here as central perspective). The position of the vanishing point alters accordingly.

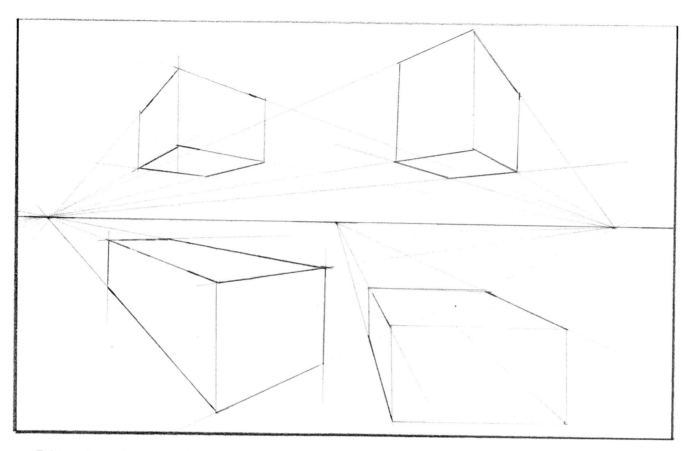

Take a piece of paper and draw a cube or a house from different angles. Try, without involving yourself in complicated constructions, to determine the various vanishing points that come from different perspectives. Here I have shown a couple of examples. Should you want to learn more about perspective, you should refer to a textbook, as I can only touch on the basics needed for drawing and painting here.

Light and Shade

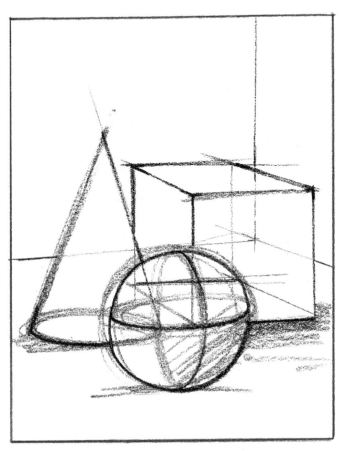
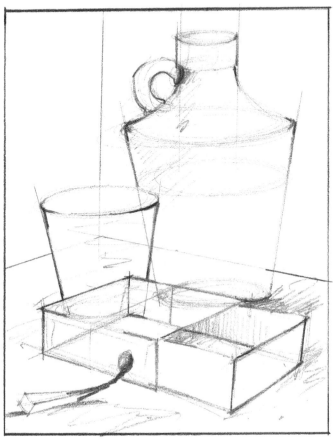

Whenever you want to draw something you see realistically you will always be faced with the problem of having to reproduce a three-dimensional scene on your two-dimensional paper or canvas.

This is not very easy, as the automatic tendency is to draw things too flat. There is a practical tip to help overcome this problem: draw through objects as if they were transparent, looking carefully to find the basic forms. For the sake of ease begin with objects that you can in fact see through, such as a water glass, a vase, or a bottle.

If you cannot find any rectangular transparent objects, you could use a matchbox. By taking the inside section out of this you will have a cubic object where all eight edges are visible.

In the pictures shown above, I have taken some simple and some not-so-simple objects and first outlined their

contours. This ensures that objects in a picture do not look as though they are about to topple over. The line in the center of the picture indicates the surface on which the objects are standing, and also helps to fix the relation of the objects to the verticals. This helps make you more aware of the spatial relationships. With your next study, you should try to include this feeling of spatiality by incorporating the factors of light and shade to mold the objects you are drawing.

Observe how an object appears to change depending on how the light falls on it, and try to capture this in your drawing.

Using the basic forms once again, notice how an object is lacking in solidity and depth when drawn linearly. It's only when light and shade are added that it starts to take shape. There are two kinds of shade: object shadow and cast shadow. Object shadow, the shadow that falls on the object itself, molds the object. The cast shadow, the shadow that an object casts onto the surface in front of it, indicates its position, whether it is standing, lying, or floating. Thus the cast shadow can be a very important means of expressing the required message of a picture.

These linear drawings of a cube, sphere, and cylinder show nothing more than a rectangle, circle, oval, and square.

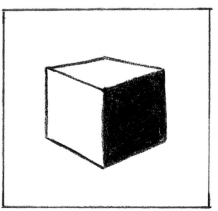

By using a source of light, however—imagine this coming from behind, on the left—we can give these basic shapes more depth. Their exact position is, however, still not clear.

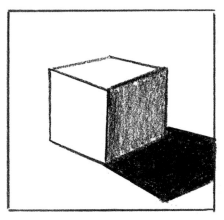

If we now add a cast shadow, we can clarify where, or on what surface, the object is to be found.

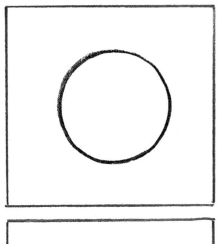

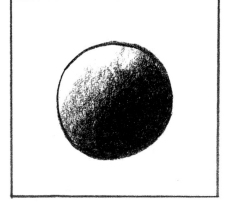

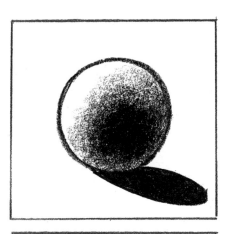

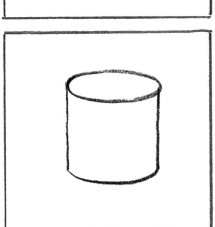

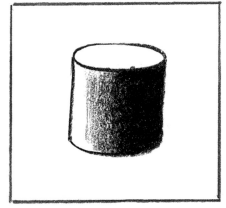

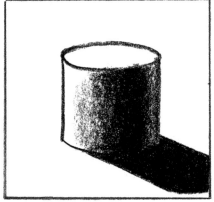

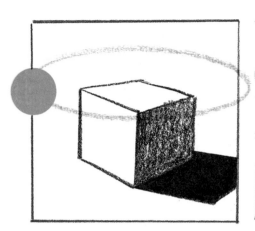

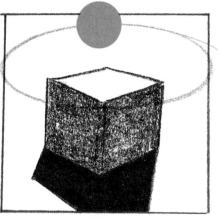

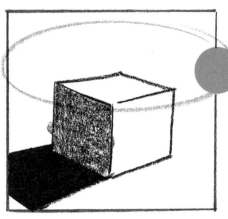

Also observe the various nuances in tone that are to be found in one shadow. You will certainly notice that an object shadow is always considerably lighter than the cast shadow. This is because the illuminated areas near the area in shadow reflect light onto the shadow, creating a diversity in the darkness.

In the above illustrations, a source of light is traveling round a cube at an equal distance from the cube. If the light comes from the left, the shadow will fall on the right. When the light is above and behind the object, all visible sides will be in shadow and the cast shadow will wander towards the observer.

Light coming from the right casts a shadow on the left. Once again, one side of the object is in shadow and the other in light.

The height of the sun varies, however, as it circles an object, as is shown here with this tree. As a result, the shadow length increases the deeper the sun sinks.

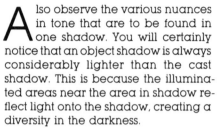

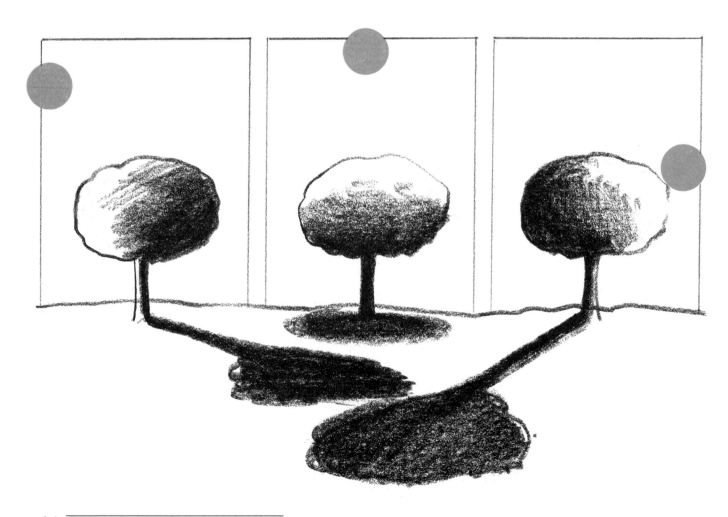

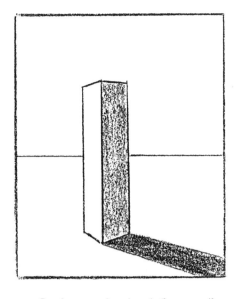
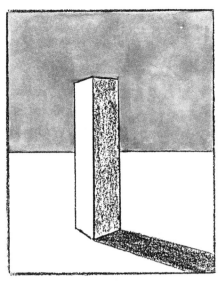
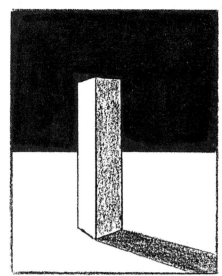

Backgrounds also influence the effect of a shadow. Look at the gray tones of the shadows in the above examples. Do you see any differences in darkness? A light background makes the shadow appear darker, whereas a dark background gives it the appearance of being lighter. A cast shadow is, however, always darker than the object shadow.

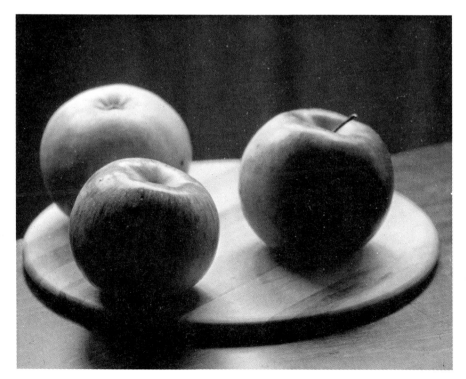

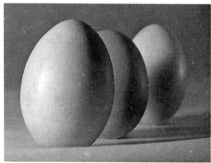

Some examples using photographs: Here we have our three apples once again and also three eggs. In the case of the apples, the light is shining from above and behind, as was illustrated in the middle example on page 34. The smooth surface of the eggs makes it very easy to discern the shadows. The light is coming from above on the left. Try to analyze these photos using the information gathered in this section.

DRAWING

The wonderful thing about drawing is that you are not restricted as to where you draw, nor are you encumbered by heavy equipment. All you need is a pencil, some charcoal or crayon, and some paper and you can set to work wherever you are. The pencil is certainly the best known drawing instrument, although pencils, as we know them today, have only existed since the eighteenth century. Graphite pencils were first introduced into England in the sixteenth century; before that silver points were commonly used. These are pointed instruments made of a mixture of tin and lead. The first lead pencils were made from a carved wooden cylinder filled with graphite and clay (or other fillers). Today synthetic graphite means that these pencils can be produced in varying grades of hardness.

The drawing below was made using a soft pencil (2B) and a carpenter's pencil to produce the different qualities in the pencil lines and add a softness to the drawing.

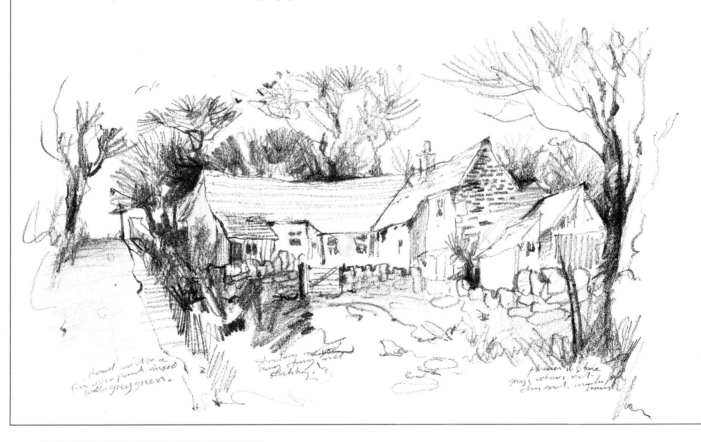

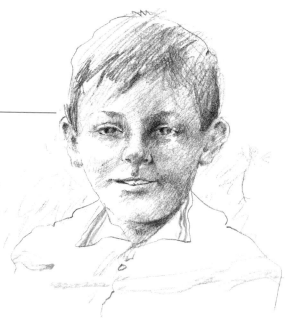

This portrait of a child was drawn using an HB pencil on soft paper. This pencil is soft and light to use, so it is especially suitable for capturing light and shade in soft, delicate forms such as those in the face of this child.

All over Venice you can watch artists making drawings like this. This effect is achieved by taking a black, sharp-edged conté crayon held flat against the paper. Italian students sell these pictures to tourists for next to nothing to finance their studies. The most amazing thing is the speed in which they can be produced. (This picture took the young man no more than ten minutes to complete.)

Charcoal has always been a favorite material for many artists when it comes to making a quick sketch or drafting an oil painting. But charcoal can be equally well used as a technique in itself. In this picture the charcoal has been used very freely, mainly to capture the qualities of light and shade.

Beginning to Draw

Drawing/sketching—what does this entail? Is it really art? Why would so many people like to master its secrets?

Almost all young children have a talent for drawing and painting, but they tend to lose it in later years. Why?

Young children have, as do many famous modern artists, a very free approach to drawing. They simply draw whatever interests them and ignore superfluous details; they're not concerned whether a picture is "finished" or not. The main difference between the child and the modern artist is that the child has no knowledge of technique.

From the moment the child goes to school, he starts to lose his spontaneity. He is taught what is right and wrong and trained to think in very rigid terms. If someone comes into contact with drawing and painting later in life, it is sometimes possible that these earlier talents and free-spirited attitudes can be reawakened.

But a good picture does not always just "happen." You usually have to try out several possibilities before you can form an idea. Most of the works of the Old Masters were preceded by numerous studies and sketches.

Sketches document the development of a picture, and help you feel clear about what it is expressing. They are the only way to prepare yourself to make the best of your picture.

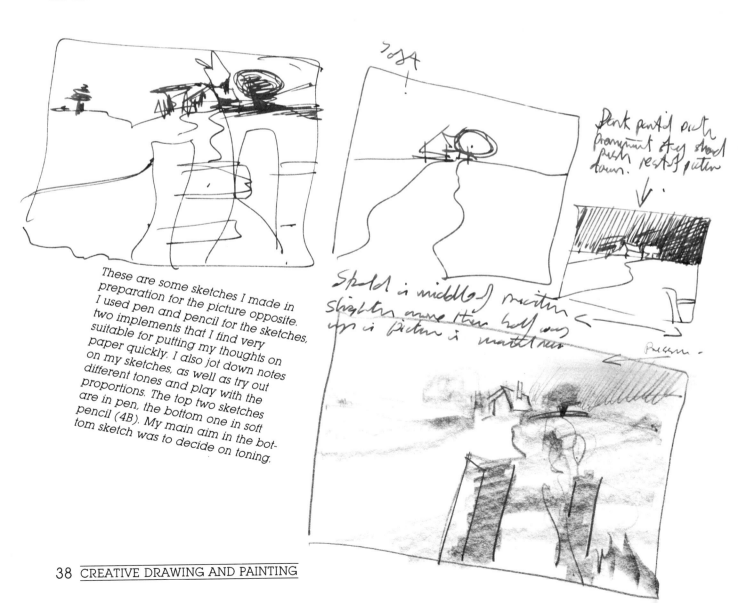

These are some sketches I made in preparation for the picture opposite. I used pen and pencil for the sketches, two implements that I find very suitable for putting my thoughts on paper quickly. I also jot down notes on my sketches, as well as try out different tones and play with the proportions. The top two sketches are in pen, the bottom one in soft pencil (4B). My main aim in the bottom sketch was to decide on toning.

What is the difference between a sketch and a finished drawing? A sketch can be seen as a quick method of recording ideas and as an aid to working out the composition and configuration of a picture. The sketches of the Old Masters often give insight into the message they wished to impart in their finished works, and it is often more informative to study their sketches and drafts than to study the finished piece of work.

There are also many different ways of sketching. Leonardo da Vinci (Italian painter, sculptor, architect, natural scientist, and engineer, 1452-1519) used to sketch fantastic machines that were way beyond his times; John Constable (English painter, 1776-1837) and William Turner (English painter, 1775-1851), both forerunners of Impressionism, used to make authentic sketches outside their studios. A third possibility is to sketch from memory.

It is only recently that sketches and unfinished drawings, which used to be stored away to gather dust in archives or back rooms of galleries, have begun to appear in exhibitions and catalogs. Over the years the general attitude towards the sketch as something subordinate has changed, and nowadays a sketch is very often displayed as a work of art in its own right.

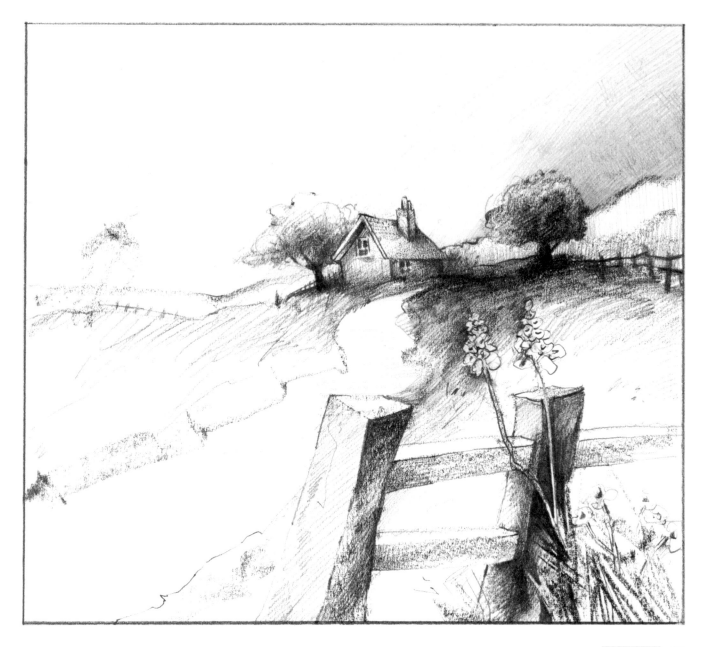

Materials
FOR DRAWING

Don't get worried! You don't have to go out and buy all the materials shown here. Let's start with the pencil. These can vary from very hard (7H) to very soft (9B). You will soon find out for yourself which of these you prefer.

There is a choice between the normal wooden pencil and the mechanical pencil. The advantage of the latter is that it is only necessary to buy the holder once because the leads, which are available in all grades, can be replaced. Another popular type of pencil is the lead holder, which can take any size of lead from very fine even up to pastels. You can, if you so desire, work with a superfine mechanical pencil, providing you do not press too hard on the delicate lead.

Whatever type of pencil you use, you will also need an appropriate sharpener. Leads also can be sharpened using a piece of sandpaper.

Another essential is a good eraser. Here again, there are hard and soft erasers on the market. If, however, your eraser is too hard, it will roughen the surface of your paper, which can jeopardize your work (ink, for example, tends to run). After erasing always clean your paper with a small brush, since it is easy to smudge if you use your hand.

Charcoal, conté crayons, and pastels are also available in pencil form, which lets you avoid getting messy fingers. The casing of a graphite pencil is lacquered to make it easier to hold.

Finally, I'd like to mention fixatives, which are used to protect drawings against smudging and to make them more durable. Fixatives are available either in the form of an aerosol spray or as a bottle with a spray diffuser.

As to all the things you can do with knives, razor blades, carpenter's pencils, ballpoint pens, and paper smearers—I'll come to all these later in the chapter.

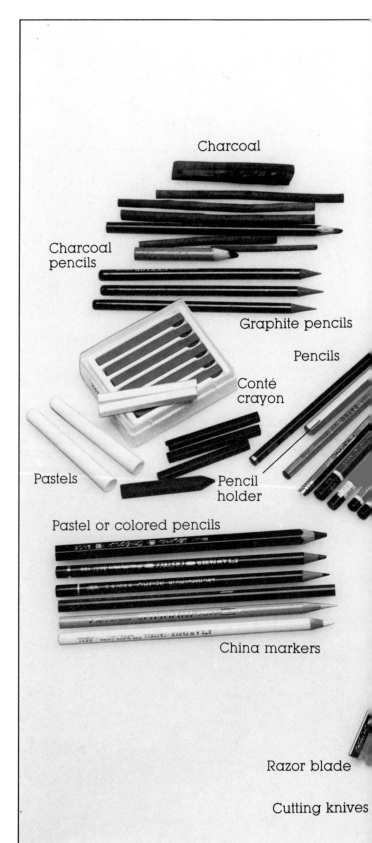

Charcoal

Charcoal pencils

Graphite pencils

Pencils

Conté crayon

Pastels

Pencil holder

Pastel or colored pencils

China markers

Razor blade

Cutting knives

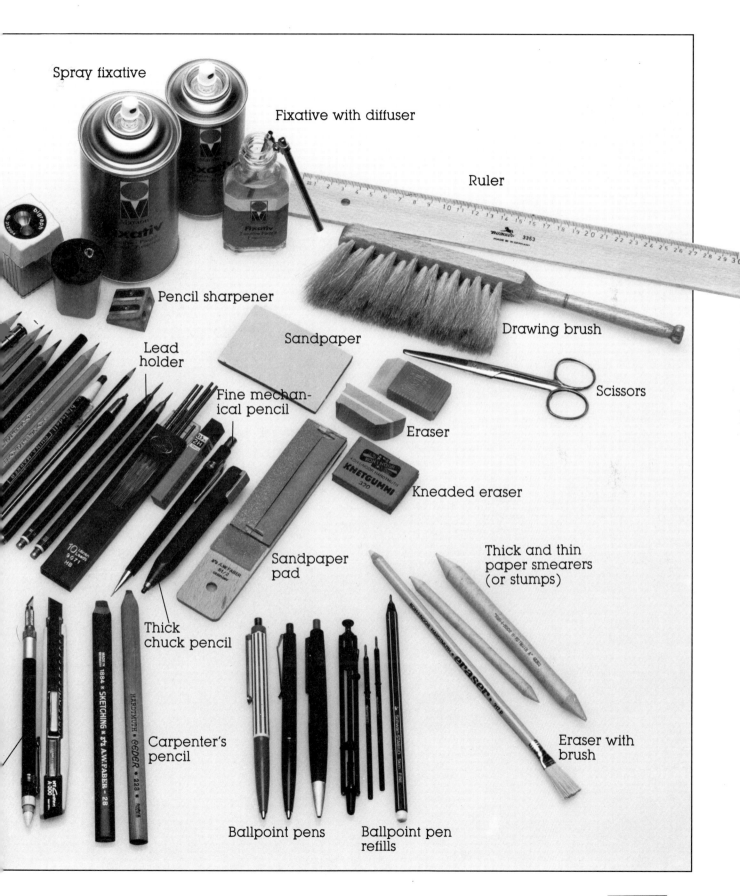

Spray fixative

Fixative with diffuser

Ruler

Pencil sharpener

Drawing brush

Lead holder

Sandpaper

Fine mechan-ical pencil

Scissors

Eraser

Kneaded eraser

Thick and thin paper smearers (or stumps)

Sandpaper pad

Thick chuck pencil

Carpenter's pencil

Ballpoint pens

Ballpoint pen refills

Eraser with brush

Drawing Paper

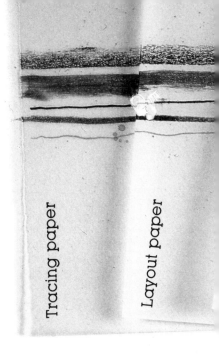

Tracing paper

Layout paper

There are no hard-and-fast rules concerning paper; it is possible to draw on any type of paper. Maybe it is best to try out several kinds to see which you prefer to work with.

One of the most important aspects you should consider in the beginning is the surface quality of the paper. As you will see from the examples given here, a pencil line has a smoother texture on soft paper than on rough paper. There are some artists who prefer to work on wrapping paper, which goes to show that it's not always the most expensive paper that's best. Don't be afraid to experiment using more unusual forms of paper! If you can find several different kinds of paper, you could make your own block by fixing them together onto a clipboard or a hard piece of cardboard. It is better if you use two clips to stop the paper from slipping or flying away when you're working outside.

Paper is graded according to weight, which is determined by how much 500 sheets (called a ream) weighs. Drawing or sketching papers may be as lightweight as 16-pound or 20-pound paper, or as heavyweight as 50-, 100-, or even 140-pound. If you want to work with ink or felt-tip pens, it is important that the paper is nonfibrous so that these materials will not run. There is also nothing to stop you from drawing on watercolor paper if you want. (You should know that drawing paper is graded according to the weight of paper that is 17×22 inches, while watercolor paper weight is based on 22×30 inches.) The structure of watercolor paper can lend a flair to your drawing and is very hard-wearing. Since it's possible to buy most types of paper in separate sheets, it's cheaper if you first buy a variety of sheets and experiment using different materials.

Rough grain

Medium grain

Fine grain

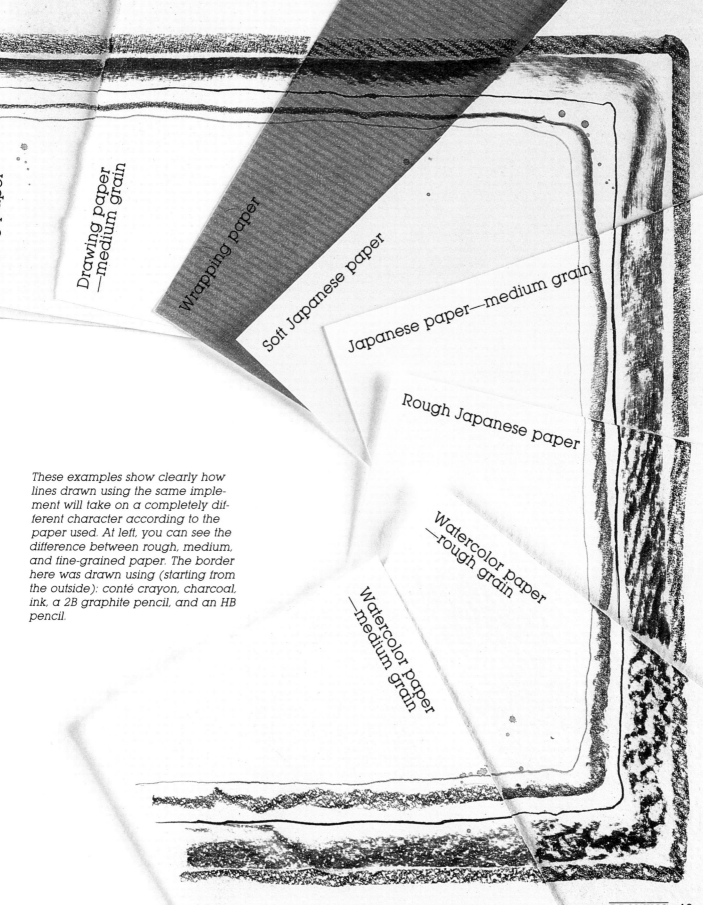

Drawing paper
—medium grain

Wrapping paper

Soft Japanese paper

Japanese paper—medium grain

Rough Japanese paper

Watercolor paper
—rough grain

Watercolor paper
—medium grain

These examples show clearly how lines drawn using the same implement will take on a completely different character according to the paper used. At left, you can see the difference between rough, medium, and fine-grained paper. The border here was drawn using (starting from the outside): conté crayon, charcoal, ink, a 2B graphite pencil, and an HB pencil.

Pencil

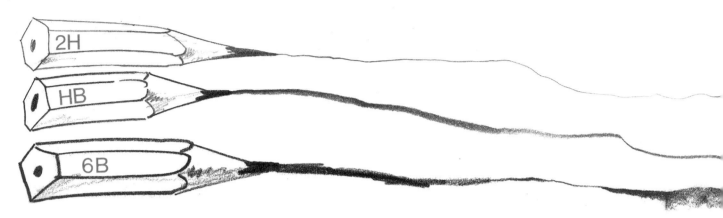

You have used a pencil thousands of times, but have you ever stopped to think how versatile a simple pencil can be? You will probably find that you use pencils more often than any other drawing implements. A pencil is called for if you are sketching out a watercolor picture just as it is for setting the composition of an oil painting. There is an enormous choice in the various types of pencils, but as a beginner you only really need three grades: a soft, a medium, and a hard pencil. You will also need large quantities of paper for experimenting and practicing. Cheap paper such as typing paper or newsprint is quite sufficient for this purpose.

To begin with, we'll use three grades of pencil:

2H	hard
HB	medium
6B	very soft

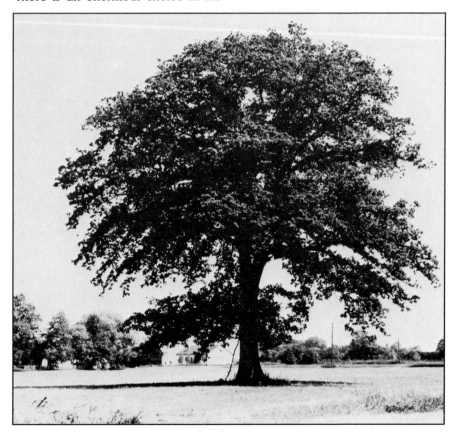

This is a photograph of a tree from which I've made sketches using these three grades of pencil. You will notice how the character of the tree changes according to the pencil I'm using.

Always make sure that you have a smooth surface under your paper, such as another piece of paper or cardboard. Otherwise you will find that the imprint of the surface you are leaning on will come through the thin paper.

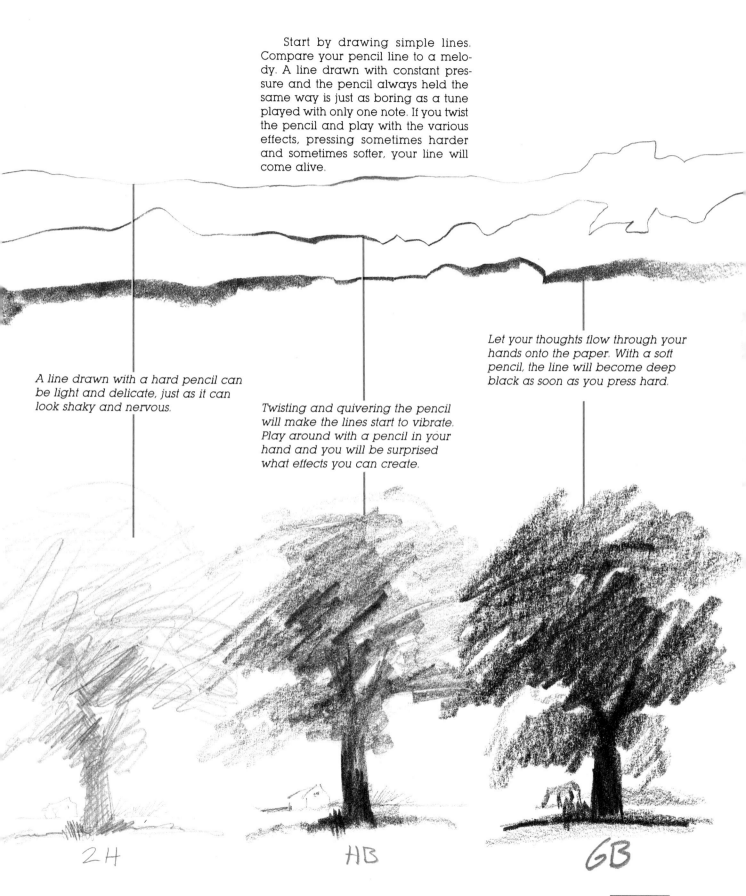

Start by drawing simple lines. Compare your pencil line to a melody. A line drawn with constant pressure and the pencil always held the same way is just as boring as a tune played with only one note. If you twist the pencil and play with the various effects, pressing sometimes harder and sometimes softer, your line will come alive.

A line drawn with a hard pencil can be light and delicate, just as it can look shaky and nervous.

Twisting and quivering the pencil will make the lines start to vibrate. Play around with a pencil in your hand and you will be surprised what effects you can create.

Let your thoughts flow through your hands onto the paper. With a soft pencil, the line will become deep black as soon as you press hard.

2H

HB

6B

Doodles and aimless drawings are a very good way of becoming acquainted with a pencil. These scribbles are stimulating in as much as you will discover unconscious shapes that you can work on.

Don't be afraid to cover a number of sheets of paper with these as you will soon see how this can help release your imagination. A circle can suddenly turn into a flower, a rectangle into a building.

From my example of the tree, you can see how many different pencil techniques can be used in drawing one subject.

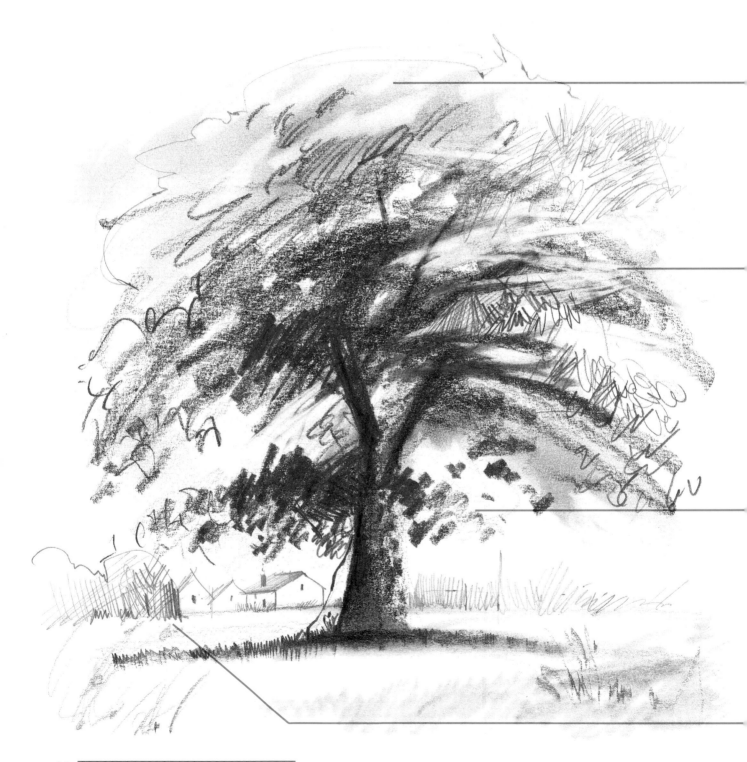

If you rub your finger over a pencil line you will produce a soft area of gray, which can be easily combined with the lines if you want. This can be further set off with lighter areas using a kneaded eraser.

Don't be afraid of rubbing over the pencil lines with various types of erasers to produce a light effect in the darker areas. The results of this will be more intense the softer your pencil is. Experiment until you get a feeling for this technique.

A pencil held upright will produce very different lines from a pencil that is held flat against the paper. Try this out!

Crosshatchings develop structures and are very useful for drawing shading. A harder pencil is used for this technique. Combined with a soft pencil, this technique can produce some very effective contrasts.

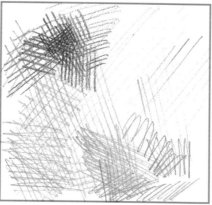

A soft pencil held flat against the paper will give a more intense effect than a harder one. The paper itself also plays an important role in this technique. Compare the results using first a piece of rough paper and then a piece of smooth paper. You will see that the lines on the rough paper are more frayed than those on the smooth paper.

The next four pages illustrate some of the many possibilities the pencil offers. Some of the structures may, at first glance, appear very complicated and difficult, but I am certain that with some practice you will be able to produce not only many more, but also very different effects.

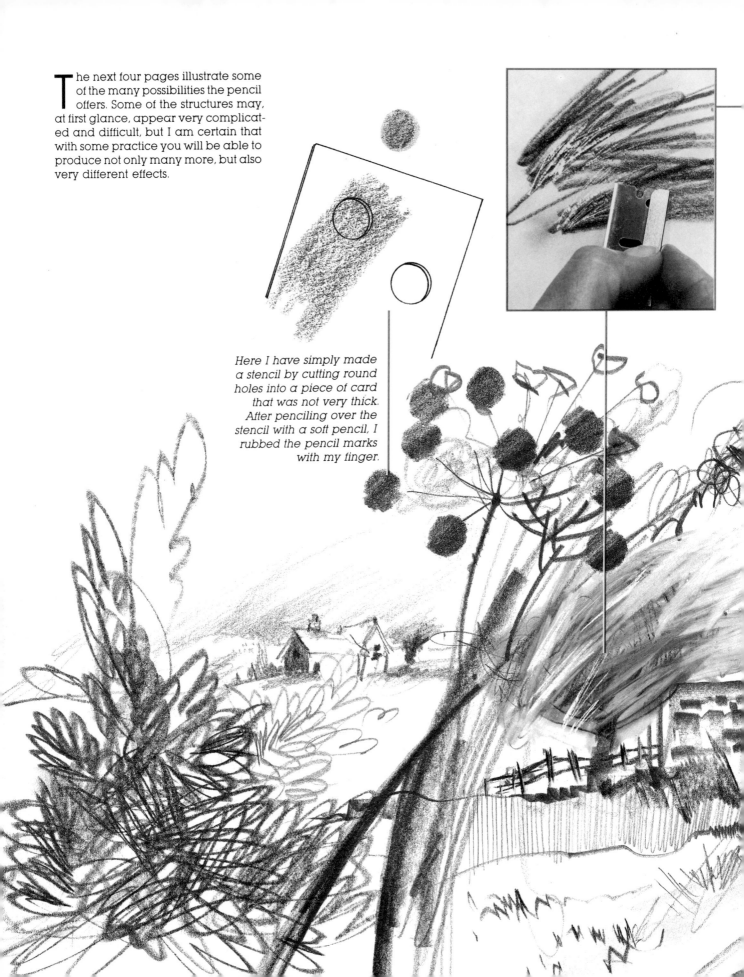

Here I have simply made a stencil by cutting round holes into a piece of card that was not very thick. After penciling over the stencil with a soft pencil, I rubbed the pencil marks with my finger.

A razor blade can be used to scratch into penciling to give such effects as a tree gently moving in the wind (smooth paper is better than rough paper for this).

Another way of producing the effect of a stone wall is as follows: Draw a base using a soft pencil or a carpenter's pencil and then trace the structure of the bricks over this with a harder pencil.

This simple tree structure is produced by quick backward and forward movements of the pencil, turning the pencil slightly at the same time. Be courageous and let your hand move freely and quickly over the paper.

The structure of this wall was achieved using a carpenter's pencil and alternating pressure on the lead.

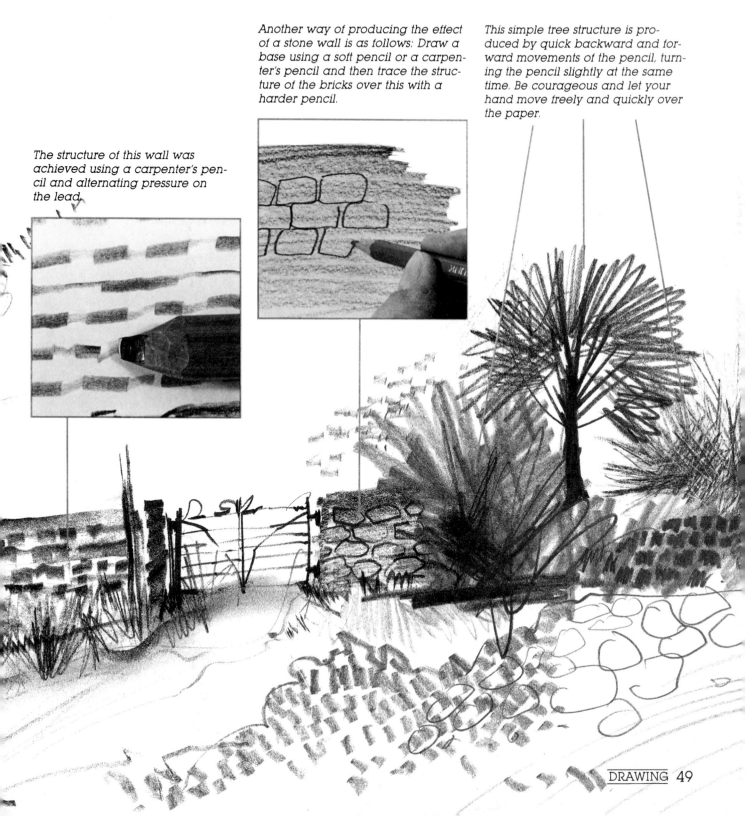

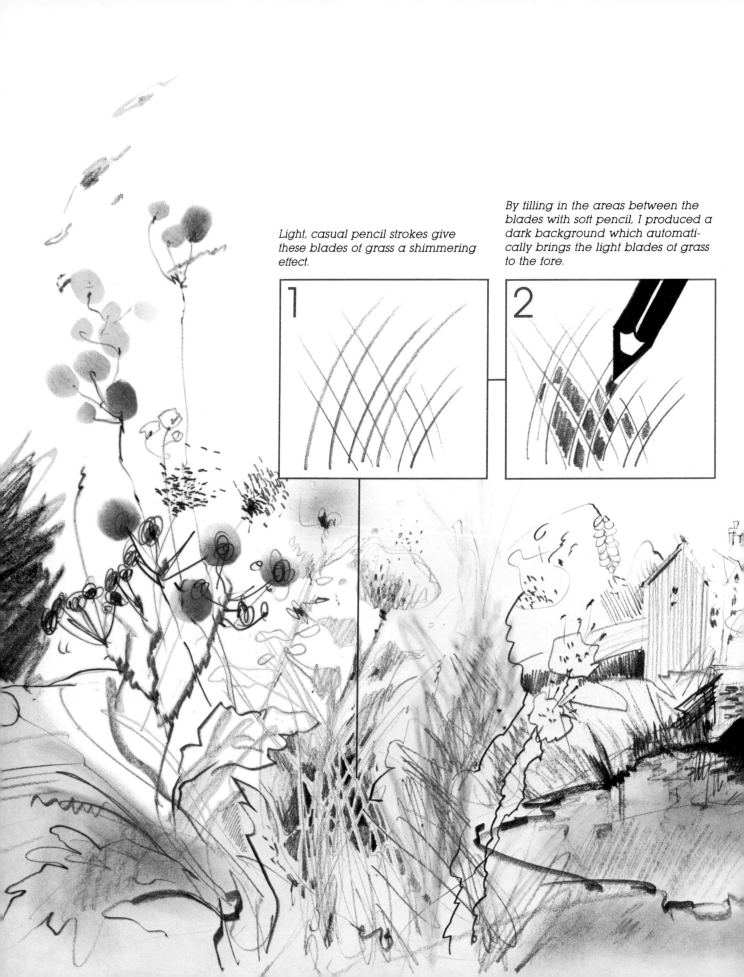

Light, casual pencil strokes give these blades of grass a shimmering effect.

By filling in the areas between the blades with soft pencil, I produced a dark background which automatically brings the light blades of grass to the fore.

This somewhat stubbly grass structure can be achieved by making short, quick jabbing strokes with an HB pencil held at a slight slant.

The technique used for the grass along the bank is very simple. A pencil is held as flat as possible against the paper and moved up and down quickly.

This tree was made to look slightly aggressive by using a thick, soft pencil, held flat against the paper between the thumb and forefinger. I moved the pencil quickly across the paper, stringing lots of little strokes together.

Step by Step

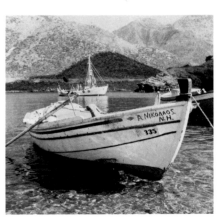

"Draw, draw, draw," Michelangelo (Italian sculptor, painter, and architect, 1475-1564) would say to his assistants, and this maxim is still valid for all artists today. The pencil, with its myriad of possible uses, is the basis for further artistic development. Once you have discovered this, you will have made a great step forward. You should not regard the pencil as a compulsory evil, but more as a friend that can help you express your feelings.

For many people a vacation is a time when they, at long last, have the

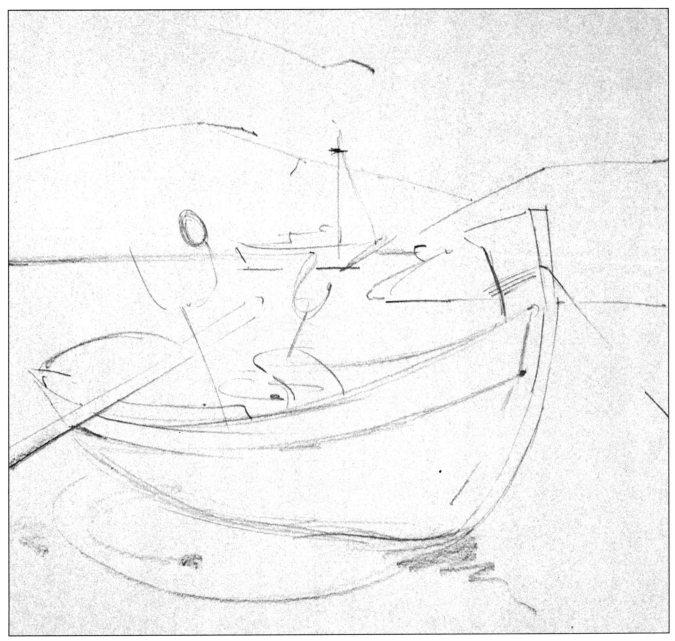

opportunity and the peace to draw or paint. The memories they take home in this form can be just as lasting as photographs—if not more lasting. Here I have chosen a motif from a Greek holiday: some boats rocking gently on the water. It is always better to draw directly from nature than from photographs, but it is unfortunately beyond my limits to be able to transpose you into nature in this book.

Step one: To set the composition and determine the relative dimensions, I used an HB pencil and slightly textured drawing paper. While your hand moves lightly and easily over the paper, you should try to keep your eye on the composition as a whole and not get lost in details. In the photo you can see, on the right, half of another boat that I decided to leave out of my picture because I felt it was a disturbing factor. I also moved the boat in the background slightly to the right to give more space to my boat in the foreground.

Step two: I built up the main areas of shade using soft pencils (2B and 6B).

The comparative roughness of the water around the boat was emphasized by way of a carpenter's pencil. I used the rubbing-in technique to contrast the softer areas of the boat. At this stage, I could make the outlines, based on the light lines of the original sketch, stronger and more defined.

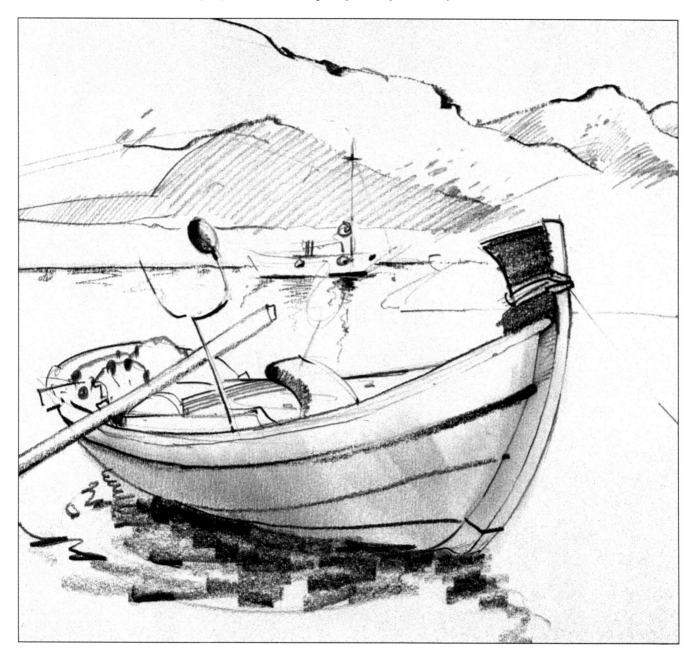

Step three: The tone values in the water, boat, and landscape were gradually brought out using pencils (HB and 6B) with the lead held flat against the paper.

I had sharpened the lead of the soft 6B pencil to make it as long as possible. This meant that I could cover larger areas with this pencil. Form and structure of the wooden boat can be reproduced by pencil lines that become gradually darker. I further emphasized the slightly churned-up surface of the water in the foreground by

jagged lines with a 6B pencil, once more holding this flat against the paper. This gives the impression that the boat is lying heavy in the water.

Step four: The lightness and darkness in the cliffs behind the second boat were also brought out by gradual toning. The dark cliffs in the front connect the close foreground to the very distant background. This diagram illustrates the progression of depth in the picture.

The reflections in the water were then made to seem softer using an

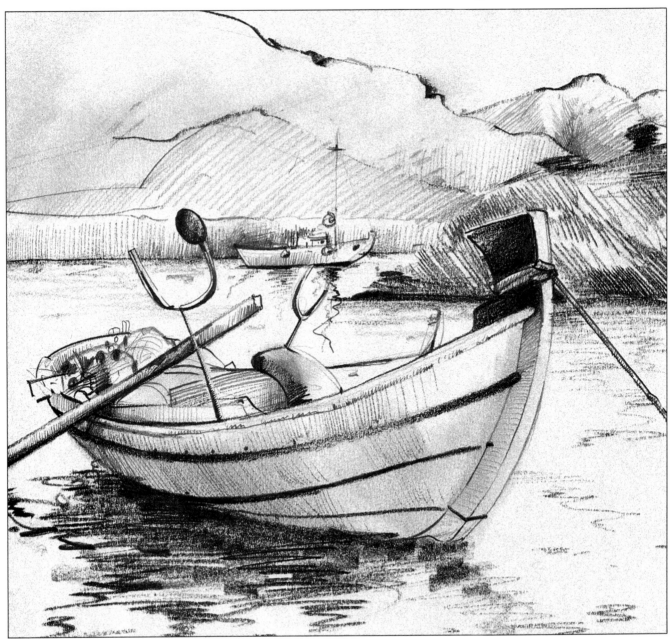

eraser and a paper tissue. This also produced a contrast to the wooden structure of the boat. After this I drew in the lettering and numbers on the side of the boat using a very sharp HB pencil, and immediately the drawing became more intimate, the situation seemed clearer. In addition, this clear lettering draws the boat even further into the foreground—if you can read the writing on something, this object must be fairly close.

Compare the tone values that become lighter the more they dissolve into the background with the points discussed on page 23 concerning composition.

It is possible to draw the same motif without concentrating on tone values and shade. You could, for example, make a detailed drawing of just the boat and only give a vague suggestion of the landscape, as I have done with the palm tree shown on page 64. In that picture I drew the palm tree in great detail and only included the monastery on the rocks to provide a background for the palm tree. Always bear in mind: your picture is a reproduction of your own personal impressions. No one can force you to draw in every single detail.

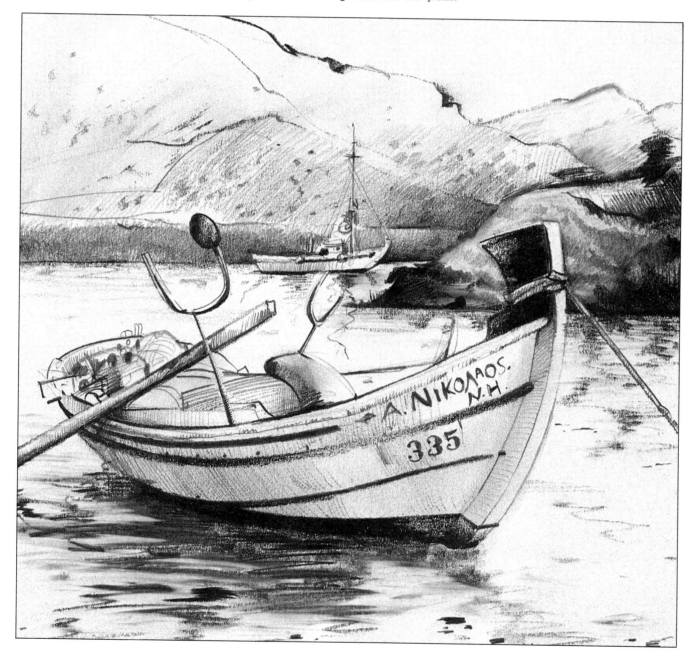

Charcoal

Fixative

Charcoal is without doubt one of the oldest drawing implements. It has proven its value for drawing linear, spacious, gentle, and dramatic pictures, but it is also well suited for quick sketches. The disadvantage: it is messy and will get not only all over your hands but also very often all over your picture, and not always where you want it! For this reason you should use a fixative (see box) for your picture and wash your hands often.

As always, the best way to discover the qualities of this material is by experimenting with it. Charcoal is especially useful if you want to combine lines and areas of tone. This can be done by intentionally smudging a charcoal line. Defined lines should be drawn with a sharpened piece of charcoal. It is also no problem erasing charcoal using a kneaded eraser if you make a mistake. Highlights can also be incorporated using this eraser.

Charcoal, chalks, and pastels tend to smudge very easily due to the fact that these materials do not contain any binders. You only have to lay one charcoal drawing on top of another to see that one will leave an imprint on the other. To avoid this you should use a fixative. These can be bought ready-made in two different forms: either as a spray or in a bottle with a diffuser. The diffuser consists of a small jointed pipe; the longer end of this pipe is inserted into the bottle to be filled with fixative solution; you then blow through the shorter end. Both types of fixative solution disperse a thin film over the surface of your drawing which prevents the charcoal from smudging any further.

You should practice the use of fixatives on a small piece of paper before using this on your drawing. You will see that if you spray too much or too close to the paper, this will cause the drawing to run and the paper will lose its shape. Always wash the blow sprayer after use to prevent sticking. It is also possible to apply fixative to a part of a drawing while you're working, providing you wait for the fixative to dry before continuing with your work. Also bear in mind that a drawing can no longer be corrected once fixative has been applied.

Take care only to spray fixative in a well ventilated room. Fixative solutions have a very pungent smell and can burn your eyes.

Charcoal can be used to draw all kinds of lines—from very thick to very thin—since it can, if necessary, be sharpened.

Charcoal and Water

There are two ways of working with charcoal and water. Either you scrape off some charcoal and mix this with water, or you can paint onto a charcoal surface. These techniques will produce completely different nuances in gray and in structure than can be achieved by simply rubbing charcoal with your fingers. The tones will become more flowing and softer. Take care, however, with your choice of paper. If it is too thin, it will warp.

Charcoal is a very flexible material. If you're unhappy with some parts of your drawing, these can be easily rubbed away using a paper tissue. Rubbing a tissue over charcoal will also produce a uniform tone of gray over large areas.

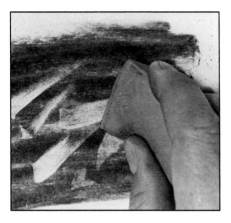

A paper smearer or stump is very useful for smearing charcoal and producing larger areas of gray. It consists simply of compressed paper rolled into the shape of a two-ended pencil. The same effect can be achieved by rubbing in charcoal scrapings with the smearer.

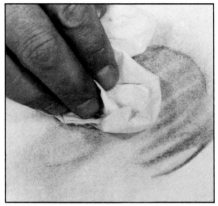

A favorite method for inserting highlights is to erase certain areas using a kneaded eraser.

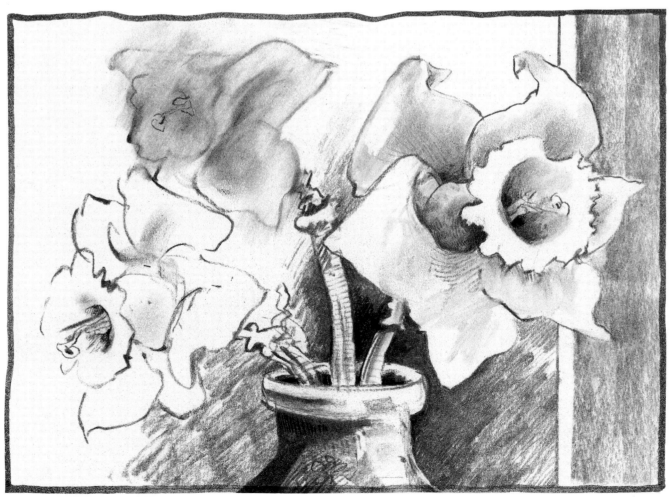

Conté Crayon

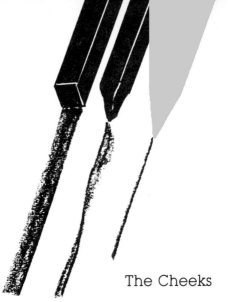

Conté crayons are made from compressed chalk and are available either as simple square crayons or encased in wood, like a pencil. They come in all the various earth tones as well as in black and in white. They are slightly harder than charcoal and do not tend to smudge as easily. Conté crayons must, nevertheless, also be treated with a fixative solution.

Because conté crayons can be sharpened or simply broken to give a sharp edge, a great variety of lines, from fine to very thick, can be achieved, making it possible to use these for fine, delicate work. This brittleness can be a problem, though, if conté crayons are not carefully kept in a separate box, away from other drawing materials.

Let's look now at a portrait in conté crayon which illustrates some of the possibilities this technique has to offer.

The Cheeks

Rubbing conté crayon with your fingers will produce a soft texture well suited for structuring facial features, such as the cheeks.

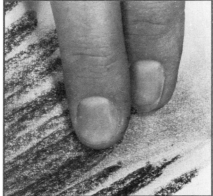

The Collar

It is also possible to combine various colors. On the collar, for example, I went over the brown with white conté crayon, to give a gray effect. By accentuating the outside contours of the collar with deep brown lines I was able to produce the impression of folds.

The Hair

Conté crayons can be sharpened, but it is just as possible to use the blunt, square, or even the broad side of the crayon, as I did here. First I lightly outlined the hair using the broad side of my conté crayon and then filled in details using one of the sharp edges.

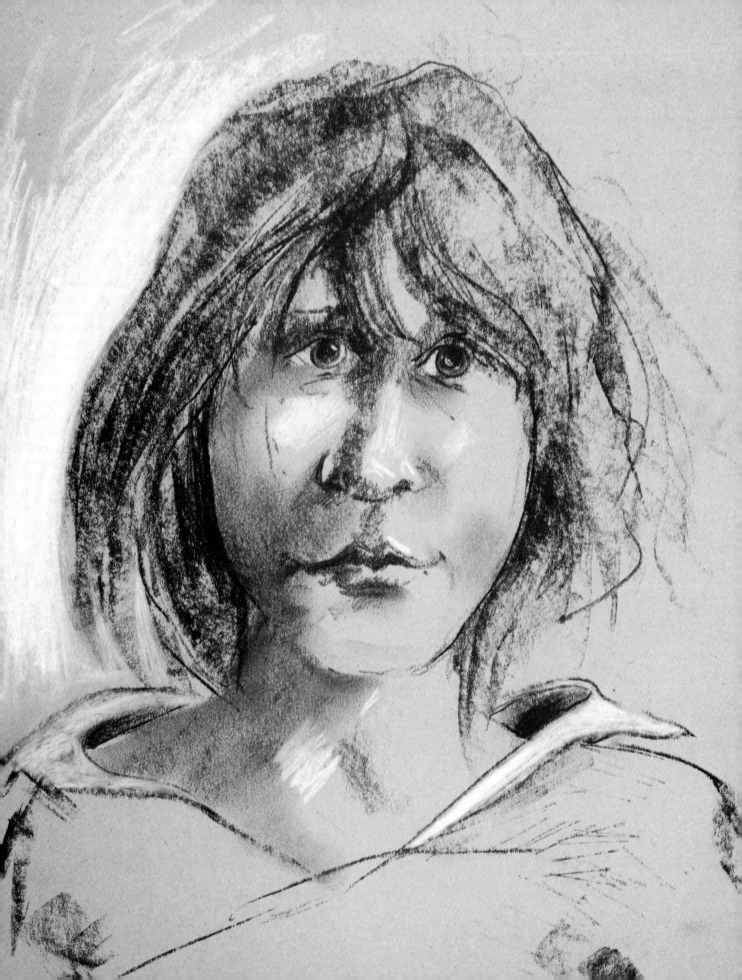

Ballpoint Pen

You might be wondering what the common ballpoint pen has to do with the subject matter of this book. In the past, it was not often used by artists due to its limited variability. But nowadays there is a much wider selection of good, nonsmearing ballpoints availa-

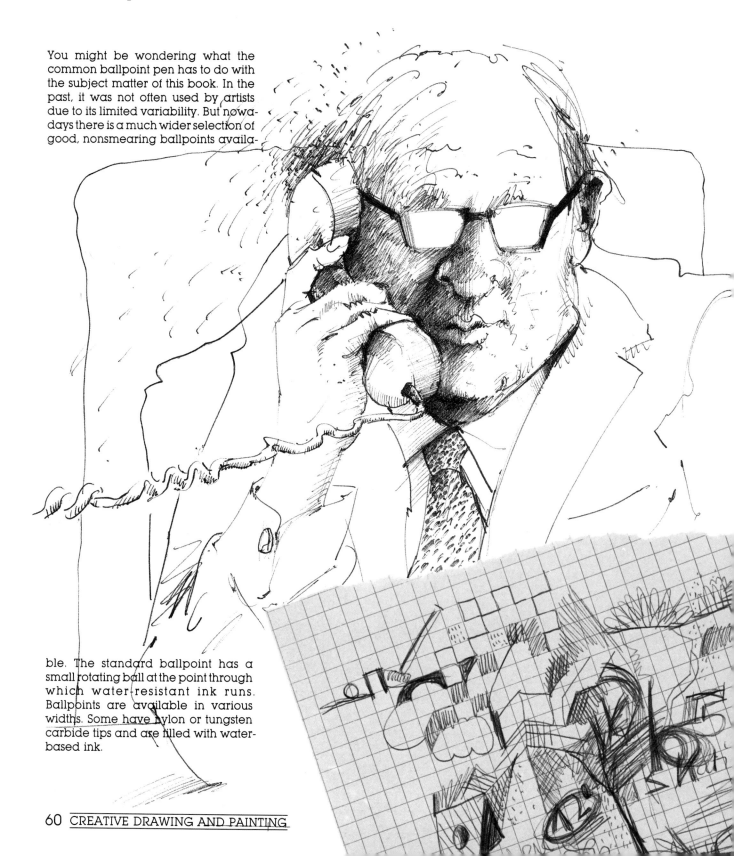

ble. The standard ballpoint has a small rotating ball at the point through which water-resistant ink runs. Ballpoints are available in various widths. Some have nylon or tungsten carbide tips and are filled with water-based ink.

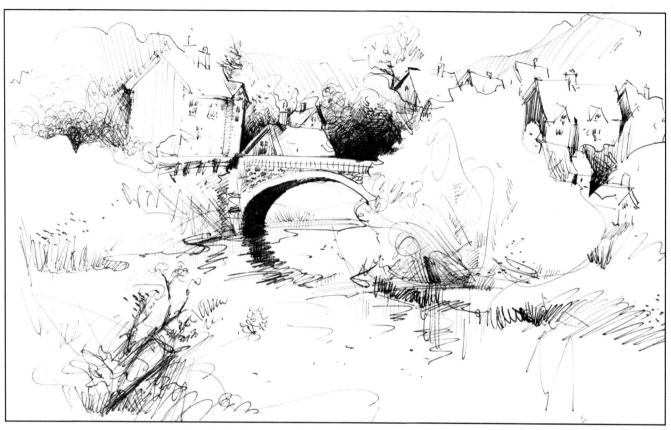

Have you ever doodled while you were talking to someone on the telephone? These are usually regarded as small "scrawls" and are simply thrown into the wastepaper basket as soon as the receiver is put down. Look at what you have drawn a little bit more carefully. These are also small compositions; maybe you will discover an interesting shape or pattern. Try to consciously turn your doodle into a picture, working just as freely as when you were doodling. Use the patterns, lines, and tones to create a real picture.

This flower arrangement originated from a telephone doodle that consisted of patches of dark and patches of light, and which made me think of plants.

A ballpoint has the advantage of being practical and for this reason it has won recognition as a sketching implement. It can be put into a pocket and carried around easily, it will not dry out and does not require any extras such as water or sharpeners. You can sketch with it wherever you are. The sketch above is a typical ballpoint sketch. Although it was made very quickly, it captures all the essentials. Various tone values can be produced by going over the same area several times, as well as with hatchings. Sparing use of colored ballpoints can produce interesting effects.

MOTIVATING IDEAS

These sections in the book aim to give you some stimulating ideas and suggestions to help you recognize potential motifs.

Once you have trained yourself to keep a keen eye open and to really observe your surroundings, you will realize that there is very little that does not offer an interesting motif for a drawing, regardless of whether you use pencil, charcoal, or chalk. It can be anything: an old chair, some windmills, or a landscape. There are motifs wherever you look. And what if you don't have a picturesque view or an attractive chair at hand? Then try, for example, drawing your telephone, or maybe a favorite object of yours.

If you first draw using simple materials, such as a pencil or crayon, you will find that this will build up your

confidence and provide you with a solid basis that will ease your transition to other techniques.

The subject suggestions given here are by no means meant exclusively for pencil or crayon studies. You can try them out using any technique. The windmill, for example, can be drawn just as well using a felt-tip pen, the chairs in pen and ink. Before you start, if you can, take the object you want to draw in your hands and feel it. This may sound strange, but once you have felt the difference between a ball of yarn and an egg, you will draw these objects very differently than if you have only seen them.

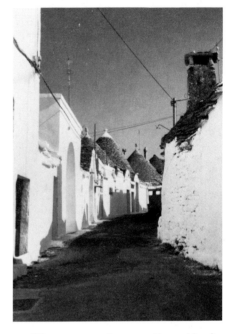

When you go for a walk and look for subject matter, try to train your eye to pick out basic shapes (we discussed these in the chapter on "Learning to See," pages 10-15). This will help you decide on a composition. The original architecture shown in the above photograph of an Italian village renders this a good subject for breaking down into basic shapes.

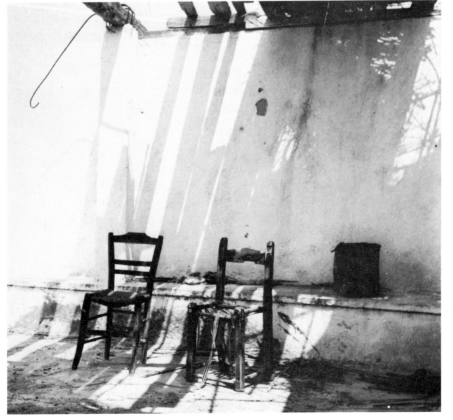

Select a section of the scene at left that appeals to you. You can draw just one of the chairs or the whole picture. Use a 6B pencil or chalk to draw the chairs; the shadows on the wall can be captured using a flat piece of charcoal and rubbing the lines with your fingers.

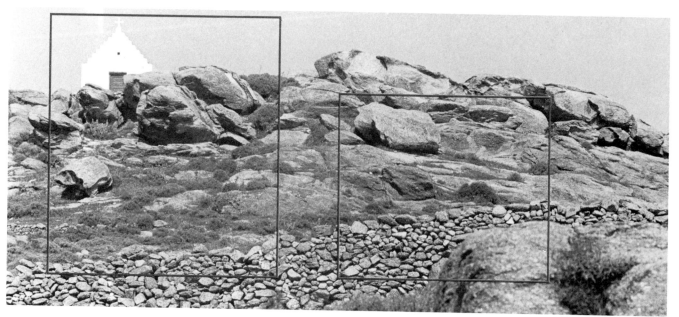

This landscape photograph offers a variety of motifs. I've outlined two that occurred to me spontaneously. Do not be afraid to mix different techniques. There is nothing to stop you from going over a pencil drawing with charcoal, or vice versa. For the section with the church you could use hard and soft pencils. To draw the stones, try first rubbing in the gray tones with your fingers and then penciling in the contours.

Maybe you would like to make one of the windmills bigger; feel free to exaggerate. The interesting feature here is the geometric lines and shapes.

Another interesting composition would be one that contrasts the soft grass with the rigid architecture. Textural contrasts such as a smooth apple in a basket, a ball of wool and a bottle, or a wooden stool on a fluffy carpet, provide very good subjects for pencil or charcoal drawings.

Try everything out. As you know, the worst thing that can happen is that you might have to throw away a piece of paper.

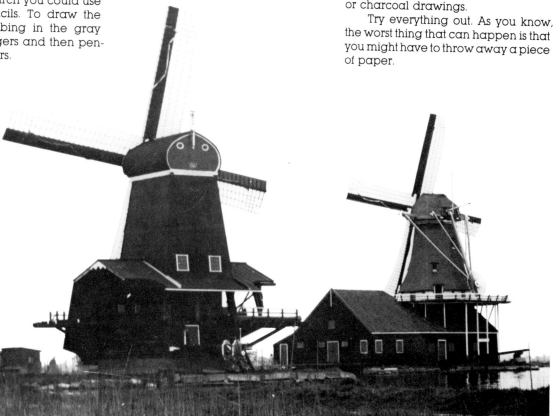

Gallery

By now you are certainly beginning to feel more confident in your use of pencils, charcoal, and conté crayon, and some of the pictures in our gallery could very well have been done by you. Look at these pictures carefully, taking note of the various techniques used. Then take your own drawing implement and try to copy those parts of the pictures that appeal to you.

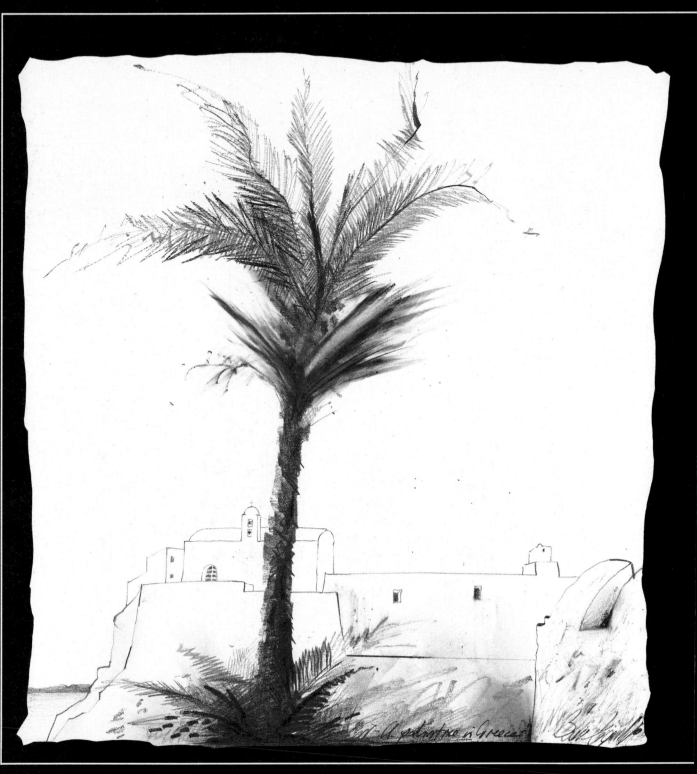

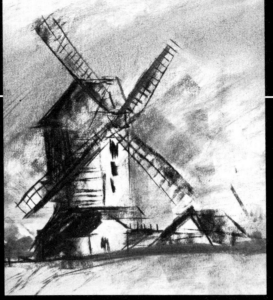

The windmill, left, shows charcoal used for more than a quick sketch. The background was done with charcoal held flat against the paper. The sails were drawn using sharpened charcoal. Original size: 110x120mm (4¼x4¾ inches). The portrait below is done in various conté crayons. Original size: 295x345 mm (11½x13½ inches).

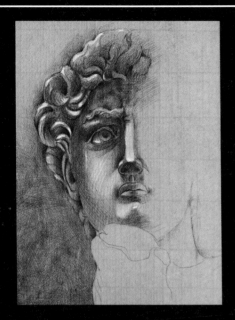

A portrait in pencil by Giovanni Greco, an Italian artist, above, uses hatching. The highlights were added using a white pencil. Original size: 240x330mm (9½x13 inches).

The palm tree, opposite page, was done with pencil and eraser. Original size: 205x330 mm (8x13 inches).

The scene below uses both hard and soft pencils. Original size: 101x85mm (4x3¼ inches).

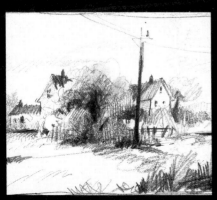

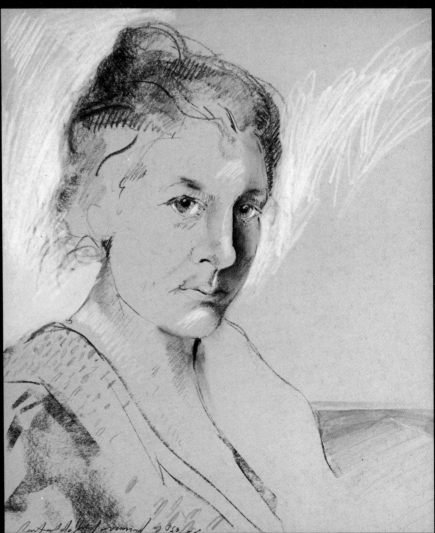

Materials
FOR DRAWING IN INK

There is an extremely large choice nowadays in materials for drawing in ink, which is in no way restricted to simple drawing pens. But all the beginner really needs to buy is a pen holder and perhaps three or four different nibs. In the next few pages, I'll be showing you what you can do with these. You should then decide on the technique that best suits you and your demands.

I'd first like to talk about inks. Besides the normal drawing inks, there are many specialized inks—for example, ink for drawing on film. Some people like to work in thick black graphic ink, especially as this is resistant to erasers. Technical pens, such as Rapidographs, require special inks which are produced by the separate manufacturers (Faber Castell, Rötring, Staedtler) for the particular make of pen. I'll deal with using these pens in a separate section beginning on page 71. Drawing ink comes in two forms: liquid or block. Liquid (or India) ink produces an especially soft, velvet-textured black; block (or sumi) ink (pine soot bonded with bone glue and compressed into blocks) is mixed with water on an ink stone and usually applied with a brush. Both forms of ink are sometimes referred to as China ink.

Now to the nibs. In the illustration, you can see three bamboo pens of varying widths. These pens can be bought from any art shop. A special variety is the pen with a built-in brush, which allows you to combine the none-too-variable effect of the bamboo pen with that of a brush. There are many varieties of steel nibs for insertion into holders, and these can be used to produce an equally great variety of effects. All steel-nib pens, from the finest to the very broadest, can be used with any type of ink. But it is imperative that you clean these nibs after use to prevent the ink drying and the nibs rusting.

Ruling pens, or pen liners, are, as the names suggest, only really useful for drawing straight lines with a ruler. For other purposes this pen is too hard and also tends to blot very easily.

The fiber-tip pens have gained great popularity in recent times, especially for black-and-white studies. These are filled with either permanent or soluble ink and are available in almost all widths, including the brush form (brush marker). Always replace the cap of a fiber-tip pen after use; otherwise it will dry out and become useless.

Additional aids for these techniques: blotting paper, paper tissues, brushes of all kinds, sponges, knives, razor blades, and even crumpled paper. I'll outline what can be done with these on the following pages.

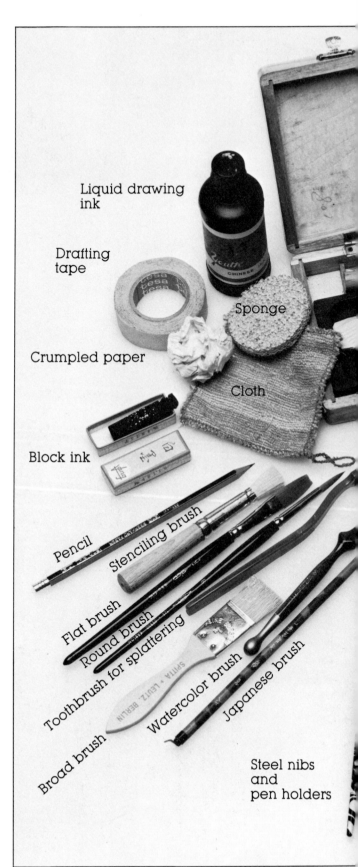

Liquid drawing ink

Drafting tape

Sponge

Crumpled paper

Cloth

Block ink

Pencil

Stenciling brush

Flat brush

Round brush

Toothbrush for splattering

Watercolor brush

Japanese brush

Broad brush

Steel nibs and pen holders

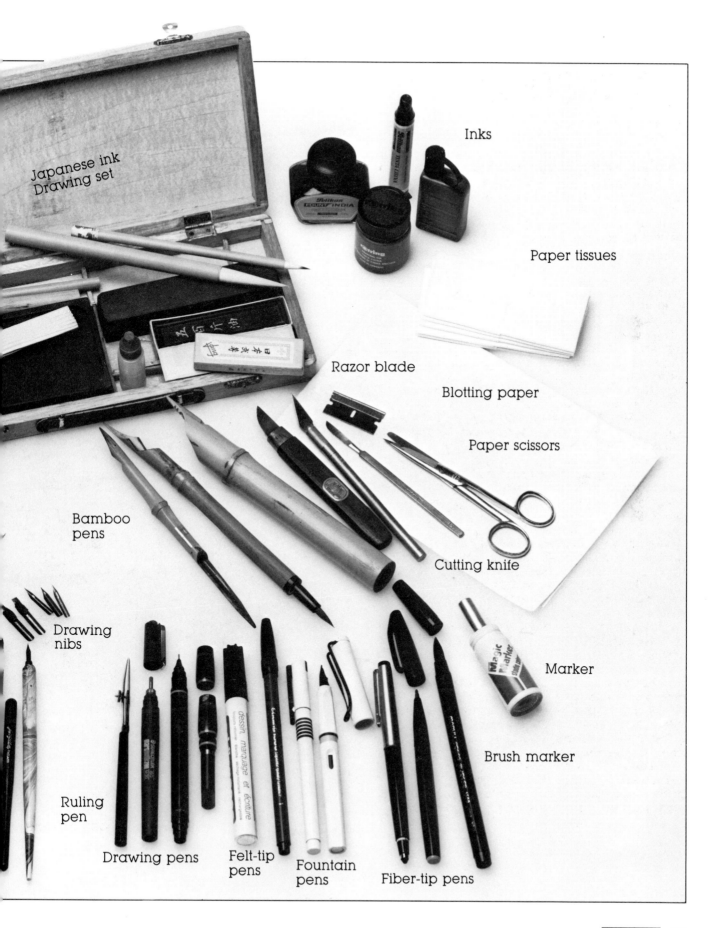

Japanese ink
Drawing set

Inks

Paper tissues

Razor blade

Blotting paper

Paper scissors

Bamboo
pens

Cutting knife

Drawing
nibs

Marker

Ruling
pen

Brush marker

Drawing pens

Felt-tip
pens

Fountain
pens

Fiber-tip pens

Ink

The original pens used for pen-and-ink drawings were made from a piece of reed (or similar material) sharpened at one end to form a nib that was then dipped in ink. A groove was cut into this sharpened end to allow the ink to run more freely. Today it is possible to buy these pens. A variety of effects can be produced by simply altering the pressure exerted on the nib. The possibilities range from a highly expressive landscape composition, with strong, pronounced lines to a precise, finely structured technical drawing. The many types of pen we know today—quills, steel-nib pens, fountain pens, and specialized drawing pens— all owe their origin to the simple reed pen.

The technique of drawing in brush and ink is very similar to that of painting itself. It is possible to produce many different effects with the brush; by mixing the ink with water you can obtain a diversity in gray tones, giving—in connection with the black ink lines—effective contrasts. Drawing ink produces wonderful gray tones and a soft black. Block ink should be mixed with water on an ink stone.

Permanent ink will not run, providing it is entirely dry. This makes it possible to paint over the ink with watercolors, for example. Here you can see a few examples showing some of the many possibilities offered by ink as a drawing material.

This picture of a windmill is a free composition in brush and ink. For the grass and fence in the foreground, I first applied ink, which I then watered down with a brush before the ink had dried.

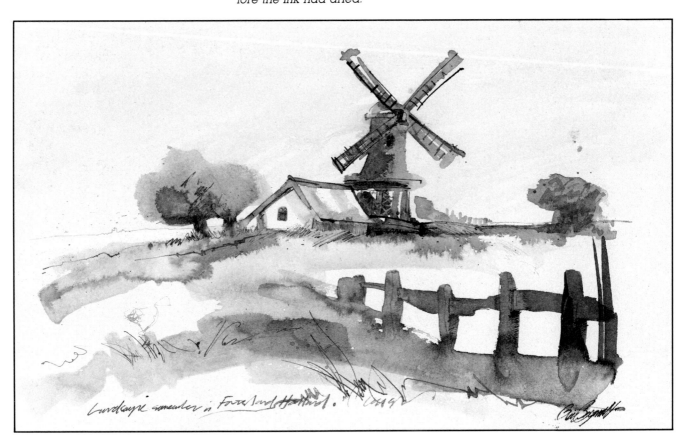

The solid snail house:

This drawing is a combination of three techniques: a technical drawing of a screw; a pen-and-ink drawing, and the watering-down technique using a brush and water.

A pen-and-ink drawing of an old car taken from my sketchbook.

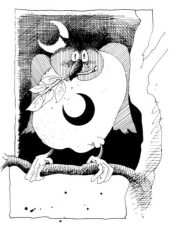

This owl illustrates the versatility of the pen. Curves and depth were produced by hatching.

On the left, a sketch on rough-grained paper, in which pen and brush were combined.

To be able to draw as well as you would like to, you must first become familiar with your materials and how to use them. It takes a bit of time and practice, but even this can be fun when you start to discover more and more of the potential uses of your brush and pen. Simply play around with these materials, trying to erase any preconceptions about the results.

One thing is very important: When you draw a line, try to make sure that your arm and hand flow easily and lightly over the paper. You can break off any time in midline and take this up again. This interruption can even lead to an interesting effect.

Do not worry about wasting paper—see this as an opportunity to try out the reactions of pen and ink to various papers. Start with simple scribbles—you will be surprised how many structures and abstract pictures will evolve.

Ink does not run freely on rough surfaced paper; this roughness also can impede the flow of your hand. Smooth paper, on the other hand, lets the ink run freely and will not check your movements. Let's look at some of the possible effects that can be produced using this material.

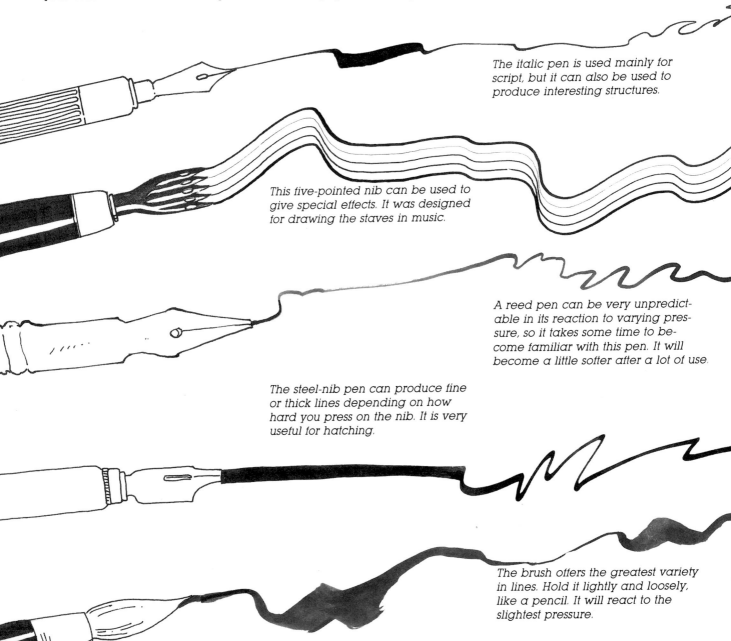

The italic pen is used mainly for script, but it can also be used to produce interesting structures.

This five-pointed nib can be used to give special effects. It was designed for drawing the staves in music.

A reed pen can be very unpredictable in its reaction to varying pressure, so it takes some time to become familiar with this pen. It will become a little softer after a lot of use.

The steel-nib pen can produce fine or thick lines depending on how hard you press on the nib. It is very useful for hatching.

The brush offers the greatest variety in lines. Hold it lightly and loosely, like a pencil. It will react to the slightest pressure.

Hatching, a system of lines drawn over one another in various directions, is a very popular means for bringing depth and gray tones into a picture. This is also a very good exercise to get away from lines that simply describe contours or shapes.

Because this nib always draws five lines simultaneously it will produce interesting patterns, often producing the effect of perspective.

The flow of ink out of a reed pen is very irregular, which means that lines can dry up towards the end.

By alternating between the broad and the narrow edges of this nib it is possible to produce fascinating combinations that are peculiar to this pen.

Dried-up ink will ruin any brush. Wash any ink out of the brush immediately after use, using a little soap if necessary. Rub the head of the brush over the palm of your hand to make sure it is really clean, as ink can be very obstinate.

Technical Pen

The technical pen, more often referred to as a Rapidograph, has a refillable ink cartridge. It guarantees a regular line no matter how hard you press on the point. It is important to hold this pen fairly upright to ensure a free flow of ink.

This pen was originally conceived for technical or other drawings requiring absolute regularity in lines, but it has also become popular with artists. It consists of a holder into which points of varying width are screwed. You can, of course, have a separate holder for each point, but this can be somewhat costly.

One advantage of the technical pen is its convenience. The ink is in the cartridge, so it is not necessary to carry extra bottles of ink around. Another good point is the constant nature of lines drawn with this type of pen. You will not have any nasty surprises, as can so easily happen with a simple pen when more ink runs out than you had expected.

Very fine technical pens are extremely delicate instruments that will dry up quickly if they are not used continuously.

It is possible to avoid a certain monotony in the lines by dipping the tip in water occasionally, as well as by using hatching and combinations of lines and dots.

Cartridge pens are equally easy to use. The lines produced by these pens might not be as regular as those produced by the technical pen, but they have more character, resembling the lines of the simple nib pen more closely. The art pen (such as that manufactured by Rötring) was developed for drawing purposes and is especially compatible with sketchbook work.

This drawing of a bunch of dried flowers and grasses is a good illustration of the various ink techniques. I made this drawing very quickly using a variety of pens and brushes. Each of the flowers and grasses has a separate character of its own, which can be brought out using different techniques.

The curve of the vase was created by simply drawing a crisscross of lines, which I then went over with water before the lines were completely dry. Before reading the explanations on the next page, try to figure out for yourself how I might have created the various flower and grass structures.

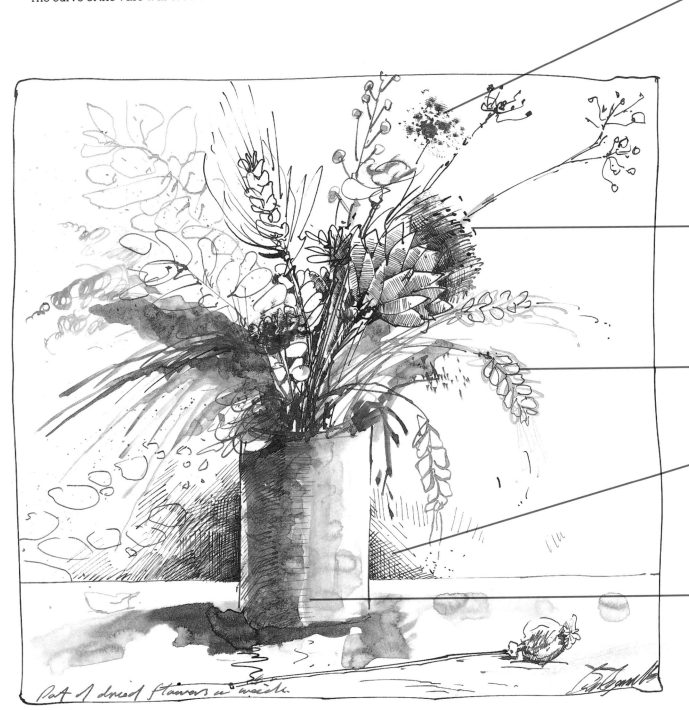

Part of dried flowers in vase.

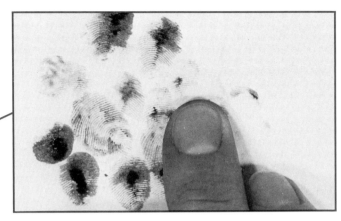

It is not always necessary to draw the complete outline of a flower. Many flowers seem hazy and translucent, as if they did not have any definite form. To capture this, I dropped a little ink onto some blotting paper, pressed my finger into this blot, and then transferred the impression onto the drawing. Practice this on a spare piece of paper first. You will see that if you have too much ink on your finger, the result will be just a series of blots.

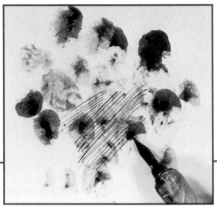

Now you can work on your fingerprints, as here, with lines and dots over and around the prints.

You can, of course, draw the outline of petals around the prints. The fingerprints then serve merely to lend toning.

I do not always use ink straight from the bottle. Fascinating effects can be achieved by first dipping your pen in ink and then in water to create watered-down lines that are less regular than if you had diluted the ink in water in a pot. This plant was made to look fuller by tracing round the outlines with undiluted black ink.

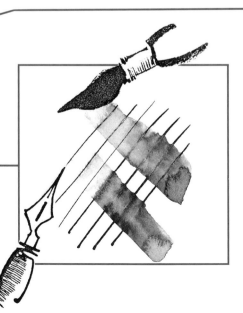

Fine-lined hatching is a very popular technique. Some artists use hatching exclusively to bring the various tones of gray and depth into their pictures.

Ink can be made to run on purpose. Draw some lines and before they have dried go over them at the desired points with a wet brush. Only the areas that come into contact with water will run, the other lines will remain intact.

Ink is a material of almost infinite potential. No matter whether you take a pen, a brush, a sharpened piece of wood, or your finger, when you dip this in ink you will always come up with some new and interesting effects. I have tried to illustrate just some of the many variations on the next couple of pages, but once you start experimenting, you will certainly find others that I haven't mentioned. Try whatever comes into your head to get to know this material.

Even this seemingly insignificant corner shows a combination of lines and dots which stands out in contrast to the hatching in the background.

In this part of the drawing I have used different forms of hatching. As you can see, there are many variations in this one technique alone, each one different from the others.

Hatching is very useful for introducing shade and form. Tone values can also be produced by altering the proximity between simple vertical lines.

You will see how a combination of crosshatching and vertical hatching can create an impression of distance.

An interesting effect: Dip a pen into ink, then into water, turn it over, and use the flat side of the nib to give broad, irregular lines. Try to work quickly to produce fresh, spontaneous structures.

It is quite easy to give an impression of flowers and grass waving in the wind if you hold your pen loosely and let it glide lightly over the paper. In this example I combined various methods: brush with ink and water; a pen held flat against the paper or turned over; fine, quick pencil lines.

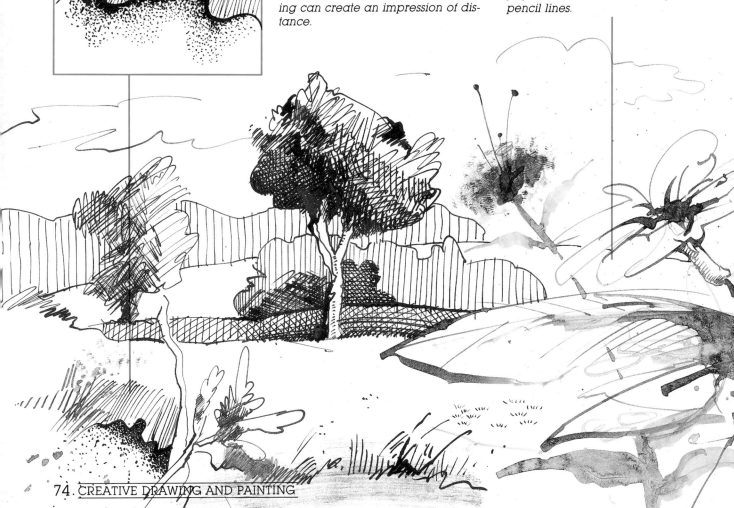

A piece of crumpled paper or material or even a sponge can produce a variety of structures. Drop some ink onto a piece of cardboard or thick paper, dip the crumpled paper (material or sponge) into this, and then dab your painting with it. As you will see from the tree, the structures change as your dabbing material dries. It is also possible to work using a stencil to give more specific form to your subject.

For the trunk of the tree, I used a brush that I first dipped in ink and then in water. Holding the broad side of the brush fairly flat against the paper. I then dabbed the shape of the trunk, starting from the bottom. The water mixes irregularly with the ink to give light and dark shading, as can be clearly seen around the middle of the trunk. Towards the top of the trunk I hardly used any water, to give the effect of a trunk in the shade of its crown.

These broad, irregular lines were produced using a reed pen. The reed pen can also be twisted while you are drawing to produce a constantly changing line intensity.

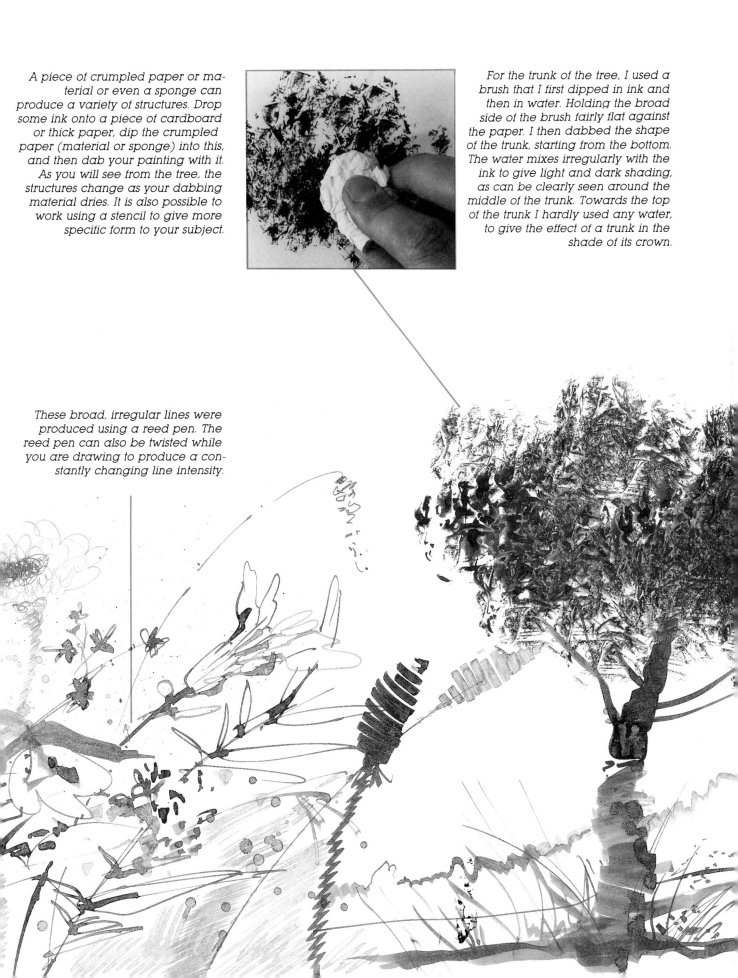

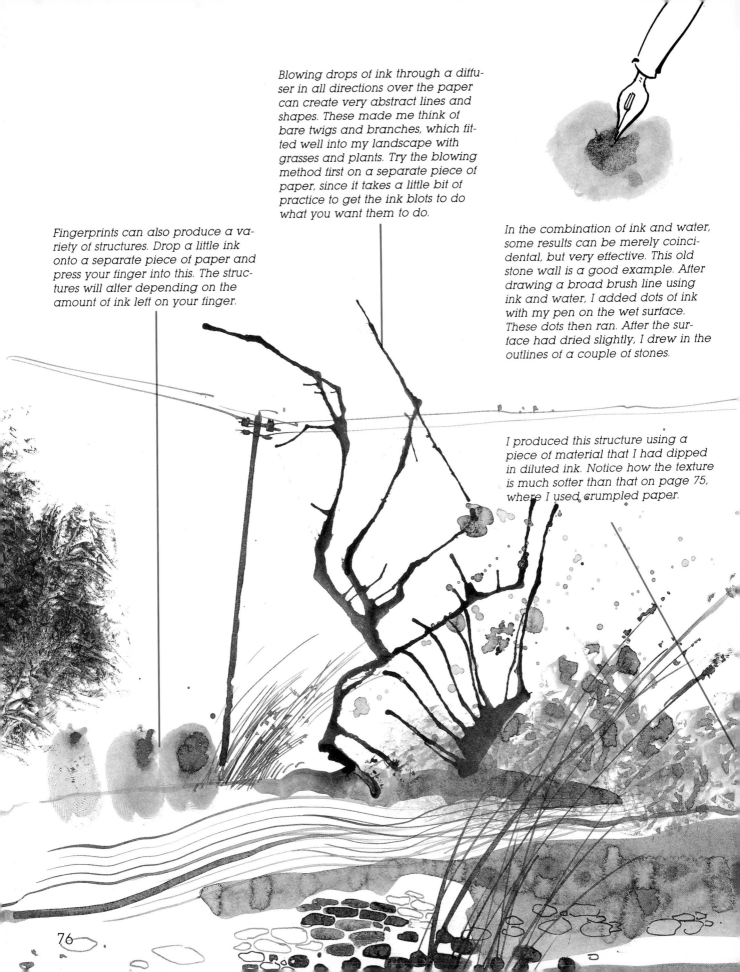

Blowing drops of ink through a diffuser in all directions over the paper can create very abstract lines and shapes. These made me think of bare twigs and branches, which fitted well into my landscape with grasses and plants. Try the blowing method first on a separate piece of paper, since it takes a little bit of practice to get the ink blots to do what you want them to do.

Fingerprints can also produce a variety of structures. Drop a little ink onto a separate piece of paper and press your finger into this. The structures will alter depending on the amount of ink left on your finger.

In the combination of ink and water, some results can be merely coincidental, but very effective. This old stone wall is a good example. After drawing a broad brush line using ink and water, I added dots of ink with my pen on the wet surface. These dots then ran. After the surface had dried slightly, I drew in the outlines of a couple of stones.

I produced this structure using a piece of material that I had dipped in diluted ink. Notice how the texture is much softer than that on page 75, where I used crumpled paper.

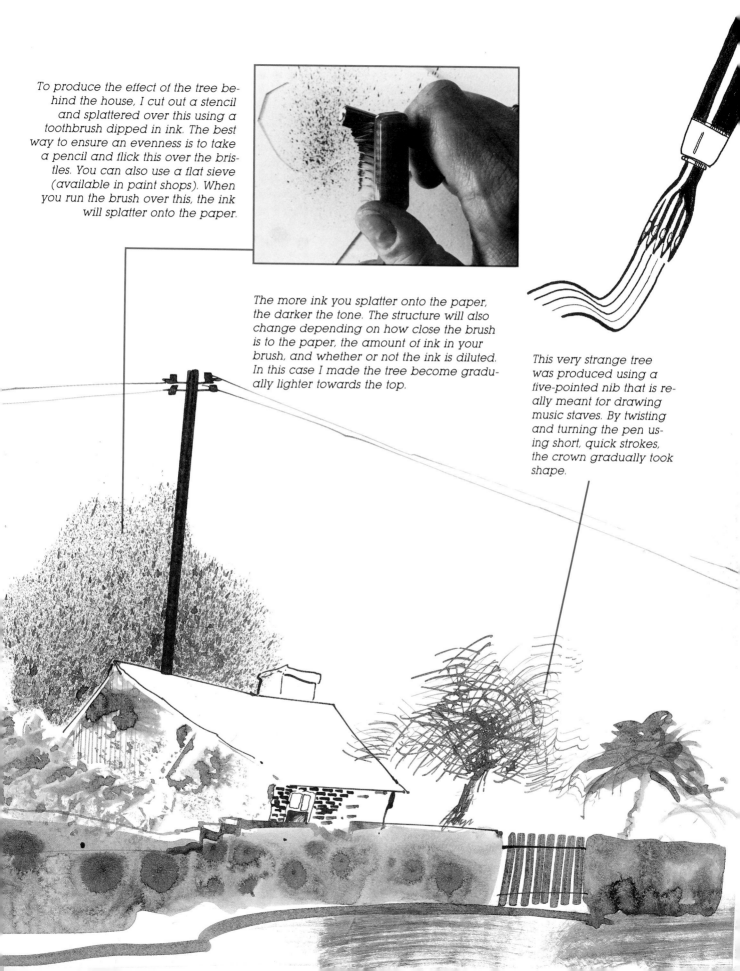

To produce the effect of the tree behind the house, I cut out a stencil and splattered over this using a toothbrush dipped in ink. The best way to ensure an evenness is to take a pencil and flick this over the bristles. You can also use a flat sieve (available in paint shops). When you run the brush over this, the ink will splatter onto the paper.

The more ink you splatter onto the paper, the darker the tone. The structure will also change depending on how close the brush is to the paper, the amount of ink in your brush, and whether or not the ink is diluted. In this case I made the tree become gradually lighter towards the top.

This very strange tree was produced using a five-pointed nib that is really meant for drawing music staves. By twisting and turning the pen using short, quick strokes, the crown gradually took shape.

Step by Step

When you start on a pen-and-ink drawing, try not to be too tense. You should be relaxed and let your hands flow. You can begin with small sketches which will help you feel more familiar with the character and style of your drawing. At this stage, it is not impor-tant to decide exactly what your finished picture will look like. Step one: After making a couple of sketches, I lightly outlined my composition using a HB pencil.

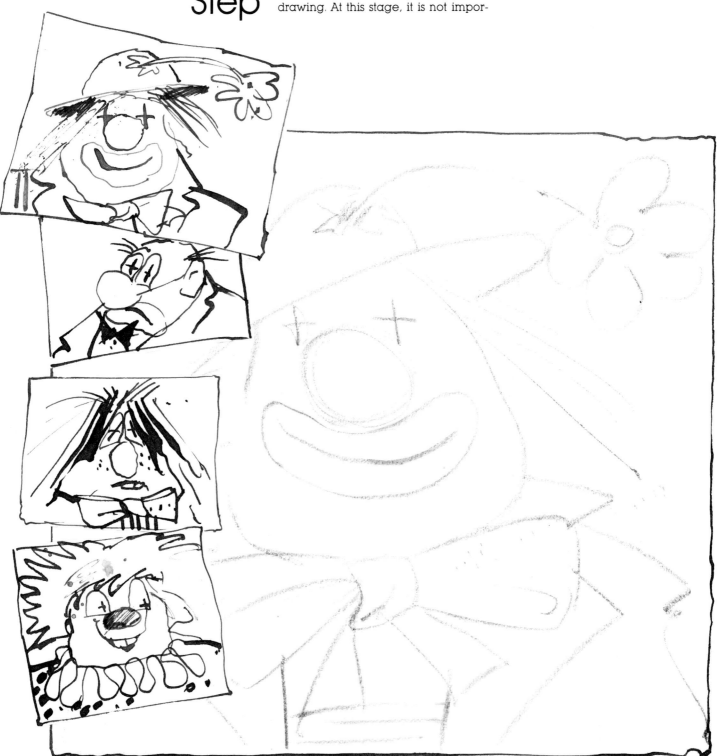

Pen and ink, like the pencil, lend themselves to very spontaneous work which can bring out the various characteristics of your subject matter in a very expressive manner.

Step two: For this stage, I used a simple drawing pen in a wooden holder. Look at the differing widths of the lines denoting the eyes, nose, and mouth. The harder I pressed on the nib, the wider the lines became. For the center line of the lips, I first dipped my pen in ink and then in a little water. To begin with the line was light. As I exerted more pressure on the pen, the line became heavier. Try to copy some of these lines. The hair is also a product of my varying the pressure on my pen.

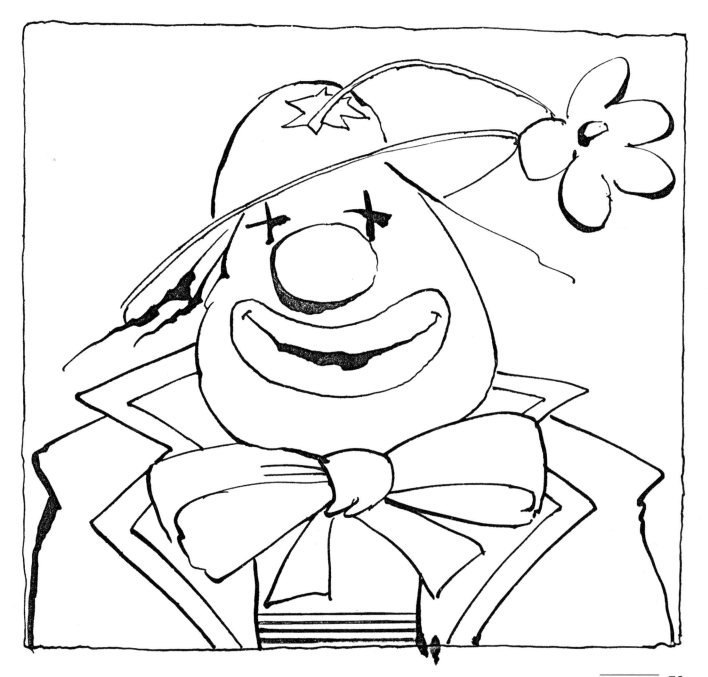

tep three: I began with the diago-
nal hatching on the hat to give
this more form. It is often advis-
able to start at the top of a pen-and-
ink drawing and work down to avoid
smudging those parts of the drawing
that are not absolutely dry—some-
thing that can happen very easily.

I used a watercolor brush for the
checkered coat, working fairly quick-
ly, wet in wet. I did not let the vertical
lines dry before drawing the horizon-
tal lines over them.

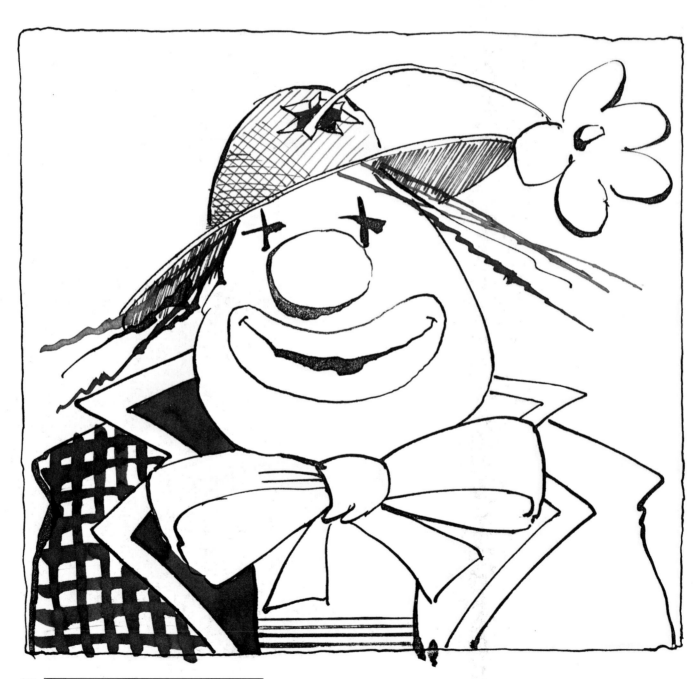

Step four: I intensified the hatching on the hat, giving this more shape and making the hole appear more plastic.

The characteristic nose was made using a brush and a little water (there is more ink in the lower part than in the upper part). I used a stencil and toothbrush for the right half of the coat (using the splattering method described on page 77).

As you can see, I accidentally splattered a bit more than the coat, but this doesn't matter at all. Little accidents like this can give a drawing a fascinating, spontaneous effect.

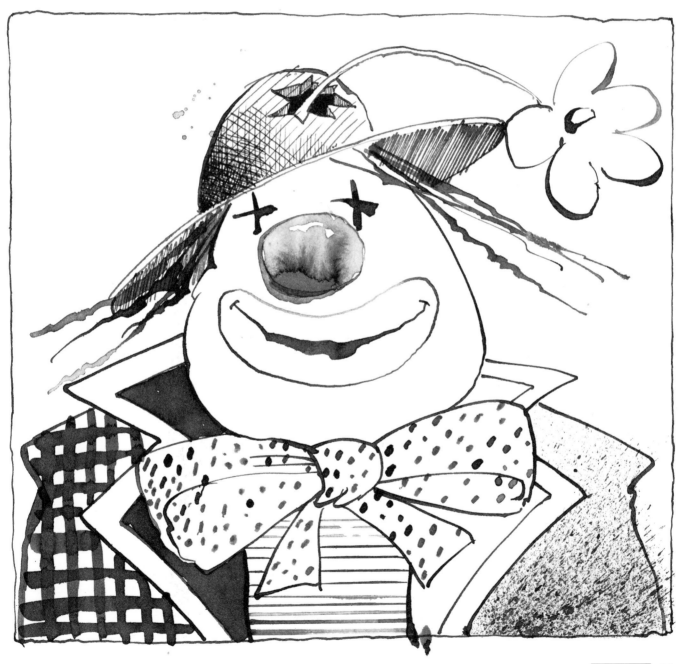

Fiber-Tip Pens

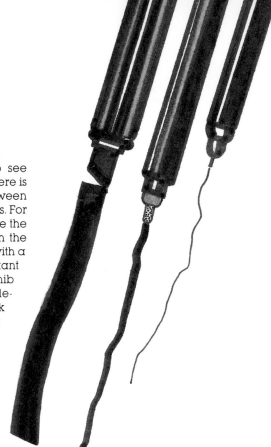

Fiber-tip pens are very good for on-the-spot sketches and for pictures with a lot of contrast. Almost every stationery store stocks these pens, usually in a variety of widths. The tips are made of nylon, vinyl, or a rubber mixture, and are saturated in either soluble or permanent ink. Nowadays there are so many different types and sizes of these pens that I can only advise you to try out a couple for yourself.

The paper you use is very important because each type of pen reacts differently to the various kinds of paper. Fibrous paper will absorb ink, whereas if the paper is hard and smooth the tip will tend to stick and the ink will smudge easily. The ink runs on some papers, which can be very annoying. Always try out a fiber-tip pen on a small piece of paper to see whether the paper is suitable. There is even a difference in texture between the front and back of some papers. For example, layout paper will cause the ink of certain pens to soak in on the front. The width of a line drawn with a fiber-tip pen remains fairly constant and will not, as in the case of nib pens, get thicker or thinner depending on pressure. The thick pens often have a wide and a narrow side, which means that you can use these pens to draw both thick and thin lines.

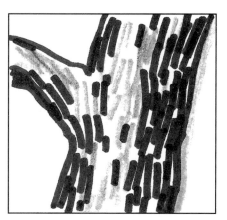

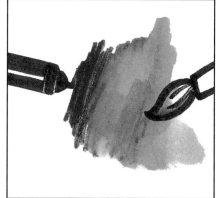

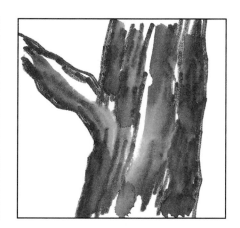

The picture on the opposite page was drawn using a medium-fine Pentel pen. If you leave these pens open for a certain period of time, the lines will become dryer; once you put the top back on for a couple of minutes, the ink will start to flow again. This can give a special effect if used purposefully. Look at the difference between the pine needles (done with a wet marker) and the lighter parts of the tree trunk (dry marker).

If you apply water to lines drawn with a soluble fiber-tip pen, the lines will run, as is shown in the above illustration. I went over the lines using a wet brush.

Brush markers have a soft, fiber tip which can produce variations in lines similar to the brush. The advantage of these over the brush is that they will not run out of ink after a short time and they do not require any washing.

To return to the example of the tree trunk: The watered-down contours make the trunk seem softer and give it a different structure. Experiment for yourself to discover all you can do with watering down. You are sure to enjoy seeing all the different effects that are possible. The chapter on felt-tipped pens (pages 150-161) might give you some more ideas in this direction.

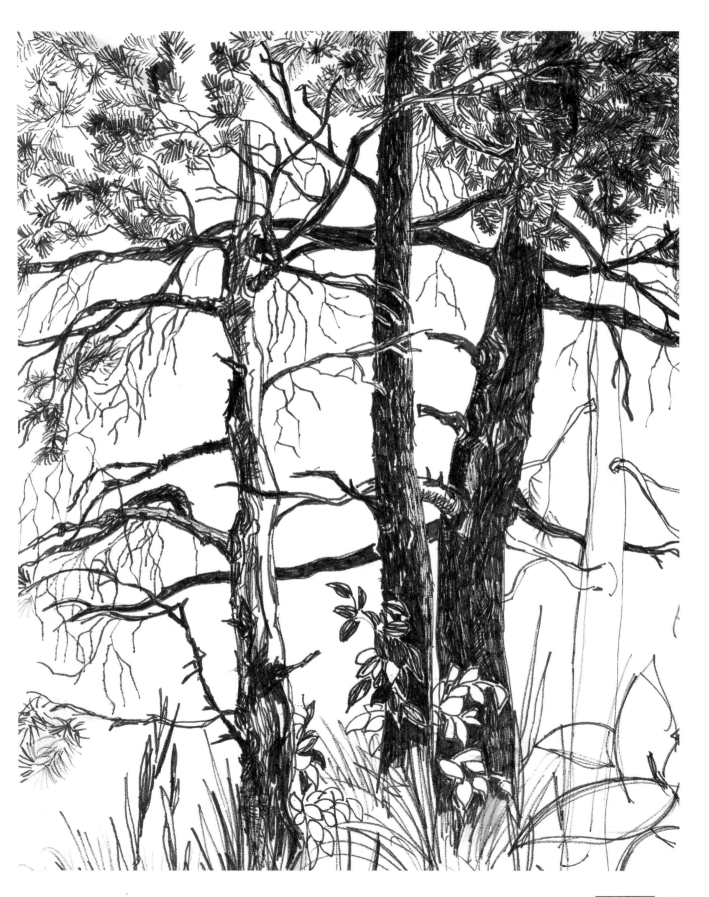

MOTIVATING IDEAS

Pen and ink is, as you have seen, a medium which lends itself equally well to drawing soft and smooth as well as hard, structured forms. I have chosen some motifs which bring out this diversity in texture and form.

This totally abstract wood surface will give you the chance to play with rhythmic lines. Should you drop some water or ink on your paper, or if some of your lines "go wrong," try to incorporate these into your picture. Such "accidents" can make your picture look fresh and vigorous.

A portrait of a doll, such as this, will incorporate a variety of techniques in one picture. The soft tones of the doll's face contrast strongly against the rough texture of her hair; the ribbons, dress, and lace collar are all of different materials. You can proceed in a fashion similar to my example of the clown on pages 78-81. Remember, you do not have to reproduce an exact image of your subject. It is more important that you use your materials freely and without constraint.

A difficult motif: wood, water, a chain, and ropes. But it is this contrast in textures that makes the picture so fascinating and challenging. The wood can be drawn using lines of varying intensity; the ropes with a broad pen or a reed pen; the chain with a fine-nibbed pen and the water wet-in-wet using a brush. These are, however, only suggestions. The choice of techniques is a completely personal matter.

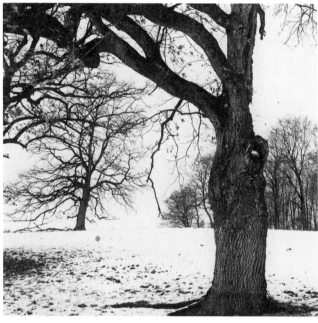

You can use any of the techniques that you have learned so far to capture the texture and feeling of these trees in a winter landscape. The only thing you have to remember is to remain relaxed and to make your own, personal picture out of the suggested motif.

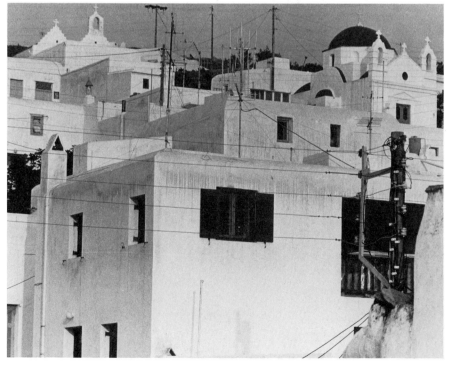

The rather austere lines of the Greek village can, if you want, be captured using a brush and water. If you look carefully at this scene, you will discover quite a few rectangles, squares, triangles, and rounded shapes. Think back to the basic shapes we discussed on pages 10-15. This picture can be easily broken down and turned into an abstract drawing. You can leave all the overhead wires and cables out of your picture altogether, or, if you prefer, incorporate them as a compositional element.

Gallery

The pictures on these two pages show a variety of ways in which ink, pen, and brush can be used.

"The Birds" by Boris Sajtinac and the "Six Cushions" from Albrecht Dürer (German artist, 1471-1528) are very typical pen-and-ink drawings. "The Birds" tends more towards a caricature, whereas Dürer used the pen to elucidate shapes.

I made the drawing shown below on watercolor paper, using diluted ink drawn into the wet surface of the paper. Original size: 257 × 160mm (10 × 6¼ inches).

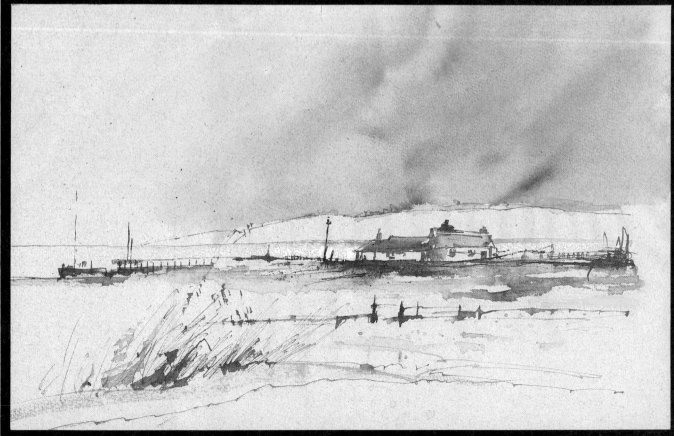

These two portraits illustrate the different effects of a fine and a thick line. The choice of technique provides us with insight into the two very different characters of these two artists. Both pictures lean slightly towards caricatures. These are, by the way, copies I made of the originals. Try copying the work of other artists. You will find that you will gain more insight into your materials when you try to find out how other people have used them.

Left, a portrait by Henri de Toulouse-Lautrec (French artist, 1864-1901). Above, a portrait by Henri Matisse (French painter, 1869-1954).

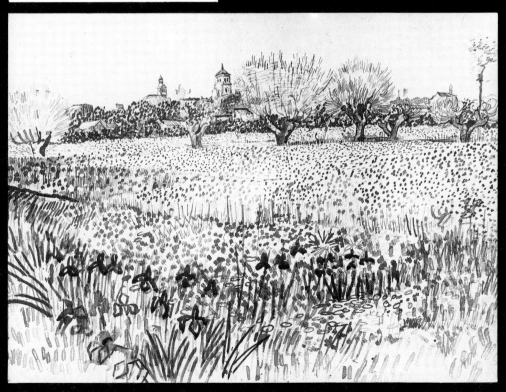

Vincent van Gogh drew this "View of Arles" using a series of lines and patterns. Look at it carefully and notice how the tones change between the lines and dots. Depth is brought in not only by use of perspective but also by the numerous variations in lines, dots, and dashes, all made by a reed pen. If you close your eyes halfway, you will be able to see the distribution of light and shade even more clearly. Original size: 555 × 435mm (21¾ × 17 inches).

Sketchbooks

Most people take a camera with them when they go on vacation, to take photos which will bring back memories or which they can show to friends.

A sketchbook serves the same purpose, and more. In a sketchbook you can capture ideas, thoughts, and impressions that are beyond the limits of the camera. If you, years later, flip through an old sketchbook, it is like looking at a combination of a diary and a photo album.

It's also very convenient. All you need, besides the paper, are a couple of pencils or fiber-tip pens, and maybe, if you want, some colored crayons or pens. The size of your sketchbook is also a personal matter. It can be small enough to fit into a handbag, or maybe something you would carry under your arm. As long as you can transport it easily and it has a hard back so that

you can sketch resting it on your knees, everything else is secondary. By making quick sketches wherever you are, you'll find that you develop your drawing confidence. You are experiencing a situation as it happens. Your pictures will, therefore, be fresh and spontaneous, even if some of the details might not be quite "accurate."

You will sometimes discover that you have difficulty trying to reproduce the same spontaneity and clarity captured in your sketches onto canvas or similar materials. Sometimes you will

be just as pleasantly surprised with the results of your sketching as you might have been with quick camera snapshots. And even if something doesn't turn out quite right, what does it matter? Forget it, and turn to the next page. This reassurance that it is "only" a sketch, and it doesn't matter if something goes wrong, can help you overcome any fears of a "clean sheet of paper" or any other intimidation you might feel not only in sketching but also in other artistic adventures.

An old sketchbook is not only a

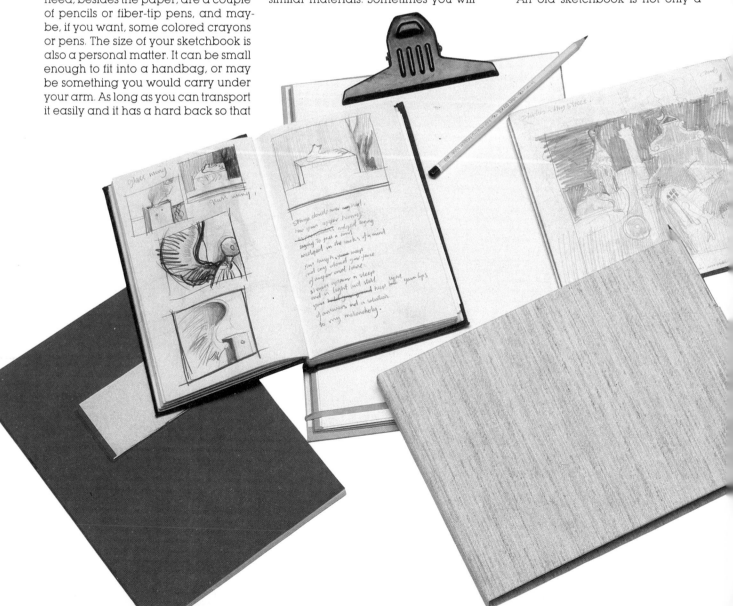

documentation of your own progress and development but also a rich source of motifs and ideas which can help you in your choice of subject matter for your next piece of work.

There are many different types of sketchbooks, but you can use equally well an ordinary pad or exercise book in the beginning, providing that this does not have any lines, as the lines can be very diverting when you are drawing.

If you have decided to work with water, ink, or fiber pens, you should be careful to use a new page, as these materials often tend to seep through paper and would ruin any sketch that happened to be on the back.

Using a new page for each sketch may seem wasteful at first, but this does allow you to separate your "special successes." Spiral-bound sketchbooks make it easier to take out pages. You can make your own sketchbook by simply clipping some pieces of paper to a hard piece of cardboard or fiberboard, but remember, as I mentioned earlier, this hard back is one of the most important prerequisites of a sketchbook.

The size is immaterial, providing it is not too big and therefore inconvenient to carry. The best paper size may be 8½x11 inches (if you're using the international paper-sizing standard, Deutsche Industrie Normie, the best size may be DIN A4). A small block has, naturally, many advantages, but the restricted space can tend to cramp your style.

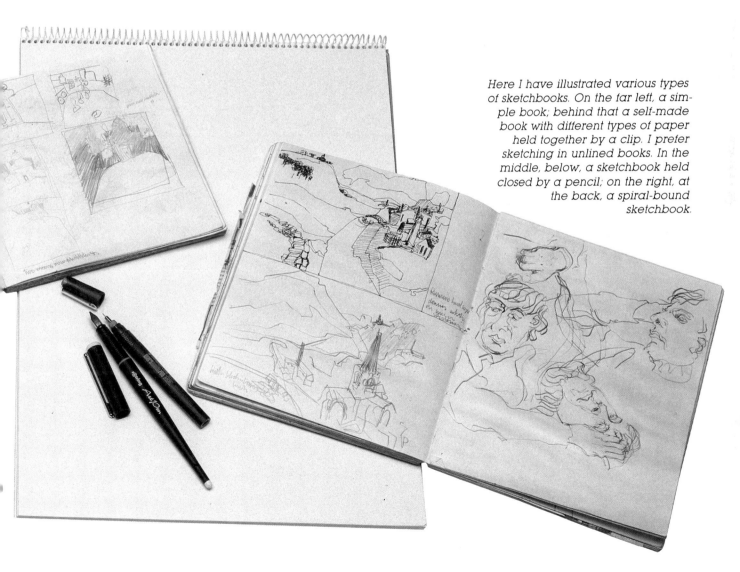

Here I have illustrated various types of sketchbooks. On the far left, a simple book; behind that a self-made book with different types of paper held together by a clip. I prefer sketching in unlined books. In the middle, below, a sketchbook held closed by a pencil; on the right, at the back, a spiral-bound sketchbook.

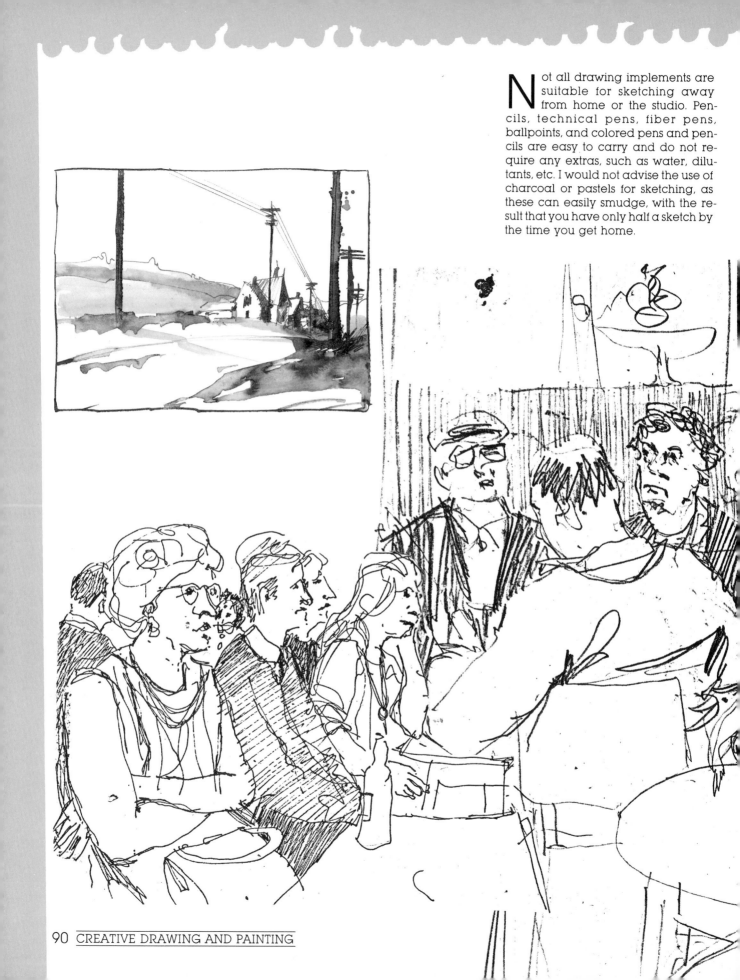

Not all drawing implements are suitable for sketching away from home or the studio. Pencils, technical pens, fiber pens, ballpoints, and colored pens and pencils are easy to carry and do not require any extras, such as water, dilutants, etc. I would not advise the use of charcoal or pastels for sketching, as these can easily smudge, with the result that you have only half a sketch by the time you get home.

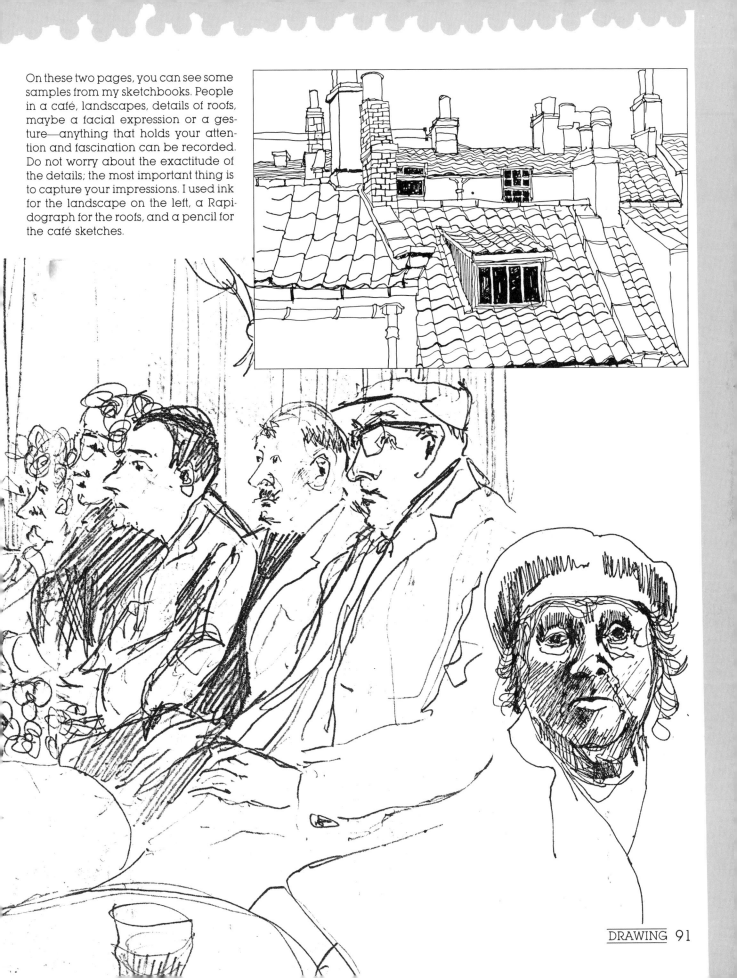

On these two pages, you can see some samples from my sketchbooks. People in a café, landscapes, details of roofs, maybe a facial expression or a gesture—anything that holds your attention and fascination can be recorded. Do not worry about the exactitude of the details; the most important thing is to capture your impressions. I used ink for the landscape on the left, a Rapidograph for the roofs, and a pencil for the café sketches.

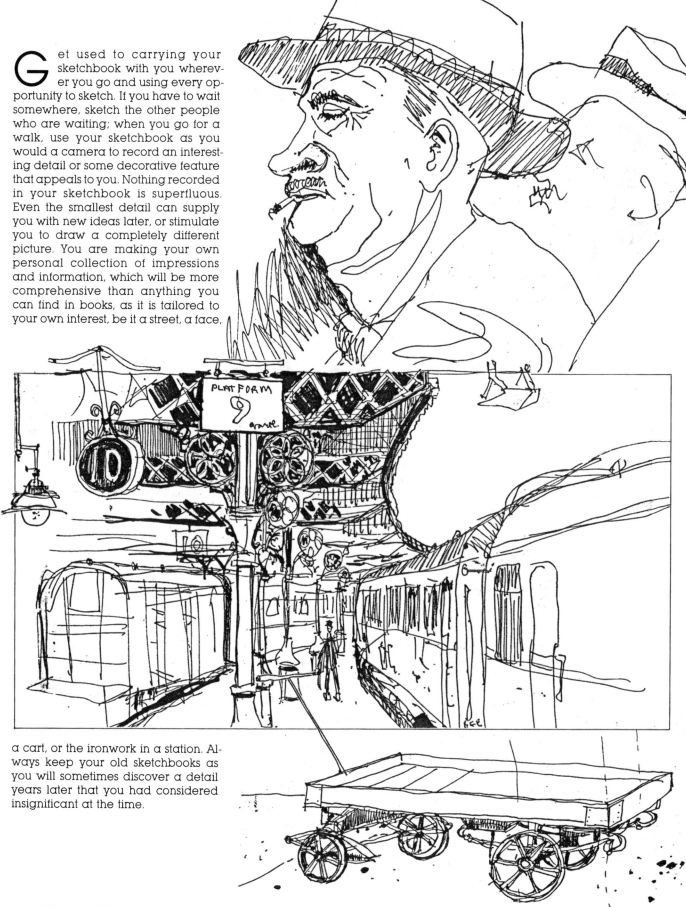

Get used to carrying your sketchbook with you wherever you go and using every opportunity to sketch. If you have to wait somewhere, sketch the other people who are waiting; when you go for a walk, use your sketchbook as you would a camera to record an interesting detail or some decorative feature that appeals to you. Nothing recorded in your sketchbook is superfluous. Even the smallest detail can supply you with new ideas later, or stimulate you to draw a completely different picture. You are making your own personal collection of impressions and information, which will be more comprehensive than anything you can find in books, as it is tailored to your own interest, be it a street, a face, a cart, or the ironwork in a station. Always keep your old sketchbooks as you will sometimes discover a detail years later that you had considered insignificant at the time.

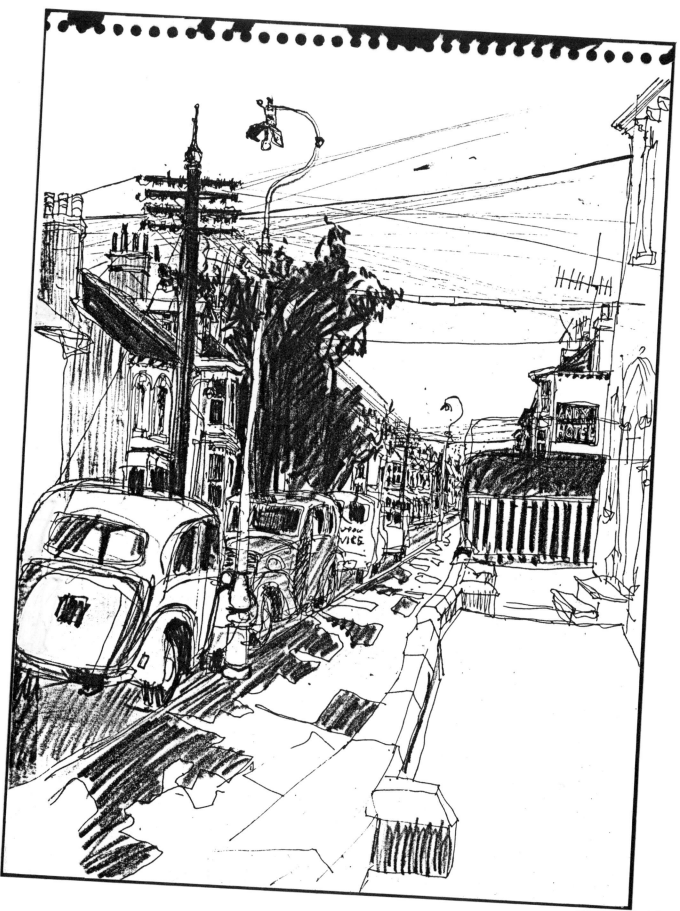

Figure Drawing

The human anatomy has itself hardly changed in thousands of years. But artists throughout the centuries have constantly seen and portrayed differing forms.

For over 3,000 years the Egyptians saw very few variations in human proportions; in the Far East, the human body when portrayed in a painting or drawing merely served as a decorative element; the Ancient Greeks and Romans created perfect godlike images; during the Middle Ages artists were intent on not only showing a body but also incorporating spiritual ideals.

The Renaissance in Florence marked a great turning point. The human body was no longer seen as merely an outward casing enclosing the immortal soul, but as a beautiful and solid form with real proportions and true expression. Leonardo da Vinci and Michelangelo were among the first artists who introduced the study of anatomy as we know it today.

Modern human portrayals have altered considerably compared to those times. Many artists today have turned completely away from realistic representation and lay more emphasis on abstraction. But before you can see something in its abstract form, it is necessary to know what it really looks like. Before beginning to draw the human body, you should first think a little about proportions—about the proportions of an ideal figure. Human bodies are very diverse. So for these initial stages we need to establish a standard form relating proportionately to the human anatomy. These basic proportions of an ideal figure will help you with all kinds of figure drawings.

There are, of course, many exceptions to this rule, but in general the body of an adult can be divided into seven or eight equal parts. The head takes up approximately one-eighth of the whole body. With the arms outstretched, the distance between the right fingertip and the left is comparable to the length of the body from head to foot. First draw some simple figures using these proportions.

These diagrams illustrate relative proportions as a person grows from childhood to adulthood. The thick horizontal line indicates the center of the body. Notice how this moves down from the level of the stomach. Notice also that the size of the head changes very little, but the arms and legs grow considerably.

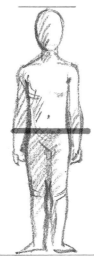
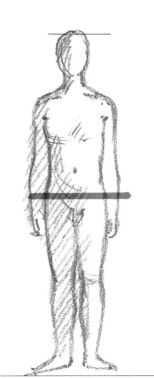
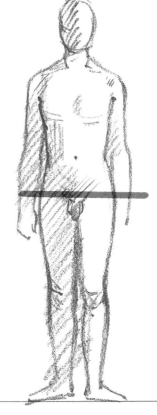

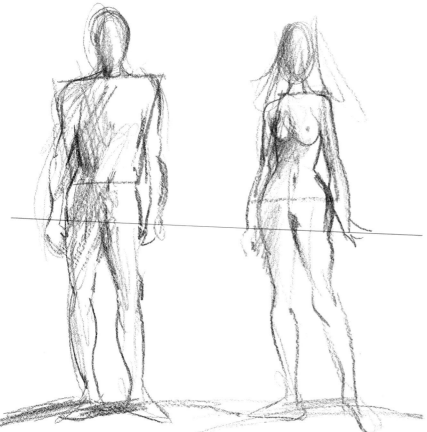

At birth a baby's head is very big in comparison to its arms and legs. A baby is in all three heads long. By the age of approximately one year the body, from the neck to the feet, will measure about three-and-a-half times the length of the head—the baby will measure a total length of four-and-a-half heads. The legs are, in comparison to the head and trunk, fairly short. The body center is approximately level with the stomach. Later the arms and legs will grow, so that by the time the child is eight the body center is situated just over the hips. At the age of twelve, the child will have reached a height of seven heads and the body center will be on the level of the crotch. No matter how much the child grows the basic proportions will remain constant.

There is a basic difference in form between the male and female figures, whether clothed or naked: the male tends to have broad shoulders and narrow hips and the female narrow shoulders and broad hips.

Very often you draw a figure and somehow something is not quite right. It looks flat and unreal. This is the main problem facing most people—how to give your figure a round, three-dimensional form.

We are all familiar with the matchstick man as a simplified symbol for a figure. Taking this symbol as a basis, we can go one step further and give it rounded forms. We can turn the head into a ball and the body into a system of cylinders. To make these look really round, we need to add light and shade. Look back at pages 32 to 35 and then try this for yourself. Draw a "cylinder man," adding the effects of light and shade. This figure, naturally, is lacking in the beautiful, flowing lines of a "real" drawing, but this exercise will help you to register the round solidity of a human figure.

With this simplified portrayal of the human body in mind, and with your knowledge about ideal proportions, you can now proceed to actual figure drawings.

The examples on the right show how a figure can be built up in three stages using the simple basic proportions.

Try to see the figure as a whole and not to get lost in details. Once your figure is roughly right—when it does not look as if it is about to fall over and when the proportions are approximately correct—then you can worry about details. Otherwise you might find that you have drawn a very beautiful face, but that you do not have any space left for the legs. It sometimes helps to use a wooden model with jointed body parts that can be moved into any position. These can be bought from any art shop, but they are not cheap and in no way as good as a live model.

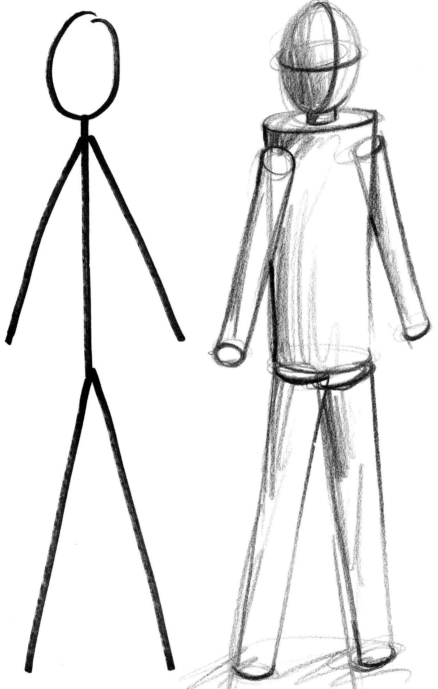

This is still almost a matchstick figure. I have sketched in the basic proportions using a soft pencil. Begin to build up the figure with as few lines as possible. Take special notice of the head and the central line which divides the body into two parts.

Once you are happy with your basic structure, you can start to build up around this. Introduce roundness and complete the proportions in this order: head, shoulders, hips, legs. When you feel that the proportions and posture are correct, then you can go on to the next step.

Given some simple shading, the figure will now take on form; it becomes plastic. Add tones and shades; you will notice yourself when the figure begins to come "alive." As you can see here, I have created a solid figure, without supplying any precise details.

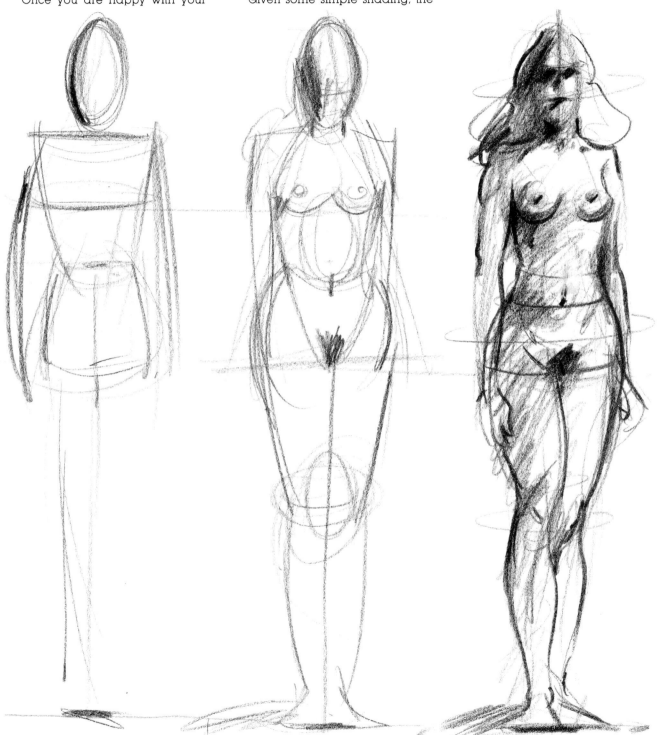

Figures in Motion

Drawing a figure in motion means nothing more than making your figure come to life. People run, sit, sleep, jump, laugh, yawn, sneeze. Each motion expresses something, every gesture shows or says something. It is the artist's task to capture this "something" in the form of a drawing.

In this respect it is completely irrelevant whether the person you are drawing is wearing a striped coat or nothing at all. It is also irrelevant if your construction lines are visible or whether you have drawn over some lines to correct them. Only one thing is important, and that is your capturing of movement, of expressions. The best way to study these is to use every opportunity to sketch people. Equipped with your sketchbook, you can sketch the people sitting in the bus or café. Wherever you go, you are surrounded by living models in a diversity of postures. Sketch them quickly, picking out the essentials. You will not learn how to draw people in motion from elaborate compositions, but from observing and jotting down your observations in the form of a sketch. In this way, the human body and its movements will soon become matter of course for you.

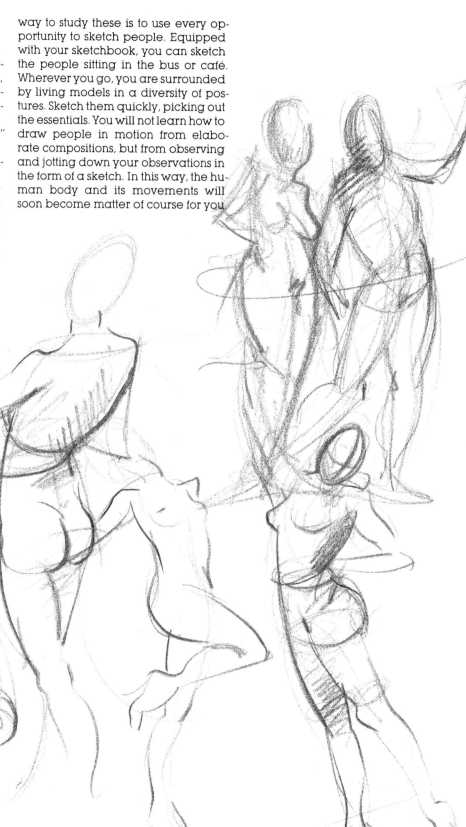

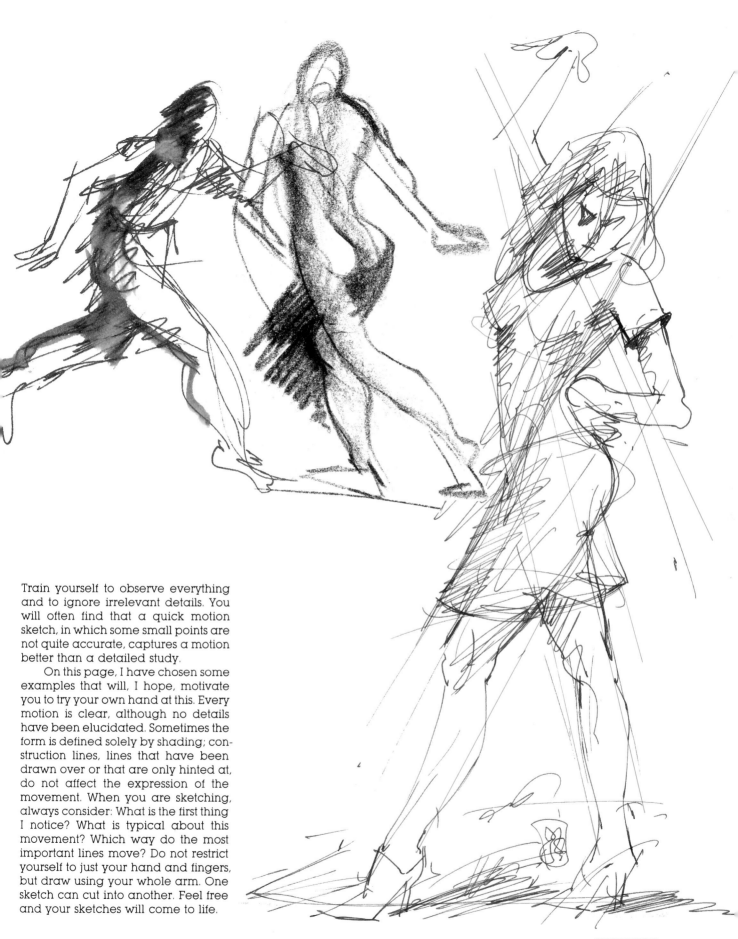

Train yourself to observe everything and to ignore irrelevant details. You will often find that a quick motion sketch, in which some small points are not quite accurate, captures a motion better than a detailed study.

On this page, I have chosen some examples that will, I hope, motivate you to try your own hand at this. Every motion is clear, although no details have been elucidated. Sometimes the form is defined solely by shading; construction lines, lines that have been drawn over or that are only hinted at, do not affect the expression of the movement. When you are sketching, always consider: What is the first thing I notice? What is typical about this movement? Which way do the most important lines move? Do not restrict yourself to just your hand and fingers, but draw using your whole arm. One sketch can cut into another. Feel free and your sketches will come to life.

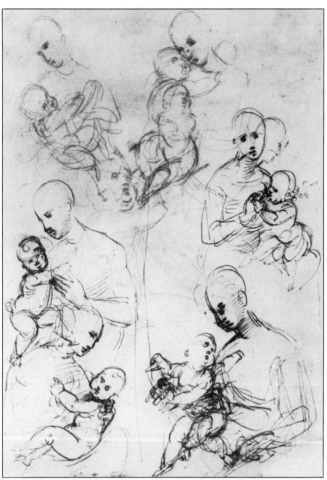

For many artists, the human body is one of the most expressive subjects possible, giving them the opportunity to capture even the most subtle of feelings and sensations.

Study the various kinds of sketches on this page, noting how the artists have used free lines to determine proportions and to lend emphasis to gestures and form. Motion studies played an equally important role for earlier artists, such as Raphael Santi (Italian painter, 1483-1520), as for later artists, such as Alberto Giacometti (Swiss artist, 1901-1966) or Gustave Klimt (Austrian painter, 1862-1918). Whenever you have a chance to examine studies such as these, look closely for the points noted on these pages.

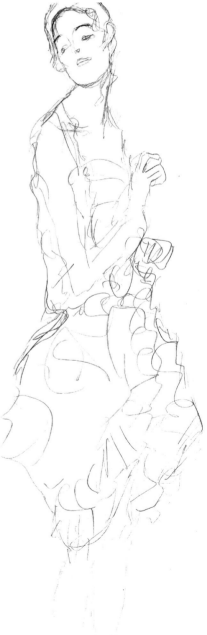

Raphael Santi: A study from the artist's sketchbook—on the subject of Mary and Child. Original size: 184 × 256mm (7¼ × 10 inches).

Gustave Klimt: Despite the loose, almost oriental fall of the dress, the body does not look flat and the motion is clear. Original size: 324 × 496mm (12¾ × 19¼ inches)

Alberto Giacometti: This sketch has no firm contours, but the figure really looks as if it is sitting and the posture is quite obvious. Giacometti used sketches as the basis for his sculptures, often reducing the body to cylindrical forms. Original size: 325 × 505mm (12¾ × 19¾ inches).

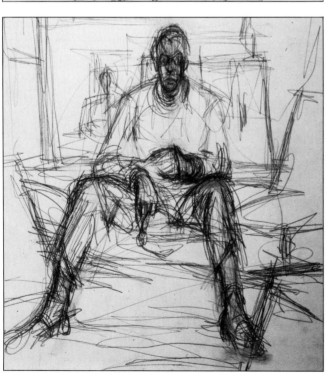

These two drawings were made in a figure-drawing course. Should you ever have the chance to take part in such a course, be sure not to miss the opportunity. The fact that the models hold their positions means that you have plenty of time to study the body proportions properly. You can also try out all the different techniques, from pencil to ink and paint. Do not be discouraged if your drawing is not perfect at the first try. Once again, the maxim is: draw, draw, draw.

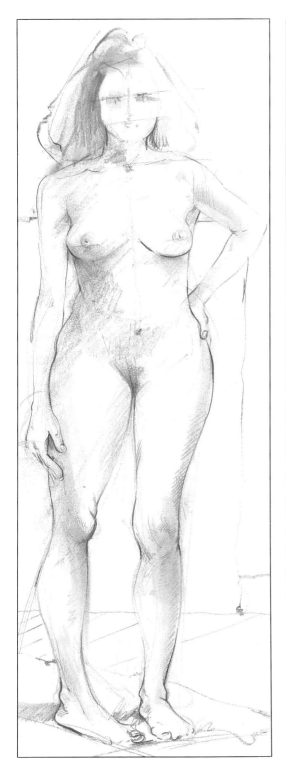

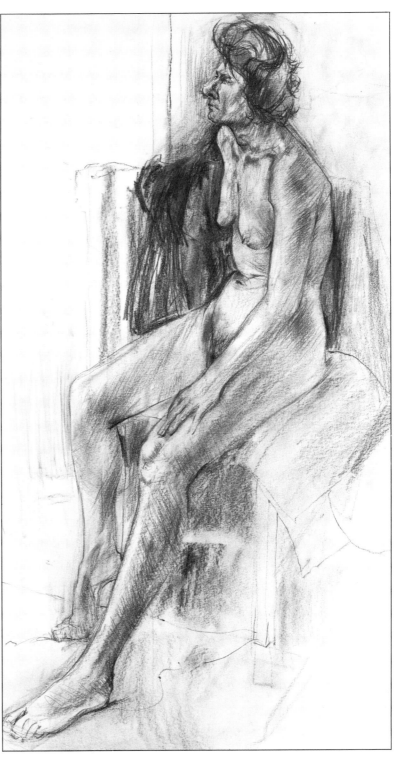

Hands and Feet

The body language of hands is a great aid to introducing expression to your figures.

A clenched fist is threatening; an open, outstretched hand symbolizes friendship (in earlier times this was a gesture to show that someone had come unarmed), and an outstretched index finger points to something, emphasizes something. People can be sized up by their hands. Someone who works manually, for example, will have rougher hands than a pianist. The hands of a young girl are different from those of a grown woman. Very often insufficient attention is paid to hands and feet when people start to draw. Sometimes you have the feeling that there are more fingers on a hand than you have space for in your drawing. Hands tend to be either ignored completely, or only hinted at, stuck in a pocket or behind a back. If hands are drawn they are often too small in relation to the body.

Don't shrink from drawing hands, even if this seems to be a difficult subject. See hands as a challenge and even try drawing more difficult positions of the hand. Getting it right will build up your confidence and this will become apparent in your work. Observation is once again the most important factor. Even if a hand might look very complicated, it can be broken down into the basic forms that will help elucidate the shape. Start with rough outlines onto which you can "build" the form, then go into details.

Observe your own hand while you're drawing: How does it hold the pencil? Which fingers cross over one another? What is the position of the thumb in relation to the other fingers? Even the most difficult motifs can be broken down into basic forms, helping you to draw a solid form and not mere outlines.

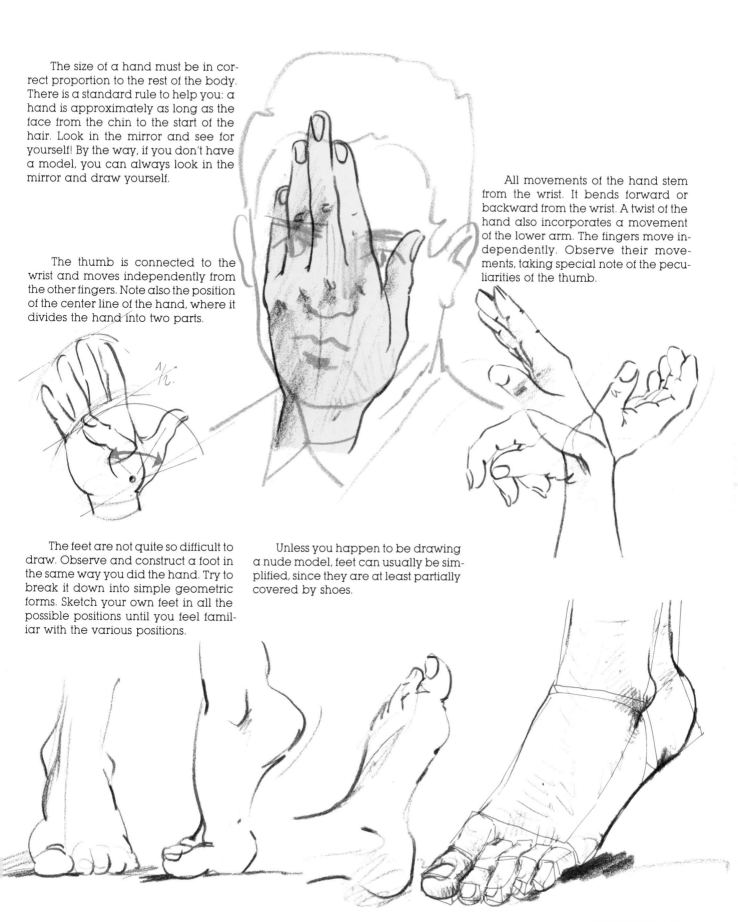

The size of a hand must be in correct proportion to the rest of the body. There is a standard rule to help you: a hand is approximately as long as the face from the chin to the start of the hair. Look in the mirror and see for yourself! By the way, if you don't have a model, you can always look in the mirror and draw yourself.

The thumb is connected to the wrist and moves independently from the other fingers. Note also the position of the center line of the hand, where it divides the hand into two parts.

All movements of the hand stem from the wrist. It bends forward or backward from the wrist. A twist of the hand also incorporates a movement of the lower arm. The fingers move independently. Observe their movements, taking special note of the peculiarities of the thumb.

The feet are not quite so difficult to draw. Observe and construct a foot in the same way you did the hand. Try to break it down into simple geometric forms. Sketch your own feet in all the possible positions until you feel familiar with the various positions.

Unless you happen to be drawing a nude model, feet can usually be simplified, since they are at least partially covered by shoes.

The Head

Facial expressions often speak louder than words. From these we can discern whether a person is happy, sad, or angry.

In the field of drawing and painting, facial expressions are a very important medium for portraying feelings and moods. When you start to study faces you will be confronted with certain basic forms that keep recurring, such as broad, narrow, or round faces. Certain physical features are automatically associated with characteristic traits, such as, "She has thin lips; she must be mean" or "He's so round and cuddly." These are associations that can be used if you are drawing from the imagination. If you wanted to draw a cheerful summer scene, you would certainly fill this with round happy faces rather than angry screwed up eyes and pinched lips. If you draw a portrait of a real person, you should however forget these generalizations very quickly. The artist always tries to portray gestures and expressions that he feels are typical of his model. First of all, however, we should examine the proportions and structure of a head.

 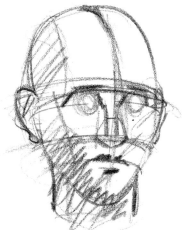 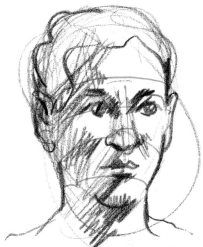

The head is basically egg-shaped. Draw this basic form and divide it into sections with horizontal and vertical lines, as shown above. The eyes are situated on the central horizontal line.

Now add the eyebrows slightly above the eyes and the nose halfway between the eyebrows and chin. The ears stretch from the level of the eyebrows to that of the tip of the nose. The mouth is in the first third between nose and chin.

The hair begins in the top third of the head.

We have now determined the basic facial features. By the addition of light and shade around the nose and eyes, we can make the face more plastic.

Take a three-quarter view of a face. The horizontal and vertical lines will move with the turn of the head.

The nose projects out of the vertical line and is in the middle section of the face, partly covering a corner of the far eye. Look at this very carefully. If the eye is too far forward, this will create the impression that the eye is sticking out.

Taking this basic structure, it is now quite simple to form the face, adding light and shade to round off the basic features.

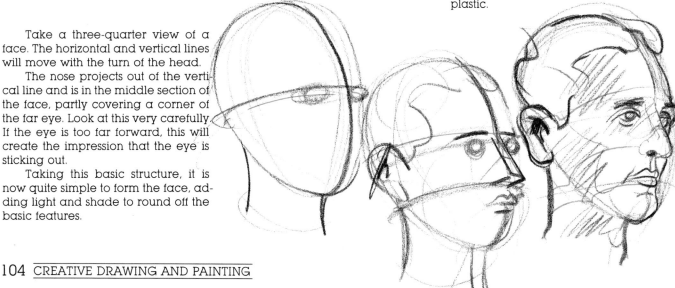

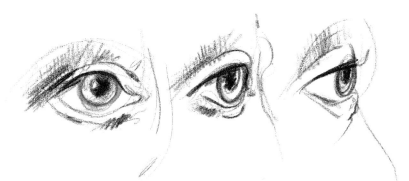

The diverse curves and arches of the eye are important. Examine carefully how the bridge of the nose relates to the eyelid and eye itself. Note which parts obscure what.

The eyes are the most expressive part of a face. There are many different eye shapes, so we'll limit ourselves to one basic form. Look at an eye very carefully before you draw it. The iris is round. As soon as the head turns, however, it looks elliptical. Every eye has a light reflex on the pupil which lends life and expression to the eye. An eye drawn without this light spot appears lifeless.

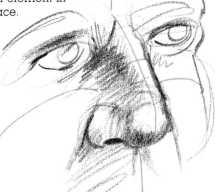

The appearance of the nose changes with every turn of the head. For the sake of simplicity, try to picture the nose as a three-sided wedge. This little trick will help you to capture the true perspective of this solid, three-dimensional element in the middle of a face.

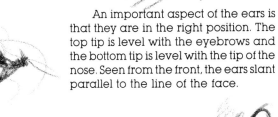

The mouth is second only to the eyes in expressiveness. When the lips are still, their full form is apparent. Lips in motion change considerably. The curve of the lips is, naturally, very important. The line where the lips meet is darker than the other lines. Emphasize this more than the outer lines.

An important aspect of the ears is that they are in the right position. The top tip is level with the eyebrows and the bottom tip is level with the tip of the nose. Seen from the front, the ears slant parallel to the line of the face.

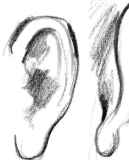

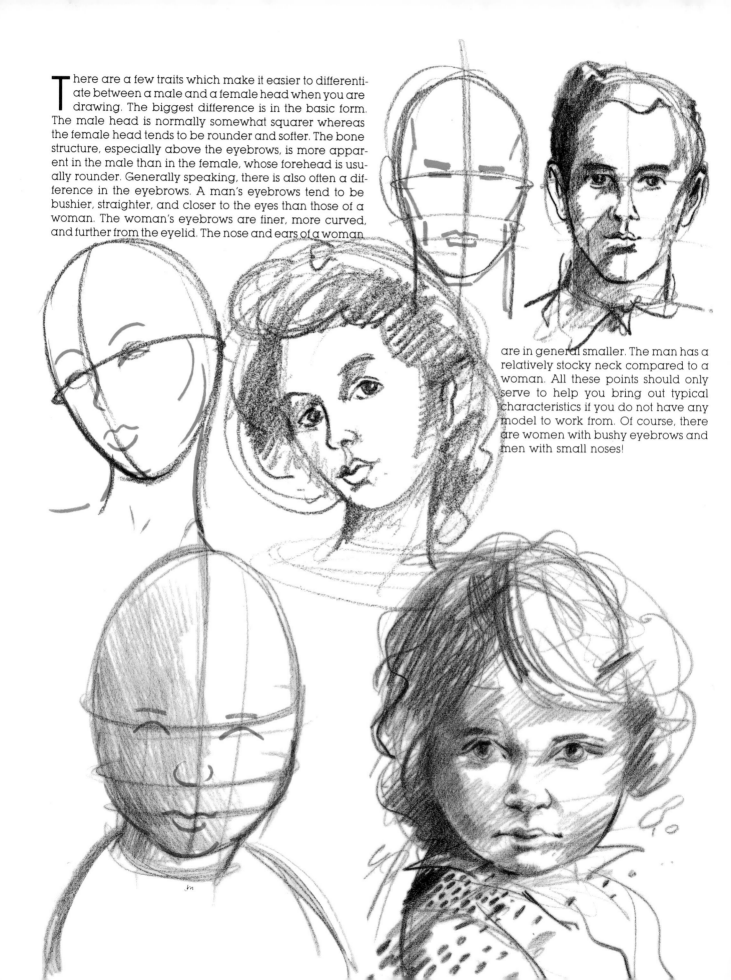

There are a few traits which make it easier to differenti-ate between a male and a female head when you are drawing. The biggest difference is in the basic form. The male head is normally somewhat squarer whereas the female head tends to be rounder and softer. The bone structure, especially above the eyebrows, is more appar-ent in the male than in the female, whose forehead is usu-ally rounder. Generally speaking, there is also often a dif-ference in the eyebrows. A man's eyebrows tend to be bushier, straighter, and closer to the eyes than those of a woman. The woman's eyebrows are finer, more curved, and further from the eyelid. The nose and ears of a woman

are in general smaller. The man has a relatively stocky neck compared to a woman. All these points should only serve to help you bring out typical characteristics if you do not have any model to work from. Of course, there are women with bushy eyebrows and men with small noses!

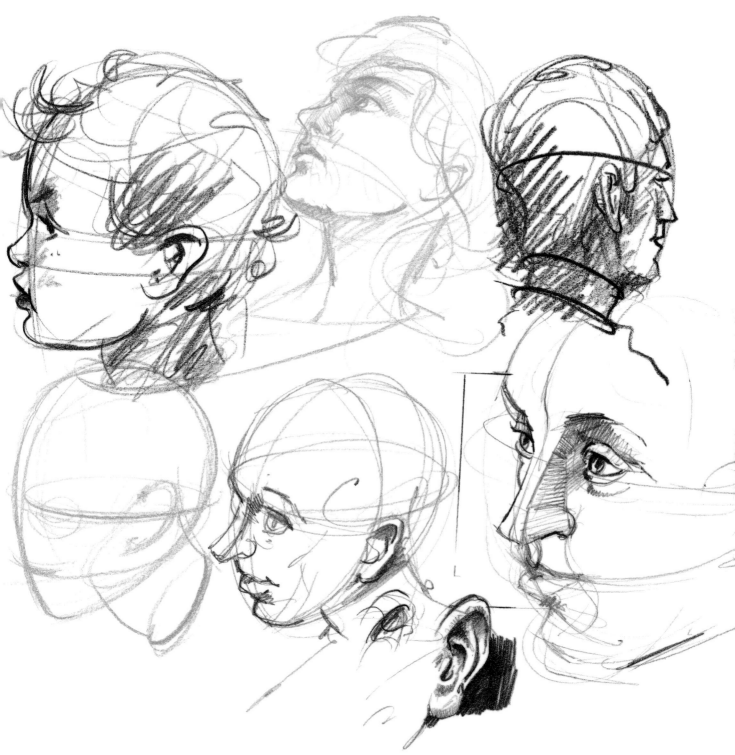

A child's head and features are soft and round. Compare the above sketches of heads. It's impossible to tell from the face alone whether the first sketch is of a young boy or a young girl. The procedure with heads is much the same as with sketches of a figure as a whole. First lightly draw in the basic shapes and determine the proportions. Don't concentrate on finishing one special section right away, but try to keep your eye on the subject as a whole. The sketches on this page illustrate very well how the construction lines can also help to work in shapes and curves. To return to the old maxim, draw and sketch as often as possible. You will be surprised how things that might have seemed difficult at first will soon slip into place. And above all, carefully observe the faces of people around you so that you will become familiar with their shapes and proportions.

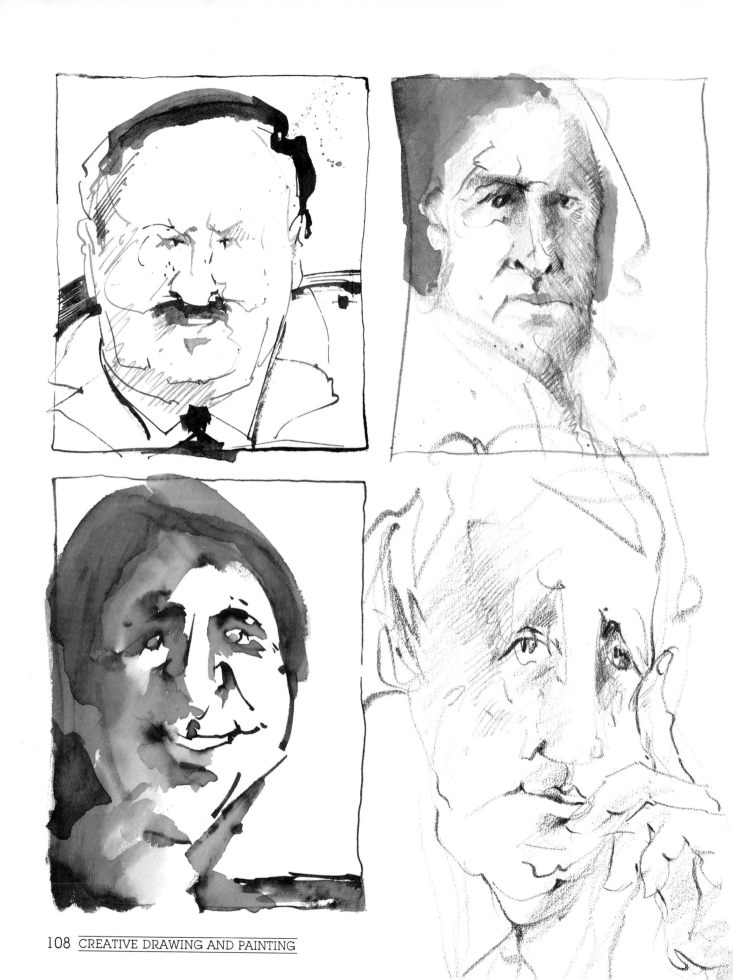

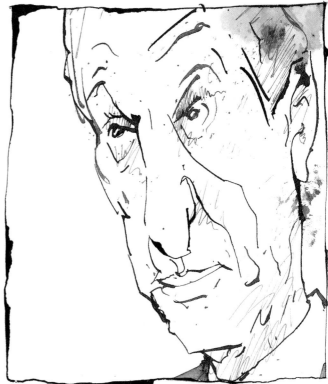

So far in this section, we've been mainly concerned with the basic forms and proportions of people. There are other aspects that also play an important role in the portrayal of a person as an entity. His personality differentiates him from other people, for example. Sometimes a portrait might not resemble a person physically, but everyone recognizes immediately who this person is because the artist has succeeded in capturing not only color of the skin or the features, but also the person's personality.

Once you are familiar with the basic forms, you are better equipped to tackle the character of the person you are drawing.

Observe facial expressions connected to different moods, try out various techniques. Draw your family, your friends, an announcer on television, or, if you do not have any other possibilities, people in photos. In this case, I would advise you to use snapshots rather than perfect studio studies, as these tend to show more emotion and movement. I have chosen here a collection of very different sketches showing diverse types of people, for which I used a variety of techniques.

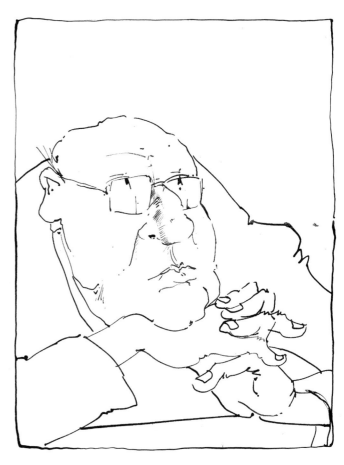

Drawing Animals

The oldest drawings known to mankind are drawings of animals: bison, antelope, horses. Animals always had a special significance for man and featured in most of his drawings, very often as religious or spiritual symbols. This phenomenon was not restricted to any particular race, country, or period in history. It applied equally to primitive tribes and dukes and kings. Even today, animals are symbols denoting war, peace, luck, etc. The eagle (independence) is, for example, the symbol of the United States. Great Britain has the lion (sovereignty) and France the cockerel (vigilance).

It is therefore not surprising that animals are so popular in art. They are more difficult to draw than people, if not for any other reason than that they will not keep still on command—quite the opposite! If you have a pet that you would like to draw, I'd advise trying this out when your dog (cat, bird, etc.) is asleep. Cows and pigs are fairly good subjects, because they move relatively slowly.

The only other alternative is to go to a zoo, providing you are not disturbed by inquisitive people looking over your shoulder, something it is almost impossible to avoid. But a zoo does offer a large choice of animals that, because they're confined to

cages and enclosures, can only move to a limited extent. Stuffed animals are, naturally, very practical subject matter, but these are not so easy to find. A tip: try going to a natural history museum. These offer excellent opportunities to study individual details.

Then we are left with photos. The danger with these is that your pictures can tend to be stiff and rigid. Once again, I would advise you to collect photos out of magazines that show the animals on the move and in their natural surroundings, rather than cold, lifeless portraits.

Build up your animal drawing in the same fashion as I explained in the section on figure drawings: First of all try to capture your animal as a whole by making a rough outline, then sketch in the proportions. Then you can go into details.

Let's first just look at some different animals. The first thing you will notice with the zebra is the somewhat confusing system of stripes. If you study these more closely, though, they will help you to define the form of the animal.

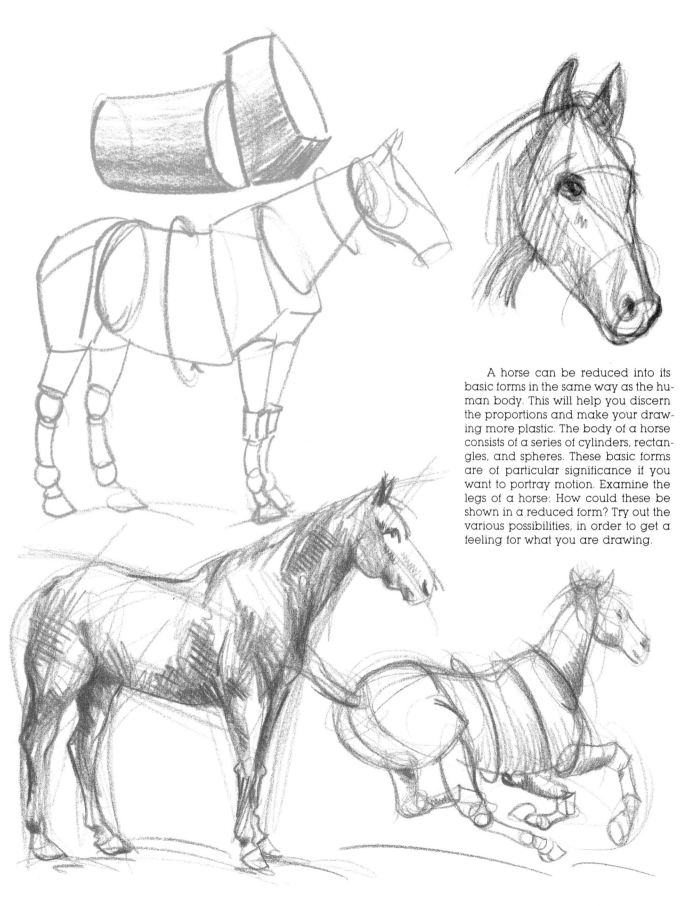

A horse can be reduced into its basic forms in the same way as the human body. This will help you discern the proportions and make your drawing more plastic. The body of a horse consists of a series of cylinders, rectangles, and spheres. These basic forms are of particular significance if you want to portray motion. Examine the legs of a horse: How could these be shown in a reduced form? Try out the various possibilities, in order to get a feeling for what you are drawing.

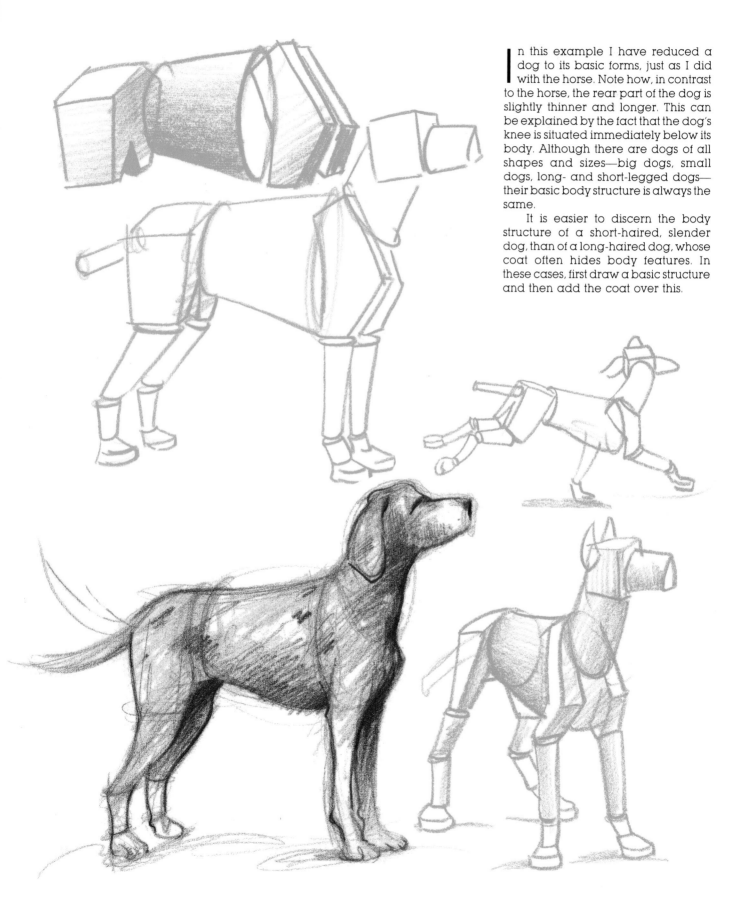

In this example I have reduced a dog to its basic forms, just as I did with the horse. Note how, in contrast to the horse, the rear part of the dog is slightly thinner and longer. This can be explained by the fact that the dog's knee is situated immediately below its body. Although there are dogs of all shapes and sizes—big dogs, small dogs, long- and short-legged dogs—their basic body structure is always the same.

It is easier to discern the body structure of a short-haired, slender dog, than of a long-haired dog, whose coat often hides body features. In these cases, first draw a basic structure and then add the coat over this.

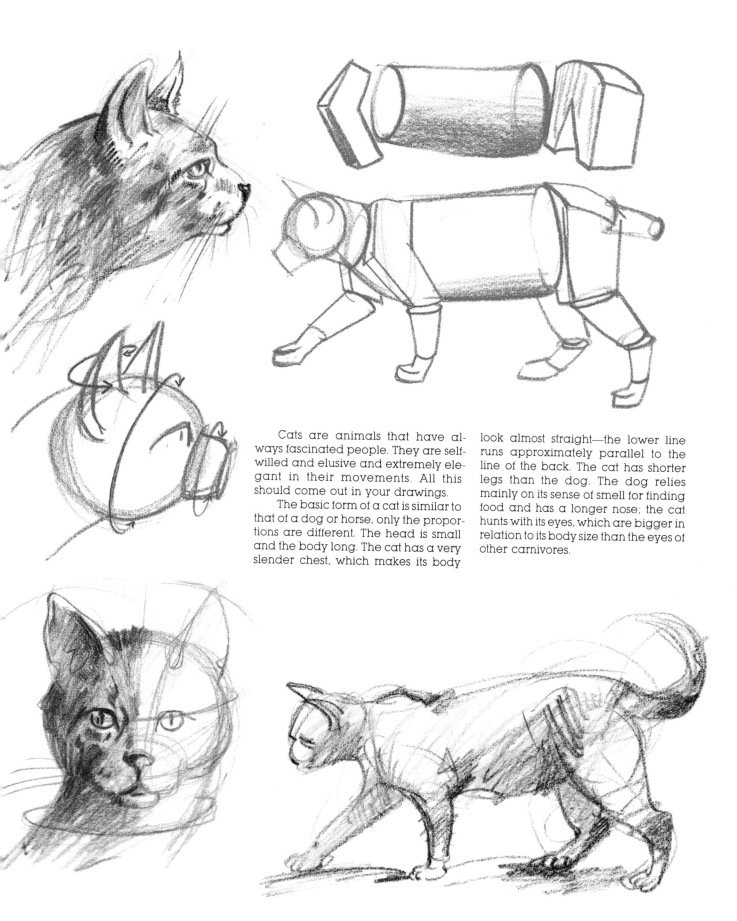

Cats are animals that have always fascinated people. They are self-willed and elusive and extremely elegant in their movements. All this should come out in your drawings.

The basic form of a cat is similar to that of a dog or horse, only the proportions are different. The head is small and the body long. The cat has a very slender chest, which makes its body look almost straight—the lower line runs approximately parallel to the line of the back. The cat has shorter legs than the dog. The dog relies mainly on its sense of smell for finding food and has a longer nose; the cat hunts with its eyes, which are bigger in relation to its body size than the eyes of other carnivores.

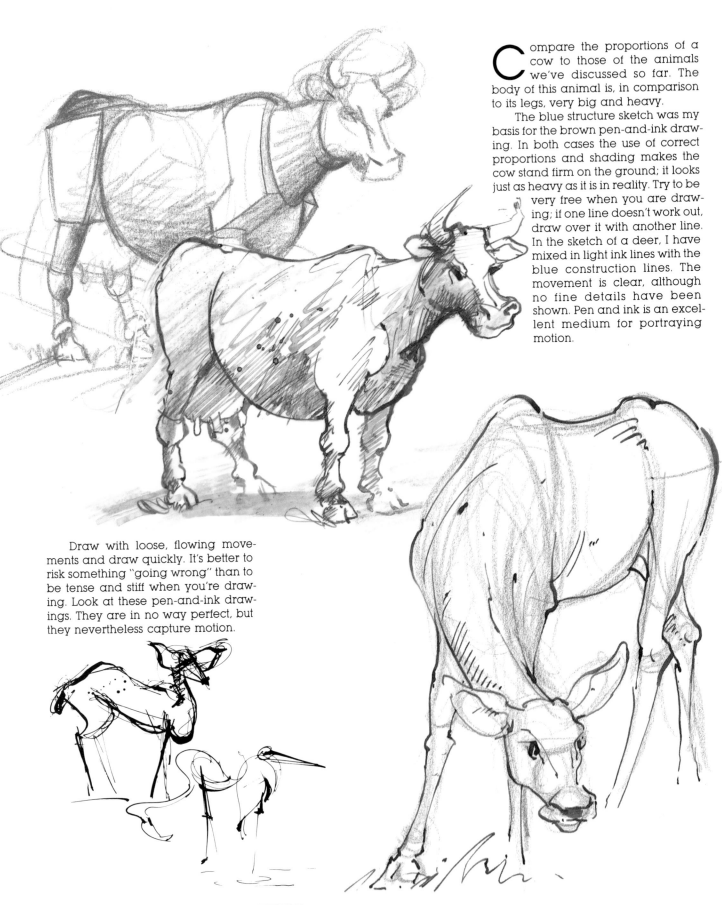

Compare the proportions of a cow to those of the animals we've discussed so far. The body of this animal is, in comparison to its legs, very big and heavy.

The blue structure sketch was my basis for the brown pen-and-ink drawing. In both cases the use of correct proportions and shading makes the cow stand firm on the ground; it looks just as heavy as it is in reality. Try to be very free when you are drawing; if one line doesn't work out, draw over it with another line. In the sketch of a deer, I have mixed in light ink lines with the blue construction lines. The movement is clear, although no fine details have been shown. Pen and ink is an excellent medium for portraying motion.

Draw with loose, flowing movements and draw quickly. It's better to risk something "going wrong" than to be tense and stiff when you're drawing. Look at these pen-and-ink drawings. They are in no way perfect, but they nevertheless capture motion.

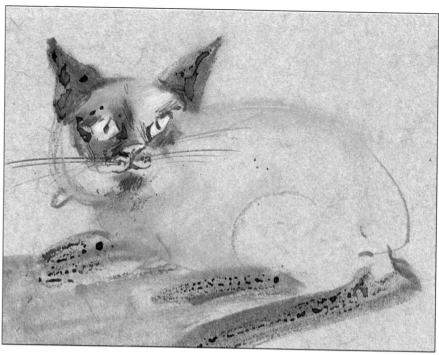

I often see human characteristics reflected in the face of an animal. The facial expressions of this monkey and dog have something very human to them.

The quick ink-and-water sketch of a cat entirely captures its watchful pose although no great attention has been paid to details. In contrast, the ram pictured below is the product of much patient work with just lines and toning to create this detailed form.

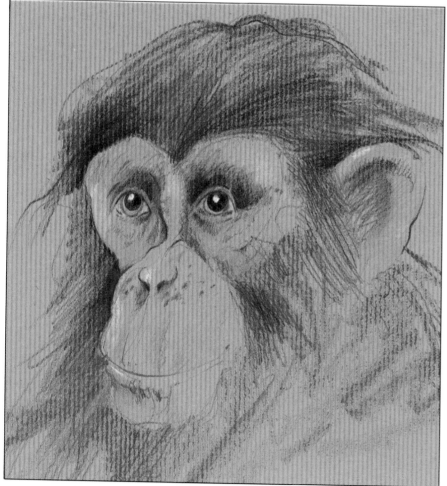

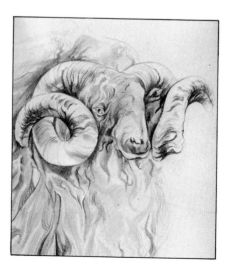

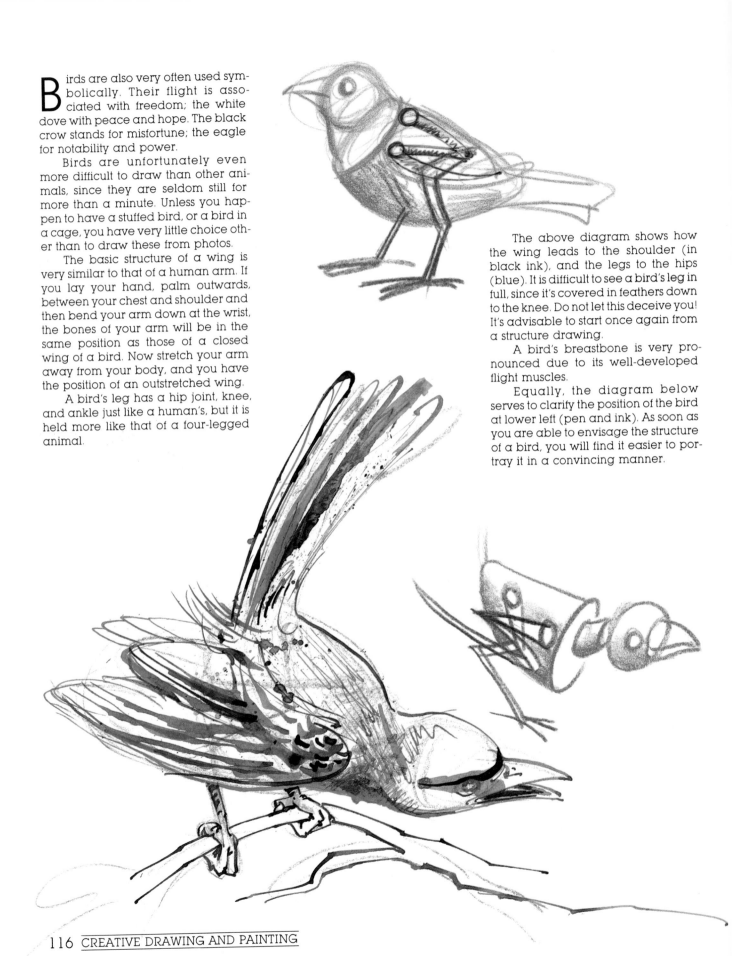

irds are also very often used symbolically. Their flight is associated with freedom; the white dove with peace and hope. The black crow stands for misfortune; the eagle for notability and power.

Birds are unfortunately even more difficult to draw than other animals, since they are seldom still for more than a minute. Unless you happen to have a stuffed bird, or a bird in a cage, you have very little choice other than to draw these from photos.

The basic structure of a wing is very similar to that of a human arm. If you lay your hand, palm outwards, between your chest and shoulder and then bend your arm down at the wrist, the bones of your arm will be in the same position as those of a closed wing of a bird. Now stretch your arm away from your body, and you have the position of an outstretched wing.

A bird's leg has a hip joint, knee, and ankle just like a human's, but it is held more like that of a four-legged animal.

The above diagram shows how the wing leads to the shoulder (in black ink), and the legs to the hips (blue). It is difficult to see a bird's leg in full, since it's covered in feathers down to the knee. Do not let this deceive you! It's advisable to start once again from a structure drawing.

A bird's breastbone is very pronounced due to its well-developed flight muscles.

Equally, the diagram below serves to clarify the position of the bird at lower left (pen and ink). As soon as you are able to envisage the structure of a bird, you will find it easier to portray it in a convincing manner.

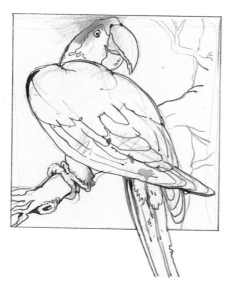

Some motivating ideas: The mere action of adding the most important shadows will give the bird its rounded form. In these pictures I have been purposely very sparing in my use of color in order to accentuate certain points. Below, you can see a purely oriental portrayal. Despite the gross simplification, the bird's posture is absolutely evident. Compare this bird to the bottom diagram on the opposite page.

Drawing Plants

Nature is rich in motivating subject matter for artists. They feel the desire to try to capture and reproduce landscapes, flowers, trees, and grasses in styles ranging from minutely detailed copies to mere impressions, in which you feel you can sense the fragrance of a plant, without actually seeing its exact form. Once again, an understanding of the structure of a plant will help you to reconstruct it in a drawing. Look for the basic forms, whether you want to draw trees in a landscape or a plant in your home. Observe the play of light and shade. Sketch what you see in your sketchbook no matter whether it is details of a flower or a whole bunch of flowers. Look back to pages 48-51, on which I described the various ways of portraying structure and form using just a pencil.

Plants are easier to draw than animals; their shape is simpler and, above all, they keep still! This means that you can examine their form and structure in peace. First capture the form as a whole, as we did with figures and animals, then add details. Take the plant in your hands to get a feeling for it and its textures and to give you a better understanding of what you are drawing. It can be extremely relaxing to draw a flower or plant in the quiet atmosphere of your home, where you can concentrate fully on your subject in the comfort of a chair, without being harassed by inquisitive zoo-goers or restless models.

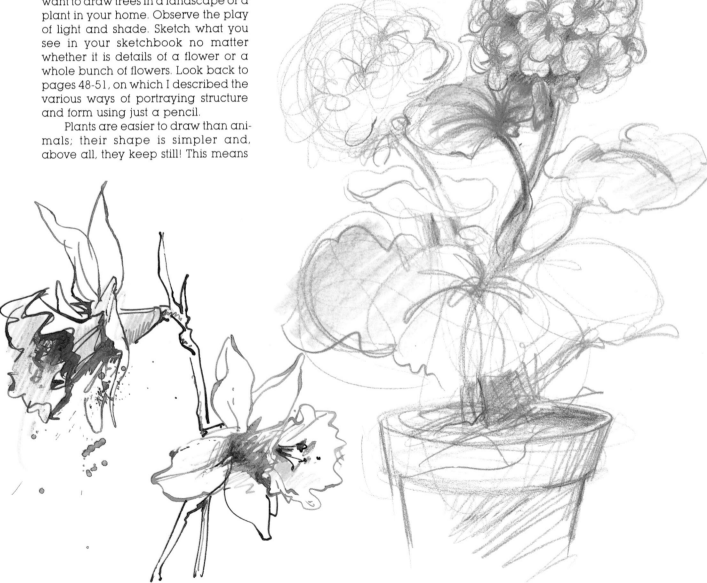

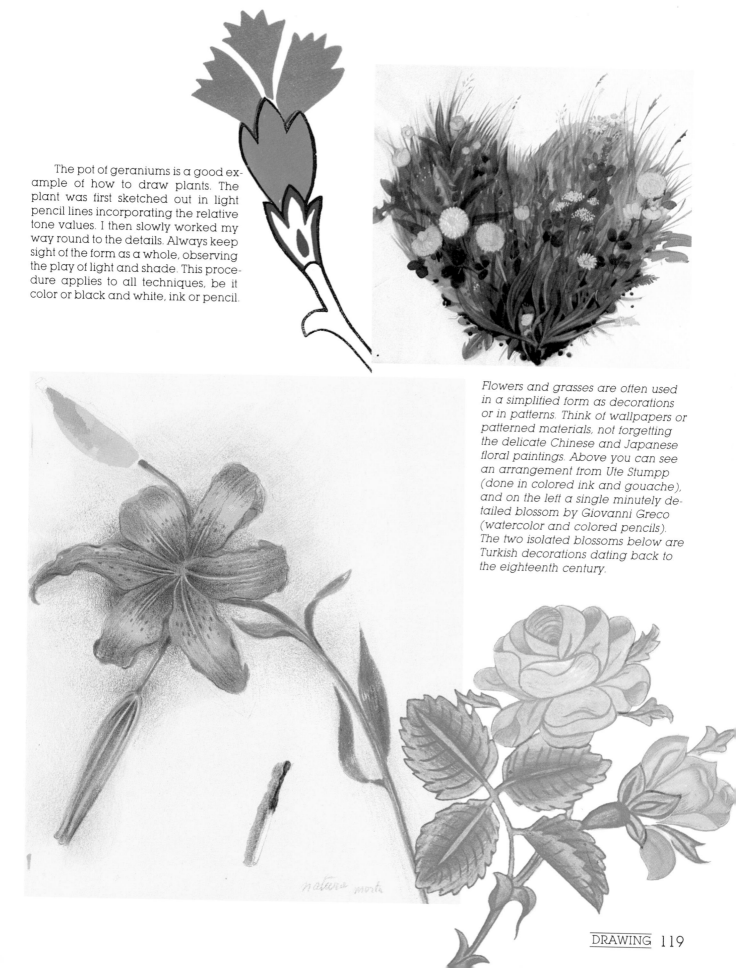

The pot of geraniums is a good example of how to draw plants. The plant was first sketched out in light pencil lines incorporating the relative tone values. I then slowly worked my way round to the details. Always keep sight of the form as a whole, observing the play of light and shade. This procedure applies to all techniques, be it color or black and white, ink or pencil.

Flowers and grasses are often used in a simplified form as decorations or in patterns. Think of wallpapers or patterned materials, not forgetting the delicate Chinese and Japanese floral paintings. Above you can see an arrangement from Ute Stumpp (done in colored ink and gouache), and on the left a single minutely detailed blossom by Giovanni Greco (watercolor and colored pencils). The two isolated blossoms below are Turkish decorations dating back to the eighteenth century.

natura morta

For as long as most people can remember, trees have always been a feature of the landscape, a feature that also turns up in many works of art and literature. To familiarize oneself with all the various types and shapes would be a study in its own right. Even in the course of a year, the tree changes its shape and colors. I love trees and will never tire of trying to portray them both graphically and in paintings. A knowledge of the basic structure of the tree is, just as with animals and people, an advantage. On pages 11 and 12, I showed the basic forms of a tree in light and shade; on page 46 I used the example of a tree to illustrate the use of various grades of pencil.

A tree can be massive, thin, small, high, round, or pointed. Sketch a couple of trees that you see daily. Study their form and structure and preserve all your discoveries in your sketchbook. First look at the tree as a whole, at its structure. It is slightly easier if you partly close your eyes to avoid being diverted by individual colors or branches. Also take note of the shapes formed between the leaves; look carefully to see where the light from the sky shines through the leaves and where they are in shadow.

Try out all possible techniques working freely and allowing yourself to be inspired by the shapes. Work quickly and loosely, concentrating at first only on the essentials. In the examples given below, I have drawn some of the more common tree forms to be found in the Western Hemisphere.

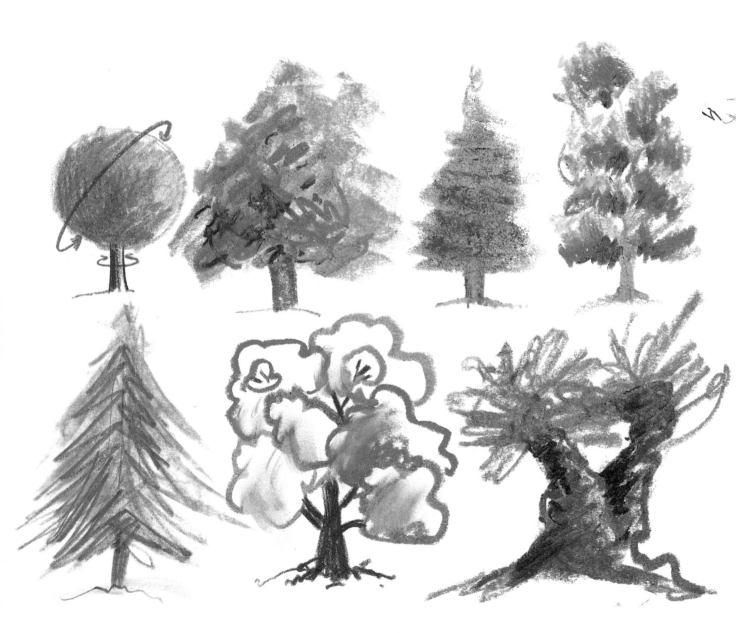

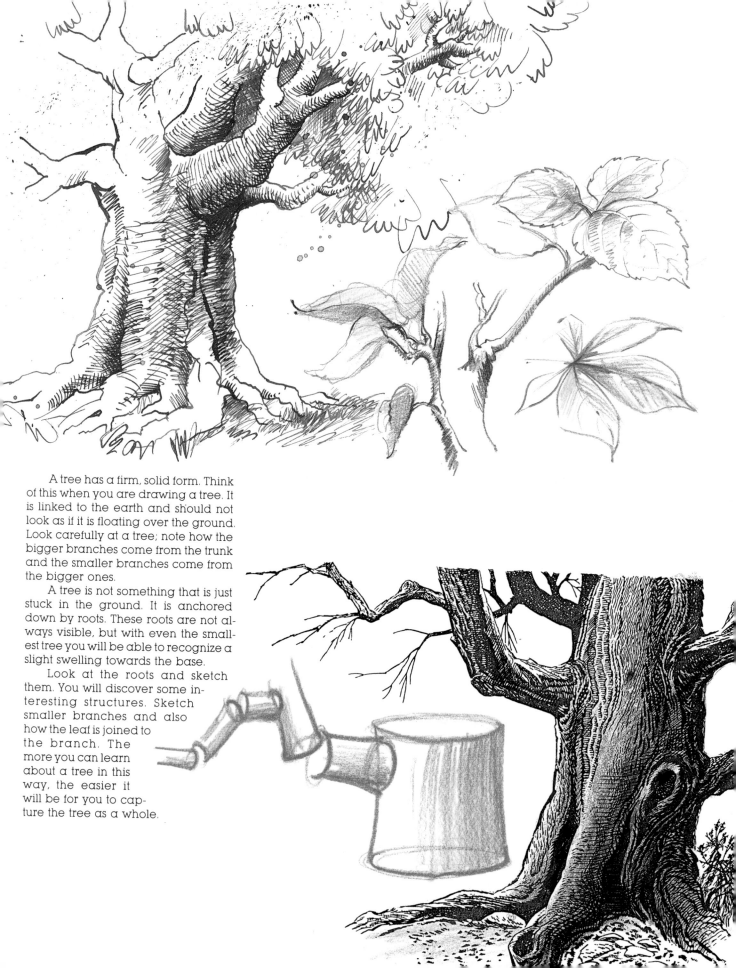

A tree has a firm, solid form. Think of this when you are drawing a tree. It is linked to the earth and should not look as if it is floating over the ground. Look carefully at a tree; note how the bigger branches come from the trunk and the smaller branches come from the bigger ones.

A tree is not something that is just stuck in the ground. It is anchored down by roots. These roots are not always visible, but with even the smallest tree you will be able to recognize a slight swelling towards the base.

Look at the roots and sketch them. You will discover some interesting structures. Sketch smaller branches and also how the leaf is joined to the branch. The more you can learn about a tree in this way, the easier it will be for you to capture the tree as a whole.

Enlarging

First, let me discuss reproducing a sketch in the same size. The easiest way is to take a piece of thin paper that you can see through and trace the main contours. Then turn this tracing paper over and scribble over your lines using a soft pencil or charcoal. Finally, lay the tracing paper onto the paper, canvas, etc., to be used for the new picture and draw over the lines with a sharp pencil. The outlines of your sketch will have been transferred lightly onto the new surface and you can then continue to draw or paint over these, adding details. But now to enlarging.

The Pantograph

This instrument consists of four rods that are joined together (according to instructions) to form a pivoted system. Drawing points are attached to the inner and outer joints. When you trace over the picture you want to enlarge with the inner point, the outer point will automatically draw an enlarged version. The scale of the enlargement is varia-

ble. These instruments are not easy to handle, as both points have to be held at the same time—your hands have to move simultaneously, which takes a bit of practice.

Projections

The sketch you want to copy is laid into a projector and projected directly onto the new surface. The room should be slightly darkened in order for you to see the contours better. The projection scale is determined by the distance between the projector and your paper or canvas.

The Grid Method

Taking your sketchbook once again, choose a section of a sketch that you would like to enlarge and draw a system of grids over this in pencil. The more detailed your section is, the finer the grid network will have to be. Then lightly draw the same grid, but on a larger scale, onto the new

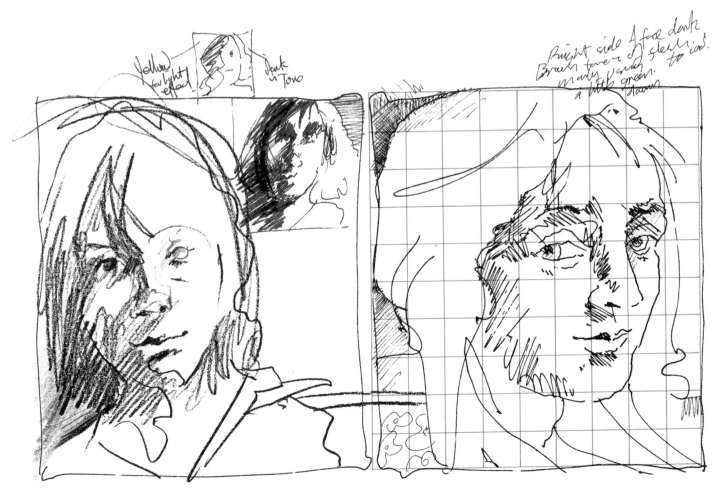

surface. The larger grid network must consist of exactly the same number of squares as the smaller network. Now you can transfer your drawing, square for square, onto the new surface in such a way that exactly the same lines are to be found in the larger squares as in the respective small-er squares. Depending on the technique used, the grid lines can either be rubbed out or painted over.

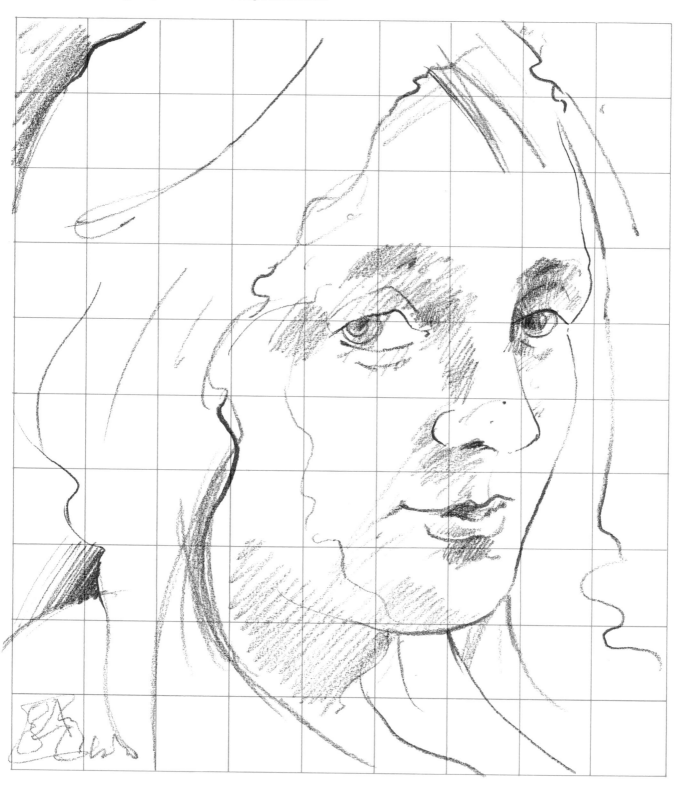

COLOR THEORY

Try to imagine a world without color—what a gray and cheerless conception! A world without color would seem lifeless, would be completely lacking in moods and atmosphere. A black sky with gray fields and gray flowers? By analogy, people would only have gray feelings!

Colors make things come to life, and lend, to a greater or lesser extent, significance to objects. Even as adults we can still be fascinated by the wealth and wonder of the colors in the rainbow.

As an artist, you are particularly dependent on colors, as the most important medium for expressing feelings and impressions, for capturing moods, and for attracting attention.

The importance of color has not diminished from the time of cave paintings to the present day. The first pictures known to us were in earth colors, since pigments and pigment mixtures were, at that time, unknown. The ancient Egyptians and Greeks learned how to produce a great variety of colors, as is apparent in their art. The Chinese possessed the secret of the use of the finest color nuances long before the birth of Christ. Color became an important component of artistic techniques—in mosaics, ceramics, painting, and illustration. Whole stylistic trends have been changed by new attitudes towards color. Up to the fifteenth century, when Giotto (Italian painter and architect, 1266/7-1337) is said to have introduced a new era of painting, colors had been applied on a flat, two-dimensional plane. Giotto broke away from the stereotyped, flat forms of Italo-Byzantine art and used color and shading to lend solidity and form to his figures.

It was not until the beginning of the Romantic Revival, however, that colors took on the character still known to us today. Based on their studies of nature and light, painters began using colors to capture moods. The most prominent representatives of this movement are the English painters William Turner and John Constable. Turner even went so far as to break away from concrete forms, concentrating only on capturing the moods expressed in air, light, and color, and he is sometimes called the first abstract painter in Europe.

The discovery that color is greatly affected by sunlight led to a revolution in the use of color in Western painting and to the birth of Impressionism. All taboos regarding the use of color were removed. The later abstract painters broke away entirely from concrete subject matter and nature, playing only with colors and shapes.

Color plays an important role in our daily lives. It can instill a feeling of happiness or melancholy; colors can attract attention, just as they can soothe. How often is our choice of a

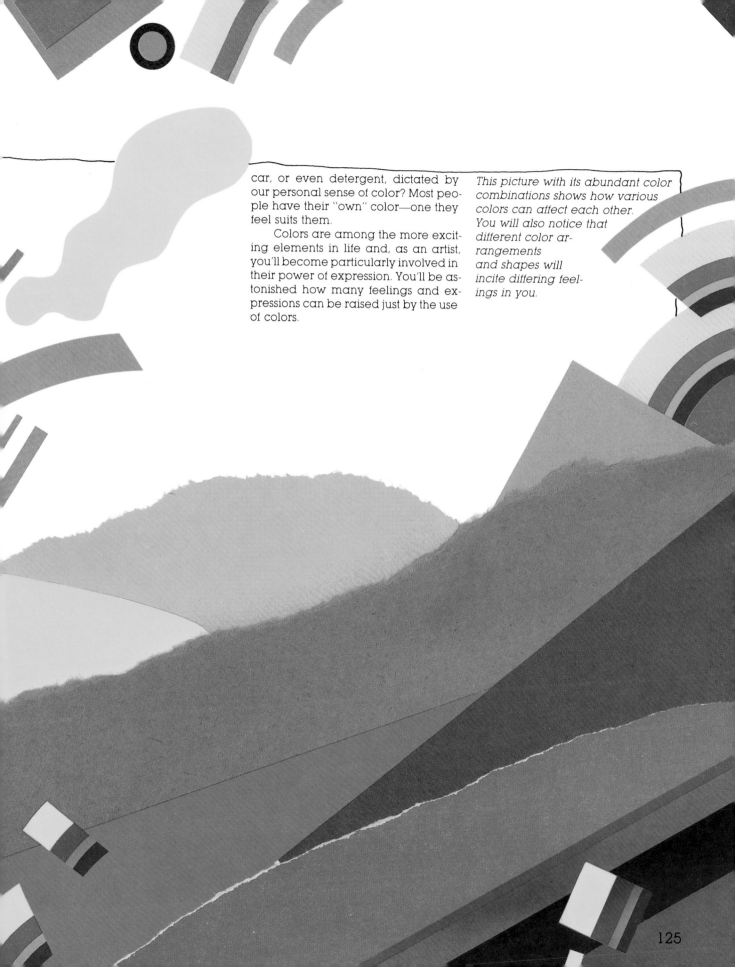

car, or even detergent, dictated by our personal sense of color? Most people have their "own" color—one they feel suits them.

Colors are among the more exciting elements in life and, as an artist, you'll become particularly involved in their power of expression. You'll be astonished how many feelings and expressions can be raised just by the use of colors.

This picture with its abundant color combinations shows how various colors can affect each other. You will also notice that different color arrangements and shapes will incite differing feelings in you.

The Color Wheel

Many people probably consider color theory, like many other theories, somewhat boring. It is quite true that not even the best book on color theory can be of any help if you're not aware of what background you should give a red house set in a snow landscape. Only experience can help remove your uncertainty as to which color combinations are suitable for your picture.

Despite this, you should know some of the basic facts about color, so that you'll be able to use them with more confidence. I'll do my best to keep the theory as simple as possible.

What is color? If we want to see something, we need light. The rays of light coming from the sun are referred to as "white light." Yet, strange as it might seem, this white light contains all the colors that we see around us. This is demonstrated when you see a rainbow during a summer shower, or by shining a ray of white light through a triangular piece of glass, called a prism. Sir Isaac Newton (English mathematician, physicist, and astrologer, 1643-1727) was the first to discover how pure white light could be divided into different goups of color waves using a prism.

All colored objects contain pigments that are able to absorb certain rays and to reflect others. All we see are the reflected rays. The pigment in the skin of a red apple, for instance, reflects only the red rays, and absorbs all the others. A green apple, on the other hand, reflects only the green rays, absorbing the rest.

Most people describe colors in a very vague, subjective way. They refer to something as being "sky blue," "grass green," or "flaming red." The problem is that my concept of the color of grass or of a flaming fire is certainly very different than that of my friends and neighbors.

Such vague descriptions might be acceptable if you're telling a story, but if you are working with colors, you will have to learn to be more precise. For this reason a logical color system was developed by Hermann von Helmholz, (German physicist, 1821-1894) who discovered in 1866 that all colors have three things in common: hue, value, and intensity.

These three color characteristics are still of importance today, although since then a very exact color classification has also been developed. First of all, we have the *color-colors*—these are the true colors in the general sense—and the *noncolor-colors*— white, gray, and black.

Red, yellow, and blue, the *primary colors*, are unique because they cannot be produced by mixing other colors. The individual colors are further classified into *pure colors*, *shaded colors* (pure colors mixed with black), and *tinted colors* (mixed with white).

Let's now look at the color wheel. All of the colors in this wheel are either pure primary colors (red, yellow, and blue) or mixtures of these.

If you mix yellow with blue you will create green; if you mix blue with red you will get violet. Orange is made by mixing yellow and red. Green, orange, and violet are referred to as *secondary colors*.

If you now mix the primary colors with the secondary colors, you'll get six more colors: yellow-green, red-orange, blue-green, yellow-orange, red-violet, and blue-violet. The colors that are opposite each other in the color wheel are called *complementary colors*. Thus yellow is the complementary color to violet, red to green, etc. If you mix a color with its complementary color, you will produce gray. You can try this out for yourself (be careful, however, to ensure that your basic colors are pure).

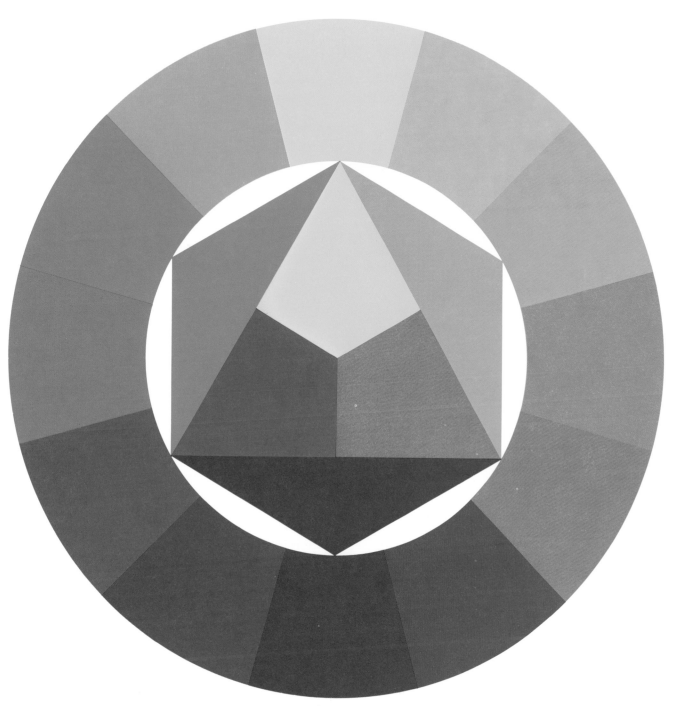

No matter which painting technique you tend towards, it will certainly help you if you have sometime made your own color wheel. Books can, unfortunately, only supply you with theory; the practice is up to you. It is this practice alone that will give you a feeling for color.

It sounds very sophisticated when you learn that a color, when mixed with its complementary color, will produce gray. But you will only really begin to understand this statement when you have mixed these colors yourself.

Compare your colors with those shown here and try to reproduce the colors in this wheel. Use whatever material you choose: watercolors, gouache, acrylics, or oil paints.

Hue, Value, and Intensity

When you describe a color to another person, you will in general name its hue, for example, "green."

If you further classify this green as either dark green or light green you are indicating its value. Some colors have a high value, others a low value. If you were to take a black-and-white photo of a palette of paints, some of the colors would come out almost black in the photo, others almost white, and others would appear to be gray. The hue is eliminated and all you have left is the value—the relative lightness or darkness of a color. A high value means that a color would photograph almost white, whereas a low color value would come out almost black on a photograph.

The concept of color intensity is slightly more difficult to explain. Imagine that the colors on your palette are brightly colored light bulbs that can be regulated by a dimmer. The more electricity that flows into the bulb, the brighter and more intense the color would shine. If you reduce the flow of electricity the color would become less intense. You have changed neither the hue nor the value, but you have altered the intensity of the color.

Hue

As I've just mentioned, the hue is simply the name given to a color and thus the easiest way to describe it. Orange, yellow, violet—these are all hues belonging to the color wheel. The closer together hues are located on the color wheel, the more related and harmonious they are, because each color contains some of the color lying next to it. Colors opposite each other on the wheel have nothing in common and contrast each other.

The hue of these apples is in the one case green and in the other case blue. This statement, however, supplies us with no details as to the type and quality of the colors.

Value

The value refers to the lightness or darkness of a color, as the two examples given below show very clearly. Both pictures were produced using the same colors: cadmium red

deep, cadmium yellow light, cerulean blue, madder lake deep, burnt umber.

In the lighter picture all the colors were mixed with titanium white. We then speak of the colors being "tinted."

In the darker picture, ivory black was mixed into the colors. This picture is made up of so-called "shaded" colors. The hues remain constant—yellow-red apple on a green napkin—only the values have changed.

Intensity

The term intensity refers to the strength, saturation, and purity of a color. An intense blue, for example, appears to be "bluer" than a blue that has been mixed with another color. This is because there is more blue in pure blue than in a mixed blue. Such

blue has a greater ability to reflect the blue rays of light.

Tube paints are usually very intense and cannot often be used in this pure state. By adding black, white, or gray, you can reduce the intensity of pure pigments. This will change the intensity but not the hue. To explain this

using another example: "blue jeans" will lose their intensity, or blueness, with frequent washing, but not their hue; they remain blue.

To take the example of the apples once again: this apple is full of intensity and pure red.

By adding gray the apple loses intensity, but it remains red, meaning that it's retained its hue.

The gray is now predominant, and the color of the apple has lost most of its intensity, but it is still a red apple. It has not suddenly turned green.

I've gradually reduced the intensity of the red in this apple by adding more and more gray.

Only the intensity has changed, not the hue. If you half close your eyes and compare the apples, you will notice that the value is the same for all three apples. When you mix colors, you change hue, value, and intensity simultaneously. Do not be misled into thinking that you now have to contemplate deeply on the value and intensity of each color. This information has been included to help you recognize why perhaps something is "wrong" with a picture, or how you can give more expression to a certain mood or feeling. With practice you will soon know what effect one color can have

on another and how you can use this purposefully. Try mixing black, white, and gray in several ways and using these mixtures on varying examples as I've shown here.

Quick Review	
Hue:	refers to the name of a color; red, green, yellow, etc.
Value:	refers to the lightness or darkness of a color.
Intensity:	refers to the strength or purity of a color.

Whenever you set colors into a composition, you'll notice that these have a reciprocal effect on each other. This is a phenomenon you'll be able to use very effectively once you have enough practice.

Let's look at the various effects more closely. If you paint a dark shape on a white surface, it will appear to be very dark. This is due to the white area around the shape. If you paint over this white surface with another color, the tone will appear to become lighter; the color has, to our eyes, put the shape "into place." This illusion of changing color is one of the normal problems facing all beginners. Hue and intensity are, as our example has shown, affected by the colors adjacent to the color in question.

You will soon discover that every color composition entails a process of arranging and adapting hue, value, and intensity.

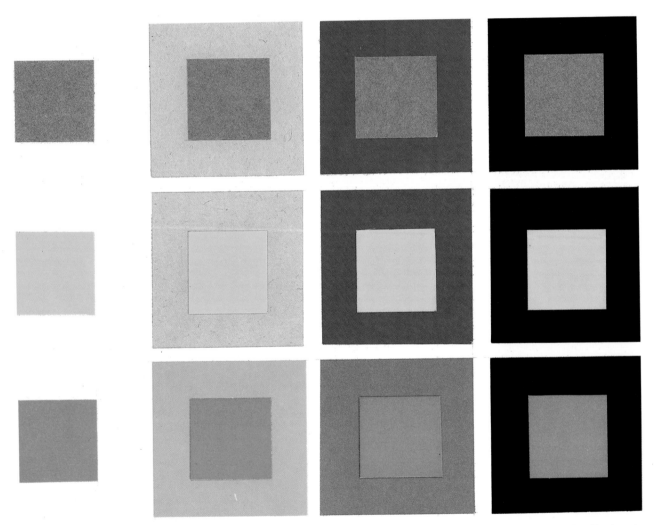

The examples shown above illustrate how one color can modify another. The colors in the inner squares have the same value from left to right; but the backgrounds are all different. Compare the inner squares in each row. The gray on the left appears darker than the gray on the far right. The same can be observed in the row of yellow squares. But the inner squares in each row are identical. By setting identical values against backgrounds of varying color, you can see how the background color appears to modify the color it surrounds. Red set against a white background looks intense and bright, but these qualities can be dampened by using different background colors.

Even a simple picture of a tree or a house can confront you with the problems we have discussed in the last pages when you start to apply color. You'll see, in the examples I've shown here, how the green seems to change depending on the background color. It appears to become lighter or darker, although I used an identical green for each of the pictures.

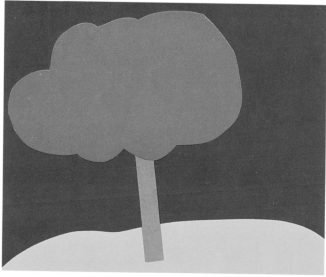

The examples shown below illustrate the drastic changes red is capable of. Against a background of yellow, it appears to be "redder," but with a green background it seems to tend more towards orange.

The background color will always affect the color it is surrounding, whether this background color is dark or light, warm or cold.

Note also how light can affect colors. This red will look very different in daylight than in artificial light.

The Message in Color

Colors can have a strong influence on our emotions. No matter whether you feel happy or sad, colors can instill a feeling of disquiet, depression, excitement, or melancholy.

Open yourself up to your surroundings. Try to discover and observe light and colors and the effect that these can have on each other. Try to watch a film or a play merely from the aspect of color. It's highly unlikely that you will see a happy love scene set against a somber, gray-blue background. Pink is the color generally used to denote sentimentality and romance. Spooky, scary scenes are commonly supported with greens and violets. We also tend to have fixed associations for certain colors in our daily lives. Moonlight is cool; the colors of a sunrise are warm and cheerful; cool gray imparts a feeling of solitude or even desperation.

The fact that colors can evoke our emotions is exploited in many ways to influence our reactions. The colors used in supermarkets are aimed towards encouraging us to buy certain products; colorful working conditions should motivate us to work; green walls in a hospital are supposed to have a calming, soothing effect on the patients.

Why, you may ask, are people so particular in the choice of color for their cars?

Why do you have different colors in your kitchen than your living room?

Try analyzing your surroundings to discover why you chose the colors in your home and of your belongings.

Warm and Cold Colors

By referring to a color as either warm or cold, we usually only mean the hue, not the value or intensity. If you draw a line dividing your color wheel from between the yellow and the yellow-green at the top to between the red-violet and violet at the bottom, you will have divided this wheel into the warm colors, clustered around the orange, and the cold colors, in the vicinity of the blue.

This concept of cold and warm is a result of the associations we make with these colors. Were you to find yourself sitting in a room with blue walls, you might suddenly feel cold, but you might feel warm in a room decorated in red and orange. This can be explained easily: from experience, we associate red, yellow, and orange with fire or warmth. Deep, cold water, on the other hand, is blue or blue-green; ice also has a blue tinge, which explains why we associate blue with cold.

There are in-between colors that are not clearly warm or cold, such as red-violet and yellow-green. Some of the colors in the cold section of the color wheel can be made warm and vice versa. Green that tends towards yellow is warm, and red can be rendered cold by adding a high portion of blue. This leads us to the general rule: mixing a hue with yellow renders it warmer, but blue makes it colder. White, black, and the neutral tones of gray are, in theory, not colors, since they lack hue and intensity.

It's not sufficient for you to be able to understand colors with the aid of a color wheel. You must be in a position to recognize these qualities in nature and in paintings. Certain objects that you would like to paint require warm colors, whereas others only really become effective when they are enhanced by colder tones. As an artist, you can decide which colors you want to use to bring out the message of your painting. But first you must come to terms with the qualities of these warm and cold tones. Once you have done this you can use your knowledge to enhance any painting.

Color is, in many ways, like music. A solitary note doesn't have much expression. But a careful combination of notes can produce a melody. This melody can be loud, quiet, aggressive, or harmonious. Use your color combinations like a melody, remembering that if you hit the wrong note, it can grate on people's nerves.

This strip of color illustrates how the "temperature" of a color can vary from a warm, deep red to a cold yellow, green, and blue, which then turns into a warm blue. Try to mix these colors yourself. I'll explain more about mixing colors in the separate chapters on painting techniques.

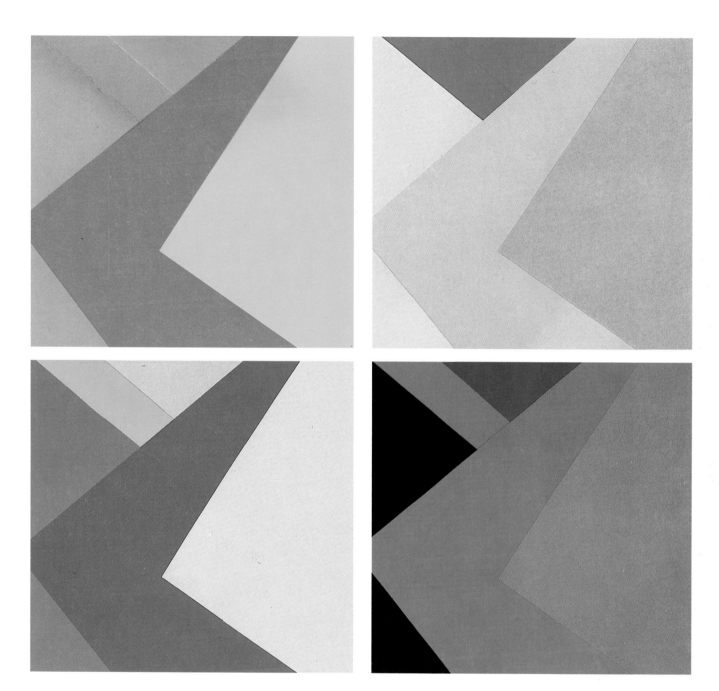

Look at these four examples very carefully. What is your personal reaction to these color combinations: what do you associate with them? Try to analyze which of these appear, to you, to be cold, warm, active, passive, aggressive, or peaceful.

The example in the top left-hand corner indicates warmth to me. The colors are active and happy. I could imagine these colors decorating the wall of a discotheque.

The combination at top right is cheerful. The colors are quiet, not too cold and not too warm.

The example on the bottom left gives me a feel-

ing of melancholy, reminding me of a rainy Sunday.

The colors on the bottom right conjure up a feeling of mystery and obscurity in me.

These reactions are purely subjective. After all this theory, it would be good practice for you to take your paints and try to portray the four seasons through colors alone, and not with the help of any seasonal motifs. Practice and observation will help you to sharpen your sense of color.

Color Composition

On the last few pages, I discussed how varying backgrounds can change the effect of colors and how the colors themselves affect one another. But a composition doesn't rely merely on form and color; it should incorporate depth and solidity. This brings us back to the question of light, since without light we would neither be able to discern colors nor would we have any shadows to give depth to our forms.

If you were to place a green leaf onto an absolutely white table standing in an absolutely white room that is lit with a white light that is neither too warm nor too cold, you would see the leaf in its true color of green. All other colors will have been excluded. There is no background, no other colored objects that can divert you from seeing the exact color of the leaf. This is, of course, a hypothetical situation. There

is always some color around us. The light of nature is changing constantly, so that the green leaf would take on a yellow-green appearance in sunlight, it would look bluish in the shade and black at twilight. The green that you would have been able to see in the white room never actually appears in nature. So, as an artist, you will always be dependent on the effects of light and colors.

In the black-and-white exercises earlier in the book, I demonstrated that objects that are close at hand appear to be darker than objects that are farther away. Equally, some color tones are more dominant than others, which is important when it comes to lending depth to a picture. Sometimes a picture can look flat, despite the colors being harmonious. One possible reason for this is that a dominant color

has been used for a background element of the picture. Red, orange, and yellow tones create an impression of proximity; green, blue, and violet tones a feeling of distance.

You should also consider that colors become cooler, lighter, a little grayer, and less intense with distance, due to the air and atmosphere between you and the distant object.

Look back to pages 23 and 24, where we dealt with this subject in more detail.

I used bright, intense red and blue for these shapes. Although both shapes are absolutely identical, the warm color appears to be closer than the cold color. In the two other examples, I applied various values from warm to cold. Make a few sketches in your favorite painting

technique, using variations of pure colors, of values, and of intensities. Keep these little compositions simple. You'll be surprised how playing around with color like this can develop your feeling for color and build up your confidence.

No perspective is needed here to show how the colder tones slip towards the back. Paint similar tones to become familiar with the colors. Turn the example upside down; look at it from all directions. You will notice that the effect is always the same.

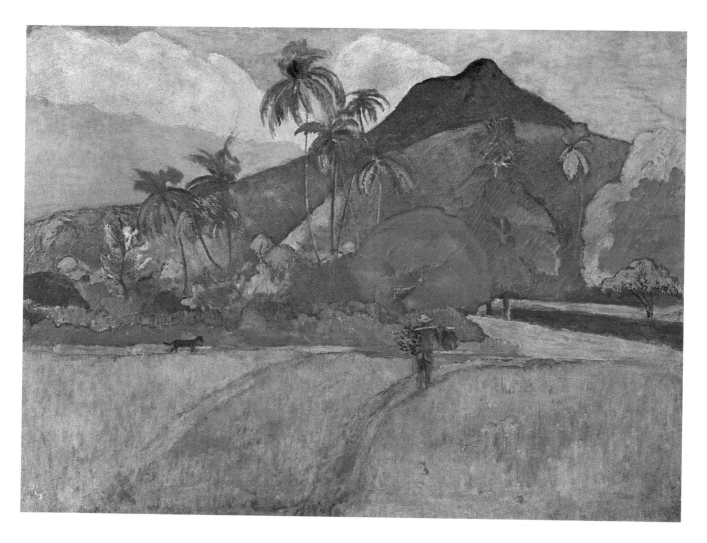

This picture by Paul Gauguin (French painter, graphic artist, and sculptor, 1848-1903), entitled "Tahitian Landscape," is an excellent example of an atmosphere that is created by colors. Light and shade are brought out by warm and cold colors. The warm colors force themselves very clearly to the fore, but the cold colors retreat into the distance. The blue plays an important role in lending depth to this picture in contrast to the warm colors of the foreground. Original size: 924x678mm (36x26½ inches).

The Impressionists recognized that the blue of the sky and of the air influences the color of all shadows. The warm red, brown, and green seem to lie right in front of our nose, dominating the foreground of this landscape. The violet, blue, and cold green remain in the background and give the picture an interesting glimmering effect.

The orange that Gauguin set in the background, behind the palm trees, reflects the sunlight and seems, purely optically, to be forcing its way to the front. This directs our attention towards the light, intensifying the warm atmosphere.

The cold blue and yellow tones of the sky and clouds give special emphasis to the depth. You get the feeling that the world behind the mountains stretches on forever.

Note the bright orange of the tree on the right. It appears to be almost on fire. This glimmering effect is created by the quantity of green which surrounds the tree. The orange of the tree also lends a balance of light to the picture. Orange has been dispersed all over the picture to reflect light. It's to be found in the clouds, in the dark mountains, in the violet strip which traverses the picture from left to right, in the figure, and in the bananas over his shoulder. A very clever effect is created by the spot of orange in the middle of the green tree, which also denotes the center of the picture. This repeated use of orange links the sunlight to the tree on the right and produces a feeling of unity.

DRAWING
IN COLOR

Color creates a whole new world of expression. As you already know, colors can seem warm and snug or cold and unattractive. Colors must also be reduced to basics, just like forms. If you want to paint a field of grass, for example, it's impossible to capture all the inherent tones of green—you'll have to decide on a few basic tones. Colored pencils and pastels are particularly useful for laying out drawings in color, since they allow you to work quickly and fairly problem-free.

The subject of sketches and finished drawings brought up on pages 38 and 39 becomes even more difficult when it comes to colors. How do you decide when a drawing is "finished"? If you have the feeling that there is nothing more to add to a picture, then it is certainly finished. You could say that this small portrait on the left is a sketch, whereas the "Girl in a Frame" is a finished drawing.

Here's an example of mixed techniques, below. Most of the picture was done in oil pastels; colored ink and pencils were used to create areas of contrast.

The portrait of the "Girl in a Frame" is also the product of mixed techniques. I used mainly water-soluble colored pencils and wax pastels and—to a very small extent—chalk pastels. The background is in gray poster paint, which I applied as evenly as possible. I went over the frame and face with a brush and water to emphasize the softness. The fine features of the face and the shading were added last.

These flowers, below right, are drawn in a very free, almost abstract manner, using colored pencils. I was only concerned about the colors and not the exact form of the individual flowers, as I was aiming at an Impressionistic picture, like the picture of the two trees on the left.

This simple drawing in soft pastels on light brown tinted paper, below left, shows how background color forms an intrinsic part of a drawing and stipulates the atmosphere.

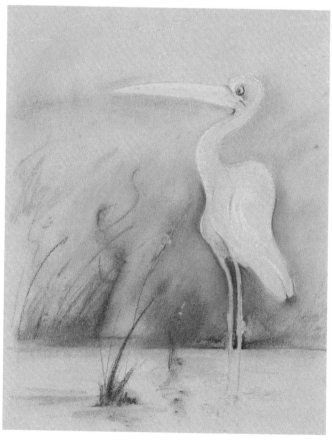

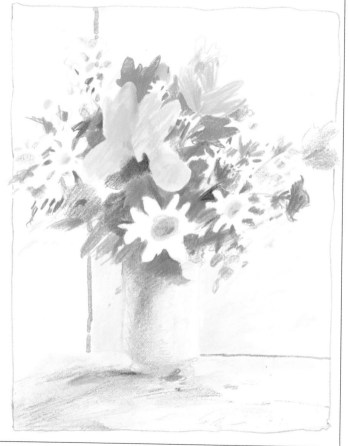

Materials
FOR DRAWING IN COLOR

Colored pencils, felt-tip pens, soft pastels, and oil pastels are drawing materials that can be fun to use, as they encourage fresh, spontaneous work and don't take hours to dry. You can take these materials with you wherever you go and use them without great complications.

Colored pencils:
Colored pencils are defined according to color and not, as with lead pencils, according to grade. Most companies produce cheap pencils for children as well as high-quality drawing pencils. I'd advise you to start by buying separate pencils from several firms, as the grade of hardness varies from company to company. Once you've discovered which colored pencils are best suited to your personal needs, then you can, if you want, invest in a set. Recommended manufacturers: Berol, Caran D'Ache, Faber Castell, Staedtler, Schwan Stabilo.

Felt-tips:
There's such a large assortment of felt-tips, ranging from very fine to super broad, that I can only recommend trying out which quality you prefer. Broad-tipped markers usually are used for making bold lines or covering large areas. Felt-tips with a smaller point are used for finer work. The following companies supply quality markers: Berol, Caran D'Ache, Design, Magic Letraset, Magic Marker, H. Schmincke, Schwan Stabilo, Staedtler.

Pastels:
It's advisable to invest in a set of pastels (soft or oil is up to you) in a box rather than buying them separately as they are very delicate and will easily break and crumble if kept loose. They come in a variety of forms: round, square, encased in wood. The following companies produce quality pastels: Caran D'Ache, Eberhard Faber, Faber Castell, Grumbacher, Talens. For oil pastels: Caran D'Ache, Grumbacher, Holbein.

There are various holders for pastels which enable you to work with small broken-off pieces. You will also need a sharpener or sandpaper (there is a special sharpener for extra thick pastels), some fixative for protecting your drawings, some brushes and a knife for making experiments, and an eraser. A simple rubber or kneaded eraser is useful not only for erasing, but also for adding special effects to your drawings.

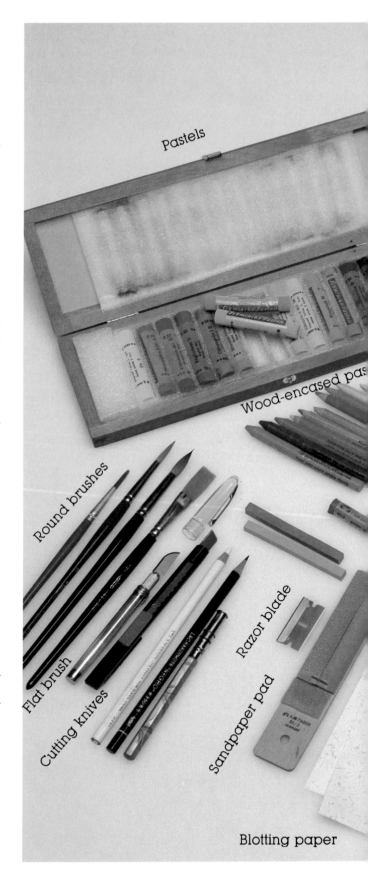

Pastels

Wood-encased pas

Round brushes

Flat brush

Cutting knives

Razor blade

sandpaper pad

Blotting paper

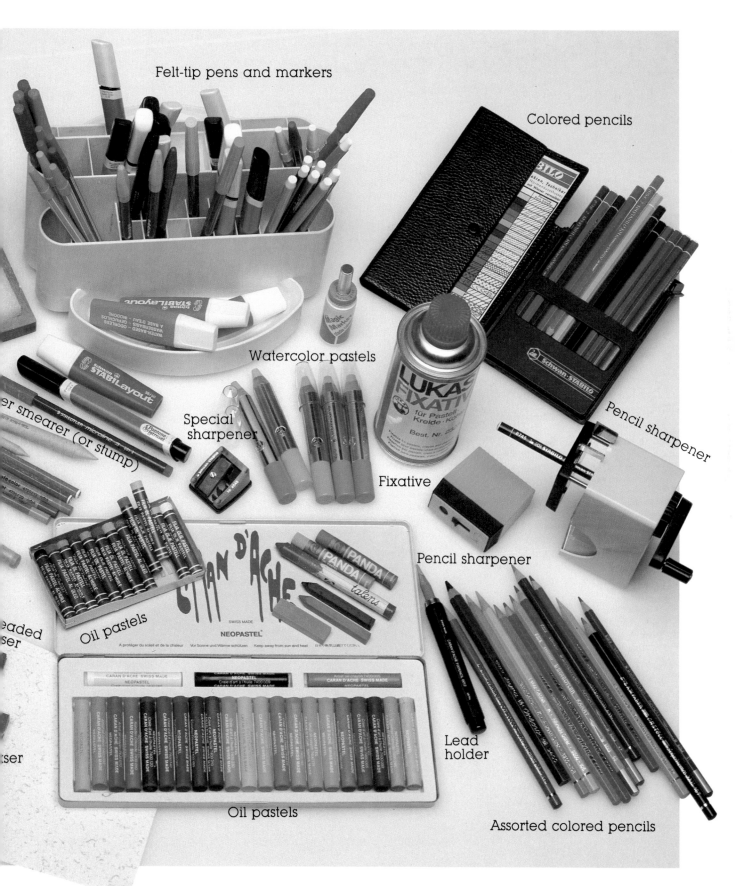

Felt-tip pens and markers

Colored pencils

Watercolor pastels

Special sharpener

...er smearer (or stump)

Fixative

Pencil sharpener

Pencil sharpener

Oil pastels

...eaded ...ser

...ser

Oil pastels

Lead holder

Assorted colored pencils

Colored Pencils

There are two common misconceptions about pencils: that they are somewhat restrictive to use and that they are for children. Both of these prejudices are false. The colored pencils of today lend themselves very suitably to a multitude of different types of drawing.

Colored pencils are essentially a derivation of pastels. In the fifteenth century, red pastel drawings interspersed with black and white were very popular. These pastels were made by mixing chalk and charcoal, forming this into small sticks that were inserted into hollowed reeds and held together by strips of leather or material. These early pastels could be sharpened and used for very fine, delicate work, such as that of Leonardo da Vinci and Michelangelo, two famous masters of this technique.

Today there is a great variety of colored pencils, but they all have one common advantage: they are ready to use. No water or anything else is needed. They are also relatively cheap. Even the most expensive assortments don't involve any great financial investment, and they're also long-lasting. Colored pencils are clean and uncomplicated to use. All you need, in the beginning, is a strong piece of paper and a few pencils. They're very suitable for sketching outdoors with your sketchbook. With just a couple of colors, it's often possible to capture a mood, which you can later use for a watercolor or oil painting. This implement offers a combination of the finesse of a lead pencil and the rough art of pastel, thus opening the door for you to an infinite variety of possible combinations and effects.

Some pencils are softer than others, some are harder, some are water soluble and others are not. You can only discover which of the many makes you prefer by trying out several varieties. Only a few firms still name their pencils by recognized color names (as is normal for watercolors and oils). The names and numbers of the individual pencils varies from manufacturer to manufacturer. Even the numbering doesn't follow any logical order. If, for example, number 222 is yellow you cannot assume that 223 will be yellow-green. This means that you must build up your collection according to the actual color value and not according to number.

Pencil Sharpeners

The pencil sharpener is an important tool. You might prefer to work with either a blunt or a sharp pencil—this is a matter of taste. But should your drawing require a precision point, you must be in a position to produce it. There are many shapes and sizes of sharpeners, but, in essence there are only three types:

1 The simple knife: This must be very sharp. It takes a bit of practice to get a smooth point, but the knife will offer you more variety, such as a chisel point. Sandpaper will help you attain greater precision.

2 Manual sharpeners: These are the most common form of sharpeners. Some have containers to catch the sharpenings, other, simpler models, have to be held over a wastepaper basket or something similar. The pencil point will always be smooth, providing you remember to change the blades regularly.

3 Mechanical sharpeners: These are either operated manually or electrically and provide fine, smooth points. Modern mechanical sharpeners will no longer "eat up" pencils. The blades must also be replaced when blunt.

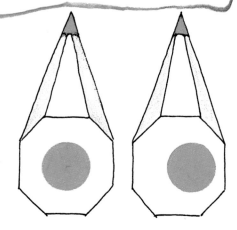

When you're buying colored pencils, make sure that the lead is actually in the middle of the pencil. If this is not the case, you'll have problems getting a really sharp point.

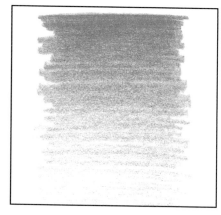

The Paper

If you're using colored pencils, you must choose your paper carefully, since this will influence the texture of your lines. The above samples show the effect of the same pencil on three different types of paper: the rough-grained paper does not allow a smooth coverage. The lines are frayed. This paper is therefore not suitable for precision drawings. The effect is fairly similar to that of dry brush strokes.

Medium-grained paper lends itself best for this work. The lines look softer than on the rough- or fine-grained papers. This paper is suitable for all types of pencils: hard or soft as well as water-soluble. It will elucidate your details and structures in an especially clear manner.

Lines come out lighter on fine-grained paper, which means that you are limited in the possibility of working tone on tone or in mixing colors. Fine-grained paper is best suited to linear work. It's advisable to experiment on different types of paper before deciding on one particular grade.

The Pencil Line

Different points produce different lines. A sharp point will give a delicate, differentiated line, a blunt point a thick line, whereas a chiseled point can be used for a variety of structures.

If you're working with colored pencils, you should work layer for layer as you would in painting. Light and shade have to be introduced with great patience. It is difficult, requiring a very subtle touch, to cover large

areas without producing an uneven surface.

A line drawn in colored pencil possesses all three of the color dimensions: hue, value, and intensity. This technique is a far cry from a child filling in the pictures in coloring books. It has intrinsic artistic qualities, as you will very soon discover.

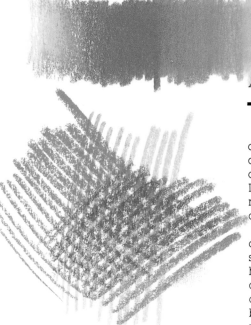

A color progression drawn using different colored pencils.

The main difference between a graphite and a colored pencil is transparency. The colored pencil can be used in a similar way to watercolors, which also means that some colors cannot be used to cover others. If you draw over blue with yellow, the result will be green—the yellow doesn't cover the blue.

The pressure exerted on a colored pencil is as important as the pressure exerted on a lead pencil. The harder you press, the more intense the color; the lighter you press, the more delicate the color. It is, naturally, possible to mix different types of colored pencil. Some interesting contrasts, for example, can be produced by mixing a chalk-like pencil with a fine, hard pencil.

The thicker pencils allow you to mix tones and interweave your lines like pastels.

Delicate midtones can be brought out by hatching with a finely pointed colored pencil.

Lovely color combinations can be achieved by the interplay of dots and dashes (similar to Pointillism).

Simple scribbling can produce some very vivacious structures.

It goes without saying that very different results can be attained by using colored paper as opposed to white paper, because the noncovering colors do not retain their original hue. Try out the effects with different colored papers. Yellow paper, for example, is expedient for an autumn scene, where a landscape with a lot of sky lends itself to blue-tinted paper. These are only ideas. You can read more about colored paper backgrounds on page 165.

Wash with water

Schwan Carb Othello 50 *Schwan Stabilotone 48/31* *Caran D'Ache 999-010*

By going over colored penciling with either water or turpentine, you can produce a watercolor effect. Many companies include soluble pencils in their collections.

Above you can see a selection of products that I have used and recommend. Nearly all pencils are soluble in turpentine, but only a few are water soluble. Some indication to this is usually given on the pencil itself, or on the box.

Wash with turpentine

Staedtler Karat *Schwan Carb Othello* *Schwan Stabilotone* *Castell Color* *Caran D'Ache* *Staedtler Karat*

New color tones can be created by coloring over other colors, pressing hard on your pencil.

Here we have the tree once again: Sky and tree were drawn freely in colored pencil (Caran D'Ache). Then I dipped a brush in a little turpentine and painted over the drawing. Turpentine usually produces a rougher structure than water.

The paper is important. If you want to go over your colors with water, it's best to use watercolor paper, since it won't warp. Strong paper or oil-painting paper is sufficient for turpentine.

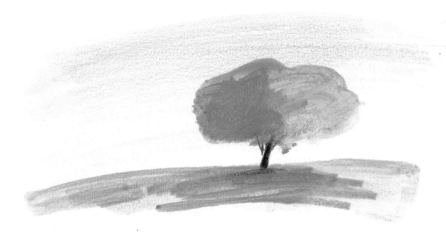

Here I'm using the example of the apple once again as a basic shape. First, here is the flat, black, expressionless apple.

Now it has become a green apple. This new dimension of color has given new life to the mere shape in the first picture.

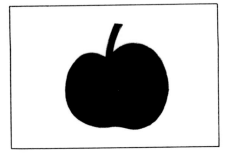

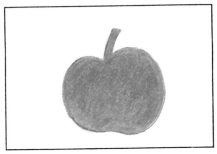

Hatching with a blunt pencil or with a pencil held flat against the paper creates a very different effect than hatching with a sharp point. Large areas can be covered quickly; the object appears to have a rough surface. Don't be afraid to mix fine and broad lines, or of filling in with some small dots and dashes.

Light and shade give the apple a round shape, even if this is restricted to gray tones (this point was covered in the chapter on composition on pages 16-25).

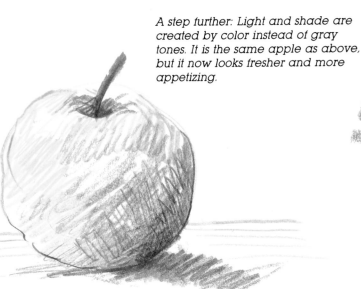

The more lines that cross each other, the darker the area will become. It's not necessary to always use the same color. A green apple has bluish and yellowish features. It may also reflect the red of a tomato.

A step further: Light and shade are created by color instead of gray tones. It is the same apple as above, but it now looks fresher and more appetizing.

Water-soluble pencil colors will run into each other when water is applied to the surface. It is possible to draw over this washed surface, as I've done here.

This structure of dots and dashes presents an attractive alternative to a background color. It reflects the color nuances in the various objects and has a colorful effect, rendering the whole picture homogenous. This kind of color pattern can be achieved by a simple system of dots and dashes or even blotches of color. I purposefully refrained from using any black in this picture in order to show you how shading can be created exclusively by using colors.

I drew very heavily with red pencils to create the solidity of the tomato below. The shadows were drawn in using violet pencils.

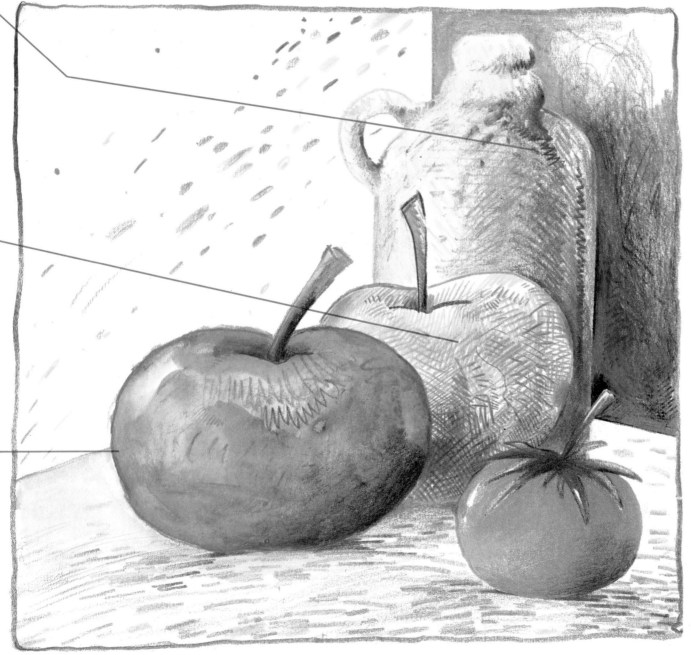

Step by Step

This portrait of my daughter was drawn on lightly struc-
tured paper that had a very soft yellow-brown coloring. I
chose this paper to enhance the soft tones in her face.

The composition is fairly unusual as a result of the hori-
zontal division into three parts (hat/face/fur). I was espe-
cially fascinated by the contrasts between the hat and
flowers, and of the delicate facial tones with the fur in the
foreground.

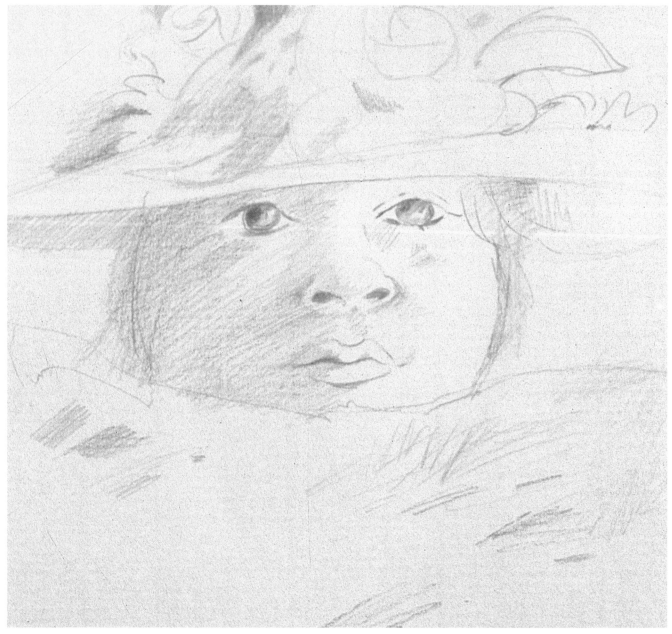

Step one: I lightly sketched the face in simplified form and laid out the basic composition, using a light brown pencil. I then sketched in the flowers and ribbon on the hat using green and blue.

Step two: My next step was to add form to the hat and give it some contrasting tones. I clearly outlined the eyes and mouth, in order to slowly build up the form of the face. The fur in the foreground was drawn only roughly using a water-soluble pencil. I went over this drawing a couple of times with water using a watercolor brush to give a soft structure that would hold the fur together later.

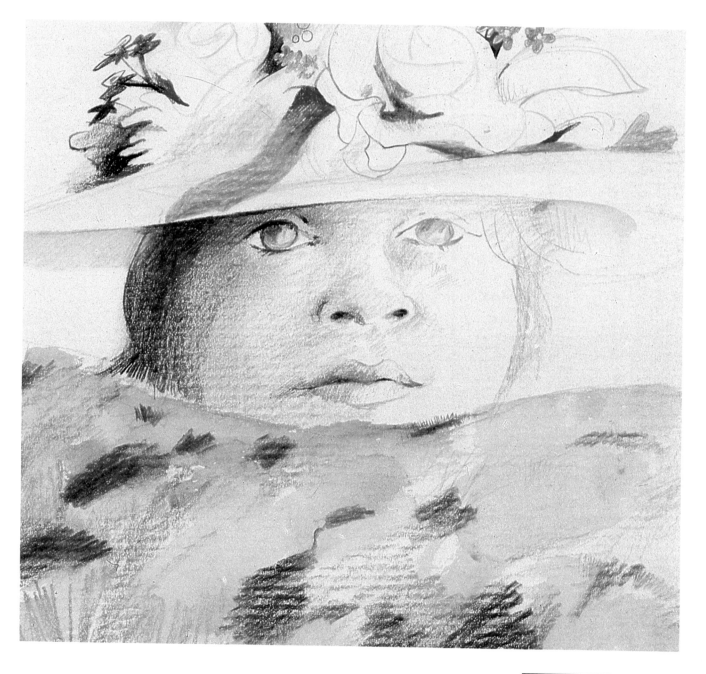

Step three: The build-up of color and structure in the whole picture is beginning to become apparent. I have strengthened the fur and elaborated the shapes of the hat and the flowers. Note how the pink and blue of the hat are repeated in the face and fur. This will lend a homogenous effect to the whole picture and combine the three main horizontal forms of the composition. The face itself is not made up of one solitary color, but various browns, oranges, and pinks, as is shown in the small example on the right.

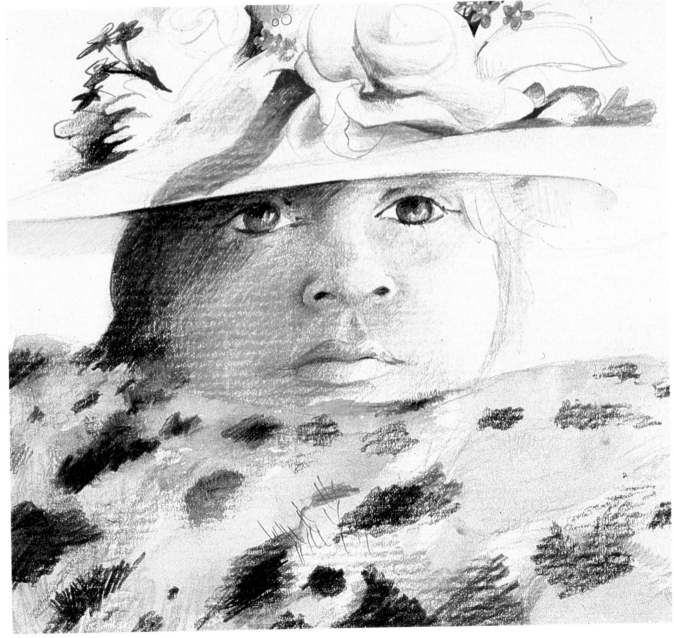

Step four: I went over the yellow of the hat with a soft, white pencil in order to force it back slightly; this produced the effective contrast to the color structure of the flowers. As you can see, I decided to break the horizontal compositional forms by allowing the blue hat ribbon to hang down over the darker side of the face. This required my having to mix a light blue color in gouache to paint over the dark parts of the face. After the paint had dried, I went over this again with a wax crayon to maintain a uniform texture in the ribbon.

The left portion of the background was covered in a blue-gray tone to give a feeling of more depth. The paper forming the right portion of the background was left in its original tone. This tone is reflected in the face, making it appear softer.

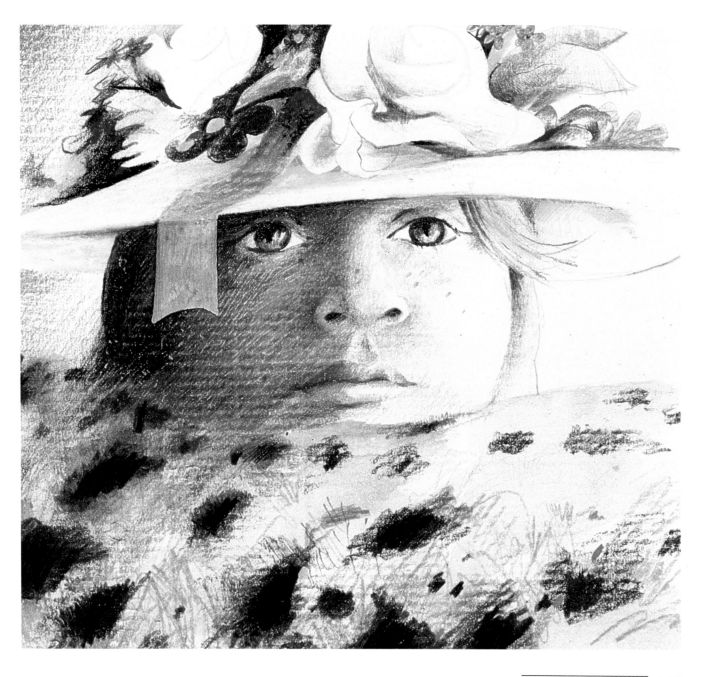

Felt-Tip Pens

Felt-tip and fiber-tip pens are available in every shape, size, and color. They're often used in advertising agencies because they make quick, problem-free sketching and rendering easier, and allow easy mixing of many colors. Paper will not warp, as with watercolors, and no long preparations are required. One disadvantage, however, is that the colors will fade when exposed to light for long periods. This is irrelevant in the case of a short-lived advertising project, but can be very annoying if you have a picture you'd like to hang on the wall. A drawing in cheap markers will fade almost completely away if left in the sun for a couple of hours.

The fresh, sometimes fluorescent colors of markers can be used to produce very attractive drawings.

Water-soluble markers can be made to run by going over the lines with a brush and water. Others require the use of a solvent, such as lighter fluid, to create this wash effect.

There are so many different markers on the market that I can only advise trying out as many as possible. Each marker reacts differently to paper. The ink used in permanent markers seeps immediately into paper and is soaked up by the paper fiber, so they aren't suitable for use with thin, rough-grained paper. It's best to use the special marker paper, which was developed specifically for these pens.

Broad markers are very useful for covering large areas. Finer lines can be drawn using the edge of these, but you will find that they are fairly unpractical for really fine work.

As I discussed in the section on black-and-white drawing, fine and extra-fine fiber-tip pens are very good for sketching and drawing. The tips of these are made of nylon, vinyl, or a rubber mixture and they are available in almost all conceivable nuances in color. Since it's not always possible to mix colors, you'll need quite a few different colored pens if you want to bring out exact gradations in color.

You can really paint with the brush-like markers. The tip of these is no longer stiff, but made out of flexible fibers, which can be used like a brush with an almost endless flow of ink.

The broad-tip markers can be rather expensive, but the fine felt-tip and fiber-tip pens are well in the range of everybody's pocket and can be found in almost all shops. They are well adapted for quick compositions and color plans; color impressions, such as a sunset, can be noted quickly in the form of a sketch as preparation for a later picture for which you might

use another technique. This sketch will help remind you of the colors you registered at the time.

Cleaning Markers

Because of the solvent ink base, most markers will pick up other colors and these will be absorbed into the tip, meaning that your next line will contain traces of the "foreign" color. If you, to give an example, draw over a green line with a yellow marker, your next line with this marker will contain traces of green.

Draw over a piece of paper, turn-

ing and twisting your marker as you do so, until all traces of the "foreign" color have disappeared, then close your marker. If you do not clean your marker immediately these "dirty" lines will appear in your next drawing, and this can be very annoying. Always keep your markers in a cool place.

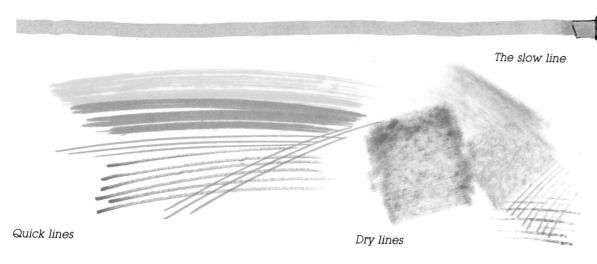

The slow line

Quick lines

Dry lines

If you draw a slow, deliberate line with a marker—the width doesn't matter—the line will be even and the color clear. Quick, short lines, on the other hand, tend to peter out, becoming less even and lighter. If you are covering large areas, the color will also become lighter after a while due to the fact that the felt tip dries out quicker than it can be replenished. If this happens, simply replace the cap for a couple of minutes and hold the marker tip down. The color will run into the tip and the marker will function perfectly once again. Don't throw felt-tip

markers away when they start to dry out. Some interesting tones or structures can sometimes be produced using these. The example above shows the effect that can be achieved with almost dried-out markers. It's also possible to rejuvenate a marker by replenishing the felt reservoir with a special solvent or lighter fuel. I usually take a syringe and inject the liquid directly into the felt. If you don't have a syringe, you can carefully drip the liquid down the side of the felt. Some markers can even be screwed open to ease refilling. Markers are not cheap,

so you should always make sure that you've closed the cap well. Never leave several markers open, even if you are working with more than one color and always check that they're really closed before putting them away. Try to avoid leaving your markers and your drawing exposed to bright light for longer than necessary.

The slow, dry line

The color of most felt-tip pens varies according to the paper used. This is illustrated very well by these two trees. The tree on the left was drawn on absorbent paper. You can see that there is a distinctive difference between the colors—they were soaked up immediately by the paper. The tree on the right was drawn using exactly the same colors, but the paper was harder, almost repelling the colors. The colors didn't seep into the paper immediately, which meant that one color could mix with its neighboring color, creating new tones.

C heaper felt-tips have, to a fair extent, replaced ballpoint pens in offices. For a long time, though, they were only considered good enough for children as drawing instruments. This attitude has changed considerably now that people have realized what, with practice, can be done with a felt-tip.

All felt-tips react to all types of paper in different ways. They can also all be mixed up with other materials, such as crayons, pastels, ink, and even watercolors and acrylics. Try out what will happen if you go over a felt-tip line with another marker and then sprinkle water over the whole surface.

Some examples:

For the pear on the left, I first drew the contours using a Rapidograph. Then I intermixed the colors from dark to light. The progression from turquoise to yellow is shown in the sam-

ple above my pear. The apple in the middle is the result of my first drawing a simple apple using red and yellow and painting into this with a fine brush and water. It's quite possible to go over some areas again in felt-tip to intensify the tone.

I produced the pear on the right using markers that had already dried out slightly. This process takes longer than with fresh felt-tips, but it also means that you can build up your object step by step to produce almost the effect of painting. Dried-out markers

also can be used to add shading to a picture that you have drawn using fresh felt-tips.

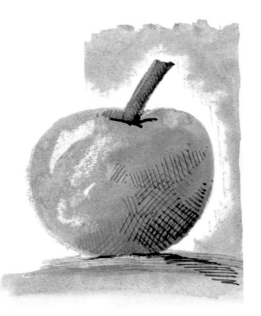

As you can see, the apple on the left shows many different kinds of structures. I first took a wax crayon and outlined the shape and drew in some highlights. Then I went over this with a water-soluble brush marker. The wax rejected the marker color, meaning that only the areas of paper without wax took on the marker color. I colored in the background to show you more clearly where I used the wax crayon. The shadow was produced using a half dried-out felt-tip. Finally, using a fine felt-tip, I added some hatching to give a graphic effect.

The above samples serve to illustrate how various values can be created by hatching. Try out several possibilities to see which type of hatching most appeals to you.

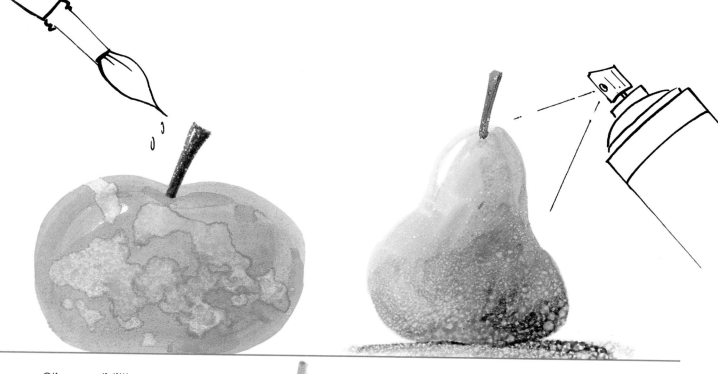

Other possibilities:

This apple and pear were both drawn using a permanent marker. Then I dripped some marker dilutant (or rubber-cement thinner) on the apple. The color dissolved, leaving marks around the edges where the ink dissolved. With this technique, you don't have full control over how the color will run, so it's better to cover up those parts of your drawing where this structure is not desired.

When I sprayed fixative over the pear, these little spots appeared, since the felt-tip solution and fixative are not compatible. This technique can be used only on papers that will not soak up color, such as hard paper or the back of marker paper. But take care with these experiments! Both marker dilutant and fixative are highly flammable.

By way of comparison, note the effect of some completely "harmless" drops of water on water-soluble felt-tip, left.

The effect to be seen in the tree on the left is the result of an experiment using tracing paper. Tracing paper doesn't allow marker to soak in; the color remains on the surface and it remains damp. This makes it easy to transfer an imprint onto normal paper. I drew each color separately on the tracing paper and transferred this color for color onto my drawing paper, slowly building up the form of the tree. Note how new tones came into being where the colors overlapped. The picture on the right illustrates the effect of colored pencil on marker. Here again, you can see how new tones are created where the colors overlap.

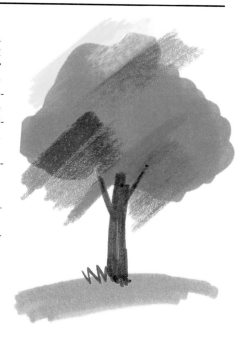

The quality of felt-tips has improved continuously in recent years, as has the choice of colors. These two pictures illustrate the great versatility of this material. On the last two pages, I gave you some ideas for mixing different felt-tip pens and for introducing other materials. You must now decide for yourself which techniques fit in best with your chosen motif. There are no hard and fast rules for this, except maybe—try it out!

You might suddenly discover that a structure looks like rocks or that another structure reminds you of grass. Felt-tips have the advantage that they allow quick, clean, and fairly uninvolved work.

More depth or solidity can often be introduced into a picture by hatching over surfaces that have either been dampened with water, or been dried. This picture gives a slight Impressionist effect; the gray marker looks like stone.

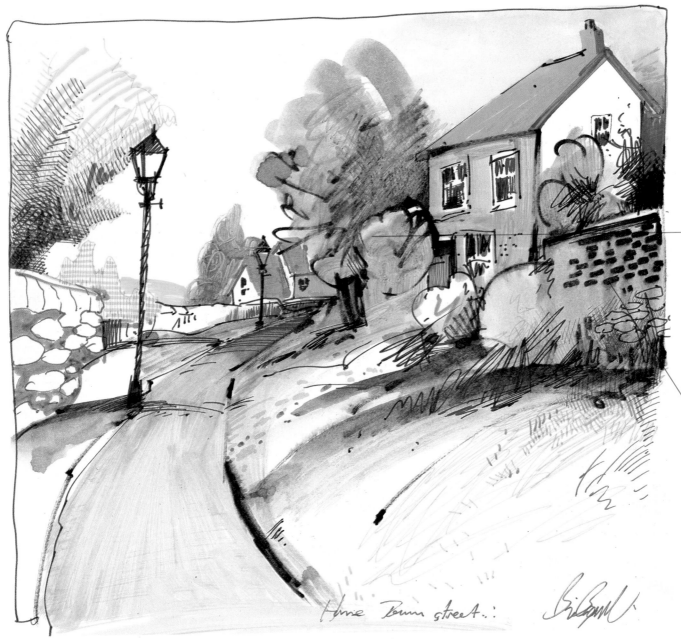

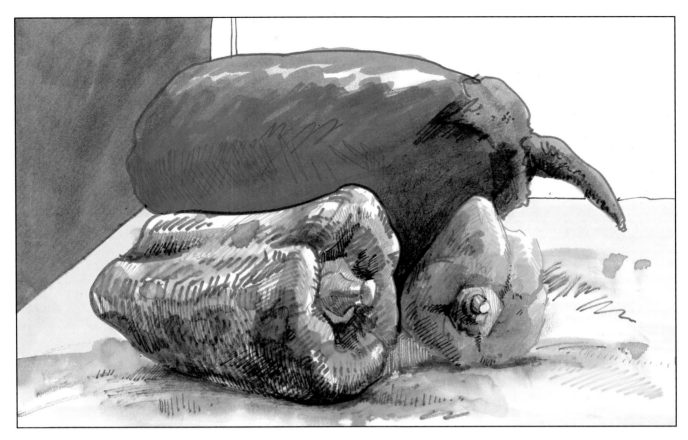

Left: A mixture of water-soluble and permanent marker was used for the bushes and trees behind the house. I then went over these with a brush dipped in dilutant. It is then possible to draw another structure over this with a felt-tip pen, as shown below.

Above: If you want to use green, you don't have to use a green marker. Try taking an assortment of blue and yellow tones and mixing these by drawing one tone over the other. The dark background in this picture, for example, was produced by layering three tones one on top of the other (see the sample below).

First I drew these vegetables linearly in their basic colors, then I "filled them in." Two tones of blue were added to the violet of the eggplant; for the smaller pepper, I added yellow, pink, and brown to the basic red; for the larger pepper, light green, yellow, and blue to the basic dark green. The reddish spots reflect the red pepper, lending unity to the whole composition.

The wall was initially drawn using a black Pentel pen. I then went over this with a white marker. The barely perceptible white took up some of the black to create this gray, somewhat streaky structure. Don't forget to clean your white marker immediately after it comes in contact with a darker color.

Hatching using a fine felt-tip brings out shapes and lends an impression of depth to a picture. The background colors in the picture above are more patchy than those in the samples at left, although the same colors were used. The reason for this is the paper. The paper used for the picture was more absorbent than that used for the sample. Colors take on quite different nuances on a smooth-surfaced paper that does not readily accept felt-tips or markers.

Step by Step

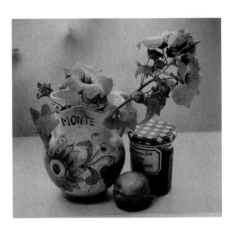

Step one: When you start a drawing in felt-tips, you should, as in other techniques, begin by roughly sketching out the composition. In this example, I used different colored pencils for this, to determine the color distribution. Pink lines indicate areas where I'll probably use some red tone in my picture. These lines will not be visible later, since they'll be covered by felt-tip. Don't be afraid of sketching the more difficult forms in detail. You can go over this at a later stage, and as we have discovered before, this can help

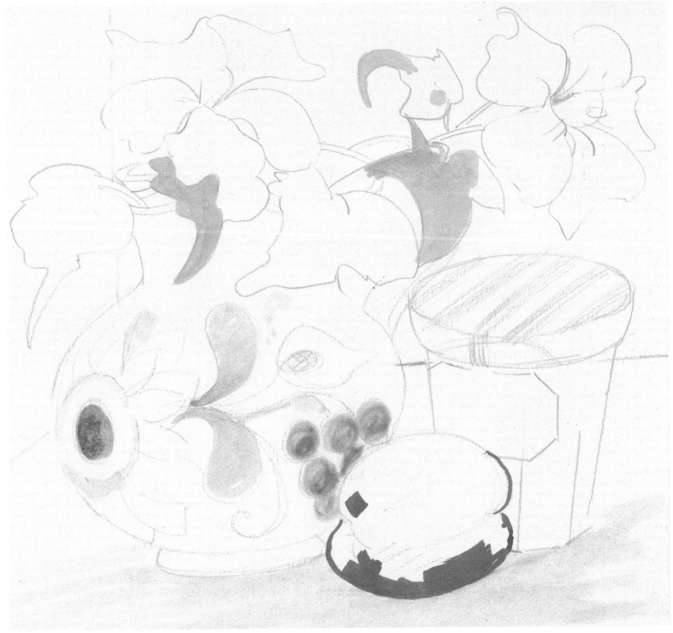

to lend solidity to your individual subjects.

At this stage, I started to slowly build up shapes and tones, still keeping my eye on the composition as a whole. As you can see I have already set the pattern on the jug in opposition to the stripes of the jam jar. It's very important to get shapes and composition correct in the sketching stage, as once you start working with markers it's rather difficult to make any corrections. This should not restrict your spontaneity, however. You can, after all, learn from your mistakes, and any experience gained at this stage will help you in your later work.

Step two: I formed the peach using a broad marker and painting into this with a brush and water. This produced a structure differentiating the peach from the smooth jam jar. It was this interplay of varying materials, patterns, and structures that most appealed to me in this still-life picture. I was able to use a water-soluble marker for the flower on the right (made to run by painting over it with water) and a permanent marker for the flower on the left and the leaves. The various tone gradations were created by painting different light tones into one another. I always work on the various elements simultaneously, to build up my picture as a whole.

Step three: All colors have now been determined and the composition has been set up. It's time to give the objects their actual form: the jug and the peach must be made round and the flowers must be given more depth. Structure was given to the flower on the left by dripping dilutant from a fine brush onto the marker surface. One problem when you are working with felt-tips is that they tend to smudge easily if they're not quite dry. To avoid this problem, I always lay a piece of blotting paper over the parts of my picture that I'm not working on. Don't use ordinary paper as this will smudge your work just as easily as your hand.

I used water-soluble and permanent marker for the pattern on the jug. The leaves are a mixture of dark green and yellow and a half dried-out mid-green marker, making the structure rougher and more like a real leaf.

At this stage I also started completing the jam jar. I left some white vertical lines free in order to give the jar its angular shape. Look carefully at the red tones of the jar. This is no simple red, but a gradation in red tones, giving the jar depth and solidity.

The surface of the table was produced using water-soluble markers and the wet-in-wet technique, making the shadows and the contrast to the three objects softer.

Step four: Next I worked on the system of fine lines in the flowers, a special feature serving, among other things, to strengthen their forms. I used a red pencil to draw these into the flower on the right (permanent marker) and a very fine soluble felt-tip for the other flower. These felt-tip lines were made to run very slightly by going over parts of the lines very carefully with a brush dipped in water.

The shadows of the leaves were first brought out using a half dried-out marker, after which I dripped a cou-ple of drops of lighter fuel over them from a fine brush. If you go over an area of soluble felt-tip with a perma-nent marker, you will produce broken lines as can be seen in the light leaf on the right.

Further shadows were created us-ing colored pencils. This can be seen if you look at the leaves and the outer surface of the jug. A mixture of water, felt-tip, and colored pencil is very good for producing a ceramic struc-ture like this.

By strengthening the shadows, us-ing colored pencils, the objects on the table were made to seem to be stand-ing firmer.

Some of the colors in the objects are reflected in the surface of the ta-ble—I used red and yellow pencils for this—to enhance the unity and lend in-tensity to the picture.

MOTIVATING IDEAS

Felt-tips are very good for capturing a motif in the form of a sketch even if you intend to use another technique for your finished picture. But don't forget that, depending on the paper quality of your sketchbook, markers can go through paper and spoil a sketch on another page. To avoid this always put a piece of paper between pages.

The two ideas given on this page can be used to illustrate the versatility of the felt-tip pen for rendering quite opposing motifs and moods. The rainbow blends into the dark sky, quite separate from the houses in the foreground. The bright colors in the unusual still life shown below can either be kept as separate entities or allowed to flow into one another.

First look back for a moment at the various ways you can create structures using markers. How would you render the reflections in this water? Note the contrast between the flowing and static lines. Don't feel compelled to copy every detail true to the original. You could, for example, add a drop of dew (using a dilutant?) to your picture of the tulip shown above.

The bird and the palm leaves are motifs which will allow you to try combining several widths of line. There is, of course, nothing to stop you from taking a section of the leaves motif and making an abstract composition out of it. Feel free to combine the use of colored pencils or other techniques, such as ink, with your felt-tips. It is important that you enjoy experimenting and that you are not solely intent on producing artistic masterpieces.

Pastels

Pastels are often categorized as a "drawing" medium, although this technique in fact is closely related to painting. Per definition, of course, it must be drawing, since it involves working with dry lines. But as you will see very soon, the intermixing and smearing of pastels will teach you several tricks you'll be able to use when you go on to painting. Using pastels, you will discover aspects about color and color combinations that will be of great assistance in painting.

Pastels are available in many different forms: round, square, or excased in wood like pencils.

The advantages of pastels:

The advantages of pastels are that only the basic equipment—your pastels and some paper—are called for, no solvents are needed, and you don't have to wait for your work to dry. This is reflected in the fresh, lively quality that can be achieved by using this quick, uncomplicated medium. Many of the famous Impressionists, such as Edgar Degas (French painter, graphic artist, and sculptor, 1834-1917) and Georges Seurat, favored this material for just these reasons.

The disadvantages:

Pastels are very delicate. Finely ground, powdered pigments are mixed with just the right amount of binder to keep them together and are as a result somewhat brittle.

Since pastel merely adheres to the surface of paper, without penetrating it, it's not possible to build up layer upon layer as in other techniques. A second layer would destroy the first.

The beauty of drawing (painting) with pastels lies, among other things, in the subtle blend of colors it is possible to achieve if this medium is used with care and understanding. Otherwise, you might find yourself ending up with an undefinable blur of colored dust. Due to this, working with

pastels requires a slightly deeper knowledge of the technical possibilities and a sounder understanding of color than is needed for black-and-white drawing, or painting with a full palette.

Fixing

You must treat your delicate pastel drawings with a fixative to avoid the great danger of smudging. This unfortunately tends to dull the velvet-like surface of the pastels a little. Too much fixative will also cause the colors to swim. I advise fixing each separate layer as you go along, so that the last fixing does not have to hold all the various color layers. If your picture is not too big, you can preserve it under glass. But be careful! The glass must not come into direct contact with the picture. A piece of thick cardboard or mat between the picture and the glass will avoid this happening (pages 326-327).

The side of a pastel (it is advisable to break a piece off) drawn flat across the paper will produce a broad line; pointed pastels held upright will give thin lines. Interesting structures can be achieved by combining these different lines.

The effects that can be achieved with pastels vary from paper to paper. Compare the lines shown in these four examples; the round structures were all produced by rubbing the pastel with my finger.

1 Rough-grained watercolor paper: The pastel clings only to the raised structures, but can be rubbed in with a finger.

2 Medium-grained drawing paper: The lines are slightly uneven. This can be used effectively for some drawings. The outside edges remain frayed after rubbing.

3 Lightly tinted, rough-grained Japanese paper: This has a smoother surface than watercolor paper. The lines are sharper.

4 Lightly tinted, fine-grained Japanese paper: This enhances the subtlety of pastels. But it's necessary to work very cautiously, as this smooth paper will take up every grain of color.

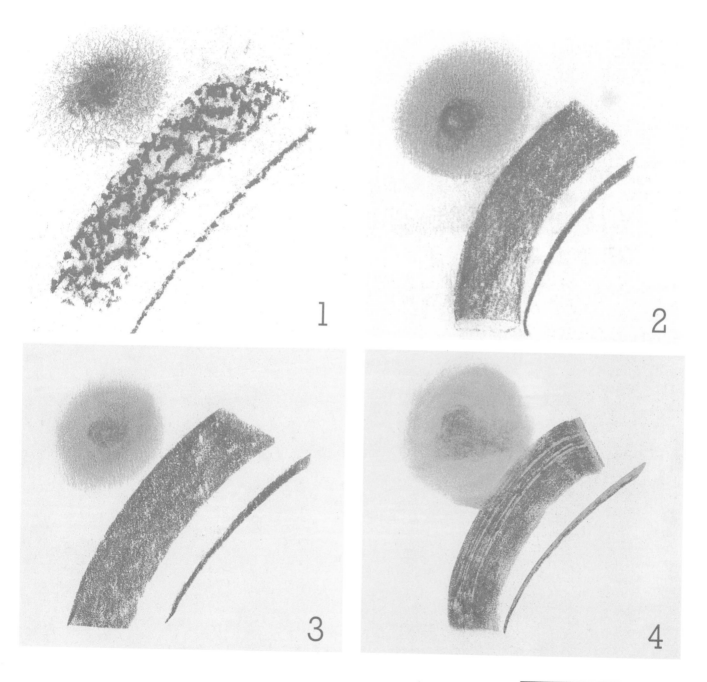

Due to the huge assortment of paper available today, it's best if you try to find out for yourself which you prefer. First study all the different paper qualities and colors. Your paper doesn't always have to be white. Tinted papers can also produce some effective results. Lighter papers tend to create a soft, muted effect, whereas darker papers will lend a dramatic, contrasting note to your drawings.

In these four examples, I used exactly the same color pastels on different tones of paper to illustrate, among other things, how the brilliance of the colors can be affected by the paper you choose to work on.

Although there is a large choice in beautiful tinted papers, it's highly possible that you might not be able to find just the tone you are looking for. In that case, you can tint your own paper. But you should always consider when you are tinting paper that pastels will react to any change in the surface finish of paper.

One of the simplest ways of tinting paper is to collect old broken-off pieces and scrapings from pastels, which you then crush to a powder in an old cup or bowl (if you happen to have a mortar, this is the perfect receptacle). Sprinkle some of this powder onto the surface of your paper and carefully rub this in using a soft rag to achieve an even toning. With this method it's possible to produce various nuances in color ranging from very light to very dark. In this example, I achieved just the tint I wanted by carefully sanding my tinted paper using fine sandpaper.

There's another very simple and cheap method of tinting paper using old tea bags: Gently and evenly rub the damp tea bag (you can also use damp tea leaves) over the surface of your paper. This will produce a light to mid-brown tone, depending on the number of times you go over the surface of the paper. Try this with various types of tea. (Hibiscus tea, for example, will give you a delicate pink tone.)

Pictured below, you can see a few examples from the enormous choice of tinted papers. This paper is available in varying surface textures as well as in varying weights. If you go to a shop dealing in art or graphic arts materials, you can get a sampler block (these are usually free, but sometimes you have to pay a minimal fee) containing the complete range of papers available. The sheets of these blocks are big enough to allow you to make some small test samples in a technique.

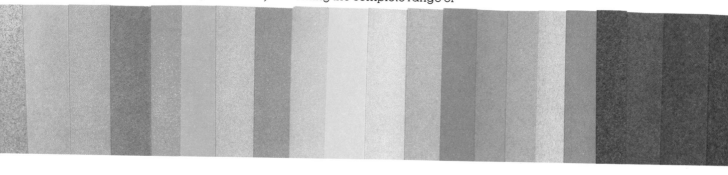

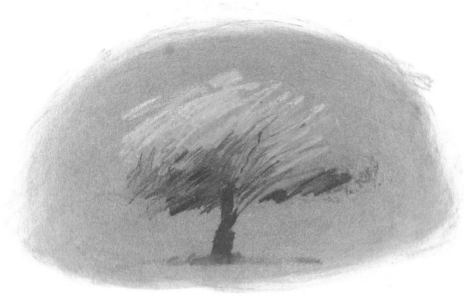

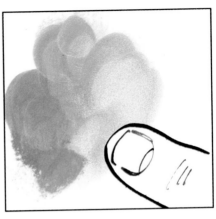

The forms of the two trees shown here, above and below left, were created by differing lines and differing colors. The pastels mingle easily into the soft paper surface, producing very quickly the impression of light and shade. I tinted the background of the top tree, using some powdered pastel.

For the tree shown below right, I first drew some very broad lines in pastel. I then sprayed some fixative over these and rubbed this in with my finger before the fixative had dried completely. This technique relies, to a certain extent, on chance, but it can produce some very effective results.

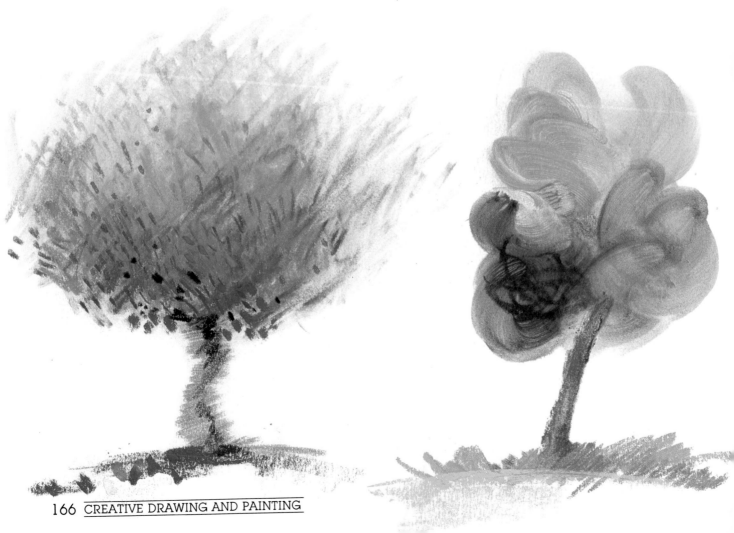

For the tree shown below, I painted into a pastel surface with a brush dipped in water. I dabbed the areas that were still wet using a paper tissue, producing the basic structure. After this, I went over the whole area again with pastels, to create light and shade. Another alternative would have been to have kept the basic structure as it was, as the dominant element, and to have just supplemented this with some pastel lines. Similarly interesting structures can be produced in the same way using fixative instead of brush and water.

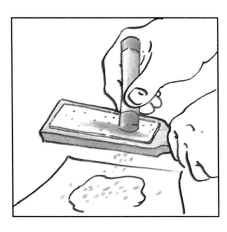

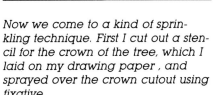

Now we come to a kind of sprinkling technique. First I cut out a stencil for the crown of the tree, which I laid on my drawing paper, and sprayed over the crown cutout using fixative.

Some pastel is rubbed over sandpaper and these rubbings are then sprinkled over the fixative surface while it's still moist. This produces a rough, sandy surface into which it's possible, for example, to make fingerprints (in the left of the crown).

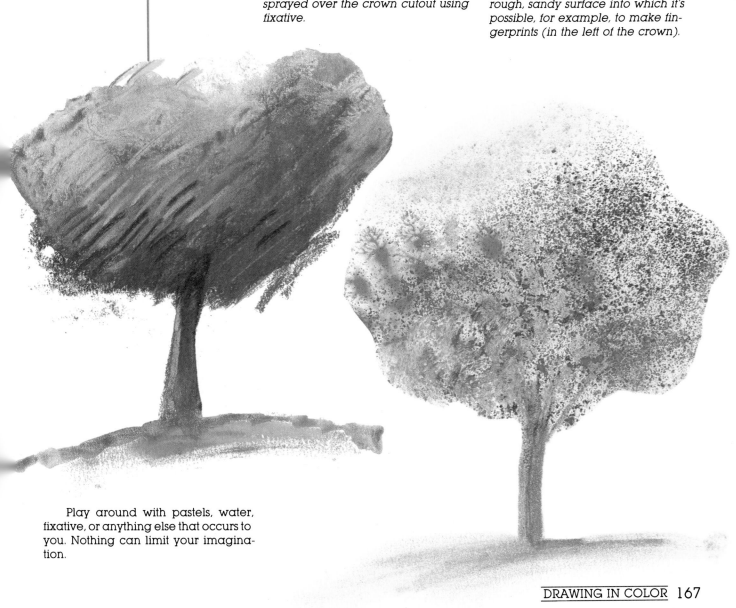

Play around with pastels, water, fixative, or anything else that occurs to you. Nothing can limit your imagination.

The atmosphere in this pastel drawing owes much to the very specific brown tone of the paper on which it was drawn. The background was left in the original paper tone, which also blended well with the flesh tones and bright red to create soft facial features. Light reflexes had to be added to the eyes in order to keep them from looking dull. The brown of the paper, combined with the pastels, could almost lead you to believe that this picture was painted. The lighter tones were built up onto the darker tones as in oil painting.

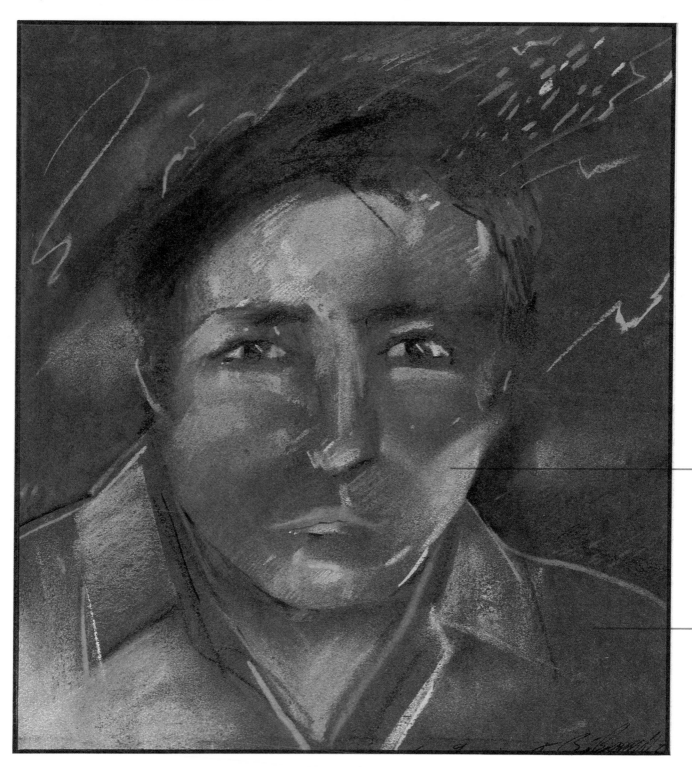

On page 165, you were shown a small selection of the multitude of tinted papers for sale. I decided on a dark brown for this picture because I wanted to emphasize, using small dashes and lines, the brilliance of the colors that are repeatedly reflected in the picture. These lines appear fresh and bright in contrast to the dark paper.

I will illustrate the techniques used in this picture on white paper, simply because this makes it easier for you to see what I'm doing.

The violet background behind the right shoulder was first laid in pastel and then made to run using a brush and water. When this had dried the tone of the paper came through in several areas, due to the fact that the wet pastel had not totally adhered to the surface.

The basic tone of the face, light pink was applied with my finger. I first spread a little pink on the surface, and then carefully rubbed this in. A more intense tone was achieved by simply repeating this process. After that I set in lights using my pastel in the normal manner.

In order to produce variety in my lines and dashes, I often break off pieces of pastel. Various lines and colors can be combined in a great many different ways.

This rubbing-in technique and the quick dashes of color were applied very freely and loosely. The points on my pastels were not fine enough for adding exact details, so I used a pastel pencil for these. These pencils are better suited for detailed work, such as the eyes and lips.

The basic brown of the jacket is the original paper tone. The white and colored pastels lend the air of a painting.

Step by Step

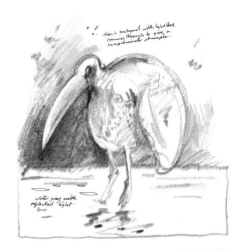

This is a sketch I made in a zoo. I only had a couple of colored pencils with me at the time, so I could not produce a detailed drawing. I made use of the colors I had and jotted down some accompanying notes. At home, I decided to render my impression of this red bird standing in glistening water in a pastel drawing. I chose a dark gray paper in order to elicit more light from my red and yellow, and to constantly emphasize the contrast between the bird and the water.

If you choose to work on dark

tinted paper, you must always see the light colors as foreground, because the dark paper automatically takes over the background, bringing depth into the picture.

Step one: First I sketched out the basic composition very lightly, knowing that these lines might be covered over later. (You can use a little fixative after each step to avoid smudging.)

Step two: For the further build-up of the picture, I continued in fairly strong colors, applying broad and thin lines, in order to bring the colors into harmony. At this stage, you shouldn't work from left to right or from top to bottom (a common practice to avoid smudging pastels) but concentrate on introducing coordination into the picture. For this reason, I immediately added the red reflex in the water after applying the red of my bird. I was especially interested in the contrast between red, yellow, and green in the background behind the bird, so at this point I applied these colors lightly so that I could go over them at a later stage, maybe adding other colors.

If you use the rubbing-in method for covering large areas, always have a cloth close at hand to wipe bits of pastel off your fingers. I don't know anything more annoying than bits of unwanted pastel stuck in the wrong place and spoiling a picture.

tep three: The next step was to work on the background in order to bring the bird further to the fore and to lend depth to the picture as a whole. By mixing different green and blue tones, I was able to create the impression of shadows; the light green and yellow areas, on the other hand, give an illusion of a shimmering light in the background.

I sometimes turn my pictures around while I'm working on them, looking at structure and patterns from various angles, as I find that this can help me to discover any discrepancies or weak points.

The concentration of various green and blue tones in the background serves to reinforce the contrast between the background and the smooth surface of the water. I had planned, in my original concept, to give this water a deep green coloring, but at this point in the picture, I suddenly realized that I liked the effect of the gray paper tone and decided to leave this as it was. You will often discover that you might change your original concept during the progress of a picture, as I did here. This can be very positive, as it helps maintain spontaneity. Rigid adherance to plans can cramp your style and rob a picture of potential freshness and vigor.

Step four: In the final stage of this picture, I aimed at condensing the background even more; to this end, I rubbed in the pastels with my finger and added a few new dashes of color. Then I applied fixative and went over the beak and legs with a sharpened pastel. The action of going over some parts very lightly for a second time tends to soften rough structures and to bring colors further together.

I used the technique of mixing pastels and fixative, previously described in this chapter, on the sky and the wings. This created an effective contrast to the structure of the feathers.

By interspersing the same blue that I had used in the beak and water among the greens of the background, I was able to reinforce the line dividing land from water. The light blue, which is reflected in the water, is the same blue that you will find in the sky.

In retrospect, I was very glad that I decided to keep the original gray paper tone for the water, and not colored it as I had planned, as this would cer-tainly have made the picture look flatter and the effect of the feathers would have been lost.

MOTIVATING IDEAS

Using pastels in a light and breezy fashion, you can capture moods and impressions that it may be more difficult to produce using other techniques. But since it is well nigh impossible, even using a sharpened pastel, to produce an exact line, such as can be attained using a brush, it's not worth even attempting to draw a street with Gothic buildings in pastel (this of course does not exclude the possibility that there might be somone capable of doing just this). Pastels are best suited for landscapes with slightly hazy contours, or for soft, flowing forms, such as grass waving in the wind, a garden in full bloom, or reflections in water. Bear in mind that pastels can also be mixed and rubbed in, giving you more possibilities of expression.

I have chosen some motifs here which I hope will stimulate you to make your own pastel drawings.

The large picture below, a scene in Turkey, is almost abstract in itself.

You should feel free to diverge from reality and make whatever you want from this motif.

The water reflections and the still life are slightly more difficult. But the forms in the still life are soft and the colors reflect one another.

You could try rendering the snow landscape on blue-tinted paper, using light and dark pastels to bring out the depths. Or you could use completely different colors and merely take the motif as a starting point.

The scene with the palm trees offers an opportunity to try out the effects of various colors and lines. Take note of the light in this picture. It plays an important role in adding depth.

The motif of a swan on water could be treated in much the same way as my step-by-step picture, but note, I only said *could*. Try out some of the ideas I've given you in these pages, adding any ideas of your own, to make your own, personal rendering of these suggestions.

Oil Pastels

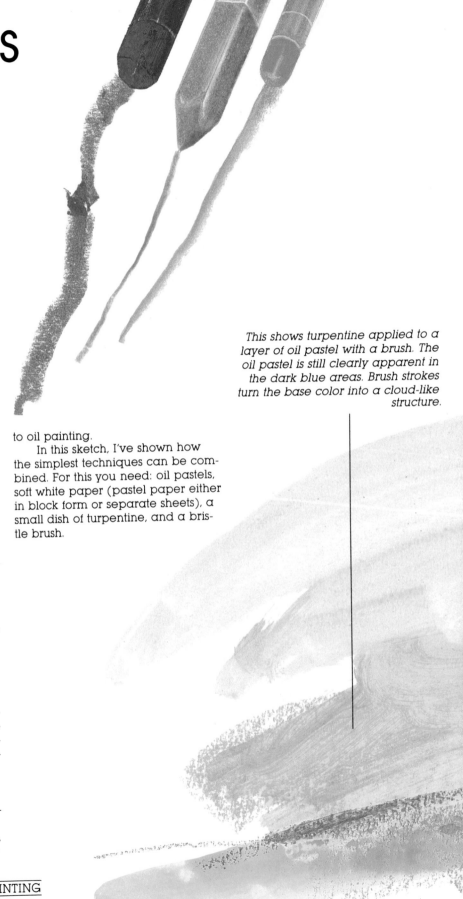

This shows turpentine applied to a layer of oil pastel with a brush. The oil pastel is still clearly apparent in the dark blue areas. Brush strokes turn the base color into a cloud-like structure.

Oil pastels are less delicate than simple pastels as they, in general, will not break or smudge so easily. They are made from a combination of color pigments and a wax mixture and do not, necessarily, have to be treated with a fixative. The colors tend to be brighter, and, all in all, they are less complicated to use than simple pastels. It's even possible to get water-soluble oil pastels. If you go over markings from these with a wet brush, you will produce an effect very similar to painting. The relatively stumpy form of these crayons, can, however, be somewhat restricting, but with the aid of other mediums, such as watercolors or pencils, this technique can become highly flexible.

You can easily carry oil pastels around to capture a chance impression or for a quick, spontaneous sketch in color. It's advisable to lay a spare piece of paper under your drawing hand to avoid any unnecessary smudging. Oil pastels might not be quite so prone to this problem as simple pastels, but prevention is always better than cure!

Try to use smooth paper for your first attempts with this medium, as it is easier to mix colors on it.

Start with some experiments to familiarize yourself with this material and the effects that can be achieved with it. These experiments don't have to be works of art; they serve to awaken your curiosity and your desire to delve deeper into your potential, and that of this medium. Try rubbing one color, or several colors, in with your finger. Try going over oil pastel with turpentine to dissolve the colors making it possible to paint with it. Try drawing into oil pastel with pencil or colored pencil. This will scrape at the surface of the pastels and create new tones.

You can also scrape some pastel onto a palette and mix this with turpentine. If you then apply this mixture to your paper using a painting knife, you will achieve an effect very similar to oil painting.

In this sketch, I've shown how the simplest techniques can be combined. For this you need: oil pastels, soft white paper (pastel paper either in block form or separate sheets), a small dish of turpentine, and a bristle brush.

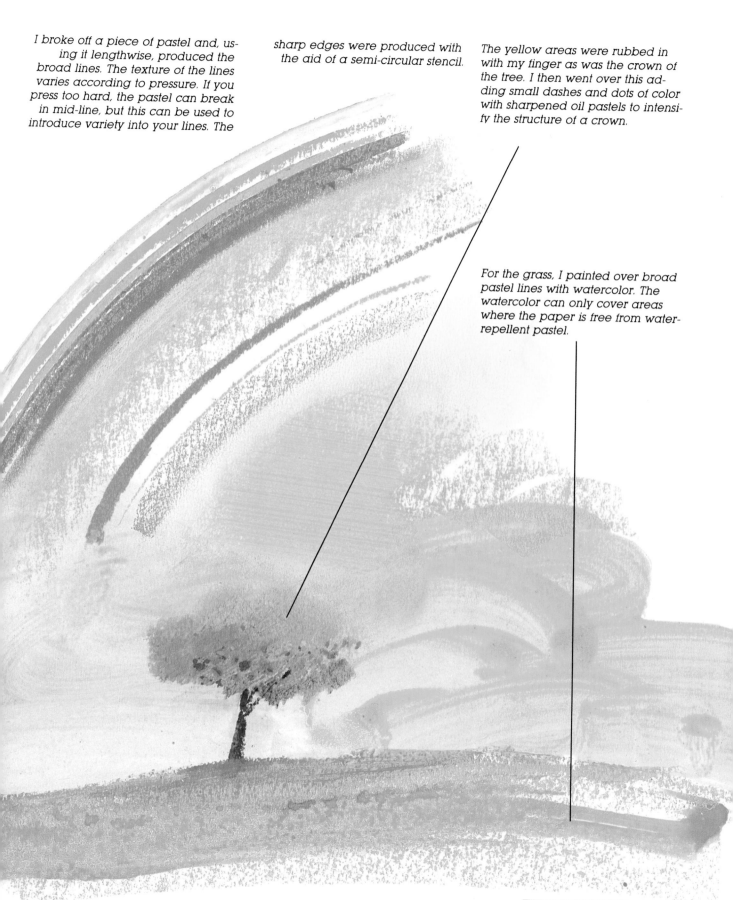

I broke off a piece of pastel and, using it lengthwise, produced the broad lines. The texture of the lines varies according to pressure. If you press too hard, the pastel can break in mid-line, but this can be used to introduce variety into your lines. The sharp edges were produced with the aid of a semi-circular stencil.

The yellow areas were rubbed in with my finger as was the crown of the tree. I then went over this adding small dashes and dots of color with sharpened oil pastels to intensify the structure of a crown.

For the grass, I painted over broad pastel lines with watercolor. The watercolor can only cover areas where the paper is free from water-repellent pastel.

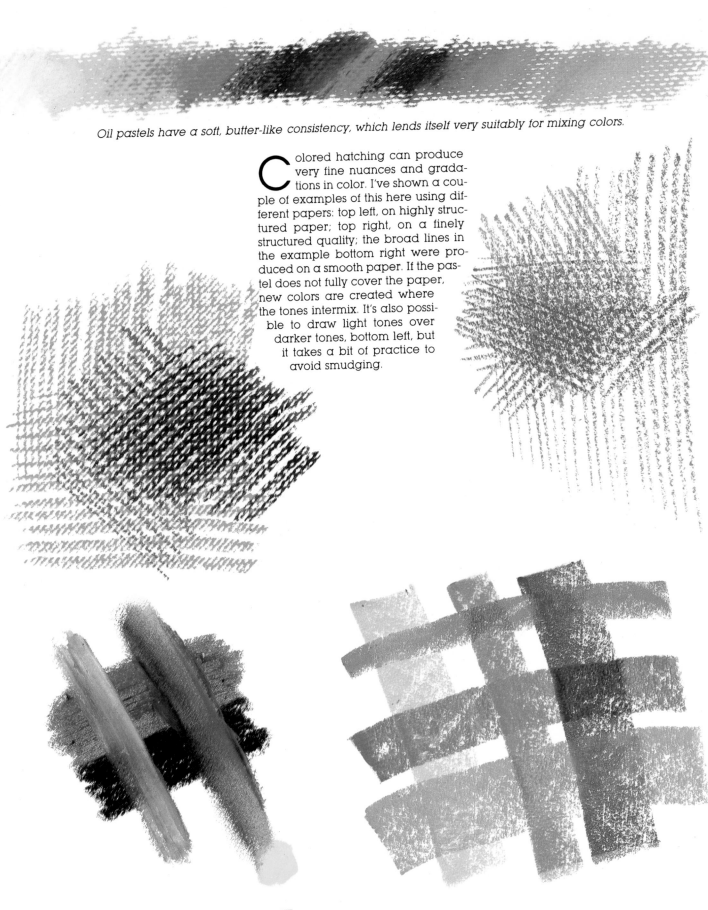

Oil pastels have a soft, butter-like consistency, which lends itself very suitably for mixing colors.

Colored hatching can produce very fine nuances and gradations in color. I've shown a couple of examples of this here using different papers: top left, on highly structured paper; top right, on a finely structured quality; the broad lines in the example bottom right were produced on a smooth paper. If the pastel does not fully cover the paper, new colors are created where the tones intermix. It's also possible to draw light tones over darker tones, bottom left, but it takes a bit of practice to avoid smudging.

With the aid of turpentine and a brush, the colors can be made to dissolve and intermix, giving a watercolor effect.

In the previous chapter, I discussed the use of tinted paper with simple pastels. This paper can equally enhance an oil pastel drawing, providing you are careful not to choose a paper that is too thin, if you want to apply thick coats of pastel. For the example below left I mixed linseed oil into oil pastel with a painting knife and applied it using the same knife. Hard pieces of pastel tend to stick to the surface, creating the impression of bark or leaves when they dry.

Below right, I used a darker blue than that of the background to shade the lower part of the crown in order to reflect this background in the tree. The effect of the blue paper shining through my lighter pastel lines in the sky lends an Impressionistic touch.

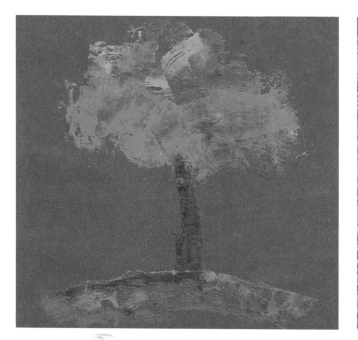

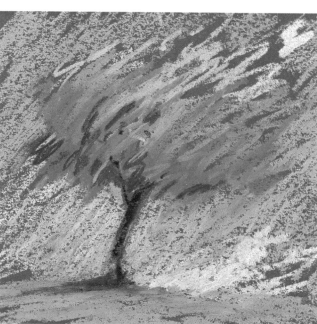

If you look at the leaves of the tree at right, you can see how a darker color can be scratched away to allow a lighter underneath color to come through. The darker areas of pastel mixed with linseed oil and applied with a painting knife stand out in strong contrast to these "scratched" areas.

Oil pastel painting is one of my favorite techniques, because using pastels I can work quicker and more spontaneously than with oil paints, but still achieve a painting effect. If I want to work outside, it's so simple to take some oil pastels along, saving the problem of deciding on my colors in advance, of carrying around a full palette, and of transporting a wet painting home.

This landscape was drawn on thick watercolor paper with a rough-textured surface, which proved to be ideal for both rough and soft pastel structures. The soft areas were produced either by rubbing in with my

finger or by turpentine wash. In some places, I simply left the white paper as it was. My grandfather always used to say: "Eat until you can eat only just a little bit more, and then stop." This can be applied to all forms of drawing and painting. Draw until you feel you could draw just a little bit more, and then stop! You will often find that you are faced with the dilemma of whether to add a little more to your picture or not. In this case, it's best to stop, at least for a while. You can usually add more details later, but it is rarely possible to remove unwanted details. This, of course, depends on the technique used. In this picture, my main aim was

to bring out the lucidity of the sky and landscape. As you can see, I left parts of the sky and foreground free, so that the structure of the paper can be seen. This lends softness to the picture. You will certainly notice that many of the

Oil pastels can be used to create pictures in a Pointillistic style. You can mix dashes and dabs of color, scratch them out, and redraw over these until you feel happy with the result.

"Scratching out" is not only a method of erasing, but also a component of this technique. As shown

on the right, I applied a thick layer of pastel, then scratched it away with a razor blade, producing a structure that I could draw over.

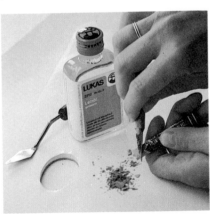

In order to mix oil pastel and linseed oil, scrape some small pieces of pastel onto a thick piece of paper or cardboard, using either a razor blade or a knife. Then mix the lin-

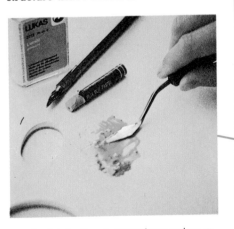

seed oil into these scrapings using a palette knife (I usually add a few drops of natural turpentine to this mixture). This will produce a soft paste that is easy to work with.

color tones are repeated in this picture, which is something that also happens in nature. This reflecting of colors helps create a stronger bond between the elements of the picture and establishes unity. The blue of the sky, for example, is to be found in the flowers in the foreground, and the pink of this foreground also appears in the sky. Similarly, the red and violet of the house are reflected in the grasses in the foreground.

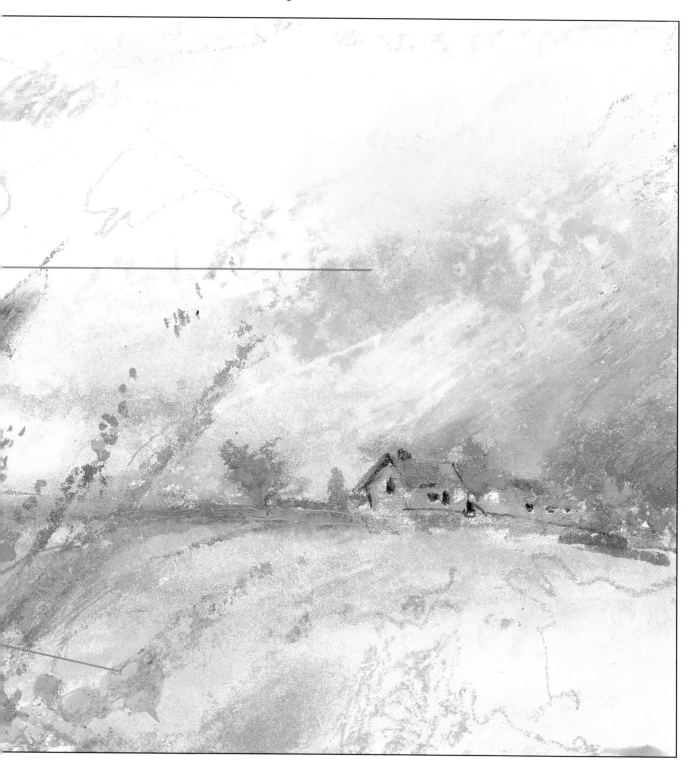

Step by Step

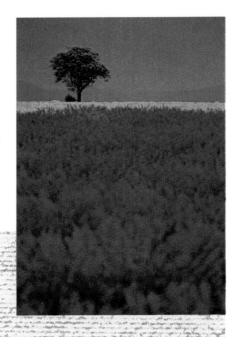

If you've already experimented with oil pastels, you're sure to be aware of the strengths of this technique: colors come out brightly and clearly, and there is an almost unlimited range of possibilities for the use of this medium.

I chose here a relatively simple motif, which I believed could be rendered more intensely, if not dramatically, using oil pastels. I used thick paper, with a highly structured surface, like that which is normally used for oil paintings.

It's very important to consider the

thickness of paper. If you want to apply thick layers of oil pastel, you will need a well-structured surface to ensure that the pastel will adhere to it.

Step one: Using a brown pencil, I first laid out the rough outlines of my composition and then added the areas of sky and foreground with the flat surface of a broken pink pastel. This broken-off piece of pastel was about an inch long.

Step two: The next step was to in-tensify the color of the sky and then to wash over this using a brush and turpentine. My original motif seemed a little sad and forlorn to me; I wanted to bring a somewhat fresher, livelier atmosphere into my rendering, so I decided to add two broad strips of yellow and light blue respectively. Then I went over these with a thick layer of white pastel, rubbing this in with my finger. Whenever you use this rubbing-in method, be sure to wipe your fingers carefully after each rubbing-in process, as bits of unwanted pastel have the annoying habit of sticking first to your fingers and then to just the wrong part of your picture.

Using very few colors, I drew in the tree over the background and then applied colors liberally to the foreground.

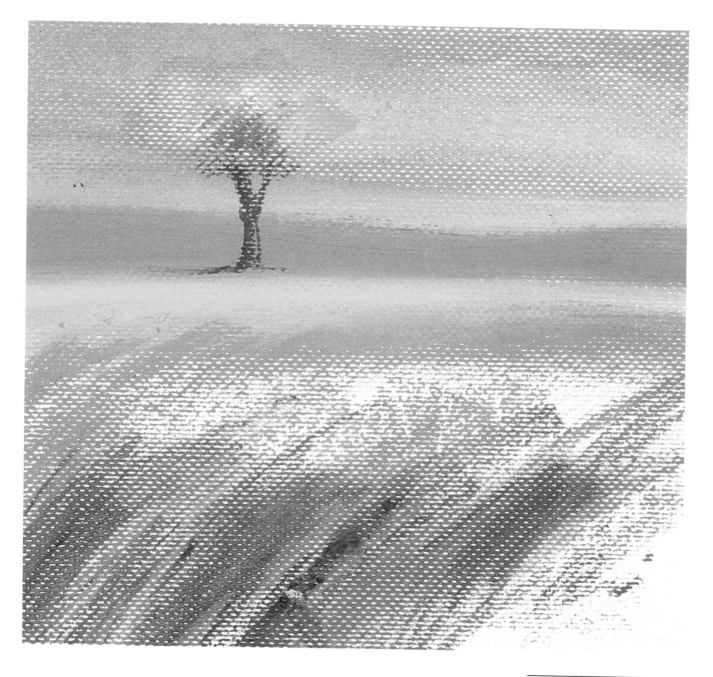

tep three: I wanted the structure of the foreground to look somewhat wild and free, so I built this up slowly, first using blue and orange and then adding violet, purple, and pink on top of these. By rubbing the colors into each other, I created a smooth surface over which I would be able to draw easily at a later stage. It's a lot easier to add quick dashes of color or to such a surface than to a rough pastel structure.

It can happen that you find that you have applied your colors too quickly and thickly. In this case, it's quite simple to scrape these off using a palette knife so that you have only a light layer of color over which you can draw again. Save all these scrapings (in a palette or a thick piece of paper), as you might want to use them later, mixed with turpentine or linseed oil.

The leaves of the tree are the product of thick dashes of pastel, which I then structured using a palette knife.

Had I not chosen to use thick, highly structured paper, I would have had problems at this stage. My thick application of pastel would not have clung to a smooth-surfaced paper; the colors applied with a palette knife would have crumbled away easily and had the paper been too thin, it would have warped under the thick layers of oil pastel.

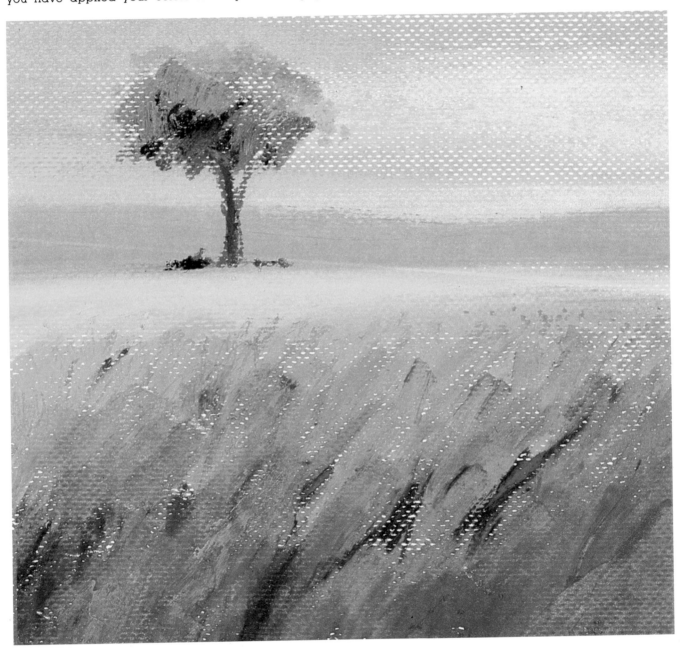

Step four: The next steps in the development of the tree were very simple: I rubbed the pastel in a little bit more, then I mixed some pastel with turpentine and applied a thick layer of this mixture over the rubbed-in pastel. I went over the edges of the yellow strip with the pink of the foreground to give it more brilliance.

The dramatic atmosphere is reinforced by the contrast between the tree and the foreground. As you can see, I was really able to let go with the foreground. I mixed colors and rubbed them in until I had created a relatively thick layer, which I then scratched into using my palette knife (you can also simply use your fingernails). As in my step-by-step picture using simple pastels, you can see that I also repeated colors in the various elements of this picture to establish unity. The tone and structure of the green in the tree are repeated in the lower left-hand corner of the foreground; the dark pink of the grasses turns up again in the right-hand section of the tree.

This reflection of tones within a composition lends integral unity to a picture, besides enhancing certain colorful effects and impressions.

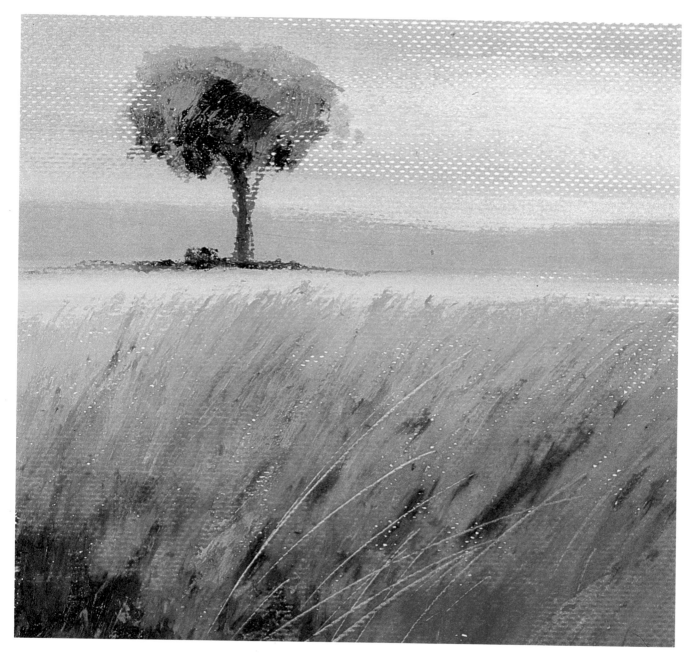

MOTIVATING IDEAS

As I've already mentioned, there is a strong correlation between oil pastels and oil painting. Motifs for oil pastel drawings are equally well suited for renderings in oil paint. The suggestions given in these sections are not necessarily restricted to the technique discussed in that chapter. They are merely ideas which I feel could be well brought out in these techniques.

Since it's possible to attain greater precision using oil pastels than simple pastels—especially with additional aids, such as turpentine and water—there's a larger choice of motifs for this technique. The best motifs are not always exotic, so first take a look around. Maybe you have a bunch of flowers that can be turned into a still life, or a brightly colored toy lying next to a houseplant. Well-structured objects are very suitable for renderings in oil pastel on account of the variety of structures that can be produced with this technique.

The old boat in the photo below, with its many layers of paint, is a perfect example. You could forget the boat entirely and make an abstract picture based on the multicolored structures.

I can imagine that the floral landscape would lend itself well to dissolved oil pastels, leaving the church white by way of contrast.

Quick Reminder

Oil pastels can be mixed with turpentine and applied to your picture using a palette knife. They can also be diluted until they are thin enough for brush painting.

New tones can be produced by applying one color on top of another. If you cover a light tone with a darker tone, this darker tone can be scratched away, letting the lighter undertone come through.

Soft color transitions are obtained by rubbing over the pastel with your finger.

A sharpened pastel can be used to go over broad thick lines, altering the structure of these lines.

The soft light falling on this wooden doll turns it into a captivating motif. At first glance, the colors seem almost monotonous, but at closer study, you will discover a great variety of tones. Take any single-colored object and turn it around in the light. A simple electric light bulb is sufficient to make the tones seem yellower. Colors are alive, and in nature they are constantly changing.

If you found that you enjoyed scraping pastels to reveal underlying colors, this motif of a cornfield may be just right for you. The run of the lines is the only evidence of the differing elevations in this scene.

Look through your own holiday snapshots. You are sure to find some suitable motifs among them. And these will have the added advantage that you will know the place or the object personally—maybe you even held the object in your hands—and therefore have a stronger affinity towards it.

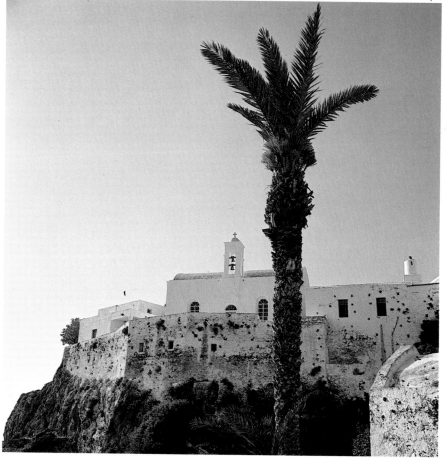

You will find many different structures in this picture of a monastery in Crete, left. The structure of the palm leaves varies from that of the trunk, the plastered wall is yet again different from the rocks. In complete contrast to this is the totally expressionless sky. If you don't like this sky, you can add a couple of clouds. No one can stop you from setting the whole picture in the atmosphere of a storm, if you want to. (See my renderings of this motif on pages 64 and 191.)

Gallery

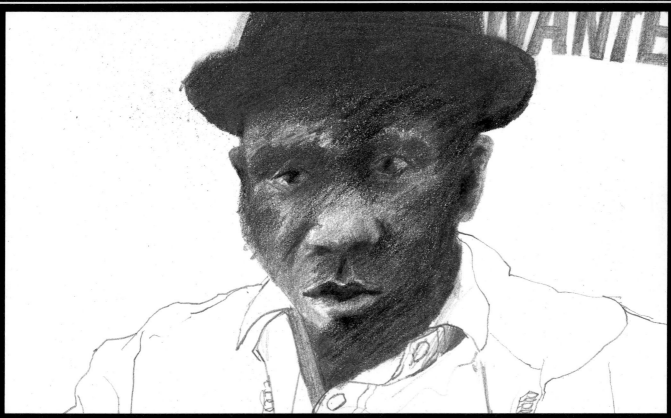

The pictures in the Gallery sections have mainly been included to illustrate the versatility of the various techniques. They are not intended to frighten you off, nor to instill you with an "I can't do that" feeling.

A portrait can express a person's character just as much through the way the picture has been drawn or painted as through minute adherence to detail. The portrait shown above is a free study in colored pencils and thick wax pastels. Tension is created by the contrast between the descriptive face and the merely outlined clothes. The weight of the picture, however, lies in the system of shadows structuring the face. Original size: 185 × 107mm (7¼ × 4¼ inches).

Compared to this, the picture on the right looks more poetic and softer. It was drawn using oil pastels,

markers, and a soft 2B pencil. Original size: 140 × 190mm (5½ × 7½ inches).

Look for qualities and contrasts in the techniques shown on these four pages. You are certain to find some inspirations.

The portrait in the bottom left of page 189 is a copy that I made of an oil painting by Alexej Jawlensky (1864-1941) using oil pastels. (Copying pictures can teach you how other artists use colors.) I was most interested by the unusual colors used by this artist to bring out a facial expression. The contrast between the smooth area of black and the painted background in which the blue of the face is reflected serves to increase the tension in this composition. Original size: 214 × 266mm (8¼ × 10¼ inches).

Right: The pastel drawing on dark gray-tinted paper is mainly the product of rubbing-in, making the colors flow into one another. The lighter lines limiting the collar, hat, and jacket were drawn using a sharpened white pastel. Original size: 164 × 193mm (6½ × 7½ inches).

Below right: A simple still-life drawing by Ursula Bagnall uses colored pencils to capture only the important impressions of color. Original size: 87 × 95mm (3½ × 3¾ inches).

Gallery

All techniques can be combined and developed to create new effects, or to reproduce an effect that you have seen somewhere else. On these two pages, you will find a wide variety of ideas most of which you can, by now, turn into interesting pictures using the techniques we have discussed.

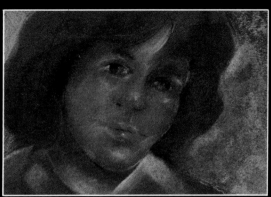

Left: A portrait in pastels on dark gray paper. Original size: 260 × 220mm (10 × 8½ inches).

Below: The flowers were first drawn using a water-soluble felt-tip, and then "washed over" with a brush. Original size: 170 × 205mm (6¾ × 8 inches).

Above: The landscape by Tom Rummonds, an American illustrator, was drawn purely using felt-tips. Original size: 230 × 160mm (9 × 6¼ inches).

Right: Two drawings in felt-tips, pastels, and colored pencils, both taken from advertising. The face illustrates especially well how this mixed technique is suited for professional work. Original size: 190 × 190mm (7½ × 7½ inches). The lobster also shows good use of mixed technique. Original size: 170 × 170mm (6¾ × 6¾ inches).

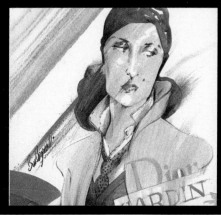

Left: The effect of an oil painting was achieved in this still life by Ute Stumpp, a Munich artist, through applying thick layers of oil pastel. The picture is vivacious, as a result of the abstract perspective and the structure of the colors. Original size: 145 × 175mm (5¾ × 6¾ inches).

Left: Colored pencils are the almost perfect technique for rendering motifs such as this baboon. Quick, fresh dashes give the skin a soft appearance. Attention is captured, however, by the bright, intense colors in the face, which dictate the expression of the whole picture. Original size: 195 × 230mm (7½ × 9 inches).

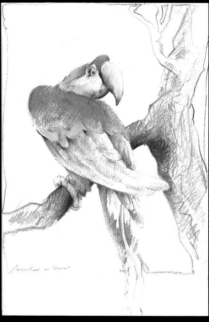

Above: Colored pencils also lend themselves for rendering this parrot, making it possible to bring out the fine feathers and—in contrast to these—the tree trunk. Note how the white gives the bird a certain air of buoyancy. Original size: 150 × 225mm (5¾ × 8¾ inches).

Left: Do you remember this motif? I have already used it once for a lead pencil drawing (page 64). Now that I've added colors, it looks quite different. The materials used were: oil pastels, colored pencils, and pen and ink. Original size: 230 × 240mm (9 × 9¼ inches).

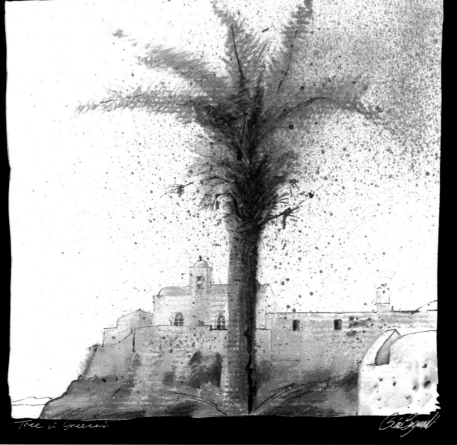

Tree in Greece

PAINTING

In case you have not, as yet, tried your hand at painting, you have one of the most exciting experiences imaginable to look forward to.

Painting has undergone all manner of colorful and momentous changes since the time when people first started to mix pigments and apply them to all types of surfaces. The paintings of the past help us understand more of the feelings, atmosphere, and even lifestyles of days gone by.

Artists were delivering detailed documentation of the styles and fashions, as well as of the architecture and landscapes, of the various periods and regions long before the age of photography, making it possible for us to view the past as if looking through a window.

The Venetian artists endowed us with clear pictures of Venice in the eighteenth century. Pieter Brueghel (Dutch artist, 1525/1530-1569) supplied us with such intense impressions of the Dutch landscape of his times that viewers often have the feeling that they only have to step into his pictures to mingle with the people. Later—especially with the growing popularity of photography—artists started diverging from precise renderings of their surroundings, but even these more abstract pictures can teach us much about the prevalent feelings and forms of expression of a certain era. The artists of today, in turn, have at their disposal a world of expression that knows almost no limitation.

We have, so far in this book, been concerned with all forms of drawing. In this section, you will learn how to approach using paints. You will discover the potentials of these mediums and how to experiment with them. My primary interest is that you should enjoy trying out everything; that you should discover the stimulating effect of these mediums; that the mere smell of paints will soon be enough to make your fingers itch to start painting.

Brushes

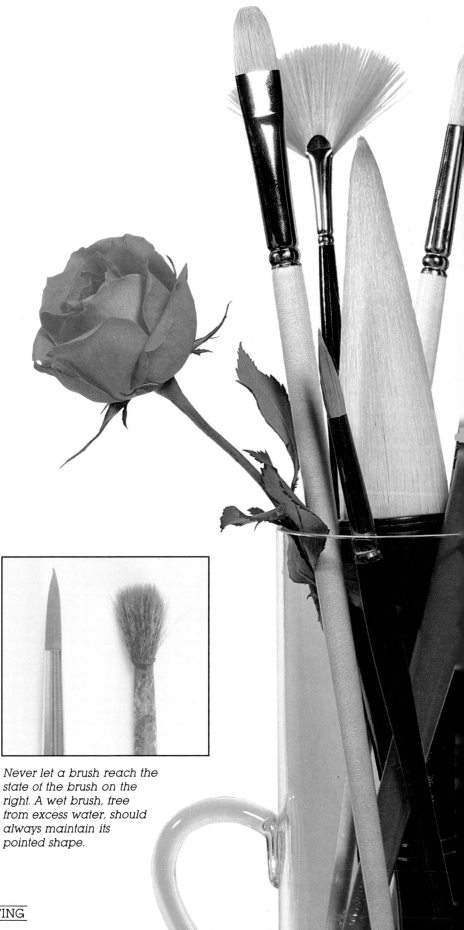

Do you remember the adage: "A poor workman should not blame his tools"? In 90 percent of the cases this is quite correct, but brushes are a slightly different matter. Quality and cleanliness play a very important role and can, to a certain extent, be the making or breaking of your pictures. Good, well-kept brushes can be compared to potted plants; if you neglect them, you can throw them away after a very short time.

It's safe to assume that the first "brush" was a finger or a hand—at least that's how the cave dwellers applied earth colors to their walls. They even dipped pieces of leather into their "paints" and painted with these.

Today's artists have been spared these difficulties and have an almost inconceivable range of painting materials at their disposal (which doesn't mean that you can't use your fingers as well!). The market is flooded with innumerable types, sizes, and qualities of brushes. It's a good idea, however, to restrict yourself to just a few top-quality brushes, even if these tend to be expensive, rather than a whole collection of cheaper, bad-quality brushes.

How can you recognize quality? A good brush maintains its shape. If you press the head down, it should spring back to shape as soon as you release pressure. It's better to test a brush while it is wet, but this is rarely possible in the store. Look for natural hair, as this is better than synthetics. The price is also a fair guideline; very cheap brushes are rarely any good. But please, do not, on the basis of what I have just said, start throwing away all your old brushes. These will come in useful for experimenting or for rougher work, for which the more expensive brushes are too good.

I'd advise investing initially in three or four brushes of different types and sizes, suitable for practicing the techniques that appeal to you.

Never let a brush reach the state of the brush on the right. A wet brush, free from excess water, should always maintain its pointed shape.

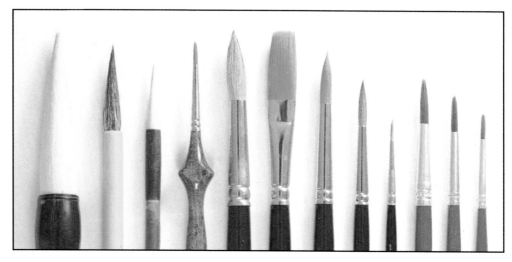

Fine, round brushes are suitable for all types of water paints. There are international standard sizes ranging from 000 to 36. The best brushes are made from red sable, but you can also use brushes made of squirrel, polecat, or ox hair, as well as Japanese brushes. Some very good nylon brushes have been developed, but I would still recommend natural hair. The first brush on the left in the above illustration is Chinese, the next two are Japanese, made from the hairs of mountain goats, ponies, badgers, or weasels. The handle of the next brush, an extra-fine round brush, is designed so that when you lay it down, it will not roll away or cover your paper in paint (due to the raised structure). The large flat brush, sixth from the left, is for covering large areas. Next to this you can see three sable brushes and three nylon brushes.

The fan brush, below, with its round, fanned-out hairs, is used for wash and blending techniques on wet surfaces. They are usually made from badger hair or sable. The sable gives a finer wash than the badger-hair brush. Bleached hog's bristle brushes are used for oil and acrylic painting. The tips of the hairs are split, which means that they will hold the paint better. Sable-hair brushes provide for a finer brushstroke, but they are less resilient than hog's bristle brushes. Brushes can be flat, round, or filbert (flat with an oval-shaped point). I'll go into their various uses when I deal with the individual techniques. In the picture below, you can see the wide range of sizes and types of brushes. You can tell synthetic brushes from natural hair by their points because natural hair forms a neater, more resilient point.

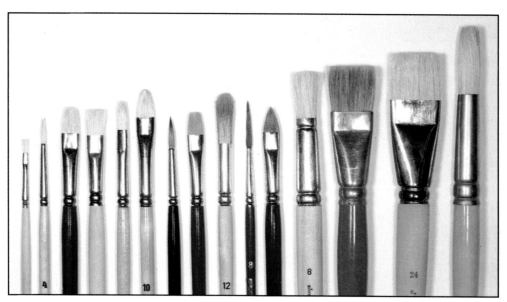

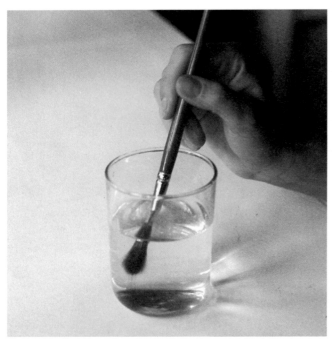

Cleaning Brushes

No matter what type of brush you use, correct cleaning is of paramount importance. After working with water-soluble paints, first rinse the brush thoroughly in water. Then draw the head backwards between your thumb and index finger to squeeze out any excess water and reshape the brush. More obstinate paints, such as acrylics, call for the use of a liquid soap such as dish soap. Put some soap into your cupped hand and rub the brush into this well (as in the picture on page 197). After this, thoroughly rinse the brush and reshape it using your fingers or mouth.

Important: Never clean out acrylics with hot water. The paint will harden and ruin your brush.

Other Tools

Palette knives or painting knives can be used for mixing oil or acrylic paints on your palette. These knives also can be used for applying paint to your picture. Some of these knives have crank-shaped handles for even easier manipulation, since this keeps you from touching the canvas or painting surface with your hand. Knives with straight handles are useful for scraping extra paint off your palette. A spatula (second from the right) has a square end and is also used for this purpose. You can paint with a smaller spatula as if it were a brush. Larger spatulas can be used for covering large areas or for thick applications of paint. Various structures can be introduced into your work using painting knives.

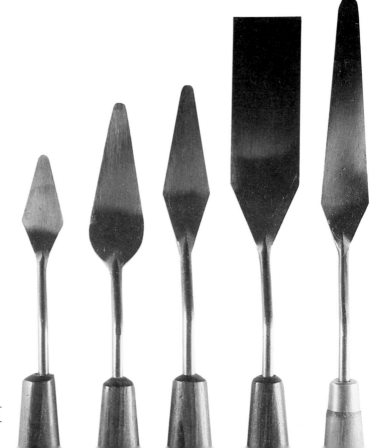

If you've been using oil paints, water is not sufficient to clean your brush. Instead you'll need mineral spirits, a paint cleaner, or a turpentine substitute. First, thoroughly clean off all paint in a pot or jar of this liquid, then rub the brush in the palm of your hand, to make sure that the cleaner has penetrated down to the ferrule (the metal part that holds the bristles). After this, rub the brush with a rag and then continue cleaning as for water-soluble paints: rinse thoroughly in lukewarm water, rub with soap, and rinse again. When you're certain that your brush is clean, stand it in a container with the tip pointed upwards to dry.

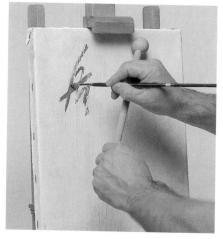

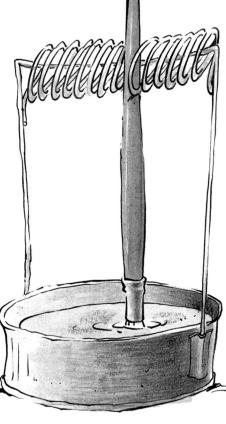

The mahlstick, sometimes called an artist's bridge, above, serves as a rest for your hand if you want to avoid touching your painting surface because some of the paints are not dry. A mahlstick is also a useful aid when you are working on details at an easel and need some support for your hand. This implement also proves very practical for drawing straight lines.

If you want to take a short rest, and don't necessarily want to clean your brush right away, you can hang it in a brush cleaner, left. This is filled with water, if you are working with watercolors or acrylics, or with a cleaning solution for oil paints. The brush, suspended from the spiral, hangs freely in the liquid, ensuring that the point will not be bent. Were you to just put your brush, head down, into a jar of water or cleaner, the point would bend, and you wouldn't be able to continue working with the brush.

Watercolor

There is something very special about painting in watercolors: the translucency, clear colors, and spontaneity of this medium lend immediate vivacity and spirit to pictures. The natural, flowing character of watercolors often misleads people into connecting this technique with simplicity, but in fact these effects are very difficult to achieve. They are a challenge that excites many artists. Everyone can see the work that has been put into a painting in oil, acrylics, or gouache, which makes watercolors look easy and effortless in comparison. But watercolor painting becomes effortless only after much practice and experience in a technique that doesn't allow you to correct or paint over mistakes. Watercolor painting is one of the oldest painting techniques, developing from the use of pigments made from natural resources such as minerals, clay, and earth. Later egg and plaster agents were introduced, and finally, after much experimenting, oil was added and oil painting was born. A watercolor basis was used by the Egyptians and by the Mediterranean civilizations for their wall paintings, and by the Japanese for scroll paintings. Nowadays, watercolors are made from finely powdered color pigments in a water-soluble binder (usually rubber-based).

The eighteenth century saw the beginning of the height of the watercolor painting era. English artists, such as John Cotman (painter and engraver, 1782-1842), William Turner, and John Constable brought this art to an exceptionally high standard, as did both the Impressionists and Expressionists at a later date.

Watercolor painting claims high popularity among hobby artists today, maybe because it is not so costly and time consuming as other techniques. In addition, a box of watercolors fits into most pockets or bags, water usually is not difficult to find, and if the picture does not turn out, you do not feel that you have wasted hours of hard work. Thanks to the development of watercolor blocks (paper that is bound on all four sides by gummed edges), paper warping is no longer a problem, nor are the sizes of these blocks cumbersome.

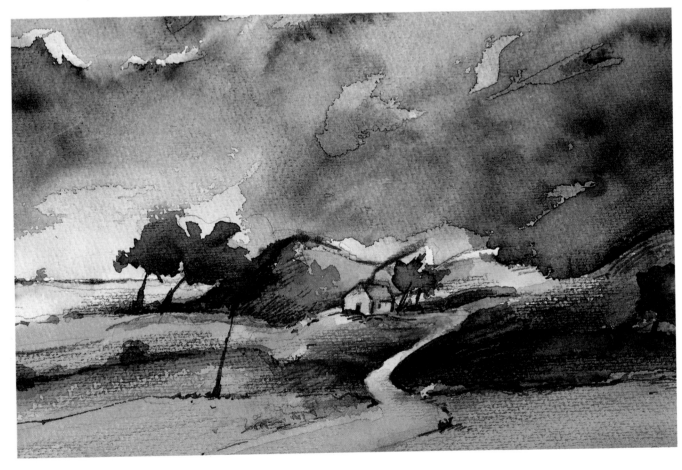

The pictures on these two pages illustrate the great scope of watercolors, ranging from the quick holiday sketch to the precision of a studio painting.

Watercolors were used in the picture on page 198 to transpose the observer into the atmosphere of a storm. In the picture at left, Uwe Neuhaus has used monochrome colors to create the feeling of fall. The paper was made to look old by using the wash technique.

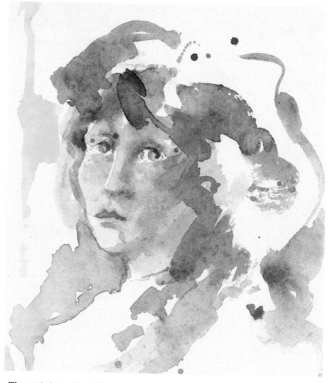

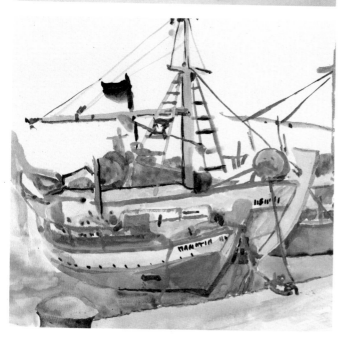

The picture by Ute Stumpp, above left, illustrates the impressive color progressions that can be created by wet-in-wet painting. The Greek harbor at left was captured by Jörg Hornberger by the use of quick brush strokes. The portrait painted on a dry background, above, and the picture of the harbor both illustrate how the unpainted areas can emphasize the effect of the other colors in a picture.

Materials

FOR WATERCOLOR PAINTING

Your choice of materials and tools is crucially important in all forms of painting. This is especially true in the case of watercolor painting, as it is difficult to "cheat" with this technique. So in the beginning it's better to concentrate more on quality than on quantity in respect to materials.

Brushes and paper:
On pages 194 and 195, I gave you some general tips about brushes. Once you've decided that you want to take up watercolor painting, it's worthwhile investing a little more and buying some high-quality brushes, such as sable-hair brushes (try red sable, which is also called kolinsky). Two or three different sizes are quite sufficient for your initial attempts. For normal sized pictures, I'd recommend numbers 3, 6, and 10. You could buy a couple of supplementary cheaper brushes for painting backgrounds or less detailed parts of your pictures. You can always augment your collection of brushes once you have gained a little experience in this technique and know what you prefer.

Watercolor paper is almost as important as the brushes, since it can have a great effect on the colors. Until you have gained some experience in this technique, I would advise using a watercolor block, which will avoid many of the problems presented by other papers, such as warping. the problems presented by other papers, such as warping. Some to try: Arches, Fabriano, Magnani, and Whatman.

Paints:
Watercolor paints come in tubes, in half and whole pans, and in a liquid form in small bottles. You can buy them separately or in boxes, but buying them separately allows you to build up your own personal selection of colors (see the section on color that begins on page 204). Tubes are more economical for larger pictures, otherwise it's a matter of personal choice which forms of paint you prefer to work with. Liquid paints (colored inks) are less light resistant, but they are a good supplement to the other forms of watercolor. I can recommend the following makes of watercolor paints in bottles: Pelikan, Rotring, Talens.

Paint boxes are very practical for transporting paints. There are usually indentations in the lid for mixing colors. Some boxes even have a hinged metal tray for this purpose. There is often a thumb ring on the base to enable you to hold the paint box as you would a palette. If you decide against a paint box and for separate paints, you will need a plate or a palette with indentations for mixing. I like to use a painting tray, as illustrated in the photograph. Recommendable pan and tube colors: Lukas, Schmincke, Horadam, Rowney, Talens, Winsor & Newton.

You'll also need some paper towels for cleaning up extra paint, a pencil for sketching, a container (or two) for water, drafting tape for fixing your paper to a surface and for experimenting, a sponge, and pen and ink.

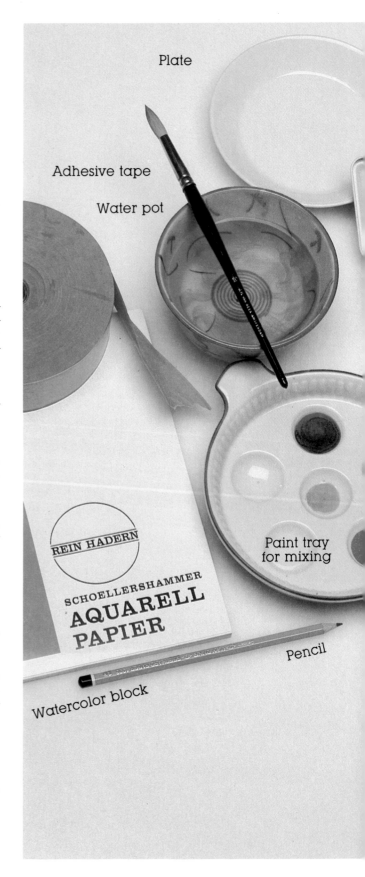

Plate

Adhesive tape

Water pot

REIN HADERN

SCHOELLERSHAMMER
AQUARELL
PAPIER

Paint tray for mixing

Pencil

Watercolor block

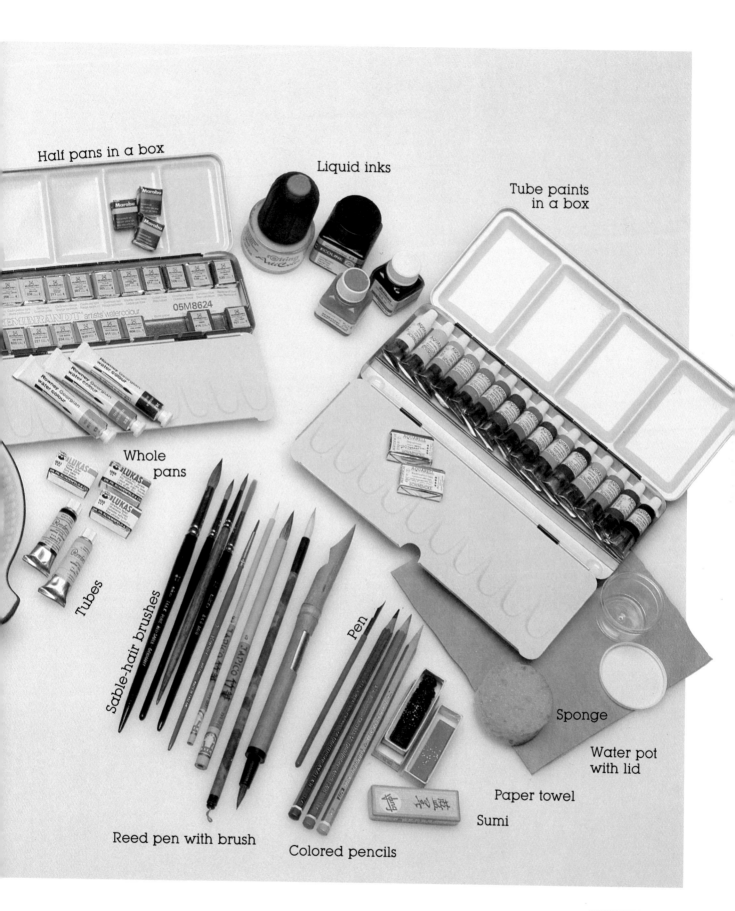

Half pans in a box

Liquid inks

Tube paints
in a box

05M8624

Whole
pans

Tubes

Sable-hair brushes

Pen

Sponge

Water pot
with lid

Paper towel

Sumi

Reed pen with brush

Colored pencils

The Paper

The brush is, without a doubt, the most important utensil for watercolor painting, but the paper also plays an important role because the structure of the paper will alter the effect of the paints. It's therefore imperative to try out different papers before you start painting. Most companies produce paper samples which you can obtain from any art supply store for a small fee. These samples are sufficient for trying out the effect of a couple of colors without having to spend a lot of money for paper you might never use.

Generally speaking, there are three basic types of watercolor paper: fine, medium, and rough. (Many manufacturers use the distinctions of *cold-pressed paper*, handmade watercolor paper with a medium to rough texture, and *hot-pressed paper*, a smooth, dense paper.) There are many different structures and weights in each of these categories. The thicker the paper, the less it will warp when it comes into contact with water. If you decide to work with separate sheets, they'll have to be stretched, as demonstrated on the opposite page.

Stretching the paper isn't necessary if you're using a watercolor block, since the edges are gummed to ensure that the paper flattens out once again as soon as the paints have dried. Thicker paper is certainly required for large pictures, although it's possible to paint small pictures on thin paper.

Watercolor blocks are very practical for working outdoors, since they're easy to handle. Always be sure, however, that your picture is totally dry before tearing the page out of your block—if it isn't dry the paper will warp. You may find that your paper warps while you're working. Don't let this worry you—it will flatten out again as soon as it's dry.

Always store your paper in a flat position (never rolled) in a clean and, of particular importance, dry place.

On the right you can see how different the same line can look on various papers.

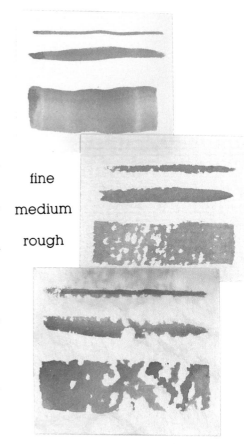

fine

medium

rough

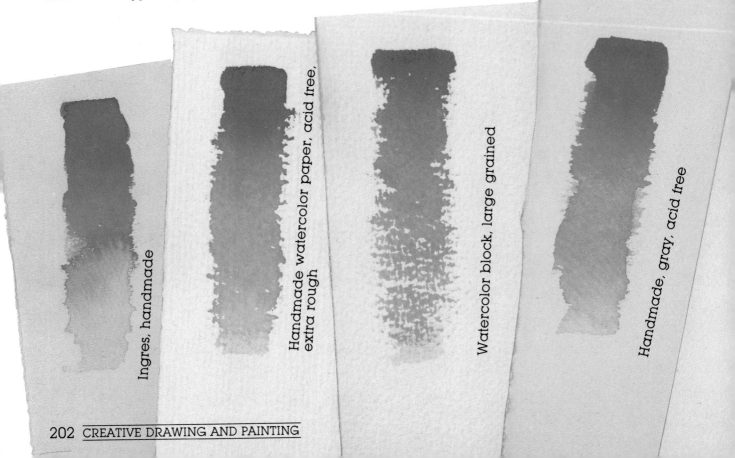

Ingres, handmade

Handmade watercolor paper, acid free, extra rough

Watercolor block, large grained

Handmade, gray, acid free

Stretching Paper

Thick paper doesn't necessarily have to be stretched (unless you are working with extra large pieces), but thin paper always requires stretching.

For this process, you'll need a drawing board or a piece of plywood that is approximately four inches bigger than your paper on all sides.

First, moisten the paper on both sides using a wet sponge; it is also possible to quickly dip the paper directly into water (in a hand basin or a deve-loping tray). Thick paper needs to be left in the water slightly longer than thinner paper.

Now lay your wet paper onto the board and smoothen it out slightly. Use adhesive tape that is approximately an inch and a half wide to stick the edges of the paper to the board. The tape should be half on the board and half on the paper. You will obviously need to use tape that will stick to wet surfaces (parcel tape). Press the tape down firmly with your fingers, to make sure that it is smooth and stuck down well. When the paper dries, it will again become taut. It'll start to warp again as soon as you begin painting, but will flatten out completely when the paint dries.

Once your finished painting is totally dry, cut just inside the adhesive tape to free your sheet of paper.

This is a small selection from the large range of watercolor papers available. I've also shown how the color runs differently on each paper.

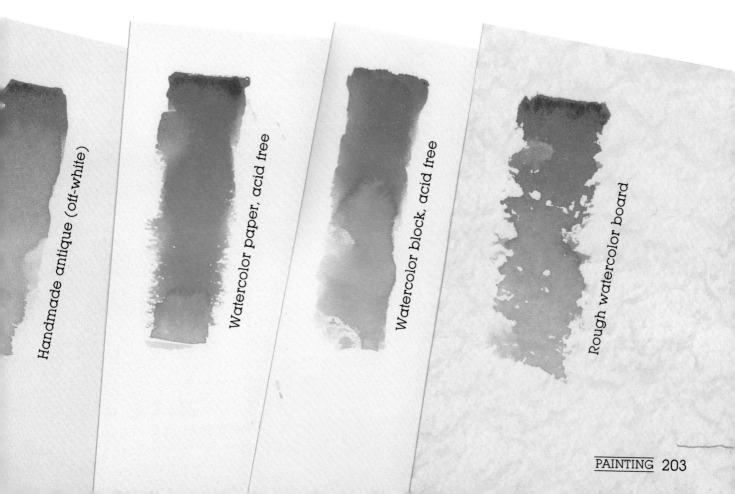

Handmade antique (off-white)

Watercolor paper, acid free

Watercolor block, acid free

Rough watercolor board

Colors

For your initial attempts at watercolor painting, you need only a limited number of colors.

If you mix the wrong colors together, you are likely to end up with an unidentifiable, muddy color, which you won't be able to use for very much. A limited palette will help you mix clear colors and become familiar with this mixing process. If you don't have a box of preselected paints, I'd advise buying three cold and three warm colors in the beginning.

At the right you can see some examples of mixing colors. Try making as many mix combinations as possible. You'll be surprised how many colors you can create in this fashion. Left-over pieces of watercolor paper, or the back of pictures that "went wrong," serve well as surfaces for these experiments.

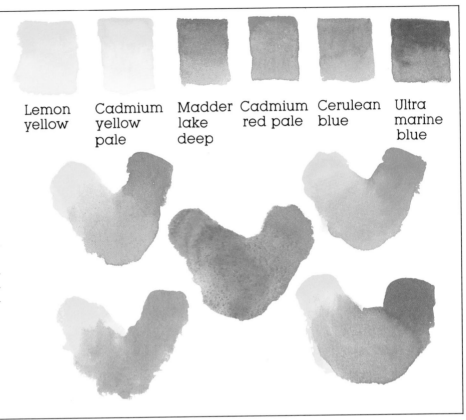

Lemon yellow

Cadmium yellow pale

Madder lake deep

Cadmium red pale

Cerulean blue

Ultra marine blue

Always try out any new tones before buying them, to see if they fit with the colors you already have and are to your own taste.

Below are some more color suggestions for a basic palette. Once you have painted an area, there is very little you can do to change it. You can, of course, darken tones, but it's impossible to paint a lighter tone over a darker tone. This means that you must have a clear concept before you start painting of where you want which colors. This is of special relevance for the light tones and for the areas of white—important components of watercolor paintings. The white areas are usually areas of white paper that have been left free from paint. Although it's possible to fill in these areas using opaque gouache white, this alternative lacks the clarity and translucency of working with watercolor and paper.

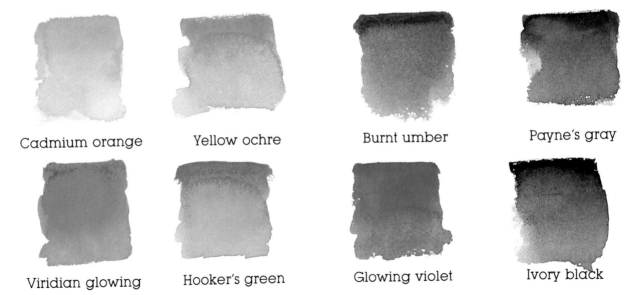

Cadmium orange

Yellow ochre

Burnt umber

Payne's gray

Viridian glowing

Hooker's green

Glowing violet

Ivory black

Here are some more stimulating color mixes using my color suggestions. You will not, of course, always produce beautiful or interesting tones, but when you do make a color that appeals to you, cut it out and note how you made it. In this way, you can build up your knowledge of colors and their potentials, and you'll have a reference you can use later, when you want to make a particular tone and can't remember which components you should use.

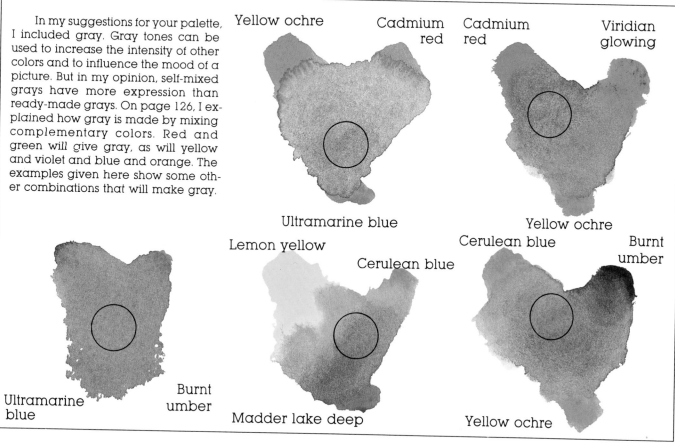

In my suggestions for your palette, I included gray. Gray tones can be used to increase the intensity of other colors and to influence the mood of a picture. But in my opinion, self-mixed grays have more expression than ready-made grays. On page 126, I explained how gray is made by mixing complementary colors. Red and green will give gray, as will yellow and violet and blue and orange. The examples given here show some other combinations that will make gray.

Yellow ochre Cadmium red

Cadmium red Viridian glowing

Ultramarine blue Yellow ochre

Lemon yellow

Cerulean blue

Cerulean blue Burnt umber

Ultramarine blue Burnt umber

Madder lake deep

Yellow ochre

A very important aspect of watercolor painting is the production of an even "wash," which can be used as a background, a sky, etc. This involves, as the name suggests, letting the paints run when they are still wet.

First moisten your paper with a sponge or a wide brush. If you use a sponge or a wet cloth, take extra care not to damage the surface of the paper as this will jeopardize the texture of your finished picture. Moistening the paper makes the paints run more easily.

Now begin to apply the color using a thick brush and smooth movements of the brush. Start from the top and work down, as shown in the diagram at right. The amount of paint you use depends on the amount of contrast you wish to create. Hold your block or stretched piece of paper at a slight angle, or lay something underneath it to create a sloping surface, so that the paint can run down easily. A slope of approximately 30 degrees gives the best results.

Always work from dark to light. This means that if you want the darker areas in the lower part of your picture, you simply have to turn your paper around, so that the bottom is at the top.

Practice with small areas first. It's also possible to make mixed colors run, although it takes a bit of practice to achieve an even finish.

Grained watercolor paper

Handmade white watercolor paper

Rough watercolor board

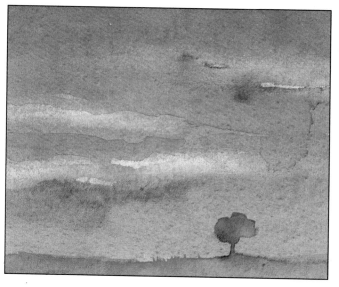

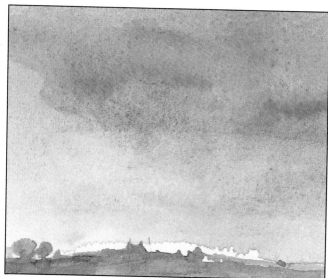

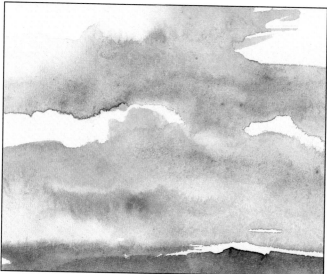

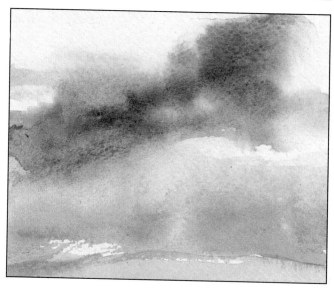

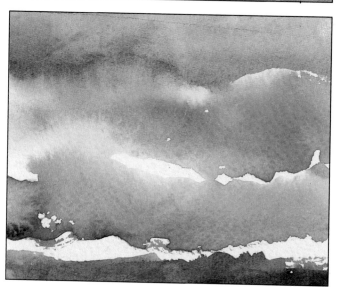

Graded and flat washes, as well as the more complicated sky structures shown here, are all techniques that can only be learned and perfected by much practice. Try the wash technique on wet, damp, and dry paper to see the difference this can make to the run of colors.

Before you start painting, whether at home or outside, first make some small color sketches, in which you note the most important points of your picture and try out color combinations and structures. You might find that the result is a muddy, somewhat indefinable mess, but this will, at least, teach you which mistakes you should try not to repeat in your actual picture. Save all your sketches that "turn out well." They can, just like your sketchbook, provide you with ideas for other pictures.

Here, I've shown some possible ways of painting a sky. You can see the importance of the areas of white. I could never have achieved these effects using opaque paints. Note that skies don't have to be just blue.

Very often you will want to capture a magnificent cloud formation, but on your paper it will turn out to be just a mass of something white and a far cry from reality. Practice is, of course, the best way to overcome this problem, but maybe this step-by-step example can help you a little.

First, when you take a good look at clouds, you'll recognize some typical basic forms: some are long and heavy, others small and meager, still others are typical cumulus clouds, as in our example. Try to avoid sketching too many heavy outlines as these pencil lines can come through the light paint and spoil the delicate nature of your cloud. My heavy outlines here were merely made in order to show you the basic form of this cloud.

Moisten your paper and apply a pale blue wash with a brush, leaving the area of the cloud free. I used ultramarine with a little indigo for the darker areas. The paint will run on the moist paper and give the cloud a soft appearance. If more paint than you want runs into your cloud, you can dab it away very carefully with a tissue or dry brush, providing you work quickly before the paper dries.

Once you feel content with the basic form and the surroundings of the cloud, you can begin to give it more shape, depth, and color.

Still using the wet-in-wet method, I darkened the sky behind the white (this brought the cloud more to the foreground) and lightly tinted the base of the cloud using burnt sienna. This lent warmer and softer contours to my cloud. Just before the paints dried, I went over the lower regions of the sky with cerulean blue, which harmonized well with the burnt sienna.

Try painting a couple of clouds of different shapes and colors, as this will help you to gain confidence for your later pictures.

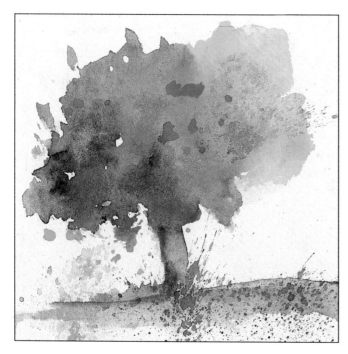

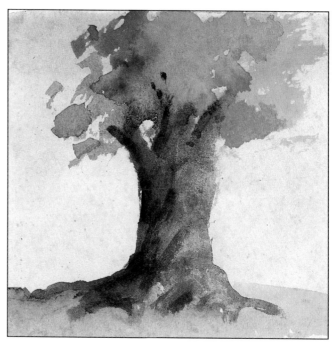

Top left: I went over the dry surface of my paper with wet colors, letting them run into each other, but only toward the center, in order to maintain the outer shape of the tree. As soon as these had dried slightly, I splattered a little paint over the surface. By the time I was ready to splatter the earth, the paint had, as you can see, almost dried.

Top right: This tree, on the contrary, was painted onto a moistened surface. As this gradually dried, I added the shading and finally rounded the trunk with a dry brush.

Bottom left: I painted this piece of fruit onto a dry surface. Highlights and the veins of the leaf were drawn using a white wax crayon, which repels color. It's possible to use wax or oil pastels instead of wax crayon for this effect.

Bottom right: Since I worked wet-in-wet, all colors ran. I drew the shapes into the wet paint using a pen and liquid watercolors. The pen lines scratched into the surface remain clearly visible, although the ink runs on both sides of these lines.

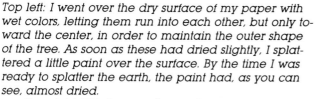

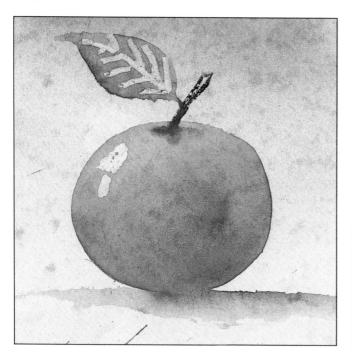

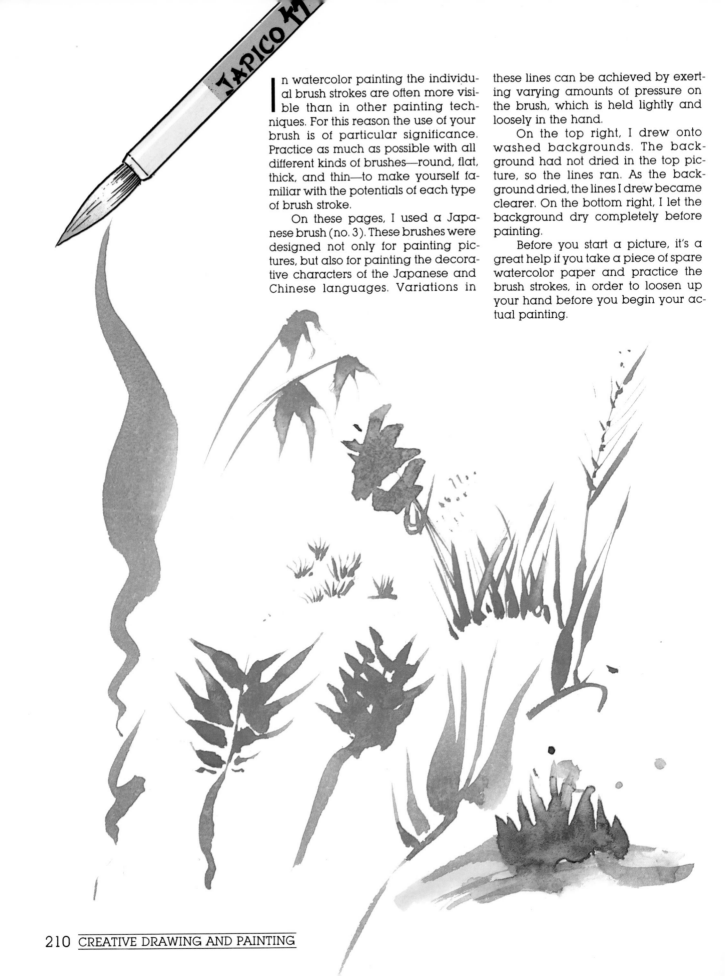

In watercolor painting the individual brush strokes are often more visible than in other painting techniques. For this reason the use of your brush is of particular significance. Practice as much as possible with all different kinds of brushes—round, flat, thick, and thin—to make yourself familiar with the potentials of each type of brush stroke.

On these pages, I used a Japanese brush (no. 3). These brushes were designed not only for painting pictures, but also for painting the decorative characters of the Japanese and Chinese languages. Variations in these lines can be achieved by exerting varying amounts of pressure on the brush, which is held lightly and loosely in the hand.

On the top right, I drew onto washed backgrounds. The background had not dried in the top picture, so the lines ran. As the background dried, the lines I drew became clearer. On the bottom right, I let the background dry completely before painting.

Before you start a picture, it's a great help if you take a piece of spare watercolor paper and practice the brush strokes, in order to loosen up your hand before you begin your actual painting.

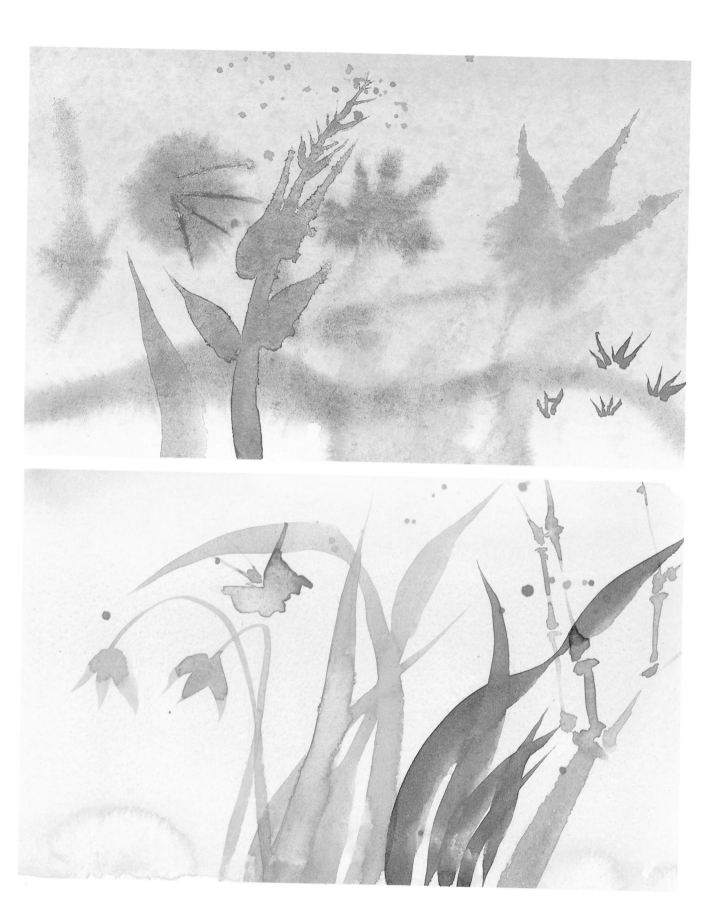

Every new picture you start is an opportunity to explore the possibilities and, maybe more important, impossibilities. Should one picture go wrong, try to analyze why and use this knowledge in your next picture. Do not, however, throw away these failures, as the back of this paper will be useful for experimenting.

Roughly sketching out the composition in advance won't jeopardize your spontaneity, but it can save you from disappointments. I first sketched out these flowers in pencil to determine the position of the light and dark areas and also made some color samples. You can still see some light pencil lines outlining the shapes in my finished picture. I started the actual picture by painting the light yellow background onto dry paper using a round sable-hair brush (no. 10), and a lot of water. Just before this dried, I added the light red flower heads, allowing chance to also play a role in their shaping. There are many different structures in this picture, depending on the degree of wetness of the background they were painted onto. I used a sable-hair brush (no. 5) for the finer shapes and also for the violet background, which was painted wet-in-wet, leaving spaces free for the white shapes.

To make the white flower at left, I first made yellow and blue washes, then painted in a darker background, leaving the form of the flowers free. Once this had dried, I could paint in the contours. For the red flower below, I made red and black run on a wet background to create this soft effect. I painted the sharp edges to this flower after the background had dried.

The yellow, bushy-looking flower was given fullness by splatters of paint dripped onto the form in various stages of the drying process.

Note how yellow is prominent in the whole picture. This lends unity to the picture and gives the observer a feeling of homogeny.

Use the tint, or white, of your paper to create lighter tones. I left part of the background white to emphasize the shadow of the vase. One side of the vase and table top were also left white, to enhance the feeling of intensity and bring out the various colors.

Small preparatory sketches like the one at left help determine a balance between positive and negative areas. Planning is of particular importance in watercolor painting, since it isn't possible to lighten areas once they've been painted over. Intensity and value also play a significant role in deciding on the various color progressions.

The following colors were used: lemon yellow, cadmium yellow, cadmium red pale, madder lake deep, burnt sienna, burnt umber, cerulean blue, hooker's green, and viridian green. For brushes, I used a round sable-hair (no. 10) and a Japanese (no. 5). I chose medium rough watercolor paper in block form.

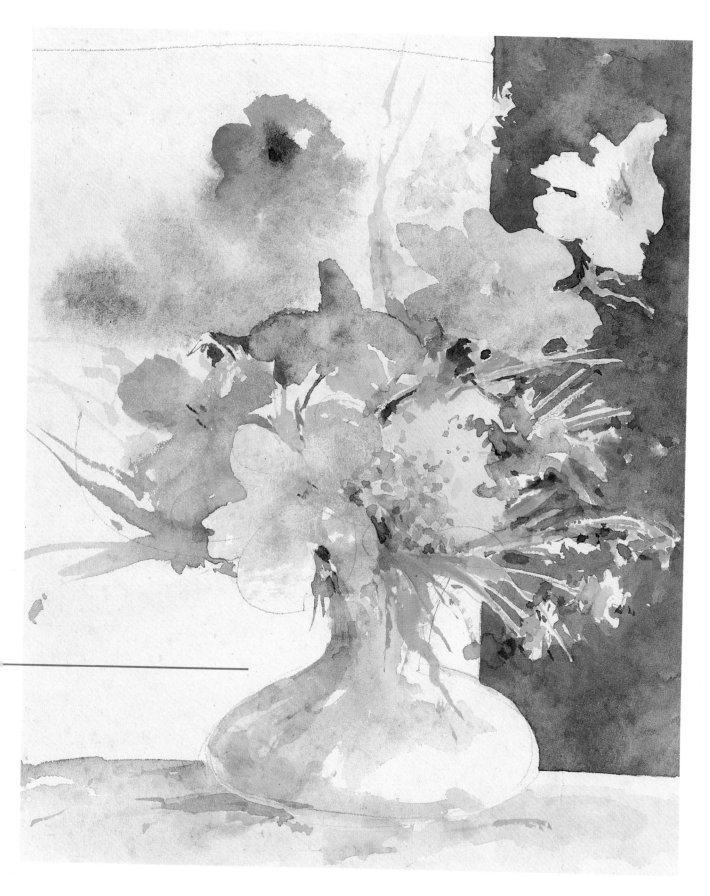

Step by Step

I used light green, fine-grained paper for this painting, stretched as explained on page 203. I chose round, sable-hair brushes (nos. 6 and 10), an ultra-fine Japanese brush, and an old toothbrush. The atmosphere of this landscape is somewhat cool. To produce that effect, I used these paints: lemon yellow, cadmium yellow, yellow ochre, burnt umber, cerulean blue, ultramarine, burnt sienna, cadmium red pale, cadmium orange pale, alizarin crimson, viridian green, a little violet, and Payne's gray.

To heighten the impression of coolness, I used larger quantities of cerulean blue and lemon yellow for my basic color mixes, but yellow ochre for the warmer tones of the brush.

Step one: I first lightly laid out the composition in pencil and filled in the areas that I wanted to remain white—the houses and church tower—using an old brush and a liquid mask. A liquid mask is a rubber solution that can be easily rubbed off once it has dried. This must be completely dry before you begin to paint.

I wanted to give the sky more depth than on the picture I was working from, in order to create more distance. The first wash was made using cerulean blue and a no. 10 brush. I added a small quantity of violet to break up the abrupt division between the foreground and background. Then I made the foreground more pronounced by adding very light washed gray and ochre.

Step two: While I let this dry, I decided which elements I wanted to keep as they were, where I wanted to

give more emphasis, and where more structure was needed. Then I completed the areas I had started, painting in the houses and the trees and darkening the tones left and right in the foreground. You will certainly notice that the picture has gained more depth. (The liquid mask repels paint. This means that you can paint over these areas, since the paint will be removed when you rub off the mask later.) While I was waiting for this second stage to dry, I changed my water and washed my brushes.

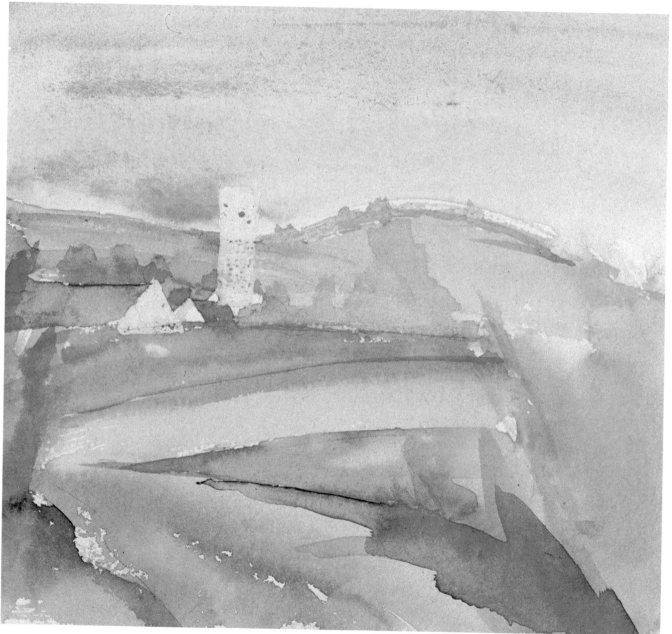

Step three: Next, I slowly started to build up the colors and shapes of the hills in the distance and the trees behind the houses using fairly wet paints. The darker tone values bring the houses and tower further to the fore, giving the picture more depth. You can now clearly distinguish between background, central section, and foreground.

After darkening the trees behind the houses, I painted the roofs. Compare this step to step two on the previous page. Do you notice how much livelier the picture has become?

I was now beginning to feel satisfied with the background, and decided to concentrate on the foreground. Always try to see a picture as a whole and don't get lost in details because this can ruin the balance of your picture. The bushes seemed important for expressing the atmosphere of the whole picture. I applied various colors to them, one over the other, and splattered a few more colors into this before it had dried. I wanted to use various warm green and brown tones to emphasize the contrast to the sky. This contrast gave a slightly misty atmosphere to the area behind the church and houses.

At this stage, the liquid mask could be removed, since the paints were absolutely dry. When removing a mask, rub very carefully, making sure you don't damage the paper, as it is possible that you might want to go over these areas of white with a light color later.

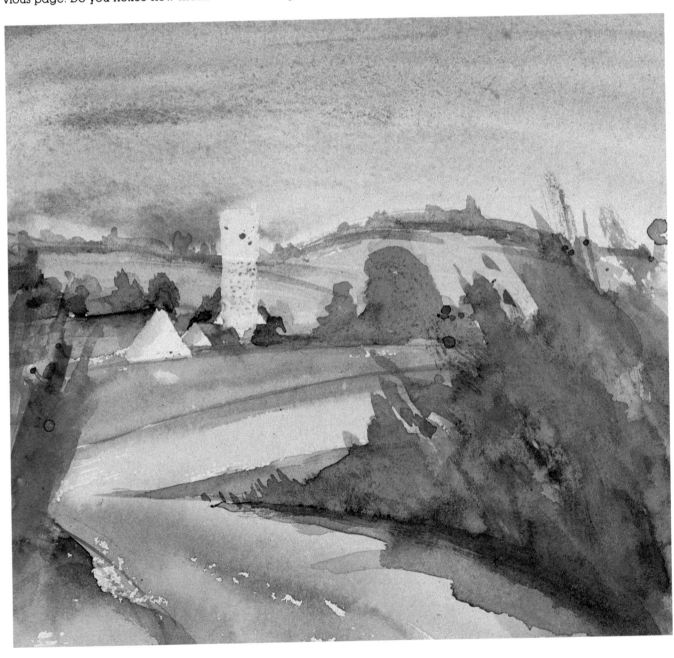

Step four: Using alizarin crimson, I next painted the onion dome. This red has a cool effect and harmonizes well with the light violet wash in the sky. I also used the same red, somewhat sparingly, in the bushes to lend coherence to the picture.

A little ultramarine was added to the tower to give this more form. I allowed the delicate blue tones to run slightly into the red, thus creating a softer effect.

At this stage I felt it was necessary to do some work on the bushes to bring them more to life. Taking an old toothbrush, I splattered virtually pure paint over the left and right corners of the foreground, first covering the church and hills with a piece of paper.

Some of the twigs were painted using a Japanese brush. Then I let the painting dry once again.

The longer I looked at my picture, the more I became convinced that I should give more emphasis to the contrast between the background and foreground, and that the foreground needed more structure. As a result, I crumpled some paper, dipped this in very wet paint and pressed this "stamp" over the areas where I wanted to introduce more structure.

There is always a slight danger at this stage of a picture of adding too much and maybe spoiling the picture. I was tempted to add structure to the road, but then decided to leave the soft effect as a contrast to the vivacious structure of the bushes.

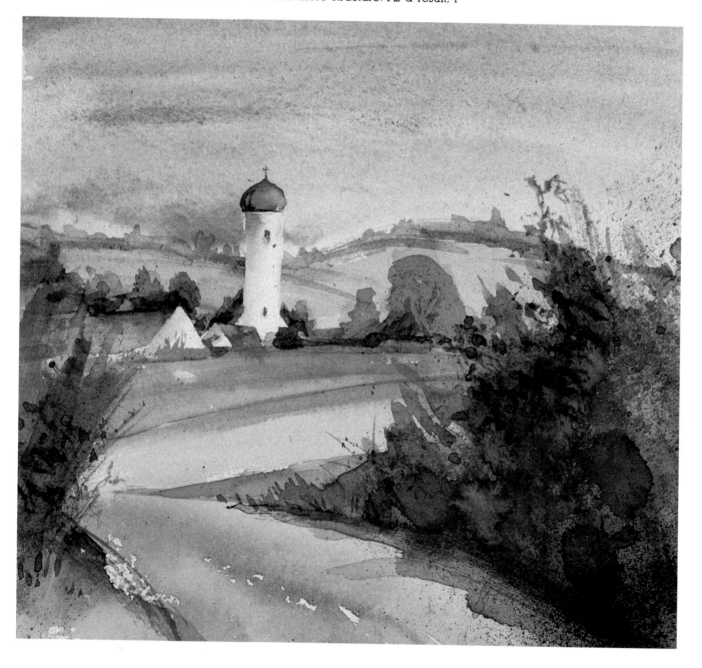

MOTIVATING IDEAS

There are motifs everywhere—the problem is recognizing them when you feel the urge to paint and are looking for a subject. The more you become involved in painting, the better trained your eyes will become to pick out motifs: your aquarium at home can offer equally interesting subject matter as a zoo, or look through the photo album that's lying around somewhere. My suggestions are merely ideas aimed at motivating you. There's nothing to stop you from rendering a suggestion I give for a watercolor picture in oils.

The still life on the right could be treated in the same way as my example of a vase of flowers on page 213. Start with the lighter tones and a lot of water and make a slow transition to the darker tones. Think also about the areas of white you'll leave free.

You could start rendering the peacock below wet-in-wet and then add the finer details and structures when the surface has dried.

If you want to paint landscapes, you'll have to come to terms with painting skies. Observe a cloudy sky for a while. See how it changes, how it moves; look for the different colors. I have shown some examples here. You can alter the colors to create different atmospheres. Study pictures in galleries or books to see how other artists have painted skies.

Flowers and plants are also rich sources of motifs that allow you to use watercolors' whole range of potential. Try to start with simple forms. Remain relaxed and take advantage of any chance structures. Above all, do not aim at producing exact replicas—leave this to photographs. The brush in your hand has life in it, and often a will of its own. Follow this, and if your picture should go wrong, remember that it's only a piece of paper after all.

Gallery

William Turner first saw this mighty rock formation, crowned by Castle Ehrenbreitstein, on his trip down the Rhine in 1817. He made several different studies of it in various lights. The severed edges of this picture, called "Ehrenbreitstein," indicate that this was taken out of one of his numerous sketchbooks. The picture is very typical for Turner and the way he utilized watercolor tech-niques to the full. The light, washed sky contrasts against the rocks. He probably applied the brown color of the rocks over the pink wash using his fingers. It can also be assumed that he drew in the bridge and boats last of all using a pen or a very fine brush. Original size: 248 × 303mm (9¾ × 11¾ inches).

Saul Steinberg (American graphic artist of Rumanian origin, 1914) who painted the scene on the opposite page, below, began by studying psychology and sociology, but then later worked as an architect in Italy. His watercolor style is experimental, and he often mixes mediums, as is evident in this painting. He now lives in New York.

"The White House, Chelsea," at left, is by Thomas Girtin (English painter, 1775-1802). The principal works of Girtin are all watercolors. He bridged the gap between the eighteenth-century stained drawings and nineteenth-century watercolor paintings. His greatest innovation was the abandonment of traditional monochrome underpainting in favor of broad washes in strong colors. Original size: 514×298mm (20×11½ inches).

With this vase of flowers, right, I was principally interested in the white shapes. I hardly made any preparatory sketches for this painting. Original size: 312 × 229mm (12¼ × 9 inches).

The rainy landscape, below, by Ursula Bagnall illustrates controlled introduction of many colors, wet-in-wet. The white of the house is the white of the bare paper surface, as is the case with the white flowers in the picture at right. Original size: 210 × 153mm (8¼ × 6 inches).

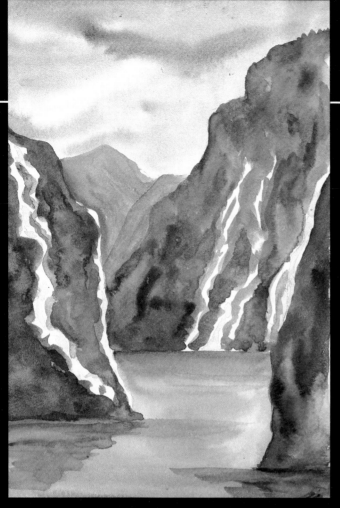

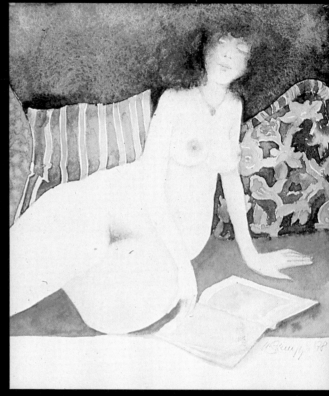

Even if you use a limited number of colors, the results don't have to be monotonous, as you can see from this ford by Kurt Preis, above left. The almost abstract scene has depth and tempts one to want to know what is round the corner. Original size: 204 × 306mm (8 × 12 inches).

In the composition by Ute Stumpp, above right, white areas surrounded by patterned cushions play a dominant role, forcing most other elements into the background. Original size: 190 × 197mm (7½ × 7¾ inches).

This painting by Ellis Kaut, right, shows the difference between whites produced by the bare paper and white gouache. The white of the water is that of paper, whereas that of the clouds was produced using gouache. Original size: 152 × 111mm (6 × 4¼ inches).

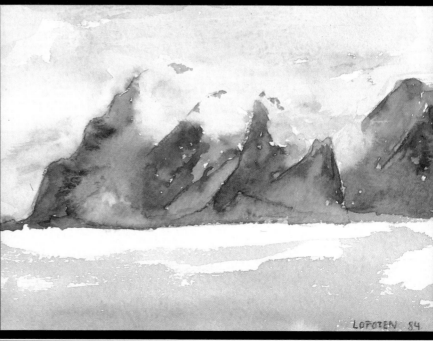

Gouache

The difference between gouache and watercolor lies in gouache's opaque quality. Gouache is often falsely referred to as tempera, which refers to pigments ground with egg emulsion. This is incorrect as gouache consists of a mixture of color pigments, a white filler, and the same binding agents as watercolors, but contains no egg.

Gouache is simpler to use and more flexible than tempera, since it's easy to alter or overpaint parts of a picture. This is possible because the inherent white pigments make gouache opaque. Added to this, gouache is more easily available than tempera.

A painting in gouache will not have the delicacy and refinement of a watercolor painting, but this is compensated for by the clarity and depth of the colors and by the advantage of being able to overpaint in lighter tones.

A watercolor artist is compelled to finish a picture as soon as possible, as it is rarely possible to paint over a dried picture. In gouache, the artist is much freer in many respects—including how he handles the painting surface. The paper can either be incorporated as an element of the picture or covered completely in paint. In contrast, the paper can influence the whole structure of a watercolor painting.

Many modern artists have worked in gouache, such as Pablo Picasso (Spanish artist, 1881-1973), Paul Klee, and Graham Sutherland (British painter, 1903-1980). Today, gouache is used mainly for commercial illustrations, lithographic designs, and graphic designs, as it will produce the flat, clean areas of clear colors necessary for modern reproduction techniques.

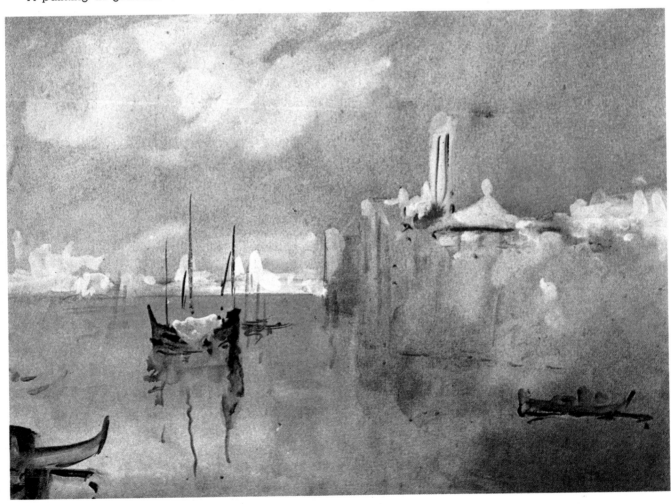

"The Newly-Laid Out Garden" by Paul Klee, left, shows that a painting must not necessarily have the character of a photograph. Gouache was used abstractly in this example to bring out the patterns and structures of a garden. Original size: 244 × 310mm (9½ × 12 inches).

The quick sketch from my sketchbook, below, was made in preparation for a series I wanted to paint on the moods of a forest. Such sketches help me determine colors and composition, as well as act as reminders of color atmospheres.

"Moonlight over Venice" by Hercules Brabazon (Belgian-French painter, 1821-1906), opposite page, uses both the transparent and the opaque properties of gouache. The lighter areas were painted over the darker areas of wash. Original size: 171 × 180mm (6¾ × 7 inches).

The landscape below, by Ute Stumpp, illustrates free use of dry brush and scratching in the gouache medium.

Materials
FOR PAINTING IN GOUACHE

The basic materials needed for gouache, are, in essence, the same as those needed for watercolor painting, with the exception of the paper, and, of course, the paints. These come in tubes, pans, or in small bottles. The bottles contain either powder or a creamy gouache compound.

There is some confusion over the terms poster colors, gouache, and tempera. Poster colors and tempera are slightly cheaper than tubes of gouache, but they have a coarser quality and the colors are less durable. Poster colors (often called poster paints) are inexpensive paints usually used for murals, posters, and commercial art. They are opaque and water resistant once they have dried. It's possible to buy them in large quantities, but this is only advisable if you really intend to use that amount, since they tend to dry up easily and are then useless. Tempera, also called powdered or school tempera, originally referred to paints that used egg binders, but very often the tempera you buy today is, in fact, an inexpensive gouache, since it doesn't contain any egg binders.

I would advise using designer gouache in tubes, as this allows for the greatest differentiation. Recommendable brands: Caran D'Ache, Faber, Pelikan, Talens, Winsor & Newton, Schmincke.

It is quite possible to combine gouache and watercolor in the same picture. You can use the same brushes—sable hair, or even the bristle brushes favored for oil painting. If you want to experiment, try applying gouache with a palette knife. But be careful, if the layers are too thick, the paint will flake off.

It's best to mix the colors in a plastic or tin palette with indentations, but you can also use plates, palette blocks, or pieces of cardboard. This paint has a tendency to dry out very quickly, so you should avoid squeezing too much paint on your palette and always be sure that you put the cap back on the tubes after use. Both watercolor paper and drawing paper supply suitable working surfaces. This paper can be tinted, rough, or smooth, but it should not be too soft as this would cause the paints to soak in. If you find that your paints soak into the paper you're using, start by underpainting or by applying a thin medium to the paper to seal the pores (this is called sizing).

Cutting knife, sponge, charcoal, and adhesive tape are needed if you want to experiment, as shown on the following pages. Gouache can be thinned using a gloss medium, which will, as the name suggests, lend a gloss to your work.

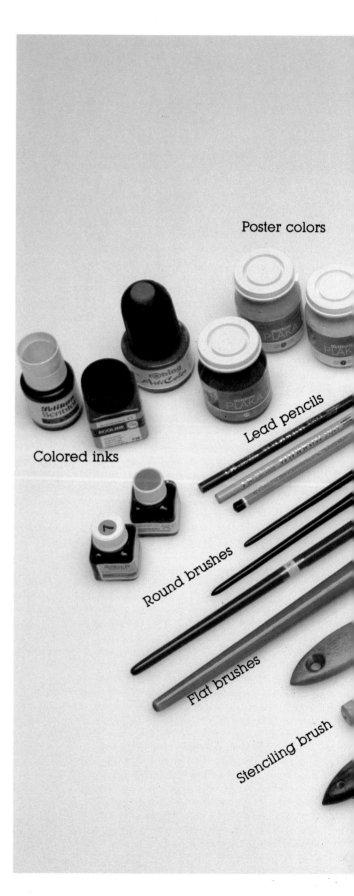

Poster colors

Colored inks

Lead pencils

Round brushes

Flat brushes

Stenciling brush

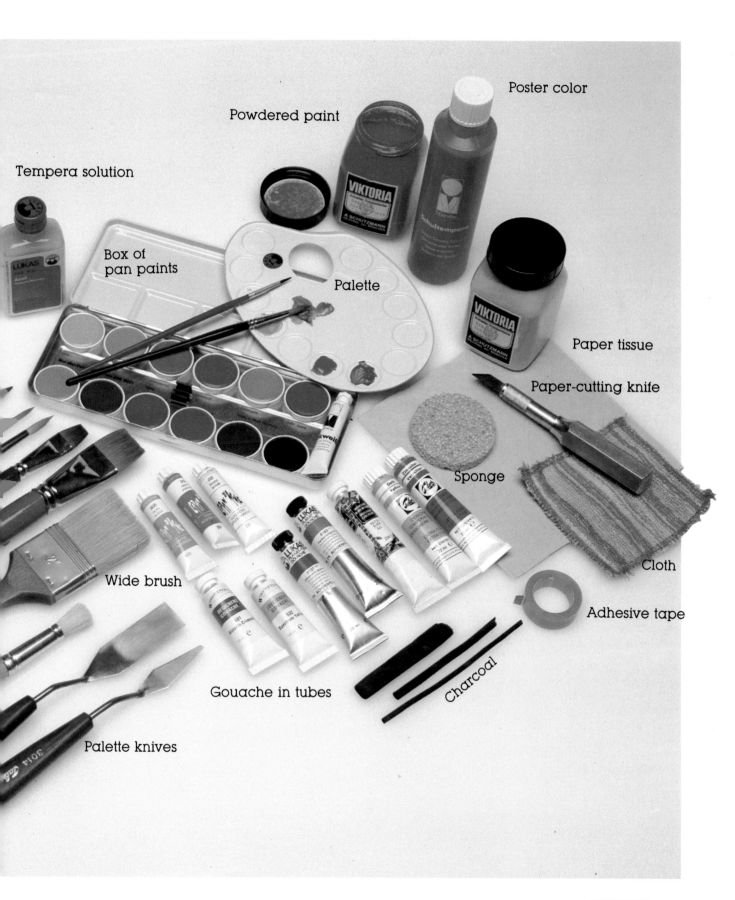

Tempera solution

Powdered paint

Poster color

Box of
pan paints

Palette

Paper tissue

Paper-cutting knife

Sponge

Cloth

Wide brush

Adhesive tape

Gouache in tubes

Charcoal

Palette knives

The Colors

Many companies offer beginner sets for all techniques. These may look attractive, but they very often contain colors that you will rarely use. I would advise you to limit yourself to the colors you'll need to build up a basic palette and with which you can mix most of the colors that you will need. You can always augment your collection at a later date. Here I have given a selection of colors suitable for the beginner. Added to these, you will, of course, also need a black and a white.

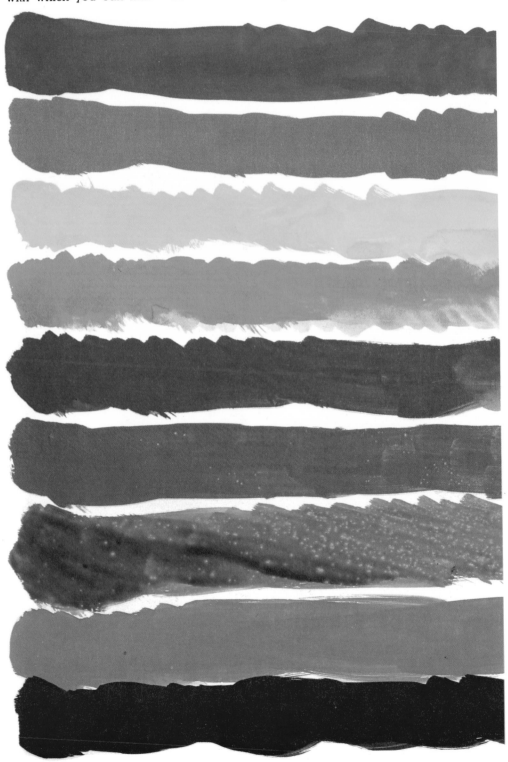

Alizarin crimson

Cadmium red pale

Cadmium yellow pale

Yellow ochre

Burnt sienna

Raw umber

Viridian green
glowing

Cerulean blue

Prussian blue

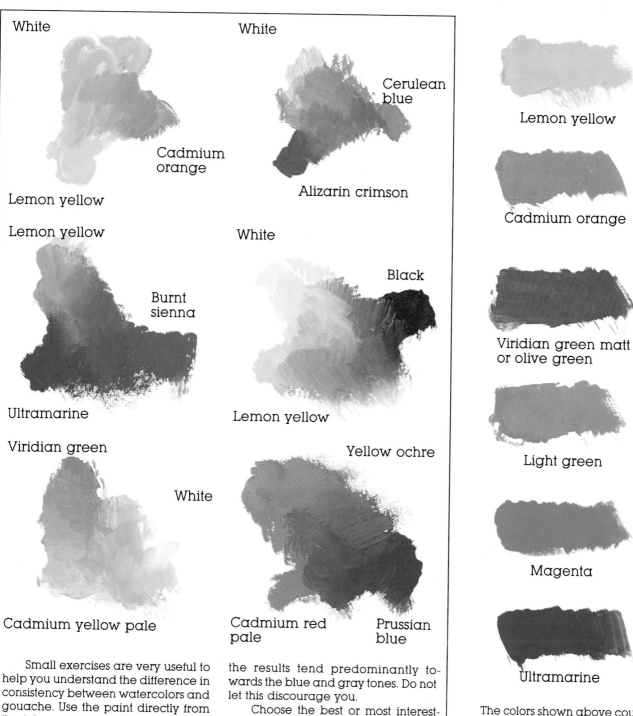

White

Cadmium
orange

Lemon yellow

White

Cerulean
blue

Alizarin crimson

Lemon yellow

Burnt
sienna

Ultramarine

White

Black

Lemon yellow

Viridian green

White

Cadmium yellow pale

Yellow ochre

Cadmium red
pale

Prussian
blue

Lemon yellow

Cadmium orange

Viridian green matt
or olive green

Light green

Magenta

Ultramarine

Small exercises are very useful to help you understand the difference in consistency between watercolors and gouache. Use the paint directly from the tubes and mix all possible variations. If you are using pans, these will produce a creamy paste when mixed with water. Mix the colors fairly thickly. Even if some of the colors you produce are muddy and uninteresting, this exercise will still help you to discover the possibilities and limits in mixing colors. You might sometimes have the feeling that, no matter which colors you mix,

the results tend predominantly towards the blue and gray tones. Do not let this discourage you.

Choose the best or most interesting color mixes and paste them onto a piece of paper with notes on the color composition. These reminders will be a cheering aid when you are later at a loss as to how you can produce the particular color you have in mind.

The colors shown above could be used to supplement your basic palette, should you want to increase your range of possible color combinations. There are, of course, a multitude of other color nuances available. Once you have gained some experience in this technique, you'll be able to choose other colors according to your own taste.

Papers

Watercolor paper, drawing paper, and tinted papers all provide suitable surfaces for gouache. Since you can overpaint in this medium, the paper doesn't play as prominent a role as it does in watercolor painting. But you should choose a paper that won't warp when wet. Thin paper needs to be stretched as for watercolors.

Painting

If you're used to painting with watercolors, you may have some initial problems getting used to these thick, opaque paints. But every technique has its attractions, and the attraction of gouache lies in the ability to overpaint, using, if desired, highly thinned paints. Gouache is water soluble, which means that this medium can be combined with watercolors and inks. Try this out for yourself!

The three illustrations given above show how light tones can be painted over darker tones. The effect in the example on the right was achieved using adhesive tape. Most of the painting was covered with tape, leaving just a thin strip free. I then painted over the tape and the bare strip. When the paint had dried I removed the tape (this is shown in more detail on page 234). The short dashes of paint in the center example show how highly thinned paint will let the structure of your paper come through. I used highly structured paper in this example.

The sample below left shows dry brush strokes over highly thinned paints. Below right, I let the paints run, as for watercolors, and drew into them using a pen while they were still wet. (Gouache is always a few tones lighter when it has dried.)

A few more motivating experiments: Dry paint on highly structured paper, top left, allows the paper's texture to show. A thicker application of paint would hide the structures.

In the experiment at top center, I scattered powdered paint over a wet surface of paint. The powder adhered to the paint.

The example below left shows the reaction of paints when they are painted, wet-in-wet, over one another. Wet paints run into each other. If the paint is dry, the top tone will cover the bottom tone.

At top right, I applied paint thickly, using a palette knife, and then scratched into this paint surface.

Below right, I applied a relatively watered-down layer of paint and then dripped tempera solution into it while it was still wet. Before my experiment had dried completely, I drew colored ink lines into the moist surface.

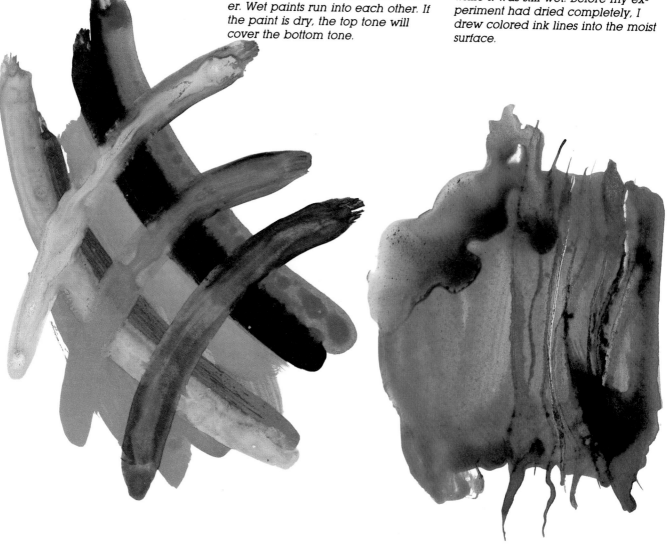

Small sketches and compositions will help you become familiar with a technique. Above, I dabbed a paper tissue into the sky while it was still wet. With another tissue, I made the green and yellow prints.

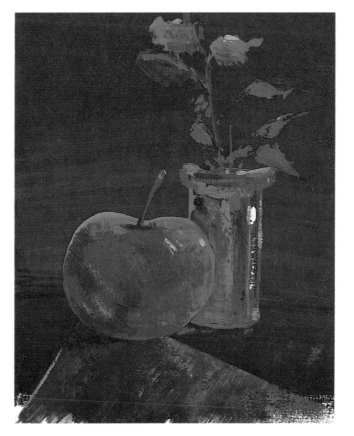

Except for the trees and the rainbow, all elements in the top right picture are imprints from another paper. In the sketch below it, I used a palette knife, applying a thin layer for the sky and a thick layer of green. The tree and the yellow hill-line were painted onto this using a brush.

The sketch on the left illustrates how light colors can be painted onto a dark surface. I first painted the background, using gray and violet, and then painted the objects onto this surface once it had dried. The lighter tones, which were added at a later stage, took on a particular intensity.

The painting of backgrounds can play an important role in both gouache and oils. In the sketch below, I first applied a layer of dark red-violet for the sky and foreground. When it had dried, I went over the surface with lighter colors. Note how the red comes through the darker tones of the foreground. By working on your backgrounds in this way you can lend added depth and vivacity to your colors and paintings.

Knowing how to use your brush is of great importance. Try some small experiments, as I've done below. These will not only build up your confidence in the use of a brush, but also show you how you can alter the consistency of paint by varying the quantity of water added. Some very interesting effects can be achieved by painting over a wet surface with a dry brush.

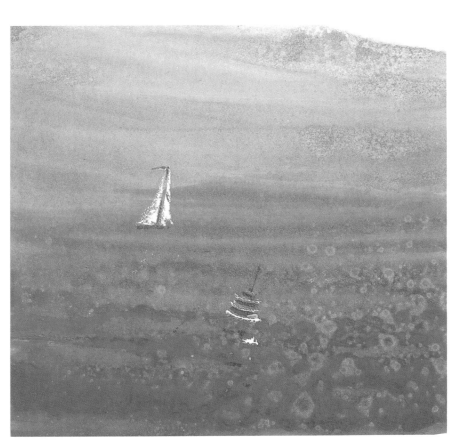

The water structure, left, looks very effective, and is quite simple to produce. I first made a graded wash. By altering the amount of water I used, I could introduce the elements of sky and water. Then I sprayed fixative onto the foreground before it had dried. The sky was dabbed with a tissue while still moist (see the top right corner). The boat and buoy were added as final touches. (You can paint over fixative. Thick paint will adhere to the fixative, but if the paint is thin the lines will become ragged, as you can see with the white of the buoy.)

Gouache lends itself well to small colored sketches in which you work out your ideas for a later picture in this or another technique. The paints are easy to work with and dry quickly.

Try to make several of these sketches before starting on a larger picture in gouache. Never cramp up when you are sketching. Feel relaxed and let your hand move freely.

These sketches will help build up your knowledge of composition and give you more experience with mixing and combining colors.

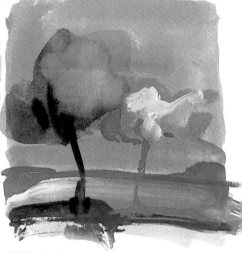

If you want to produce clear, well-defined forms such as those above the trees in the large picture on the opposite page, you can use the masking method. Using adhesive tape or acetate, cover the area surrounding your form (specific shapes can be cut out of the acetate), and then paint over the whole surface. When the paint is absolutely dry, carefully remove the tape or acetate (see below). If the paint is not dry, there is a danger of smudging the lines. Also make sure that the paper you use is not too soft, or it will come away with the adhesive tape, leaving ugly tear marks.

Dripping in is a technique involving dripping ink into a paint surface that has not dried.

With the large painting on the opposite page, I started with the background, using highly thinned paints. In some sections I dabbed the paint with a tissue. The red splattering was produced using a toothbrush, in the same way as I described on page 77. I covered the sky with a piece of paper while I was splattering, to avoid splattering the whole picture.

Structures, such as in the sky, can be produced by imprints from another piece of paper. The random nature of these structures often gives me inspiration for other motifs.

If you're working with tube paints, you should avoid squeezing too much paint onto your palette, because it will dry very quickly and is then difficult to use. You can always add more paint if necessary. Save any dried-up paint, though, as this will dissolve in water and can be used in a diluted form.

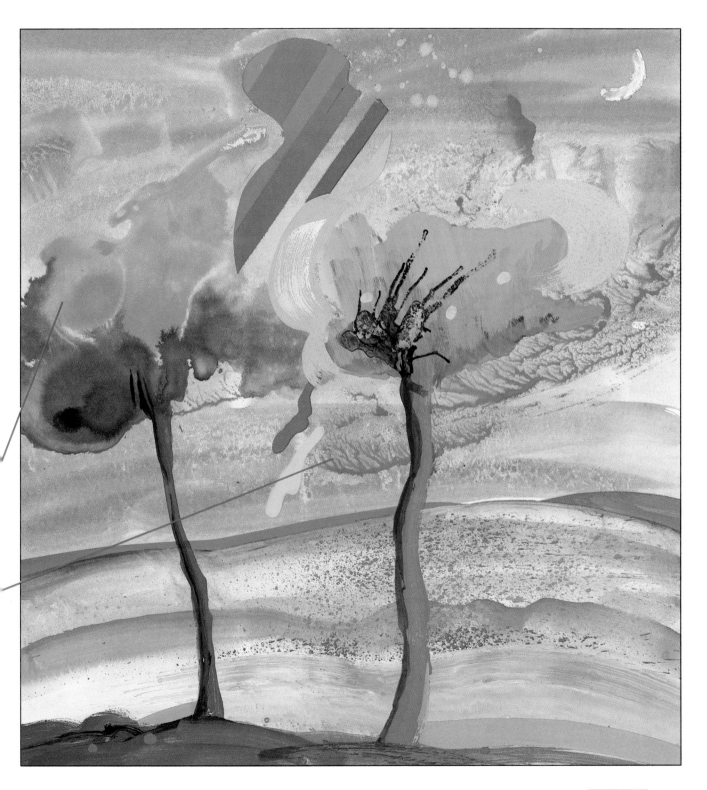

I used these colors for this picture: white, cadmium yellow pale, cadmium red pale, raw umber, magenta, cadmium orange, cerulean blue, and assorted colored inks.

Step by Step

For this painting, I chose thick, white drawing paper. The brushes I used were round sable-hair (nos. 6 and 12) and flat (nos. 6 and 12). My palette consisted of these colors: cadmium red, rose, cerulean blue, ultramarine, lemon yellow, cadmium yellow, viri-dian green, black, and white.

When you start a portrait in any technique, it's advisable to first make some pencil sketches. These will loos-en you up and give you a better feel-ing for the shapes and characteristics in the face. These sketches also will

help you decide on the composition and find the most interesting aspect of the face. After this, you should make some small color sketches to come to terms with the colors and their values. Should you still feel slightly unsure, make a couple more sketches before starting your actual picture.

Step one: In this portrait, I was aiming at capturing the inherent mixture of warm and cold colors. I began by laying a free wash of highly thinned ultramarine, using a flat brush (no. 12) over the whole surface. Then,

using somewhat thicker paint, I marked in the basic shadows. While this was still moist, I painted in the basic forms of the face, hat, and shoulders, using a round sable-hair brush (no. 6).

Step two: I emphasized the form and color of the blouse and started working on the silk flowers around the brim of the hat. I greatly simplified these, to keep them from becoming too dominant. Some of the colors in these were to be repeated in the face at a later stage. I liked the random

structures of the brush strokes and decided not to alter them. My next task was to roughly set the color of the face using a mixture of white, cadmium yellow, cadmium red, and ultramarine. I let the darker basic contours of the eyes and mouth come through slightly because I would need these later on in my painting.

You can try painting with ready-made skin or flesh tones, but you will probably discover that these do not allow you as much flexibility as mixed tones.

Step three: Now I had reached the point when I needed to bring expression into the face. Using a flat brush, I painted the darker parts of the hat and a shadow between the hat brim and the forehead. Then I shaded the nose, mouth, and chin with a mixture of red and blue. The basic contours from step one were still visible. Next I

painted the eyes using a round brush and completed the eyebrows and mouth. The picture, I felt, still lacked depth—there was not enough differentiation between background and foreground—so I went over the background with lemon yellow and white. This brought the hat, head, and shoulders further to the fore.

Step four: As I mentioned in the chapter on watercolors, there is a great danger of adding too much to a picture. For this reason, you should stop occasionally and review your

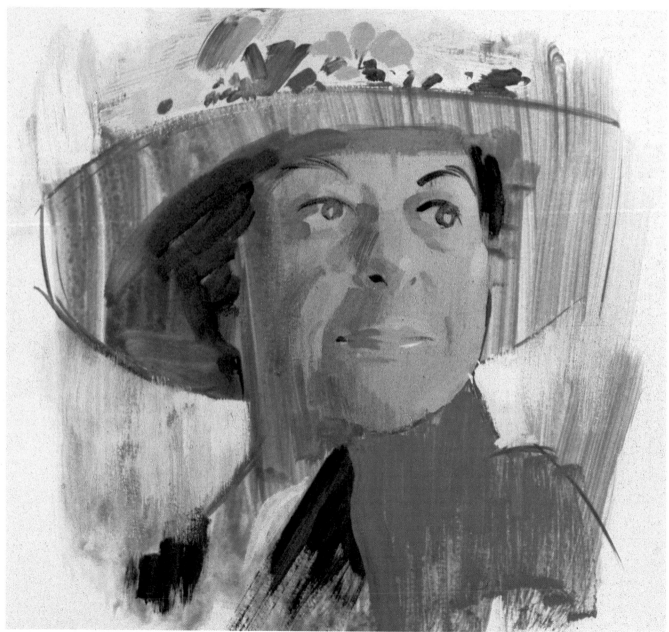

picture critically: compare the picture elements and decide which need reinforcing and which need less emphasis.

Here, you can see that I reinforced the hat shadow and that of the left side of the face with blue. The facial expression is supremely important, and it is, to a great extent, dependent on the eyes. If you observe eyes closely, you'll notice that nobody has two identical eyes; one is always slightly different from the other. This presents one of the greatest challenges in cap-

turing a facial expression. Remember, eyes always have light reflexes in them, and it is these that bring the eyes to life. Observe which parts of the eyes are prominent and which parts lay deeper back. It might help you to turn back to page 105, to review what was said about the shape and expression of eyes.

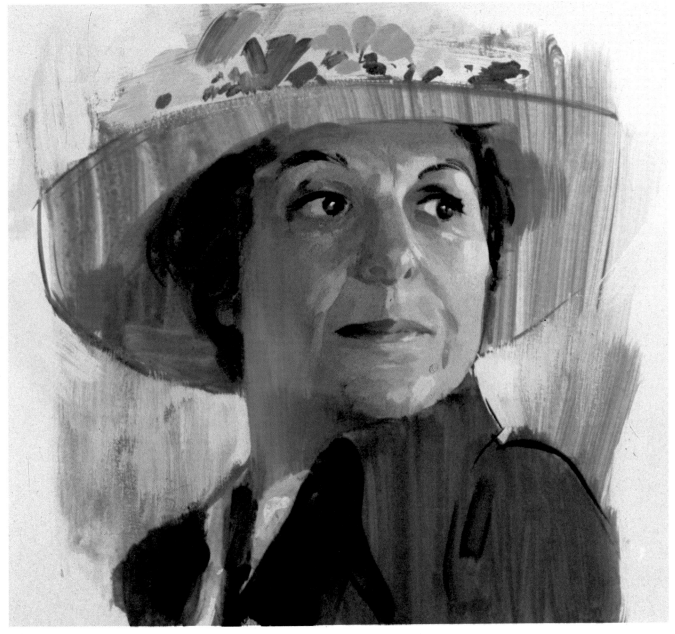

MOTIVATING IDEAS

All the motifs on these two pages could be rendered in transparent or opaque paints, making them very suitable for gouache, oil, or acrylic paintings. These techniques have the added attraction of intense colors that can be applied in thick surface structures.

The stone structure on the right is almost a picture in itself. This is the perfect subject matter for experimenting with scratching, overpainting, and making impressions. The duck, on the other hand, provides an excellent model for practicing fine painting using a dry brush. The contrast between the duck and the glistening water could be brought out by painting the water with highly diluted paints. Keep your eyes open for unusual subject matter, such as a child's toy. This doll in a boot, for example, is an interesting and unusual motif. Give it a crazy background, if you feel so inclined—it's your picture.

Maybe you think that this rusty old car would look better in the middle of a vegetable patch. Then paint it in one! How would you render the contrast between the sky, the grass, and the rusty metal?

The large, structured area setting off the delicate, but sharp lines of the red bench offers an interesting motif that could be rendered using a brush; equal-

ly, it could be a motif for palette knife or impressions.

The decorative reflection of leaves in water is a good opportunity to try painting using the thick and thin method rendered possible by gouache. You could turn it into a pattern or into a romantic, mystic, abstract composition.

Gallery

The colors in this rendering of a bird by Ellis Kaüt, top left, were made to appear especially bright by her use of a black background. Original size: 241 × 176mm (9½ × 6¾ inches).

The picture of an apple, top right, shows a thick and thin application of warm colors. The speckled effect came as a result of using rough watercolor paper. Original size: 190 × 174mm (7½ × 6¾ inches).

"Plants and Tree Forms in Front of Hills I" by Graham Sutherland, left, shows why this British painter is famous for his expression of moods in landscapes. In this picture, he used a combination of primary and secondary colors to produce a particularly expressive atmosphere. Original size, section: 330 × 430mm (12¾ × 16¾ inches).

Samuel Palmer (English artist, 1805-1881) gave "In a Shoreham Garden," opposite page, a nostalgic atmosphere. Note how the red of the dress—a focal point of the picture—is repeated in the trees, background, and foreground. Original size: 222 × 295mm (8¾ × 11½ inches).

Acrylics

Acrylic painting is a very young technique in the history of painting, having been first developed in the twenties by a group of Mexican artists. These artists found themselves faced with the task of painting large murals onto outside walls that were exposed to the elements. After trying oil and fresco techniques, both of which proved unsuitable for withstanding extremes of temperature and rain, they happened on the use of plastic resins as an additive to color pigments. Plastic resin had, to date, only been used in industry for weather-resistant coverings. After much laboratory experimenting, a paint was developed that was quick-drying and water soluble. It could be applied to give transparent or opaque finishes and would not oxidize or decompose chemically.

Later that decade scientists in New York resumed experiments on this medium, seeking to produce a paint that was suitable for more than murals. It was not until the mid-fifties, however, that a mixture of color pigments in a watery dispersion of polyacrylic resins called acrylic paints was introduced onto the market in the U.S. American artists immediately set to work to explore the various properties of this new medium: Jackson Pollock (American painter, 1912-1956) used glazing and impasto (thick application of paint); Kenneth Noland (American painter, 1924-) tended more towards clearly defined shapes.

Acrylics did not reach the European market until the mid-sixties, but were very soon taken up by many artists, such as David Hockney (English painter and graphic artist, 1937-) and Peter Blake (English painter, 1932-).

It's possible to apply acrylics to almost any surface, including metals such as copper and zinc, providing these have been pre-roughened. These paints can be thinned to any consistency using water. They also dry very quickly, making it possible to overpaint. Acrylics are also light resistant and retain the same color intensity when dry or wet.

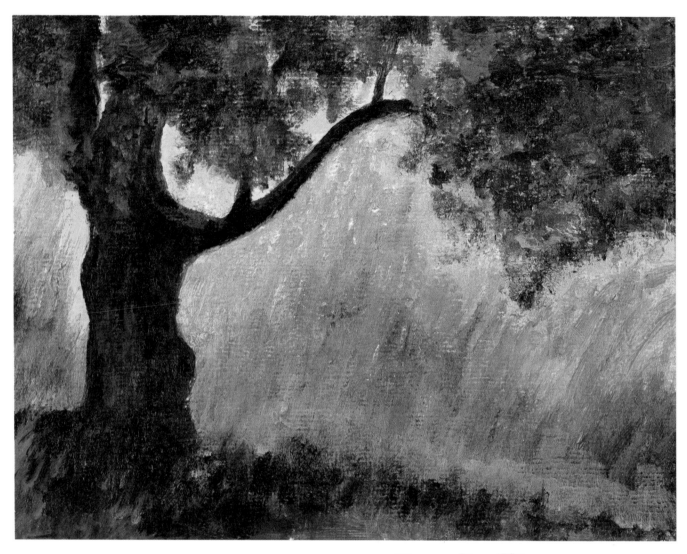

The portrait on the far left, by Tom Rummonds, shows the intensity in colors and structures of acrylic painting. The artist has dispensed with conventional skin tones in this spontaneous portrait, but the rendering is still unmistakable.

The lion's head at near left is the product of repeated layers of thin paint. Some of the structures were achieved by painting into moist surfaces with a dry brush.

The tree and grass in the above picture by Ellis Kaüt illustrate the impasto effect clearly. From the structures, this painting looks very similar to an oil painting. In oils these thickly layered paints would have taken weeks to dry, but this process was speeded up considerably by using acrylics, requiring about ten minutes.

"Cross Country Skier" by Tom Rummonds, right, captures the action in quick strokes. By staggering the overpainted lines, the artist created the impression of fervid movement.

Materials
FOR ACRYLIC PAINTING

There is little difference between oil painting and acrylic painting with regard to equipment, except maybe that acrylic painting requires large quantities of water, for use both in thinning paints and to keep this quick-drying paint from clogging your brushes. So it's helpful to have fairly large water pots or jars. You can use either bristle or synthetic brushes (sable hair tends to soak up too much paint and become awkward to handle). For your first attempts at acrylic painting, it's quite sufficient to limit yourself to two or three round brushes and one small and one large flat brush.

The following companies offer recommendable paints: Talens, Lukas Cryl, Binney & Smith, Liquitex, Winsor & Newton. I'll discuss the colors suitable for an introduction to acrylics on the following pages. You'll find that you use more white than any other color, so buy it in larger tubes. Acrylics are available either in sets or as separate tubes. Water is quite sufficient as a thinning agent, but you can, if you want, also use a thinning solution that will also slow down the drying process. Should you want to work with a combination of inks and acrylics, you can mix some acrylic binder into the inks, to keep them from separating from the acrylics.

Paper or plastic mixing palettes (without indentations) are better than wooden palettes, as acrylic paint tends to soak into wood, making it difficult to clean. Make sure your palette is big enough to allow plenty of space for mixing colors. If you don't like holding palettes in your hand, try using a glass surface. The paints can be easily cleaned off these once they have dried.

You will also need several rags for cleaning your brushes. It's very important to clean your brushes while you're working, and to keep them in water when they're not in use. Slightly hardened paint can be cleaned out of the brush using a special brush cleaner. Palette knives or painting knives are useful for both mixing and applying paints.

Apart from this special equipment, there are a few other basic necessities: pencils for sketching, a sponge for sponging up paint and for adding structures, and a ruler or adhesive tape for painting sharp edges. If you're using paper that needs stretching, a paper-cutting knife is handy for cutting the paper away from the tape. You can also varnish your finished painting if you like.

Colored inks

Acrylic pai[nt]

Adhesive tape

Palette knives
(painting knives)

Tubes of acrylic paint

Cloth

Paper towel

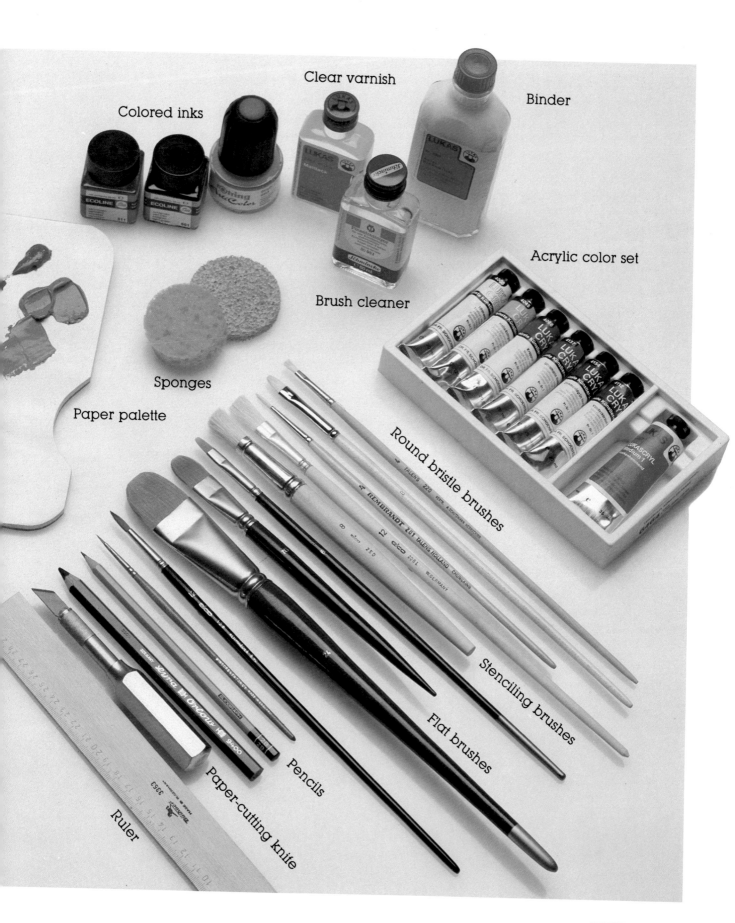

Colored inks

Clear varnish

Binder

Acrylic color set

Brush cleaner

Sponges

Paper palette

Round bristle brushes

Stenciling brushes

Flat brushes

Pencils

Paper-cutting knife

Ruler

ost acrylic painting techniques are similar to those used for oils. Should you have already painted in oils before trying acrylics, it's advisable to first experiment with this new medium before starting a picture. Acrylic paints are slightly thinner than oil paints and will dry considerably quicker than oils.

I'm certain that you'll have a lot of fun using acrylics, especially since they are so quick drying. If you don't like something in your picture, you can paint over it immediately, saving you the misery of having to stare at your "mistakes" for hours or days before you can correct them.

Acrylic paints can be applied thickly or very thinly. It's possible to scratch into or intermingle colors, creating interesting effects fairly quickly.

Colors

Once again, I suggest limiting your choice of colors to start with, until you are more aware of the various potentials of this technique. In comparison to oil paints, acrylics are brighter in color and even look slightly artificial. If you compare the red, yellow, and orange tones, you'll notice that these dazzling tones in acrylics look somewhat darker in oils. Shown below are twelve colors that mix well together.

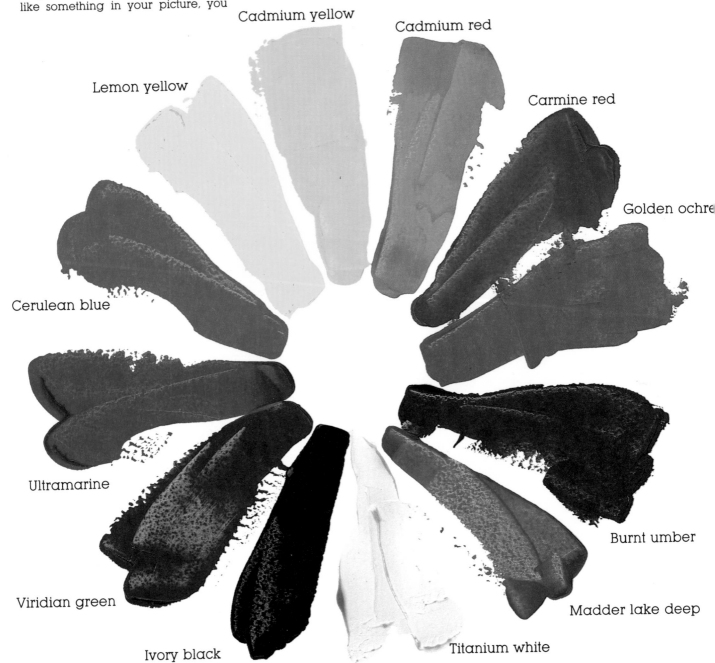

Cadmium yellow

Cadmium red

Lemon yellow

Carmine red

Golden ochre

Cerulean blue

Ultramarine

Burnt umber

Viridian green

Madder lake deep

Ivory black

Titanium white

Painting Surface

One of the great advantages of acrylics is that you're subject to virtually no restrictions regarding painting surfaces. Canvas, cardboard, thick paper (thin paper warps easily), or walls—all provide suitable surfaces. The one main restriction is that the surface should have no oil content, because these water-based paints will be repelled by oil. But it's quite easy to get acrylic-primed canvas, as opposed to the traditional oil-primed varieties, so this shouldn't present any great problems. Still, you should always check oil content when choosing a surface.

Brushes

You can use the same brushes as you would use for an oil painting—round and flat bristle brushes. It is a waste to use expensive sable brushes for this technique as they will wear out very quickly; cheaper varieties, such as squirrel, ox, or nylon are perfectly sufficient. Thorough cleaning of brushes during and after use is an absolute essential, since it's impossible to remove this paint once it has dried.

Thinning

You don't need any thinners besides water. With water, you'll be able to produce either a creamy paste or a watery paint, similar to watercolor in consistency. You can, however, add a medium to your paint to produce a special matte or gloss finish.

Another additive available today is texture paste. This contains powdered marble and produces rich impasto effects. Apply this in thin layers to avoid cracking.

Mixing

Paper mixing palettes are the most practical, but failing this, you can use a plastic palette or even a plate. The structure of the paint application will vary according to the amount of thinner you use. Once again, I would recommend trying out several color mixes and keeping the best results along with notes as to how you made each.

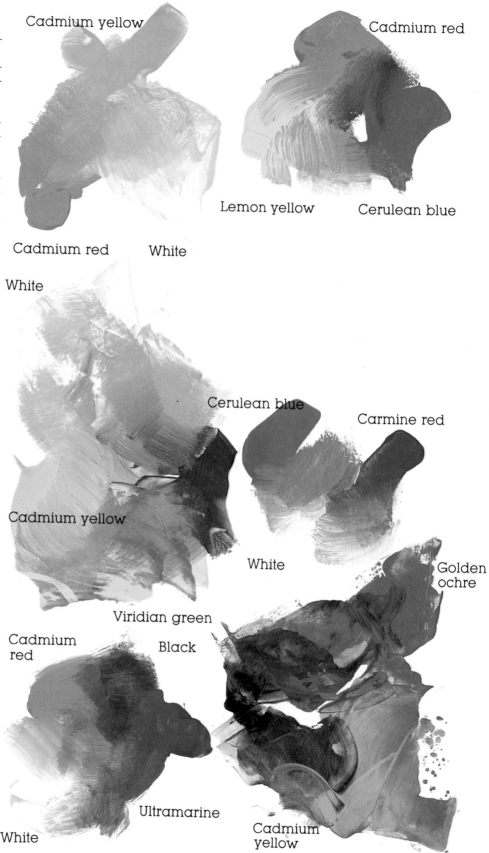

Cadmium yellow

Cadmium red

Lemon yellow Cerulean blue

Cadmium red White

White

Cerulean blue Carmine red

Cadmium yellow

White Golden ochre

Viridian green

Cadmium red Black

Ultramarine Cadmium yellow

White

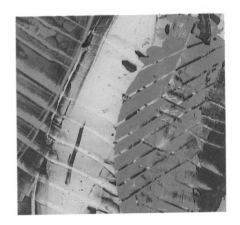

P aints straight out of the tube will look relatively coarse. If you only lightly mix the paints, they will produce a variegated color structure, as you can see in the marble-like red and white stripes in the example at top left.

Sharp edges can be produced using adhesive tape or acetate as a mask. In the middle example above, I painted the separate elements consecutively, letting one color dry before painting the next shape over it. Always be sure the paint is absolutely dry before sticking any adhesive tape or acetate over it.

The sample at left illustrates the intensity of colors when painted over black. The circular shape was produced by simply pressing the cap of a tube first into yellow paint and then onto my painting surface.

The example at right shows short, densely intermingled brush strokes using various colors. You can clearly see how structures were formed by the bristles of my brush.

I applied thick paint onto a rose base coat, top right, and then scratched into this thick paint.

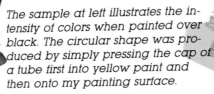

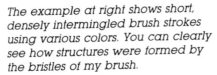

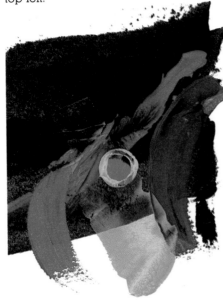

Thick applications of paint using a palette knife produced the structure at right. This impasto work would have taken weeks to dry in oils, but I used acrylics, which dried within a couple of hours. Due to this quick-drying property of acrylics, you should avoid having too much paint on your palette. Once acrylic paint has dried it cannot, as with gouache, be thinned down and reused. Always be sure that the caps of your tubes are screwed on tightly, otherwise you'll find it difficult to squeeze the paint out once the top layer of paint in a tube has dried.

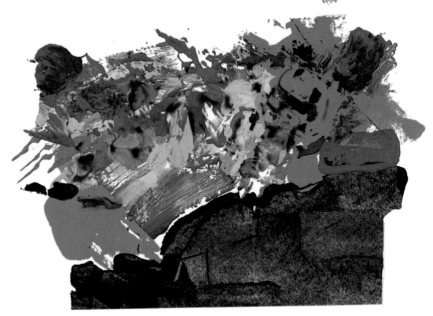

In the sample at top left, the white was imprinted from another piece of paper onto the painted surface. At the center, I used thinned paint on highly structured paper. Highly thinned paint, such as I used at top right, allows intermixing of colors on the painting surface.

In the sketch of a tree, above, I first made a red-orange wash and then added the green of the landscape, using a painting knife in such a way that the red surface still shone through the green in places. The tree itself was painted using colors straight from the tube.

The flowers, left, were made with a combination of dry and moist brush strokes. The circular shapes were, once again, produced with the aid of the cap of a tube; the petals with cutouts made from potatoes. Try experimenting for yourself with the objects around you. You'll find that you can produce some interesting structures to augment your painting structures using imprints from all sorts of different materials.

The picture on the opposite page, "Figure in a Room," illustrates the opaque and transparent effects of acrylics. The basic idea behind this picture is the combination of three separate pictures into a single composition. I chose this rather complicated approach in order to make it easier for me to capture the connection between the girl and the atmosphere of the room. You might often find it difficult to render a whole room and a figure in the room without diverting attention either from the figure or from the surrounding atmosphere, especially when, as in my example, the room is full of different shapes, colors, and objects.

Sharp edges can be painted using acrylics quicker and easier than in other techniques. Always check that your surface is hard and smooth enough to allow problem-free removal of adhesive tape or acetate, which would tear away parts of your picture if the paper were too soft. If the paper is highly structured, there is a danger of the paint creeping under your mask. If you are aiming at a round, defined shape, first stick a square piece of acetate over the relevant section of your picture and then carefully cut out the round shape. Paint over the unmasked surfaces. In the example shown above, I worked consecutively first with violet and then with green. The acetate can be removed once the paint has dried completely.

By flecking the paint used for the blanket and socks with small dots (a process called stippling), I was able to create a woolly texture, which contrasted with the washed color of the jeans.

Wet and dry brush strokes and an intermixing of colors directly on the painting surface are typical characteristics of acrylic painting. Try to see how many different effects you can produce with just these simple means. You can leave the brush strokes, or you can produce a smooth surface, as in oil painting. Mottled colors mixed directly on your painting surface often create a lively, glowing effect.

The washed background and foreground colors resulted from my painting highly thinned white paint over black surfaces, as illustrated below. This thinned paint will sometimes run. I left this effect, incorporating it into my composition. (Always try to incorporate any "accidents" into your picture.)

I tried to keep the background as simple as possible, so I started by painting the radiator, bed, and hat in the foreground fairly abstractly. I also simplified the folds in the bed cover, using the same blue as in the girl's jeans.

In the main picture (indicated above as section 2), I wanted a contrast to the abstract background. For this reason, I painted the girl's head and hat almost naturalistically. You will notice a certain similarity in the dark lines of the girl's nose and eyes and those of Snoopy's head and ears. My main aim here was to establish a correlationship between the cartoon character and the girl. The yellow of the background served to produce a warm-cold contrast.

Acrylics allow you to apply thick or thin, wet or dry layers of paint. More life was given to the dog's head by working with wet and dry brushes.

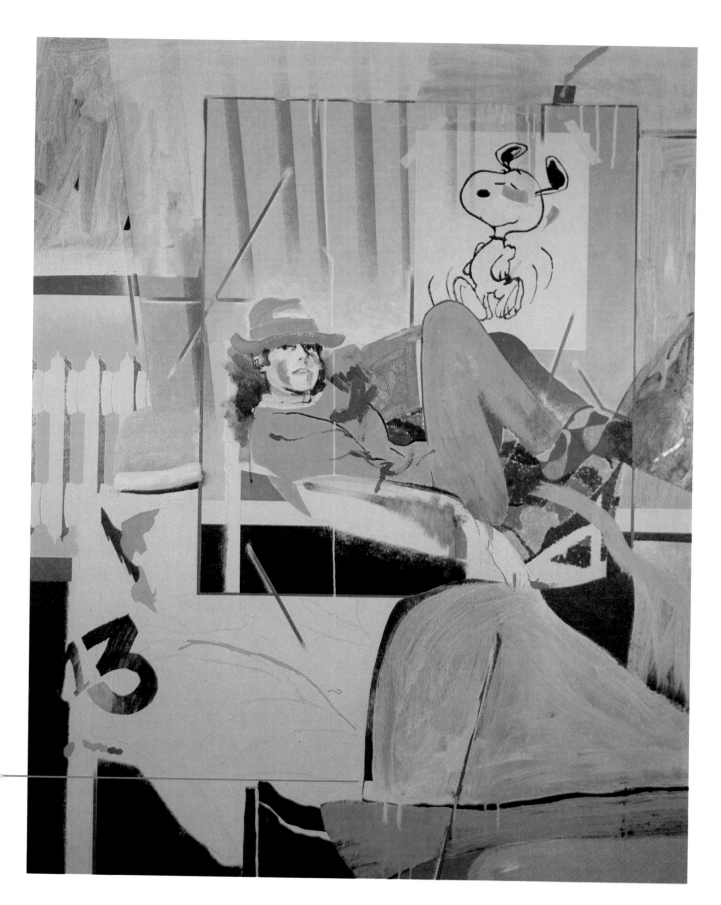

Step by Step

The paper I used for this painting was thick drawing paper. For brushes I chose a flat natural hair (no. 14), a round natural hair (no. 3), and a flat bristle brush (no. 8). I used lemon yellow, indian yellow, cadmium red, carmine red, gold ochre, cerulean blue, viridian green, ivory black, and titanium white. I also used an acrylic medium, adhesive film, and a painting knife.

Irish landscapes have always fascinated me. Their colors and structures are well suited to rendering in acrylics. In this motif, my interest had been captured by the contrast of the grass and fields to the rigid, graphic road signs.

Step one: I decided to alter the composition slightly to create even more tension between the landscape and the road signs. I made two quick sketches, of which I chose the simple composition you can see below. I roughly painted the two signs, using a thick brush, to help me to decide whether I should bring the houses further to the fore and which aspects of the landscape I wanted to emphasize. As you can see, I decided to bring my picture elements closer together than on the original.

Step two: Using the same thick brush, I then roughly painted the landscape, setting the proportions, after which I was able to add the houses and the background hills.

After I had established the basic shapes, I could lighten the sky slightly using white paint and set the correct tone value for the road signs. I decided to leave the brown brush structures behind the grass and the signs, as I felt that these would supply a good contrast to the rambling grass and angular road signs.

I added the same carmine red I had used for the roofs to the foreground to bring more unity into my picture.

tep three: Having already laid out the basic shapes I wanted to include in this composition in my initial sketch, all I now had to do was work on the various details. I felt the picture needed more depth, that the houses and background hills should appear more distant. I lightened them in color, reducing the intensity of the sky, houses, and hills. Then I painted the green of the trees and fields behind the houses.

In the meantime, the grass structures in the foreground had dried, and I was able to go over them with a palette knife and paint to strengthen the structures. Note how the yellow of the road signs turns up repeatedly throughout the whole picture and how this yellow, the blue of the sky, and, to a lesser extent, the red of the roofs are all reflected in the grass. Experiment with several different grass structures until you find a structure that fits your picture. Grass can be rendered in a variety of ways—wet and dry brush strokes, precise, detailed painting, or using imprints. Should you decide to use this last method, you will find that you'll get better results if you work over the imprints slightly rather than leaving them in their natural state.

Step four: Up to this point, I had left the road signs without a post to make it easier to work on the grass structures. Once the grass had dried I was able to start completing the signs.

I started with the sharp edges of the angular signs. If you decide to use adhesive tape or acetate as masking, be sure that the surface is totally dry

before applying the adhesive mask. I stuck down two parallel rows of tape for each edge, the first along the yellow and the second a short distance away covering sky, fields, and grass. Then I painted in the strips between the masks using brown, blue, and black paints. Had I only used black, this would have made the edges look too hard.

It's a good idea, by the way, to test the surface quality of your paper on a spare piece before you use adhesive masks to make sure that you can re-move the adhesive tape or acetate without tearing up the surface of your picture.

After completing the edges, I moved on to the arrow on the sign and the post. I wanted to reinforce the painting effect, to take some of the graphic rigidity out of the angular signs, so I painted the arrow freehand using a brush. Finally I painted the post over my grass structure, adding light reflexes to enhance its round solidity.

I'd like to reiterate here that you should never forget that your rendering of a motif is an entirely personal matter; paint what you see in it, not what you think you *should* see in it. It is absolutely irrelevant whether your painting closely resembles the original or not.

MOTIVATING IDEAS

Bright acrylic colors lend themselves well to rendering this rather dejected puppet. Try, maybe, breaking this motif down into abstract areas and creating contrasts as I did for the picture on page 253. Or you could paint him in a naturalistic way with a slight fairy-tale touch.

Since acrylics are a suitable medium for almost every application technique, there are very few motifs that cannot be rendered using this material. Here I have given some suggestions that will allow you to experiment freely.

The field of grass, above left, supplies plenty of scope for playing with your materials, maybe using some of the techniques I used for my Irish landscape. The windmill could be rendered with clear, defined contours, using the masking technique, to provide contrast to the wavy grass. The motif on the bottom right could be turned into a totally abstract picture. A palette knife and imprints would produce interesting effects.

Perhaps you feel like trying a portrait. A mellow grounding (or base coat) used for the skin, hair, and blouse would accentuate the softness of this girl's face. Painting her eyes and hair using thicker paint would create interesting contrasts.

There are innumerable possibilities for rendering brightly colored toys, such as this tin clown. You don't have to give him the same background as in this photo. What background do you think would fit him?

This still life, left, could be turned into a picture brimming with atmosphere. The duck would lend itself well to working with dry brush strokes over a tinted base. It is also interesting to work with a limited number of colors once in a while. Why not try this out? Take special note of light and shade, as well as the curves and soft shapes of the objects.

Maybe these photos will help you realize that many seemingly insignificant objects lying around your home are, in fact, potential subject matter for your next paintings.

Gallery

Peter Blake, a famous English pop artist, often seeks inspiration for his pictures in celebrity photos, postcards, or pin-up pictures, as is clearly illustrated in this "Tarzan" rendering. The head and hand act as contrasts to the flat colors of the background. Original size: 600 × 500mm (23½ × 19½ inches).

The two pictures at the top of the opposite page, by Herbert Klee of Munich, illustrate fine use of paint and brushes. In the picture on the right, the chair seems very prominent in the foreground, whereas the girl seems to be pushed into the background despite the use of perspective. Original size: 1200 × 500mm (46¾ × 19½ inches).

A striking feature of the picture of the three men is the artist's use of warm and cold colors. He created a highly expressive atmosphere between the red of the figure in the background and the cold colors of his foreground figures. Original size: 1200 × 900mm (46¾ × 35 inches).

Terence Milligan's "Sofa," below, shows how effectively acrylics can be used to capture an everyday object. Warm tones lend an inviting air to this otherwise static sofa standing alone in a room. Original size: 508 × 812mm (19¾ × 31¾ inches).

Oils

Most people immediately connect the word "painting" with the most popular of the techniques I've discussed—oil painting. The Dutch brothers Hubert (c. 1370-1426) and Jan (1390-1441) van Eyck are generally regarded as the grandfathers of this art, and they did contribute much to the growth in popularity of this technique in the fifteenth century.

The first oil paintings were made on specially primed wooden panels, but these proved to be too rigid for convenience, and they caused the paint to crack when exposed to changes in temperature.

This led to the idea of painting onto a woven surface. Flax was woven and stretched onto frames, giving a canvas that would expand and contract according to the humidity of the air. More and more artists started using this canvas because it was more flexible and considerably easier to transport than the earlier wooden panels.

Next artists started experimenting with dyed and tinted surfaces. Many fifteenth-century Florentine artists painted on cool, green surfaces. These grounds are to be seen in the paintings of Sandro Botticelli (Italian painter, 1445-1510) and Michelangelo, to name just two examples.

Other artists of this period, such as Titian (Italian painter, 1487/90-1576) and Giorgione (Italian painter, 1477-1510), used dark red-brown surfaces, giving their paintings a deep, warm atmosphere.

Later the Impressionists started working on white surfaces, lending light and color to their paintings.

Up to the seventeenth century, artists, or more correctly, their assistants, produced their own painting materials. After that time, however, fewer artists could afford assistants and more and more people took up painting as a hobby. Thus the path was cleared for factory-made paints, which became very popular in only a short time.

Tube paints were first introduced in the nineteenth century. Prior to that, paints had been sold in pig's bladders. William Turner liked to hang these up and then pierce a hole in them, through which he could squeeze out the paint.

Oil paints are still very much alive today. Anyone who has ever explored this medium will feel animated and stimulated merely by the characteristic smell of the mixture of paint, linseed oil, turpentine, and canvas. When you feel like biting into the paint, then you're in the mood to paint.

Left: A still life by Ursula Bagnall. Above: Landscapes by Hartmut Blank.

Materials
FOR OIL PAINTING

There is a fairly extensive range of materials and aids for oil painting, which might seem a little confusing for a beginner. It's better to try to manage with as few materials as possible when you start oil painting, and to build up slowly once you have gained some understanding and practice and know which aspect you would like to concentrate on. The basic equipment you will need consists of a limited number of paints in different colors, a small selection of various shaped brushes—such as a few round and flat bristle brushes and one or two fine sable brushes—and a painting knife. You will also require some pure turpentine for thinning the paints (turpentine substitute is more for cleaning brushes than for thinning paints), linseed or poppy-seed oil, and an oil medium to speed up the drying process.

Paints are mixed on a palette. This can be made of wood, paper, or plastic; some artists use a simple piece of glass. Finally you will need rags and paper towels to keep your brushes clean while you're working. I'd also advise finding an old smock, shirt, or apron to wear while you're painting, as paint and turpentine stains are very difficult to remove from clothes.

I'll discuss which colors I'd advise you to buy on the following pages. You can, of course, invest in an oil-painting set, which usually contains not only paints, but also brushes, turpentine, mediums, a palette, and dippers. But it is equally possible to buy all items separately. Should you be interested in a set, pay special attention to which colors of paint it contains, since they often contain tones you'll rarely need. Whether you work on an easel and which type of easel you choose should depend on the amount of space you have. There are many different types of easel: table easels, folding easels, and solid studio easels. Always check before buying an easel to make sure that it really is easy to transport.

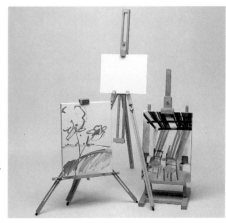

Here are two types of table easels and a large folding easel.

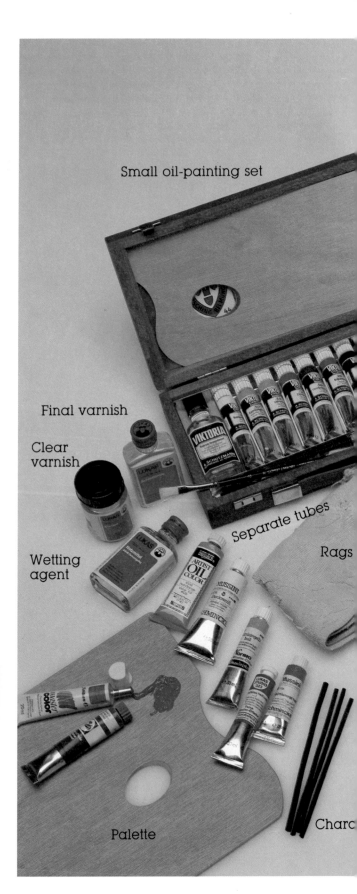

Small oil-painting set

Final varnish

Clear varnish

Wetting agent

Separate tubes

Rags

Palette

Charc

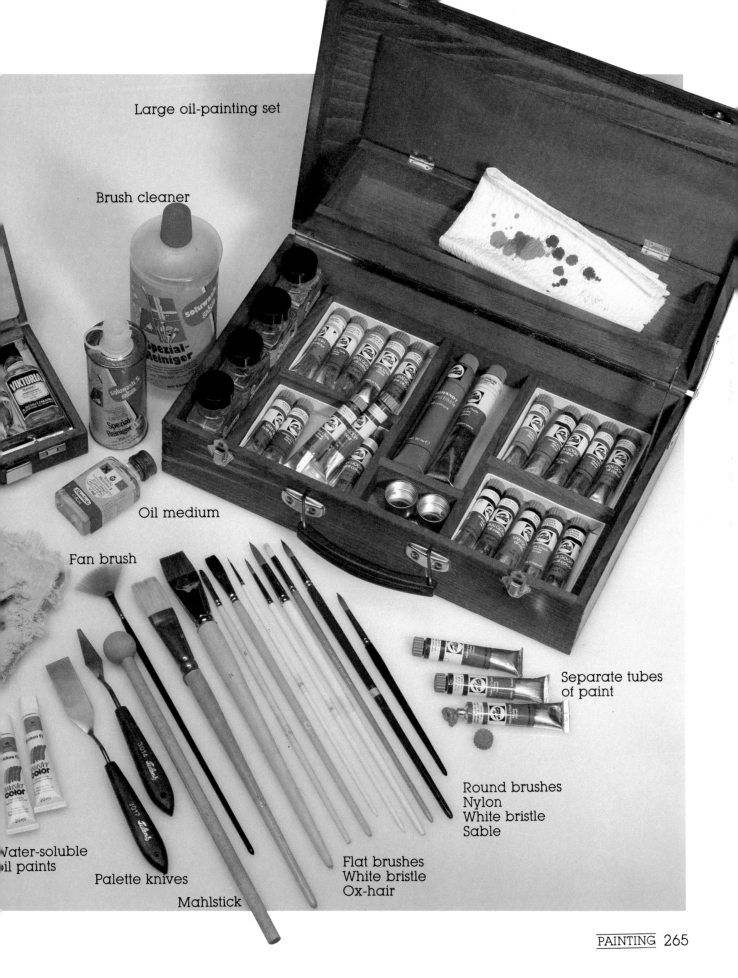

Large oil-painting set

Brush cleaner

Oil medium

Fan brush

Water-soluble
oil paints

Palette knives

Mahlstick

Separate tubes
of paint

Round brushes
Nylon
White bristle
Sable

Flat brushes
White bristle
Ox-hair

Brushes and Palette Knives

Your choice of brushes depends on the size and style of your picture. The main type of brushes used for oil painting are made from bristle, although a hair brush can be used for calmer, more mellow areas. In general, the brush stroke will vary according to the length of the bristles: long bristles give softer brush strokes; short bristles leave a more marked brush structure. Sharp lines are better achieved with a flat brush and flowing, softer lines with a round hair brush. The fan brush (as described on page 195) is used to create fine transitions and soft washes.

The palette knife serves for mixing paints on the palette and for scraping excess paint from a picture. When you first start oil painting, it's quite sufficient to have just three or four different brushes, such as one long, one round and one flat bristle brush, and a hair brush, together with a medium palette knife.

Painting Surfaces

The most common painting surface is still the canvas. It is available in various sizes that have already been stretched. You can, of course, stretch and prime your own canvas, but this is a fairly time-consuming and tricky process, which is rendered superflu-ous by the great variety of prepared surfaces available today. Even so, if you're interested in this, you'll find instructions on page 326.

Art supply shops also have a stock of primed painting blocks and boards. It's a matter of personal choice which of these surfaces you prefer. Brush strokes are softer on a canvas and the paints will blend more easily.

Some artists prefer to paint on wood. A popular surface for painting is Masonite, a pressed wood. You can prime wooden surfaces yourself very easily, using a thick white ground, called gesso, which can also be obtained from art supply stores. This is simply spread over the whole surface of the wood using a thick brush. It can, if necessary, be thinned with water. Unless you're using very thick paints, the structure of the priming brush strokes will, to a certain extent, dictate the surface structure of a picture. A picture painted on wood will look smoother than a picture on canvas.

Below, you can see a selection of various types of canvas.

Paint Colors

As I've mentioned, it is advisable to limit your selection of colors at first, and then add to it according to demand. On the opposite page are the main basic colors. You'll notice that these colors are similar to those I suggested for other techniques.

The line-up of your colors on the palette plays an important role in oil painting, since it can help avoid your mixing up the paints while you paint. I'd recommend placing the warm colors at the top and the cold colors at the side, as shown. You can always change the order once you know which colors you use more often and add more colors.

You can see that I have two mounds of white on my palette. You'll find that you will use an amazing amount of white. So I prefer to have a white for the yellow and red tones and another white for the blue and gray tones. Titanium white is the best for normal use as it is more opaque than zinc white and cremnitz white. Great care is called for in the use of cremnitz white as it is highly toxic and should not come into contact with any open wounds. Ask your art paint dealer for color catalogues from the various firms, as these will usually give details as to the contents of the various colors.

Never buy a palette that is too small as this will cramp your mixing;

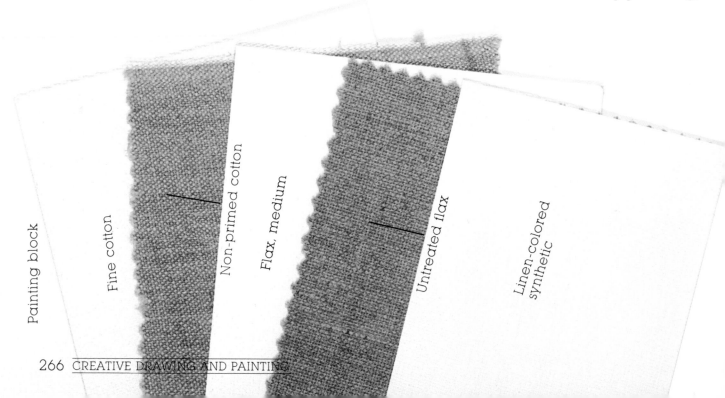

Painting block

Fine cotton

Non-primed cotton

Flax, medium

Untreated flax

Linen-colored synthetic

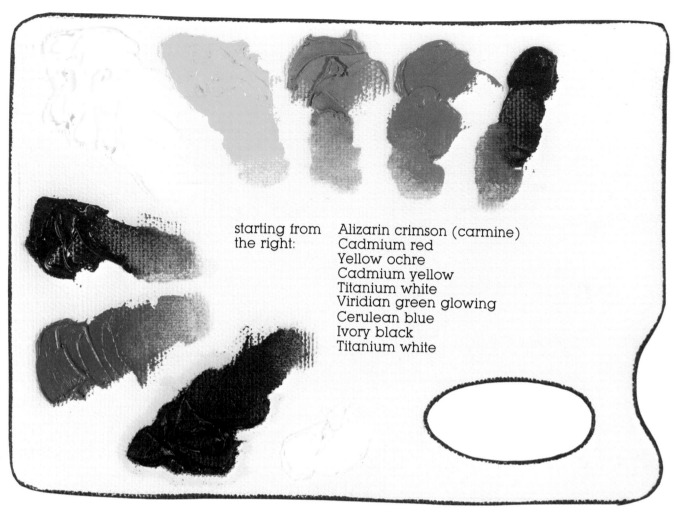

starting from the right:

Alizarin crimson (carmine)
Cadmium red
Yellow ochre
Cadmium yellow
Titanium white
Viridian green glowing
Cerulean blue
Ivory black
Titanium white

also be sure that it doesn't have identations, as these will also be a hindrance to mixing.

Quality paints are, without a doubt, extremely important, but this doesn't mean that you have to buy the most expensive brands on the market.

Try a couple of tubes from different manufacturers and then decide which you want to buy. The colors given below are some suggestions for supplementary colors.

If you like to hold your palette while you paint, dippers (see the illustration at left) are very practical for holding turpentine and mediums. Dippers, single or double, are simply clipped to the edge of the palette.

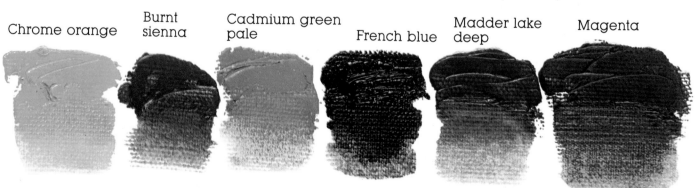

Chrome orange Burnt sienna Cadmium green pale French blue Madder lake deep Magenta

Mixing Colors

Mixing various colors is an excellent exercise to promote a feeling for oil painting. Start by mixing two colors and white together. Generally, colors are rendered cooler by adding white, and black will make them warmer.

These examples show how many color nuances will result from these restricted mixes.

By limiting your choice of paints, you will be able to mix most tones directly on the palette, which will help considerably in building your confidence.

It doesn't take long to fill your palette with a variety of dirty colors. To avoid this, place your paints as close to the edge of your palette as possible, leaving plenty of space in the middle for mixing colors. Always wipe the brush with a rag before dipping into a new color.

Should the paints become too thick or dirty, scrape them off the palette using a palette knife. Also avoid mixing too many colors together at one time—two or three colors plus white are usually sufficient. Oil paints dry slowly, so keep any colors that "went wrong," because you might

be able to use them again. If you're having problems getting the right tone, it is often better to start over.

In the examples above, I mixed the following colors with white: cadmium red and cadmium yellow (top); cerulean blue and cadmium yellow (middle); and cadmium red and cerulean blue (bottom).

Another mixing example using three colors, plus black and white.

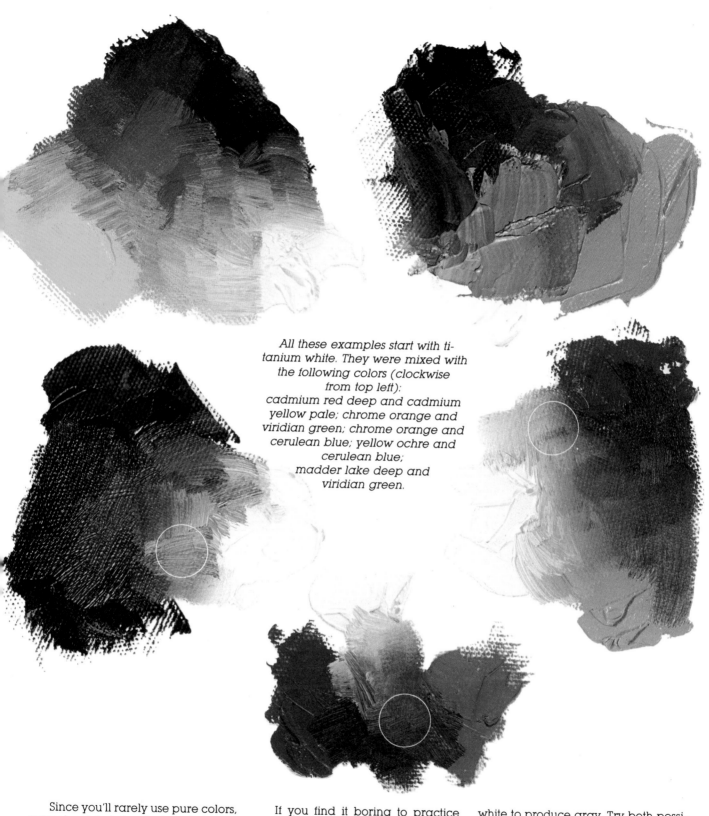

All these examples start with titanium white. They were mixed with the following colors (clockwise from top left):
cadmium red deep and cadmium yellow pale; chrome orange and viridian green; chrome orange and cerulean blue; yellow ochre and cerulean blue; madder lake deep and viridian green.

Since you'll rarely use pure colors, correct mixing is of utmost importance. Very fine nuances in gray tones can be produced without using black, but these in particular should be tried out prior to painting.

If you find it boring to practice mixing colors, use small compositions to discover the secrets of mixing.

The circles in the above examples show where gray has been created. You can, of course, also mix black and white to produce gray. Try both possibilities and you'll find out which method you prefer.

Oil paints are similar in consistency to acrylics, but they take longer to dry. This can be an advantage as it means you can remove unwanted elements easily and mix new colors into the painting.

Above, I've shown three ways of using oil paints. On the left, the paints were highly thinned using an oil medium. This could be used to produce a wash. Thicker paints were then applied to create a contrast. The example in the middle shows how the structure of the bristle brush becomes clearly visible when the paints are applied thickly.

The example on the right shows that oils can also be used for fine painting. I used a flat hair brush for this wash as this is softer than bristle brushes. Experiment with various brush strokes before you start a picture. Canvas samples, which you can obtain from an art store, provide useful surfaces for experimenting.

The color progressions at left go from dark to light, and the brush strokes are visible.

A palette knife was used for the tree at lower right, producing the variety of different structures. Use these structures consciously, leaving nothing to chance. The same applies to the example on the lower left.

The broad lines in the example at top left were produced using a flat brush. I first painted the horizontal lines and then went over these with red, from top to bottom, and green, from bottom to top. Note how the colors mixed into one another.

An impasto effect was produced in the example at top center by applying thick paints with a palette knife. These structures can produce interesting contrasts to softly painted picture elements as the center example at left shows.

I mixed an oil medium to increase the drying speed and a little plaster of Paris with the paint and applied this with a palette knife, bottom left. New effects were created by scratching into and scraping the paint surface.

The example at top right shows imprints made with various colors onto a highly structured surface.

The examples below and at bottom right demonstrate opaque painting. Different dabs and dashes of paint produce a lively Pointillist effect.

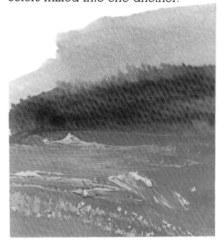

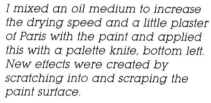

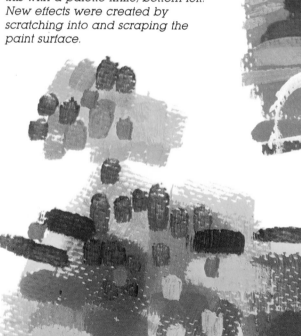

Oil paints can be applied in numerous ways, so they can be used for infinite variations in painting, ranging from precise, detailed still lifes to totally abstract color compositions. Sometimes I only have to smell oil paints and turpentine to feel my fingers itching to put something on canvas.

I was inspired to paint this picture by the sight of a blue cognac glass full of dried flowers, standing in bright sunlight on a windowsill. The reflections of shapes and colors in the glass created an abstract composition of their own. Most of the colors were affected by the light shining through the blue glass, making them look unreal.

I first made a quick sketch with a thick pencil to capture the effects of the ever-changing light and to set the composition of the light and dark areas.

Then I made several oil pastel sketches. I used oil pastels because they allowed me to obtain the correct colors fairly quickly. As you can see, I greatly simplified the shapes.

When you're painting an abstract composition, you are expressing yourself in colors and shapes, and not in recognizable objects, which means that you can let your spontaneous feelings take over. It is a great help to paint an abstract picture now and then in which you are concerned exclusively with colors and shapes, forgetting any need to render similarity or precise details. You'll find that this will increase your confidence in and your knowledge of painting techniques. The leaves and stalks of the flowers in this picture provide an interesting contrast to the reflections in the glass, which were applied with a brush and palette knife, using thick paint. This picture isn't totally abstract as it is based on something concrete, the shapes merely being transposed.

The light background at the top left of the painting was painted using a fine round brush and a creamy paint consistency.

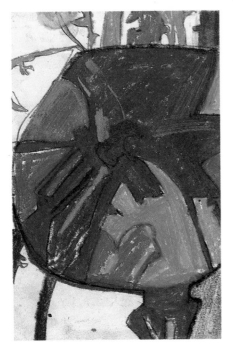

You can use a palette knife to vary the thickness of your paint application. The fine red lines in the right of the picture, the rose-colored lines in the left of the glass and the dark blue sections were all applied with a palette knife.

As an experiment, paint a dark violet area and set a light rose patch into this. You will be astonished how the violet area will suddenly spring to life.

Always try to avoid letting your colors become "dirty." Try also setting a light point on a dark area.

The structure in the top right of the picture is an imprint. This technique is clearly illustrated in the example above.

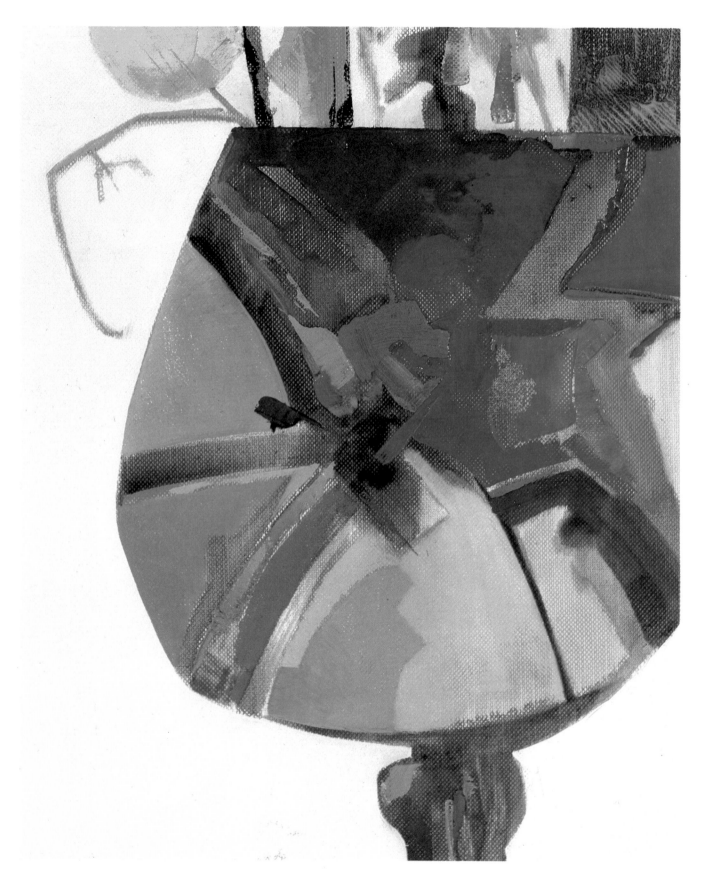

Step by Step

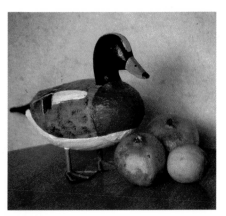

Since I knew that I wouldn't use thick applications of paint for this motif, I used an oil painting block. The brushes I chose were a round sable-hair (no. 2), a flat sable-hair (no. 4), and flat bristle brushes (nos. 8 and 14). The paints used were titanium white, very little ivory black, alizarin crimson, magenta, cadmium yellow, cadmium orange, burnt sienna, burnt umber, cobalt blue, Paris blue, and viridian green glowing.

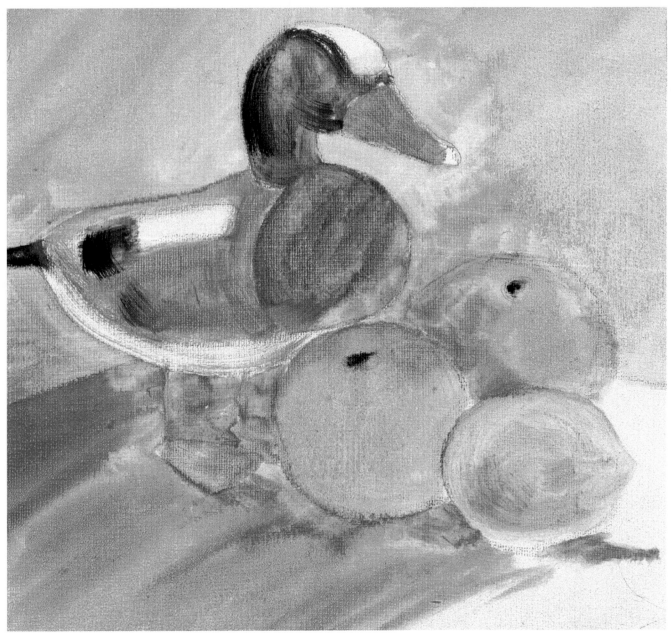

Step one: Oils are almost the perfect medium for still-life paintings. You can make a still life out of any objects you would like to draw, and since these objects are "still," you have all the time you want to find the right composition. In this case, I was attracted by the combination of wood (the duck) and fruit. I made a quick charcoal sketch of the basic composition and then carefully wiped off the charcoal, leaving faintly visible outlines. If you don't wipe away some charcoal, charcoal dust will mix into the paint later and

produce a gray, dirty color.

Using a large, flat brush, I then set the basic areas and tones. I used some pure turpentine and a little quick-drying medium to thin the paints. I usually set the larger areas of a picture fairly early, in order to decide how I want to continue building up my picture.

Step two: Since I did not want the canvas tone to be visible in my finished picture, I painted over the lighter areas of the duck using white, a little blue, and black. Next I made the table top darker, trying to bring out the

wood structure with areas of dark and light. Even in this early stage of a picture, you should start giving your picture depth. The objects should "stand firm" and not look like they're about to topple over.

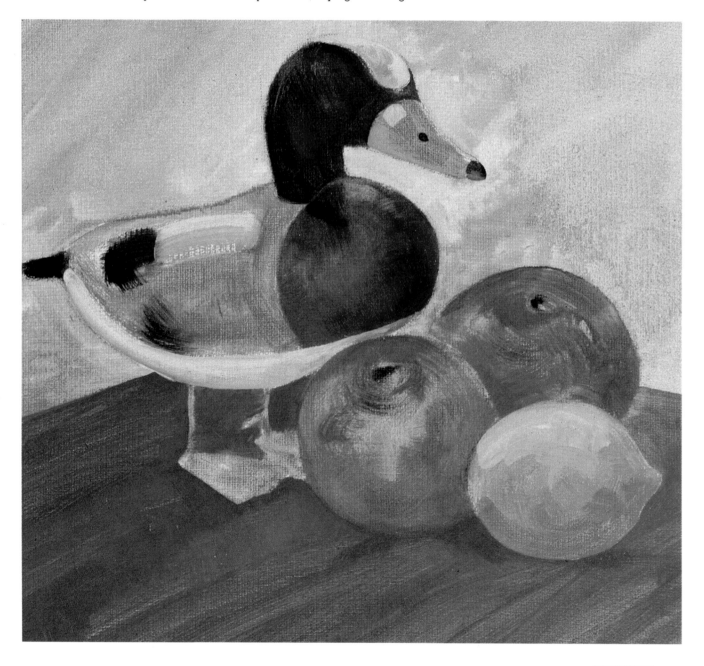

The surface structure of the table is very important, as this not only gives more depth to the picture, but it also creates the impression that the objects are really standing on it. The success of a still life depends to a great extent on light and shade. The area surrounding an object is just as important as the object itself. Never rush into a picture; take time to consider colors and structures before you start to paint.

Step three: I worked on the feet and legs of the duck, trying to bring out the metal effect. I wanted to render these as finely as possible, by way of contrast to the body and fruit.

I still didn't feel happy with the shape of the pomegranate, so I made a pencil sketch to give me a better feeling for this shape, its light and shade. This showed me what was wrong with my painted fruit and how I could improve my rendering of such details as the core and the stem.

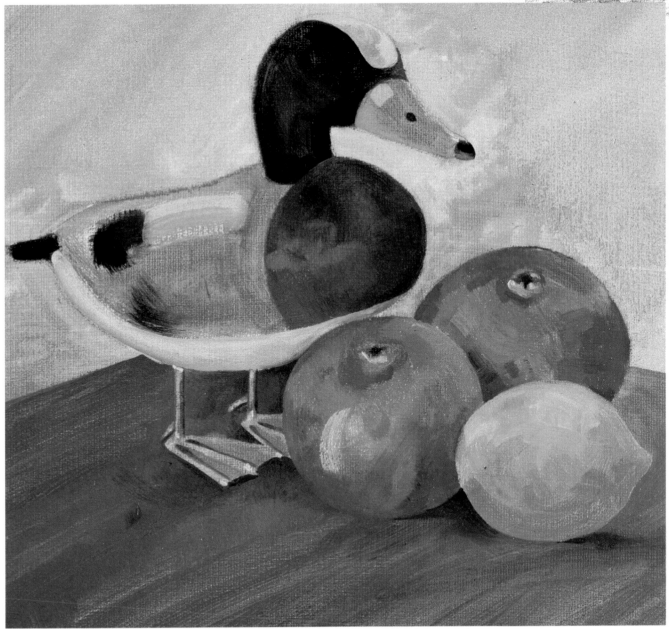

Never forget to look at your painting as an entity. If you have spent some time working on a detail, step back from your work for a bit and view this detail in connection to the whole picture. Take note of color reflections and combinations. Here, the red of the pomegranate affected the cool yellow of the lemon and vice versa. Try to capture these color changes in your picture; this will certainly lend more unity to your composition. Your picture is not a rendering of individual objects that just happen to be standing together, but a unification of an arrangement.

Step four: The lines of the table were scratched into the paint using a palette knife and a ruler. This simple technique helps to give depth to the composition.

Next I took a very fine flat brush to give more substance to the shapes and color structures. The lemon was given more shade with the help of a little green and orange. I also completed the background. The dark patches in the background created the impression that the objects in the foreground were closer together and the soft structure of this background made the whole picture calmer. Look carefully at the background, it contains many colors that you will also find in the foreground. I used a sable brush, as I did not, under any circumstances, want visible brush strokes in this area. (The same effect can be obtained using a fan brush.)

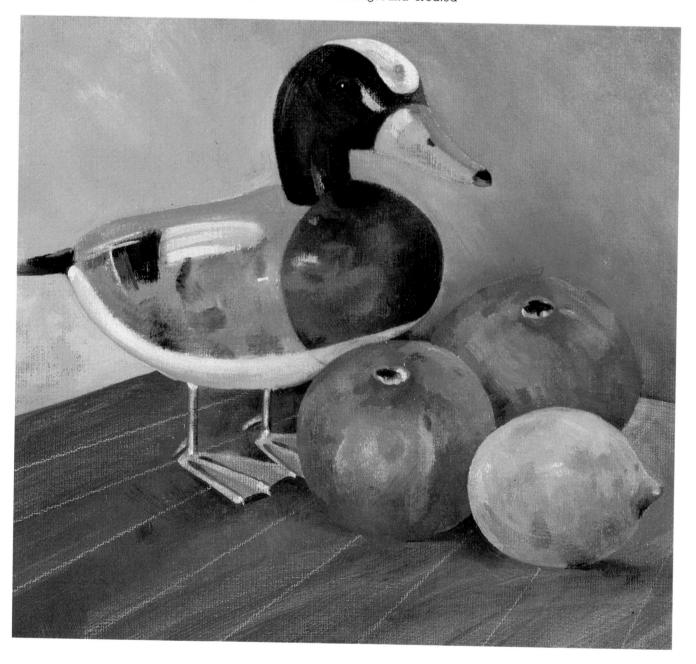

Step by Step

This time I opted to work on thick canvas with two flat bristle brushes (nos. 6 and 12), a round bristle (no. 6), a round sable (no. 4, very fine), and one long and one short palette knife. I used titanium white, cadmium red, cadmium yellow, chrome orange, yellow ochre, burnt umber, magenta, cobalt blue pale, and viridian glowing.

The inspiration for this picture came from a colored pencil sketch of a peaceful country scene out of one of my sketchbooks. The colors in the af-

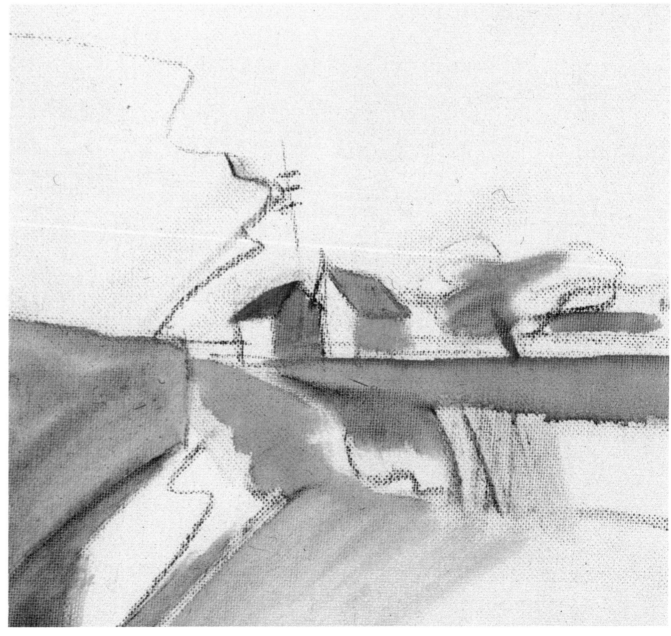

ternoon light had a shimmering effect, calm but full of expression. The wall leading to the focal point in the scene had a violet and rose tinge which contrasted with the vivid color of the roofs, adding extra interest to the scene.

Step one: Once again, I sketched the contours in charcoal and then wiped them off, as in my still-life picture. Then I laid the basic areas using a wet wash of colors mixed with pure turpentine and a quick-drying medium. Try at this early stage to concentrate on the composition. Once this has

been established, you can begin to think about color combinations and introducing atmosphere.

Step two: I applied all the colors onto which I would base my picture. Some parts of the basic background became lighter later in the course of painting.

If you compare this picture to the still life on the preceding pages, you'll notice that the painting in this picture is more spontaneous and freer. I was aiming, in this picture, at producing a combination of various brush strokes

and palette knife structures. Landscapes lend themselves well to this type of rendering, as they include so many different structures and are open to personal impressions.

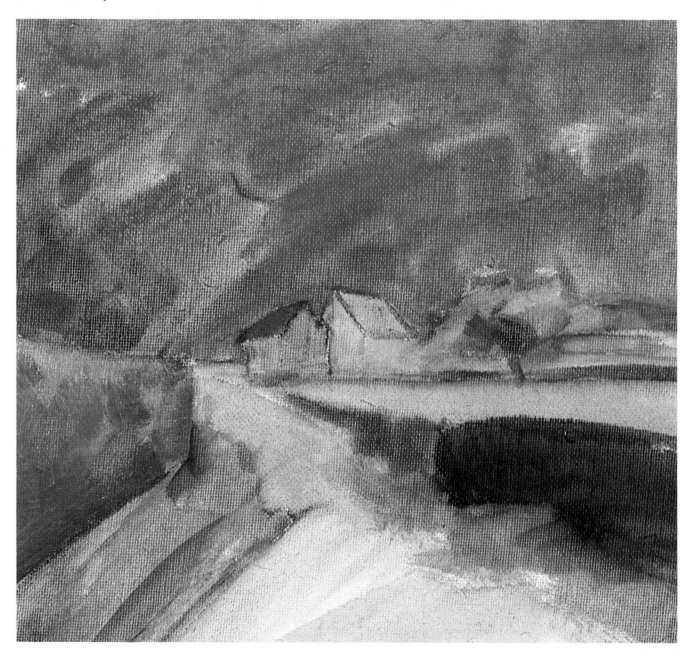

Step three: At this stage, I still didn't have a clear concept of how the sky should look, so I concentrated on the houses and trees in the foreground as well as the background. I used thick paint, into which I had mixed some quick-drying medium so that it wouldn't be too wet when I wanted to paint over it at a later stage. The path was given a feeling of movement, contrasting it with the solid wall, with the aid of a thick brush. The dynamic lines lead the observers' eyes not only to the focal point of the picture, but also tempt them to follow the path around the corner behind the houses. If you compare this step to step one, you will see that the basic composition is still the determining factor.

My next step was to slowly build up the wall using brush structures and my palette knife. The patches of color (applied with a palette knife) look like stones. This later produced an interesting contrast to the oblique foliage. Note how some patches of color are repeated in different parts of the picture. When I was working on a roof, for example, I added a few patches of this color to the wall or the background. This intensifies the unity of a picture and combines the various picture elements. These added colors do not, necessarily, have to be in any way typical or characteristic for the object in question.

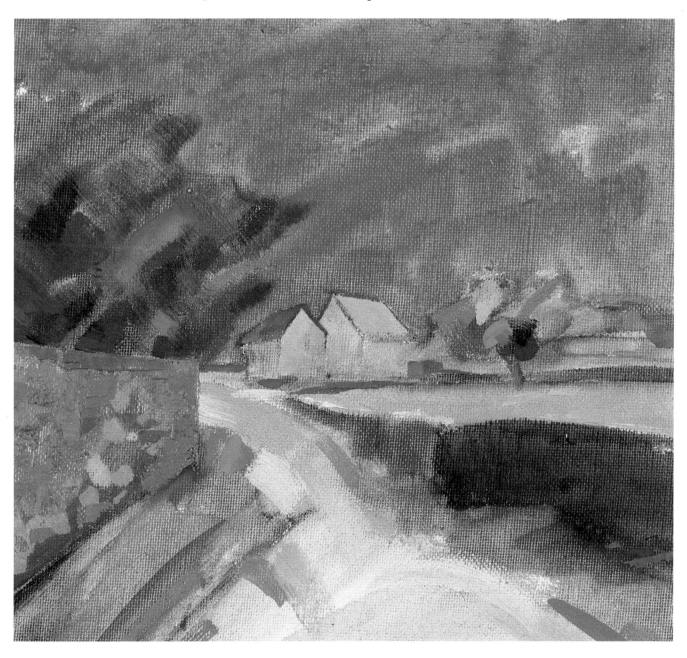

Step four: At this point, I decided that the sky needed to be slightly lighter in order to create an agreeable contrast to the trees. I mixed cerulean blue and white and lightly spread this over the dark blue using a palette knife. The dark blue still penetrated the lighter blue in places, giving the sky more depth and intensity.

It seemed to me that the picture did not have enough dark blue tones, so I added some pure blue, using a palette knife, to the foliage. As a result, the foliage suddenly looked consider-ably livelier; it looked lighter and had gained depth. It also set the houses further into the background, giving more depth to the whole picture. I liked the dark shape of the hedge on the right, but felt it was lacking in structure. For this reason, I painted the green patches into it with a small brush. This gave more life to the hedge and unified it with the rest of the picture. For the vertical gate posts, which were simply painted over the hedge, I used the sharp edge of a palette knife to produce slightly broken lines. This preserved the vivacity and spontaneity of the hedge. Practice using a palette knife before applying this technique to a picture because it is very easy to botch a painting. But when you have mastered the palette knife, you will find it a most versatile tool.

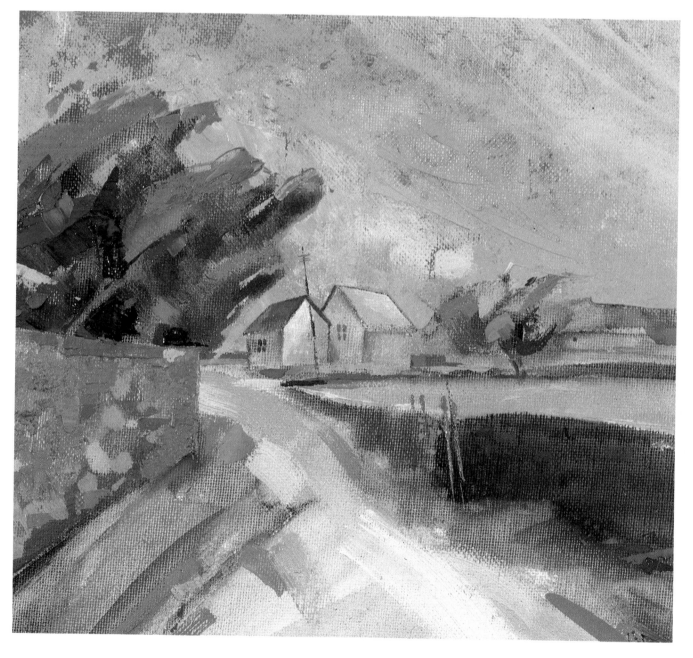

MOTIVATING IDEAS

The fresh quality of a classical still life or the beauty of a sunset seems almost to be waiting to be rendered in oils. I chose this particular still-life motif mainly on account of the inherent play of light and shade. This almost dramatic composition presents a true challenge to your abilities not only for rendering atmospheres, but also for exhausting all the possibilities of oil painting. Look carefully at the light and shade and at the constantly recurring colors. In your rendering, you could, naturally, alter the sizes or make one object more prominent than the others.

This sunset could be rendered using a palette knife, or equally, using a bristle brush. The possibilities range from a fine wash composition to wild palette-knife structures. You will discover that the yellow tones and chrome orange of oil paints have an intensity of their own and will bring out the strength of the sun very well. This motif could be used to create a calm, peaceful scene, just as it also possesses potential for a misty, mystic picture.

Plants and trees really give you an opportunity to play with this technique, using both palette knives and bristle brushes. The atmosphere and mood of the whole picture are more important than adherence to precise details. Maybe you can remember a particular summer afternoon and would like to incorporate your own personal emotional experiences into your picture.

The structures and light in the Irish landscape at the right lend themselves to a rendering packed with contrasts. Parts of the landscape could be presented with thick applications of paint, whereas other sections seem suitable for the wash technique.

Oils have always played an important role in the history of portrait painting. Think of the portraits by Francisco de Goya, Vincent van Gogh, or Francis Bacon (English painter, 1910-). Observe faces—look for the inherent play of light and the various shapes. Distinct faces, as shown below, are very challenging.

This rock formation on the left is almost an abstract composition in its own right. Let the shapes and shadows stimulate you, and, most important, remember that this is your picture. If you feel your picture calls for interspersing areas of yellow, or maybe a red background, paint it that way!

283

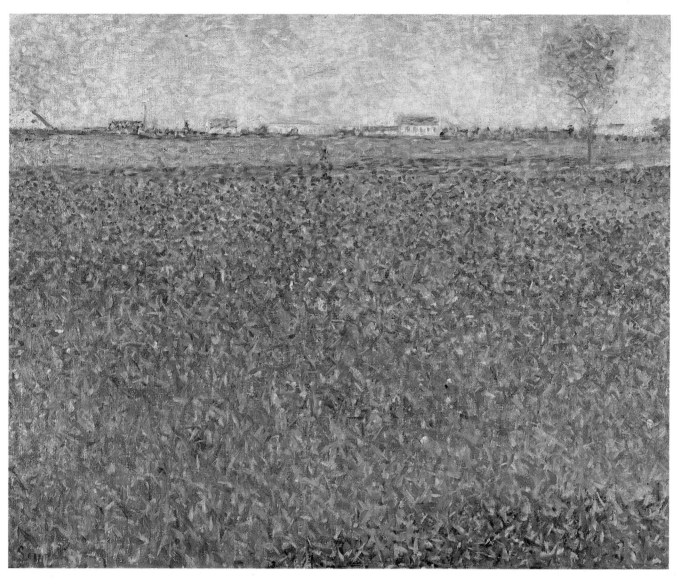

If you find that you really enjoy painting and experimenting, it might be a good idea to go to an art exhibition once in a while. You are sure to see the pictures with completely different eyes, now that you are aware of the problems confronting your "fellow artists." Analyzing other people's pictures can help to develop your own techniques. Look for color combinations; observe how the artists laid out their compositions. You will discover a great diversity in the means and media used by the various artists. Very often these pictures will give you an idea for a picture and you will find that you can hardly wait to get home to try it out. If you want to go one step further, try copying a specific picture, an exercise that will certainly increase your understanding of color value and intensity.

"La Luzerne, Saint Denis," by Georges Seurat, above, renders the impression of a landscape. The structure, made up of numerous short brush strokes, is virtually abstract. This is one of Seurat's earlier works, in which the development of Pointillism (the juxtapositioning of dabs of color), to become more pronounced in his later works, is clearly evident. Compare the generously laid out foreground to the trees, houses, and sky of the background. If you observe this picture from a distance, the colors blend into homogenous areas, whereas a close inspection will reveal that the color is, in fact, a combination of many colors. Original size: 810×640mm (31½×25 inches).

This portrait, "André Derain" by Henri Matisse, upper right, forms a strong contrast to the two other pictures shown here. It shows the typical effects of a brush technique, using creamy paints on a canvas surface.

Matisse did not shy from leaving his brush strokes and structures in an almost crude state in order to bring expression into his pictures and maintain liveliness. It is this aspect that makes this picture look so fresh, as if it has just been painted and that the paints are still wet. I've shown a detail of an eye, above, to elucidate the brush technique. Original size: 289 × 394mm (11¼ × 15½ inches).

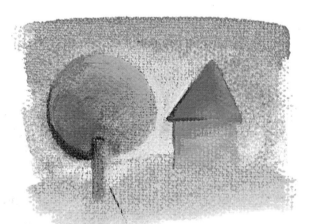

Fernad Léger (French artist, 1881-1955) illustrated in "Village Landscape," lower right, not only the use of color values and intensity, but also the breaking down of a motif into basic forms (do you remember this point on pages 10 and 11? See also the example of basic shapes above). Paul Cézanne once said, "Everything in nature is shaped like a globe, a cube, or a cylinder." This picture by Léger seems to verify this statement. This example, showing a landscape through the eyes of a Cubist, illustrates the Cubist concentration on breaking a picture down into basic forms. The observer is given the impression of viewing the scene through a segmented window. Original size: 810 × 910 mm (31½ × 35½ inches).

Gallery

René Magritte (Belgian painter, 1898-1967) did not lay much value on the philosophy of Surrealism. He preferred to simply paint according to his own whims. The French Surrealist writer André Breton once said, "To me, a picture is like a window looking out over something, the only question is—what?" This statement fits the works of Magritte more than any other of the Surrealists. In the picture above, "La Chambre d'E- coute," the apple is blown up to disproportionate size, filling the room. This might remind you of our earlier composition examples, when we discussed positive and negative areas. This picture clearly illustrates the importance of the negative space surrounding the apple. Original size: 553×451mm (21½×17½ inches).

"Willy Lott's House," by John Constable, opposite page, was painted on a sized paper surface, which prevented the oil paints from destroying the paper fibers. Constable was an ardent painter of landscapes. He is said to be the first artist to use the palette knife for painting, and not merely for mixing paint. Note the simple means by which Constable rendered the dog in the foreground. Original size: 181×241mm (7×9½ inches).

Uwe Neuhaus
1972

This unusual still life, by Uwe Neuhaus, a Munich artist, shows how eccentric motifs also offer interesting subject matter for painting. By giving the painting a dark background, the artist accentuated the lively colors of the foreground. Neuhaus often incorporates the frames into his pictures. Thus you can see that the brown of the frame is repeated in the front surface.

The classical still life, by Paul Cézanne, opposite page, top right, is also somewhat unusual due to its spatial arrangement. Everything is carefully planned: the build-up of space and depth, the composition of shapes and colors. The colors in the background, blending to give the effect of a monochromatic wall, reflect all the colors of the various objects. Original size: 724 × 584mm (28¼ × 22¾ inches).

My picture of an apple on a table, opposite page, bottom left, shows how an interesting composition can be built up from a limited number of shapes and surfaces. This picture relies on colors and structures to give it life. I've often used an apple as an example in this book. This classic, but simple form elucidates clearly the different painting techniques. Original size: 240 × 190mm (9¼ × 7½ inches).

Vincent van Gogh was a master of Expressionist landscapes. He understood how to introduce emotions even into country scenes. Using thick, short brush strokes, he brought movement and life into the scene above. The tree became monumental and dominating, the sky was turned almost into a religion. Original size: 710 × 910mm (27³⁄₄ × 35¹⁄₂ inches).

I copied this portrait of a young girl from Pablo Picasso in order to gain a deeper understanding of his use of shapes and colors.

EXPERIMENTING

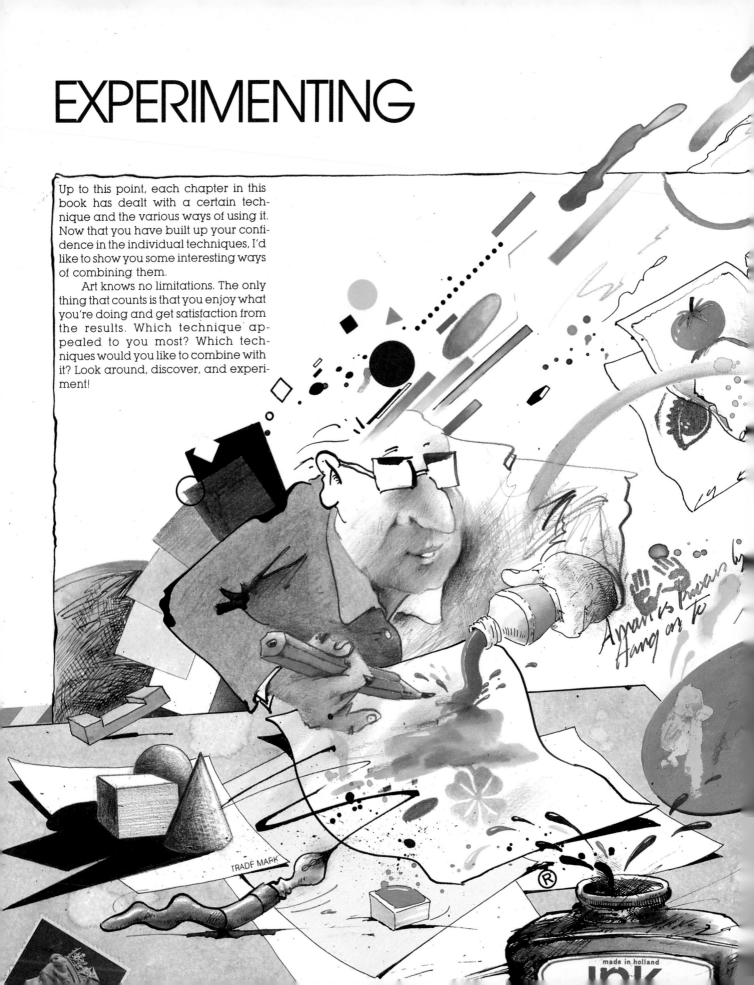

Up to this point, each chapter in this book has dealt with a certain technique and the various ways of using it. Now that you have built up your confidence in the individual techniques, I'd like to show you some interesting ways of combining them.

Art knows no limitations. The only thing that counts is that you enjoy what you're doing and get satisfaction from the results. Which technique appealed to you most? Which techniques would you like to combine with it? Look around, discover, and experiment!

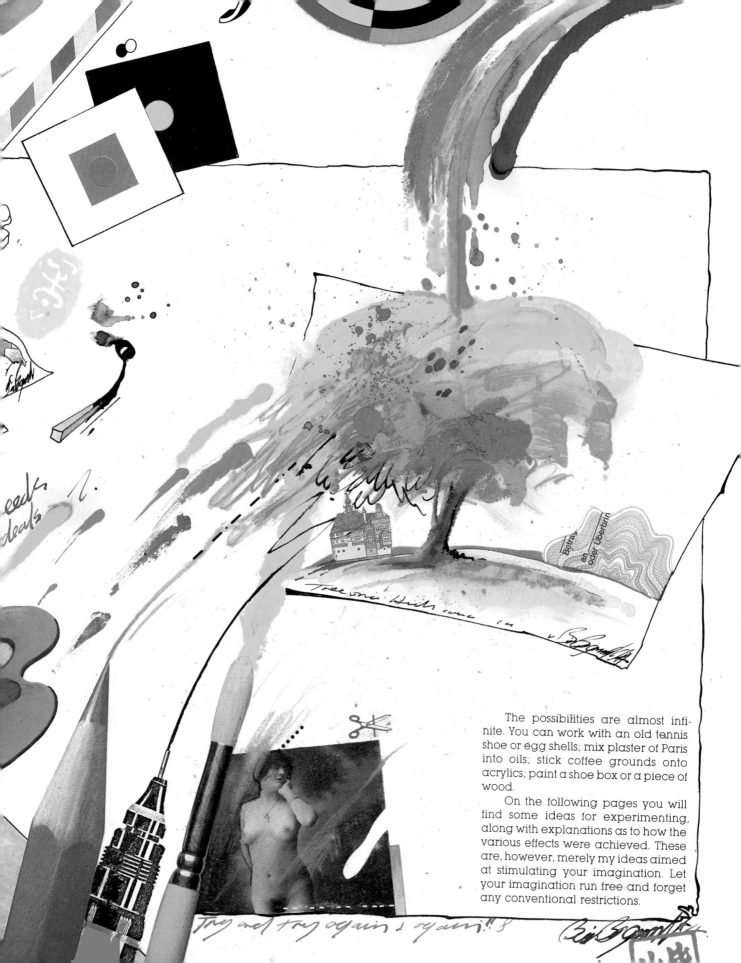

The possibilities are almost infinite. You can work with an old tennis shoe or egg shells; mix plaster of Paris into oils; stick coffee grounds onto acrylics; paint a shoe box or a piece of wood.

On the following pages you will find some ideas for experimenting, along with explanations as to how the various effects were achieved. These are, however, merely my ideas aimed at stimulating your imagination. Let your imagination run free and forget any conventional restrictions.

Materials
FOR EXPERIMENTING

The materials you can use for experimenting are, by nature, not so clear-cut as those for the conventional techniques. You must forget any "you can't do thats." Everything is possible and everything should at least be tried out. An abortive attempt at a watercolor painting can, for example, be turned into an interesting picture by drawing over the paints with colored pencils; you can use oil pastels over a gouache painting, or you can apply colored pencils to a charcoal drawing.

This photo aims at supplying you with ideas for various materials that could be combined or mixed in your experiments.

It's possible to obtain mixed technique sets in a variety of sizes. The set shown here, from Caran D' Ache, contains an assortment of drawing and painting mediums, including gouache paints, pastels, watercolor crayons, a large tube of gouache white, brushes, clear varnish, a thinner, dippers, and a mixing palette.

I haven't covered airbrushing in this book as this is a very involved technique. Should you, however, like to try your hand at this, Letraset has produced a simple airbrush system using special markers, thus allowing the user to vary the colors easily. These systems have the advantage that they will not cause paper to warp, as markers contain no water. Airbrushing takes quite a bit of practice, but once you've mastered the technique, it's possible to produce interesting and attractive effects, especially in combination with other techniques.

Another important item is spray adhesive. Some spray adhesives are fast sticking and others can be peeled off paper. If you are making a collage, you will require an adhesive that will produce as flat a surface as possible. Spray adhesives are the ideal solution in this case.

How about painting a block of wood or a miniature picture on an empty sardine can? There are no limits to the objects that can be incorporated into a composition or used for a collage. Some ideas shown here include: used postage stamps, an old passport, rubber stamps, etc. What about using the footprint from an old tennis shoe? In the next few pages I'll try to cover just a few of the endless possibilities.

Frames

Poster colors

Sponge

Watercolor crayons

Markers

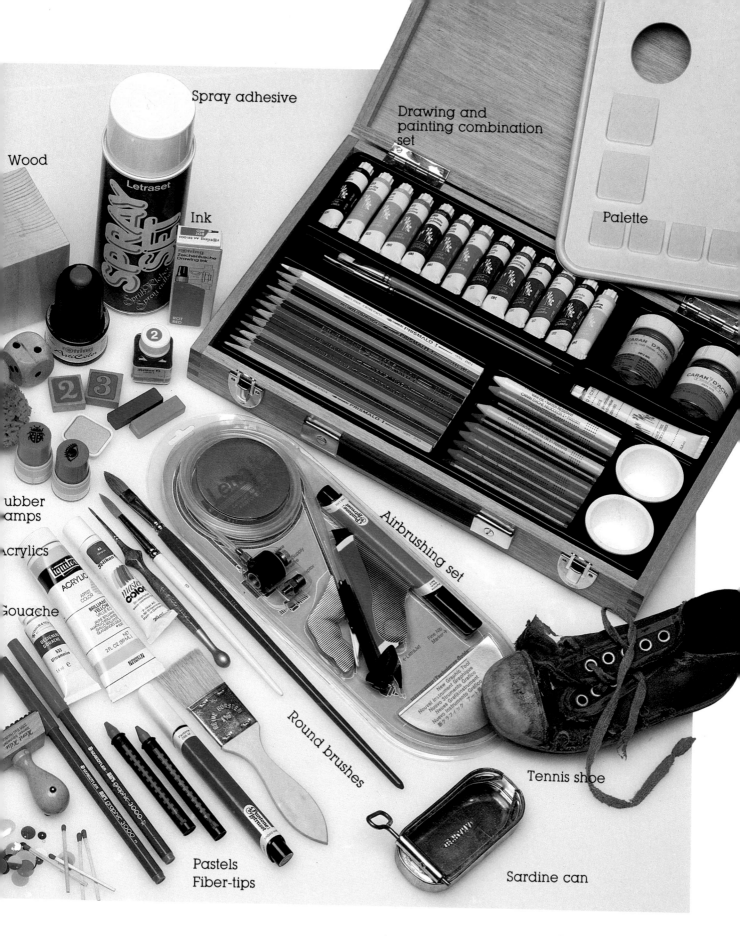

Spray adhesive

Drawing and
painting combination
set

Wood

Ink

Palette

Rubber
stamps

Acrylics

Gouache

Airbrushing set

Round brushes

Tennis shoe

Pastels
Fiber-tips

Sardine can

Mixed Techniques

Let's start by investigating what results can be achieved by mixing just a couple of techniques, so that we can observe how the various mediums react to one another. Some will repel other mediums, others will run. As always, the working surface plays a decisive role. Rough paper will produce more defined structures than smooth paper. I'd advise using thick paper for your first experiments.

At right, the base is a mixture of pastel and oil pastel, painted over with watercolors. The pastels mixed into the wet paint turning yellow into ochre. The black lines drawn over this are in conté crayon.

At the bottom left you can see a consecutive build-up of broad lines made with pastels, colored pencils, and water-soluble markers. I went over some of the areas using a brush and water to dissolve the colors. Before this had completely dried, I drew ink lines over the structure.

Above I've demonstrated prints on canvas, using oil and acrylic paints. For the large circle, I painted the top of my aerosol fixative with oil paint and pressed this onto the surface. The smaller circles were made using the caps of paint tubes. The other prints are from paper painted with acrylics and watercolors.

In the center example below, I first applied a thick line of opaque paint and then made a graded wash by continually adding more water as I worked down the paper. I also drew into the painted surface with ink before the surface had dried.

In another variation, bottom right, I started with acrylics at the top, spreading it with a palette knife, then I produced a graded wash by introducing watercolors. While this surface was still slightly moist, I drew over it using colored ink.

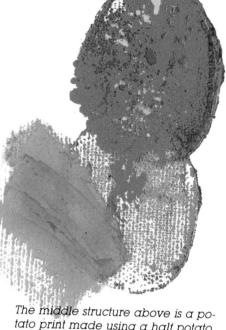

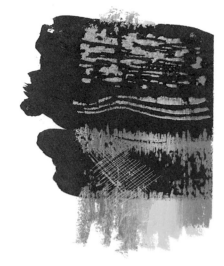

At top left I mixed oil pastels, pastels, watercolors, and colored ink.

The middle structure above is a potato print made using a half potato and oil color. I scattered powdered paints onto the wet oils. The lower structure was produced by mixing plaster into the color and applying it with a palette knife to produce a matte texture.

This is a technique that you can probably remember from your school days, top right: A thick layer of poster color is painted over wax crayon. Once the poster paint has dried, you can scratch or scrape into the top layer using various instruments since the poster color does not mix into the oily pastel surface.

In the experiment at bottom left, I made a potato print with a half potato thickly covered with acrylics. Following that, I drew into the moist color with a yellow pencil. When the structure had dried, I went over it carefully with oil pastels, rubbing them in with my finger around the edges.

Interesting effects can always be achieved by simply drawing into wet acrylics with colored pencils, as the pencils will take up the color of the acrylics. The red spots in the middle example below were created by scattering powdered paint onto the moist acrylics. The powdered paint will adhere to acrylics just as it does to an oil surface.

If you use colored poster colors the result is softer than with black. Using a fine scratching instrument, you can achieve fine structures. In the example on the bottom right, I did not paint over the whole pastel surface. I also added some ink structures to give it a final touch.

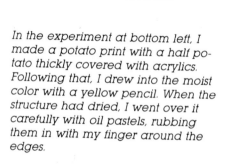

Left, you can see a combination based on oil pastels. I mixed linseed oil and plaster of Paris into pastel scrapings and applied this mixture using a palette knife. Once this had dried, I drew pastel and colored ink lines over it. A thinner application of this pastel mixture allows you to create finer structures, as is shown on the right.

By simply adding a border, structures such as those above can be turned into small abstract pictures. Above left, I rubbed over coins, pieces of material, and jigsaw pieces laid under the paper with colored pencils. If the paper is thin enough, the impression of the underneath structure will come through the paper.

Rubbing over stencils, cloth, and other objects can produce interesting effects. At right I used a blue Stabilo pencil, a green Stabilotone, and a red water-soluble pencil. The yellow in the center is an imprint with oil pastels.

In the example above right, I mixed acrylics, plaster of Paris, and water-colors and spread a smooth layer of this using a palette knife. By dabbing at this wet structure with the palette knife, I produced a new rough structure. Small objects will stick to the wet mixture, but you must be careful, because the sticking power of this mixture is, in comparison to glue, rather limited.

Oil painting paper lends itself well to use with acrylics. Areas of thinner paint will allow the structure of the paper to penetrate (in the example at left the paint was applied with a palette knife). The stars and circles were stuck onto the wet paint.

Oils and liquid mask were mixed and spread onto the paper with my fingers, right. Careful! Liquid mask is an adhesive that can be removed by rubbing, so don't rub too hard! When this structure had dried, I painted over it using watercolors.

The graded wash, above, was produced by drawing into wet oils with a conté crayon.

I applied some acrylic paint with a palette knife, above left, and used this as a background into which I pressed a piece of string, a leaf, and some stars. I was slightly afraid the leaf and string would fall off the paper, so I added some adhesive tape for good measure. This also became an element of the picture.

At right, I first drew some lines using water-soluble marker and then went over them with colored pencil. Finally I smeared the structure using a permanent marker.

I painted the underside of a leaf green and then made an imprint, above right. The earth is a potato print, the sun a paint tube cap covered in paint and pressed onto the paper.

How about also using some objects for embossing? For this you will need some soft, fibrous paper. The best is Japanese paper or thick handmade paper. This is first soaked for a time and then laid over the object. In the top left example I used a wire coat hanger, on the top right a toy pistol. Carefully mold the paper over the form with your fingers.

You can now either carefully peel the paper away from the object for drying, or, if you prefer, leave the paper over the object until it has dried. Once the paper has dried you can paint over the paper. But be careful! Colors will run on soft paper, so it is better to make some test applications first.

The lower pictures show a sophisticated example of embossing by Jens Reese. He first scratched his motif onto a plaster block and then pressed the wet paper over this. Self-made paper will produce particularly interesting structures.

Dorothea Reese-Heim combines paper making with the use of textiles and weaving (opposite page). She stretches threads over a paper-making frame before she immerses it into the pulp solution (she uses a fibrin bath) to make the paper. In the process of drying, the textiles combine with the paper fibers. In this case, tinting leaves were added when wet, but it is equally possible to paint over the surface once it has dried. In this example the paper itself serves not only as a surface, but also forms a picture element.

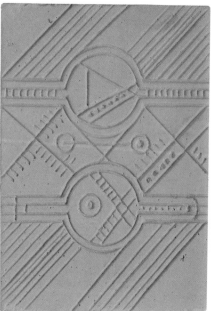

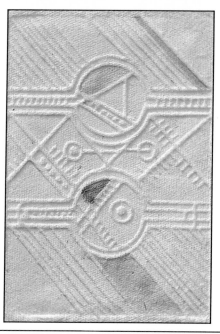

Paper making

There is a long tradition of papermaking that is slowly regaining importance today.

Paper can be produced from cellulose or vegetable fibers, such as cotton or linen. Some hobby shops stock cellulose that is specially manufactured for this purpose. Hobby shops and art supply stores also sell the paper web and frame that will be used to form the pulp into sheets of paper.

To make paper, first you must crumble the cellulose into water and soak it overnight to produce a pulp.

The pulp must then be mixed thoroughly (if you want to make your life easier, use an electric mixer). At this stage, various substances can be added, such as gum (this prevents inks from running), colors, or tinting leaves. Tinting leaves often produce a mottled effect such as you can find with some kinds of blotting paper.

The paper web and frame are then dipped vertically into the pulp and taken out in a horizontal position so that the paper web is covered with pulp. Once enough water has dripped away, the web is taken out of the frame and the moist fiber of the web is carefully laid out on a clean cloth.

Next the cloth and the wet paper are hung over a line to dry. Once the paper is dry, it can be pressed. If you do not happen to possess a paper press, you can use heavy books or even iron the paper.

Should you want to try paper making, I'd advise buying a hobby set for your first attempts, as this will supply you with all the basic equipment needed.

Collages

The name collage derives its origin from the French word *coller,* meaning to stick, just as the pioneers of this technique were also French. Georges Braque and Pablo Picasso started incorporating such things as papers and newspaper cuttings into their pictures in 1910/11.

This extension of painting opened completely new dimensions in the field of art. Other artists, such as Henri Matisse, Hans Arp (German-French painter, sculptor, and poet, 1887-1966), and later Robert Rauschenberg (American painter and graphic artist, 1925-) soon adopted this highly effective technique.

The term collage is very flexible as it includes any type of picture with glued-on elements. On page 297, for example, I glued a piece of string and a leaf into acrylics. A collage can be made up entirely of glued-on elements, or it can include drawn or painted structures. Maybe you will find stimulation in newspaper cuttings or by simply playing with the effects of different colored papers.

On the following pages I'll attempt, with the aid of some examples, to demonstrate the versatility of this technique. I hope this will stimulate you to play around with various materials yourself.

Below you can see a combination of greatly varying materials, such as postage stamps, foil, pieces of packaging, and blotting paper interspersed with impressions.

In 1914, Pablo Picasso produced "The Violin," left, which looks like a collage, but is, in fact, a combination of painted structures and patterns.

I first drew the tomato below using watercolors and oil pastels. I then cut out the lower half and glued silver paper under it. I was particularly taken by the contrast between the warm and cold colors in this simple composition.

A collage can be based on a photo, as in the example on the left. The original photo was of a red chair in a white tiled room. By cutting out sections and drawing over the photo using a pen, tempera, wax pastels, and colored pencils, I was able to create a new picture, very different from the original. The photo itself had given me a feeling of orderliness and emptiness, so I had great fun introducing chaos with a diversity of materials.

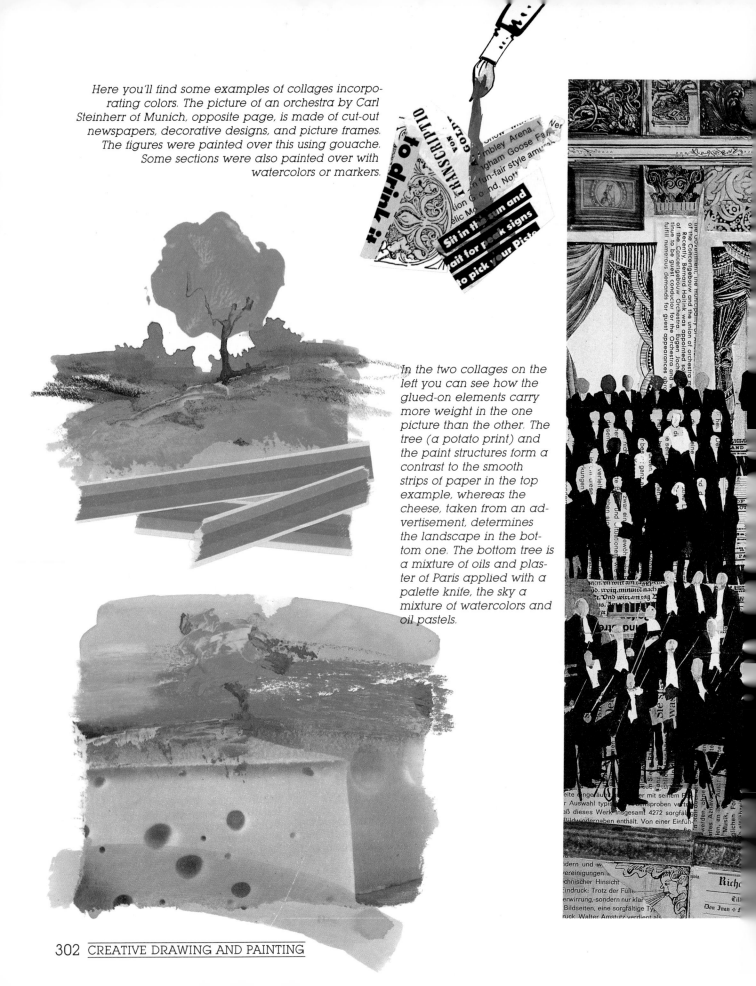

Here you'll find some examples of collages incorporating colors. The picture of an orchestra by Carl Steinherr of Munich, opposite page, is made of cut-out newspapers, decorative designs, and picture frames. The figures were painted over this using gouache. Some sections were also painted over with watercolors or markers.

In the two collages on the left you can see how the glued-on elements carry more weight in the one picture than the other. The tree (a potato print) and the paint structures form a contrast to the smooth strips of paper in the top example, whereas the cheese, taken from an advertisement, determines the landscape in the bottom one. The bottom tree is a mixture of oils and plaster of Paris applied with a palette knife, the sky a mixture of watercolors and oil pastels.

The picture "Linda" by Stan Smith (English painter, 1929-), above, is a good example of mixed techniques. It was drawn and painted using pen and ink, gouache, and watercolors. Wet-in-wet painting, dry brush strokes, and wet-on-dry structures are all evident.

I personally like the structure of the window, table, tea pot, and chair, as this clearly illustrates just how effectively the various techniques can be combined. Movement and life are introduced into the picture by the various types of lines. Original size: 508 × 381mm (19³/₄ × 14³/₄).

On the right, I have simplified some of the basic techniques used in Stan Smith's picture: pencil over a watercolor wash, wet-in-wet (the hair), dry brush, gouache lines, and pen-and-ink drawing.

On the right, I drew and painted over a page of a calendar using pen and ink, watercolors, and pencil, as well as imprints from photocopies. This last technique can sometimes add interesting little details to a composition. First you will need a photocopy of the motif in question. Lay the photocopy face down on your paper and rub lighter fluid or rubber-cement thinner over the back of the motif using a rag or a paper tissue. The ink will be released onto the surface of your picture. Remember, however, things will come out backwards (as below with the word "experiment"), so if you want to make a print of a particular word or text, you will have to take this into account.

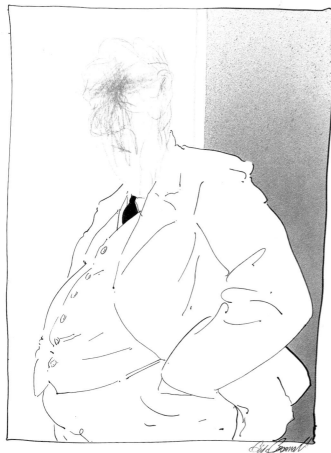

After making a photocopy of an old photograph, I was able to make an imprint using the method described above. Once this had dried, I painted over my imprint with watercolors. This is a technique that can be used very effectively in all kinds of collages.

The portrait of a red-headed man, left, is a simple mixture of ink, colored pencil, and spray paint. It's possible to achieve interesting effects with sprays, but practice using them as it is, at first, difficult to judge amounts. The larger spots of color in the gray area on the right side were not an accident. I splattered these with the aid of a toothbrush.

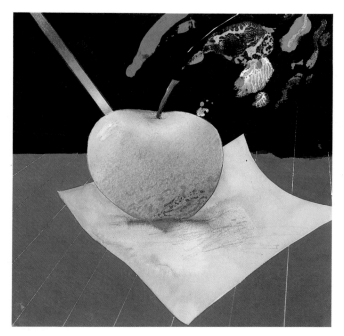

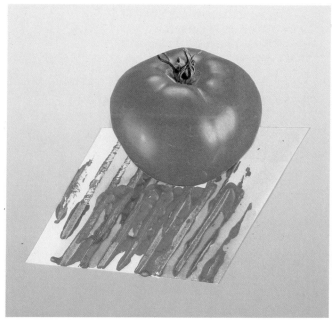

Making small compositions using various techniques is a good way to experiment without wasting too much material. The knowledge that these do not have to be works of art makes this fun and relaxing.

At top left, the black background was produced using ink, the brown area is gouache into which lines were scratched. The light napkin was painted with watercolors and the apple itself drawn using oil pastels. The blotches are gouache, partly using the imprint method; the rainbow progression was drawn with colored pencils.

The experiment in the top right is slightly simpler. The background was first sprayed. Then a light blue

watercolor wash, with an imprint from a piece of corrugated cardboard that had been painted with acrylics, was glued to it. Finally the photo of a tomato was also glued onto the composition. The contrasting structure would have been equally effective had the tomato been finely painted.

The foreground in the painting below left is an oil pastel structure over a gouache base. The background was sprayed and the tomato produced using watercolors and colored pencils. On the bottom right broad lines of water-soluble oils form the background. A cutout of a photo of a peach, a piece of torn orange paper, and an imprint from a photocopy make up the rest of the composition.

In the still life below, Ute Stumpp combined the following techniques: watercolors, gouache, oil and wax pastels, colored pencils, charcoal pencils, and a piece of a printed poster. The simple composition is turned into a spirited picture by the artist's use of different color structures. Some of the structures were produced by painting various watercolor tones over oil and wax pas-

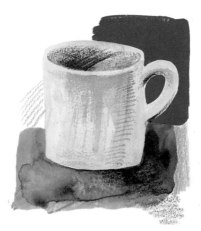

teling. You can see these effects clearly if you look at the tea pot and the stripes in the sides of the tray in the background.

The interest of this composition, however, doesn't rest entirely in the techniques involved but also in the arrangement of the various objects

in the given space. Look at the shapes formed between the objects; they are almost as important for the composition as the objects themselves. The contrast in the arrangement of the torn poster with its Oriental lettering adds much to the composition. These decorative elements all add stability and depth.

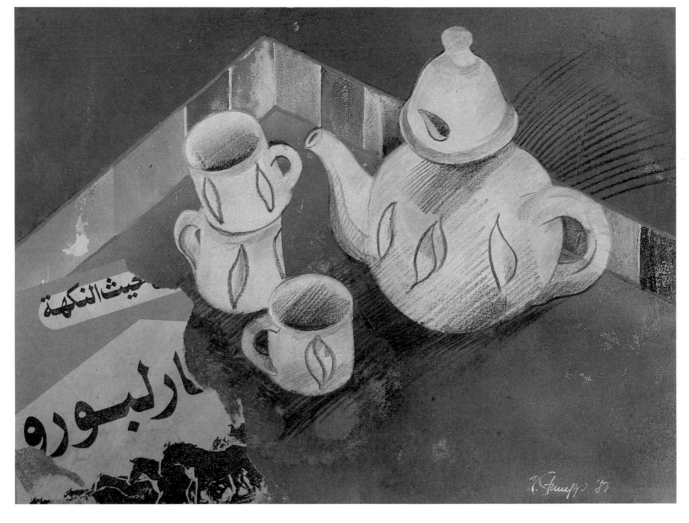

Tom Rummonds named this picture "What is happening behind the door?" and technically he does allow a lot to happen. The combination of felt-tipped marker and fixative is not only important for the structures, but also for the total atmosphere. A smooth fiber-free paper was used as a base. The intense blue-black was achieved by first applying a layer of gray pastel and then going over it with broad lines of black and blue markers. This paper will not absorb the marker, which means that the marker lines will mix and form a smooth surface. The floor is a mixture of several layers of different colored markers (blue, brown, and gray) onto which fixative was sprayed repeatedly. Fixative will dissolve the marker solution to give this mottled, bubbly effect.

were carefully scratched out using a knife. The tiling effect was produced by drawing straight lines in the floor with a pastel pencil and a ruler. These precise lines lend a more explosive effect to the free-hand elements. To complete the picture, the spontaneous "happening" behind the door was added by way of splashes, splatters, and painted structures, all in gouache. Splattering can be very effective providing this is properly incorporated into the picture and not left entirely to chance. By adding drawn shapes or stickers bought in art stores to splattering, these random structures can be turned into conscious picture elements.

The light ray was produced in the same fashion using lighter colors on a separate piece of paper, which was then cut out and glued onto the picture. The white patches are a mixture of gouache applied with a stenciling brush and powdered paint scattered over the wet paint to give a particularly shimmering effect. The door was drawn on yet another piece of paper and painted over. After it was cut out with a sharp paper-cutting knife, it was glued onto the main picture.

The light reflexes in the door

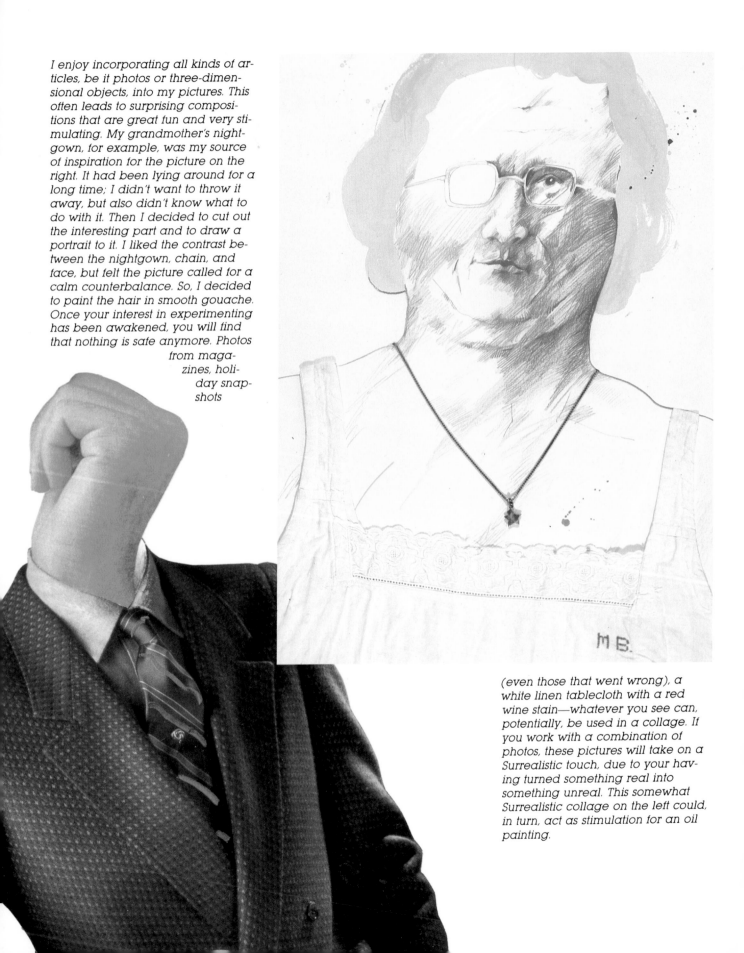

I enjoy incorporating all kinds of articles, be it photos or three-dimensional objects, into my pictures. This often leads to surprising compositions that are great fun and very stimulating. My grandmother's nightgown, for example, was my source of inspiration for the picture on the right. It had been lying around for a long time; I didn't want to throw it away, but also didn't know what to do with it. Then I decided to cut out the interesting part and to draw a portrait to it. I liked the contrast between the nightgown, chain, and face, but felt the picture called for a calm counterbalance. So, I decided to paint the hair in smooth gouache. Once your interest in experimenting has been awakened, you will find that nothing is safe anymore. Photos from magazines, holiday snapshots

(even those that went wrong), a white linen tablecloth with a red wine stain—whatever you see can, potentially, be used in a collage. If you work with a combination of photos, these pictures will take on a Surrealistic touch, due to your having turned something real into something unreal. This somewhat Surrealistic collage on the left could, in turn, act as stimulation for an oil painting.

While thumbing through a magazine, I found an interesting photo of a man with his hands over his eyes. I cut out the face and drew another body to it, including arms and hands, crossed quite normally in the man's lap. The smooth gouache background brought the face and body further to the fore.

I originally photocopied the finished picture in order to decipher the inherent gray tones, but then I liked the photocopy so much that I decided to make it into the actual picture. I continued to work on the collage, adding the woman on the tie and some touches of color. The only problem is that it has to be kept in a drawer, since photocopies will fade if exposed to light for long periods.

This portrait of a clown came to pass when someone gave me a tie for a present, which was supposed to close my ever-gaping shirt. It was, of course, meant as a joke since I would never wear a tie, but it did lead me to the idea of this clown picture incorporating the famous tie (it did not, by the way, lead me to the idea of wearing a tie!).

As I've said before, anything that fits a picture can be used, from an old pocket watch to a Mickey Mouse sticker. In the picture on the right, Tom Rummonds wanted to portray a normal face together with the tension hidden behind that face. He chose to use a zipper to divide the two halves of the face in order to strengthen the symbolism. A piece of material served as a tie. Pieces of photos and strips of paper completed the picture. A sparing use of color reinforces the implications and strength of meaning.

The composition on the opposite page is a conglomeration of forty small pictures made from all kinds of collages, drawings, and structures. Although each box contains a separate picture, the lightness and darkness, forms and colors are distributed in such a way that the combined composition forms a whole. The picture is, basically, nothing more than a collection of small experiments, such as I suggested you make to practice, arranged into a composition of its own.

The composition on the left by Uwe Neuhaus is a combination of painting and collage. The fascinating aspect is that it's almost impossible to distinguish between what is painted and what is glued. The ace of hearts, for example, is painted, whereas the joker is glued. Examine the picture carefully. What appears painted and what does not?

The crazy head below was made up using a variety of objects set within drawn contours. I think you might have fun producing a head incorporating glued and painted elements.

Painting on Objects

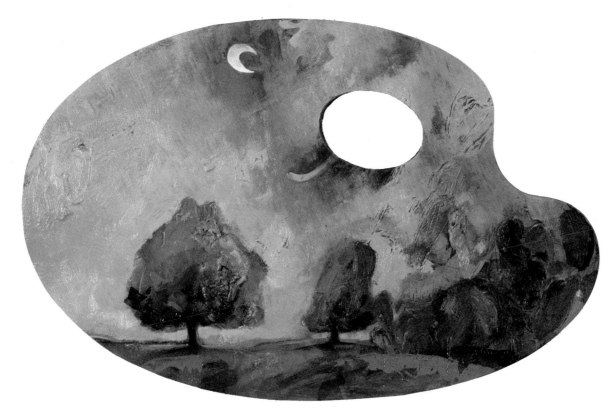

The palette is for most people the symbol of painting. If you try to imagine an artist standing in front of an easel, he or she will certainly be holding a palette.

Since I now tend to use the more modern palette blocks, with tear-off layers, this old palette, full of dried paints, had been hanging on the wall of my studio for ages. I liked the way the green and yellow colors reminded me of a slightly muddled landscape. When I started this book, I knew that I wanted to base the cover on this palette, and to turn the random color combinations into a picture. It was obvious to me that the picture would be a landscape, as this is what I had been seeing all that time.

I always feel rather nostalgic when I see a palette and for this reason I wanted the landscape to convey the atmosphere of evening, with the green and brown tones reflecting the setting sun. On the opposite page you can see my old palette in its almost original state. I had merely started to work on the tree in the foreground.

Below that you can see my next step. I was intent on retaining the basic forms made by the various colors as they were important for the composition and for lending depth. The white shape looking like a moon was purely coincidental, by the way. Later I would make a real moon out of it.

Then I worked on the sky and slowly built up the composition. I had to be very careful to retain the charac-

ter of the palette. I had almost finished my palette picture when I decided to turn the moonshape into a definite moon and at the same time to work more on the background and sky. At this stage I also decided that the tree in the middle was leaning at too precarious an angle, so I altered the shape slightly.

Now my palette picture was ready for use as the main element for the cover of this book.

If you look around, you'll realize that there is an infinite number of objects that you could paint on: wooden boards, plates, basketwork, roof tiles, to name just a few. Now that you are able to mix techniques, your imagination is subject to no restrictions.

Who is to say that a picture has to be drawn or painted on a flat, four-sided surface? Why can't it be on something triangular, round, or even spherical? It can, in fact, be on anything.

Most people have, at one time in their lives, painted an Easter egg, a tin soldier, or the kitchen cabinet. What they have in fact produced is a "painted object." From these beginnings, it's easy to imagine painting on all kinds of surfaces. It seems fairly logical to paint a rainbow as a symbol of colors onto a palette, or, to take this thought further, something edible on a wooden platter, or a face onto a hand mirror.

When I saw the round plate on the opposite page, I immediately felt like filling it with a painting of fruit and vegetables. The over-precise round form needed breaking, to which purpose the long carrot shape came in very useful. I had intended painting a self-portrait onto the mirror without glass, but somehow this frame did not quite fit me—I would never use something like that. It seemed more suitable for a girl's face. Almost any object can either be integrated into a picture or be used as the determining factor for the form of a picture. Even an old television screen or a tea pot provides potential material for an interesting composition.

Wood provides a suitable surface for almost all drawing and painting techniques. If you want to use other surfaces, try out the various techniques before you start on your picture. Oth-erwise you might meet with problems such as how to paint on porcelain using inks or watercolor, for example, or how to apply oils to toilet paper.

Wood owes its popularity as a painting surface not only to its versatility in respect to the various techniques, but also, and maybe to a greater extent, due to the structures in the wood itself. These can easily be incorporated into a picture, as can be seen in these two examples by Uwe Neuhaus.

In the first example, at the top on the opposite page, the structure of the wood suggested water to the artist. He colored it only very slightly and added another piece of wood as a boat and a matchstick as a mast.

The picture above was also determined by the wood. Worm holes were turned into a starry sky, which was painted over only very lightly, so that the structure could dominate. If you find a piece of wood that you would like to paint, first look at it from all sides and angles. Wait for inspiration from the wood. Maybe you will discover an eye or a tree in the various structures. Such discoveries can have a great influence on your picture.

Don't allow yourself to be led into thinking that wooden objects are the only thing you can paint. When I was a child, I used to paint on anything I could lay my hands on. Best of all was wrapping paper. Later I started decorating envelopes. Maybe I can trace my partiality towards stamped packages and airmail letters back to this. Sometimes the arrangement of the postage stamp and address forms a composition of its own. The combination of stamps, ink, postmarks, and string can have a very inspiring effect. On the opposite page and below, you can see what happened to two pieces of mail sent to me.

Should you have the urge to paint something on a package, you ought to check with the post office regulations first. Unfortunately, not everything that appeals to you will meet with the approval of the authorities. But, if you paint on the inside, who is to know?

The examples on these pages show how materials such as porcelain, glass, and toys can be included in pictures.

The breaking of an old porcelain cup that she was too fond of to throw away led Ursula Bagnall to produce the picture below. The much-loved cup was glued into a small wooden box and the missing part of the cup painted onto the base of the box (using soluble oils). The box, including the cup, was mounted onto the sky—a thick piece of cardboard suitably painted. By the way, there is real coffee in the cup (mixed with plaster of Paris to prevent spilling).

The example shown top left includes not only a watercolor painting, but also the frame as part of the composition, to which a small toy model of a ship in a bottle was added.

In the example on the top right, I painted over a puzzle using acrylics and then took out some of the pieces. This idea could be used effectively if the puzzle were to be put together in the wrong order after having painted over it. On the near right, there is another use of toys—this time building blocks with the letters "YOU" placed on top of a paint box. I drew the eye using ink and pencil.

The example on the far right shows how picture and frame can be seen as an object. The real matches are simply attached to the frame by way of a piece of string. Never fear jumping the limits of frames. Try to see them as part of a picture and not just an annoying necessity.

MOTIVATING IDEAS

Just take a look around you and you're sure to find a multitude of objects suitable for experimenting—objects that can be cut up, glued together, or painted over. If you feel like hanging a moon from an old light bulb, or painting a landscape around a telephone, then do it!

The bright red peppers at right present good subject matter for mixed techniques. You could, for example, spray the background and draw the peppers on using pastels. How about incorporating real cling foil? The unusual still life below could be turned into a collage using shells and different types of silver paper on a background of thick color structures.

A window is, in essence, a framed picture in itself. The broken window motif lends itself to a three-dimensional picture using wood, black paper, and plastic wrap. I can imagine the red shutters painted on wood, just as I can also see this motif rendered in various cardboard structures glued together and painted over. Don't feel you have to stick faithfully to the actual colors. There is nothing to stop you altering the colors, if you feel this is what your picture needs.

The doll at center right has the potential for a very attractive picture. There is a strong inherent contrast between her face and dress, which gives you free license to use very contrasting techniques, ranging from watercolors to acrylic structures. Soft pastels would also bring out the fine features of this little face. The dress could be made out of material remnants.

The bag of peaches also contains strong contrasts. How about using crumpled wrapping paper and a little color? The peaches could be painted realistically on another piece of pa-

per, then cut out and glued onto the wrapping paper. I am sure your head is by now bursting with your own ideas. Try them out—this is the best possible way to learn.

SURROUNDING POINTS

Once you have finished a picture, or several pictures, there are a couple of things left to consider. What, of course, depends on whether you intend to hang the picture, or just keep it. Any delicate techniques must be treated with a fixative. If you want to keep your pictures in a drawer, make sure they can lie flat and in a dry place. Lay thin pieces of paper between and over your pictures for protection.

Almost all pictures look better if they are matted. I usually cut out a simple mat while I'm working on a picture and lay it on the picture occasionally. This lets me concentrate on the effect of the composition by cutting out any disturbing surroundings.

Even the simplest picture will look considerably better once framed and hanging on a wall. This also allows you to contemplate your work critically in different lights and from different angles, and often stimulates a new picture.

Frames are available in all shapes and sizes. They are also fairly simple to make. Simple glass frames are very practical, especially if you paint a lot. The actual hanging of your pictures depends on the nature of your walls. Concrete walls are not very accommodating towards nails, so it's better to hang your pictures from invisible nylon threads attached to a picture rail. Nails or hooks are quite sufficient for other types of wall.

Preserving Pictures

The more you draw and paint, the more pictures you will collect that you'll want to keep. But where and how? The most important point to consider, in this respect, is that you should find a place where your pictures can be kept dry and safe. If you have a lot of pictures, it might be worthwhile getting a small drawing cabinet, in which you can keep all your finished pictures as well as paper and painting surfaces. These cabinets are standardized and available in art shops.

Portfolios which allow you to store your work flat, even if the portfolio is standing up, are considerably less expensive. Some varieties have interior flaps to protect against dust.

Display portfolios have plastic pockets to accommodate each picture separately. These have the advantage that you can show your pictures without fear of getting fingerprints or dust all over them, but they are, naturally, more expensive than the simple card portfolio.

Only roll a picture if you intend to mail it in a specially designed mailing tube. It is very difficult to flatten a picture once it has been rolled for a long time.

However you decide to store your pictures, always lay a thin piece of paper over and between your pictures—the best is tissue paper or tracing paper—as many colors tend to smudge or stain after a time.

Stretching a Canvas

It is only really worth producing your own canvas and wedged frames if you want to work on non-standard sizes, or if you are an ardent do-it-yourself person. You can use canvas that has already been primed or linen that you prime yourself. In the latter case, I would advise using a cotton drill material.

The canvas is stretched over a wooden frame, called a wedged frame. This name owes its origin to the wedges inserted into the frame to keep the canvas taut. Should you not have a workshop in which you can cut the wood to the exact measurements and angles, as well as produce the wedges, then purchase these items, as precision is imperative.

Once you've constructed and squared the frame, lay it over the canvas and cut the canvas, allowing an overlap of a few inches all around. Make sure that the side of the frame with the rounded edge is against canvas as this prevents the frame from becoming evident in your picture.

For the actual stretching you will need either upholstery tacks or a heavy-duty stapler. The canvas should lie flat under the frame, with the weave parallel to the sides. Now fold one side of the canvas over the frame and fasten it in the middle. Then repeat the process first with the opposite side and then the two remaining sides, pulling the canvas tight as you do so.

Fold the corners in such a way that the fold of the canvas concurs with the corner joint of the frame and fasten it down. The canvas will shrink slightly after priming, so it should not be too taut prior to priming (nor should it be too loose). Then apply the ground you are using to prime the surface.

The wedges are not inserted until the ground is completely dry. Ready-made frames have grooves into which the wedges can be inserted. Your canvas will slacken while you're painting, but this can be rectified by inserting the wedge further into the groove. You will need two wedges per corner.

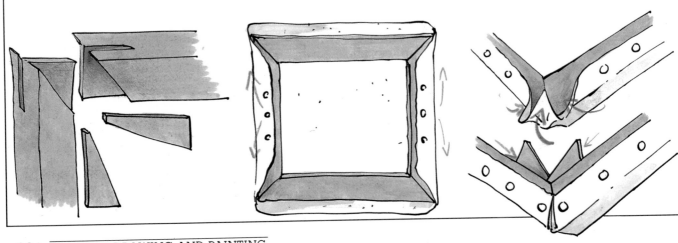

Mats

Mats are nothing more than card frames which set a picture off from its surroundings. These mats can be tinted, black, or white depending on the picture concerned.

Your first consideration is the dimensions. Sometimes setting a minute picture in a relatively big mat can add significance to a picture, sometimes not. There are two important guidelines to follow in respect to dimensions: Never make a mat too narrow as this will jeopardize the effect, and always make the bottom side of the mat slightly wider than the top side. A picture placed in the center will look as if it has slipped down. This trick will counteract that optical illusion.

Now you need a paper-cutting knife, a cutting surface, a metal ruler, and some adhesive tape.

Before beginning, make some practice cuts on spare pieces of card, to get a feeling for cutting. If you are using thin card, you can lightly draft the cutout in pencil on the back. Al-

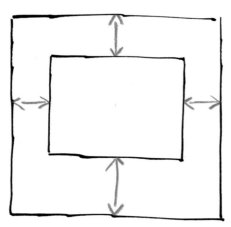

ways cut from behind to ensure that the front stays clean. Hold the knife at a sharp angle to obtain a sharp cutting edge.

The window should be slightly smaller than your picture all around, in order to hide any ugly edges. Careful with the corners! It's very easy to cut too far. It is perhaps advisable to practice these first. If you're using thick card, make sure that you always hold your knife at the same angle, otherwise you might produce an uneven edge. If the edge is sloping, this is not important—it can even enhance a picture. If you want to produce this effect on purpose, hold your knife at the desired angle and without altering the angle, cut along your guiding ruler. This calls for a very steady hand and quite a bit of practice. The picture itself is attached to the back of the mat using adhesive tape (see the diagram at right). At this stage you can add little personal touches, such as drawing a fine, colored line on the card parallel to the edges of the window. If you don't intend to frame the picture, you should cut another piece of paper the same size as the mat and attach it to the back of the mat using double-sided adhesive tape. This ensures a clean finish to your work and protects your picture against dust and dirt. (Be careful with double-sided adhesive tape. It sticks to everything!)

It's also possible to mount a picture onto a hard backing. If you don't intend to use a mat, you will have to cut your picture to the desired size (using a paper-cutting knife, not scissors!). Then spray the back of your picture with spray adhesive and glue it onto your board in the appropriate position. Once again, leave more space between the picture and the bottom of the board than above. If you don't want to use spray adhesive, you can also utilize double-sided adhesive film. Stick the film carefully onto the back of your picture before cutting it to size. Then peel off the protective paper and stick the picture to the board in the desired position (mark this out first). As was the case with double-sided adhesive tape, care is called for here as adhesive film sticks to everything, and sticks well! Use a rubber roller to flatten out any bubbles or folds that may have occurred as these could show through onto your picture.

This form of mounting is useful should your painting have warped or lost shape. If you feel uneasy about cutting the picture, mount it in the described way and cover the edges with a mat.

Another important aspect of matting is the color. The choice of color depends primarily on the picture. The color you choose can enhance and improve a picture, but it can also ruin it. The three examples below illustrate how the effect of a picture can be altered by the surrounding color.

Framing

The frame must fit the picture and the color, and all three need to harmonize with the room in which the picture will hang. Should you be a do-it-yourself fan, you will certainly want to make your own frames. Most art hobby shops stock various frames with joints that are correctly angled and square. When deciding on a frame be sure that it enhances the effect of your picture rather than smothers it. Try the various frames against your picture (above you can see some cross sections of frames).

If you don't want to make the whole frame, you could get a framing kit. These usually include a frame (made of wood, plastic, or aluminum), backing, and glass. These frames are usually simple in their form. You can paint or decorate them entirely according to taste.

Glass frames can be bought almost everywhere. These are usually quite simple in design. The most common glass frames consist merely of sheets of glass with clips and have neither wood nor aluminum edges. This means the mat plays an important role as it forms the frame setting off the picture.

Glass frames are very practical if you have a lot of pictures of the same size, as you can always hang your latest picture without trouble. Should your picture have an unusual shape, it's advisable to have it framed by an expert. This might be more expensive, but an expert's opinion can be very informative and helpful and he will usually know how to achieve the effect you want.

The Glass

You can either use normal or non-reflecting glass—glass which cuts out any light reflections for your pictures. Pictures behind non-reflecting glass can be hung almost anywhere, as it is not necessary to consider the influence of light from windows or lamps. This type of glass is not suitable for pastel pictures, however, as the static electricity built up by the glass attracts the fine pastel dust magnetically and the picture will slowly disintegrate into dust. (Pastel pictures, by the way, should never come into direct contact with glass, because after a while the fixative will stick to the glass. This can be avoided by producing a space between the glass and picture using either a piece of cardboard (top diagram) or inserting a support into the frame (bottom diagram).

Hanging Pictures

There are a couple of points to be considered when deciding where and how to hang a picture. Ideally, pictures should be hung at eye-level—the middle of the picture should be on a level with the eye of the observer (top diagram). If you want to hang several pictures adjacent to each other, either the top or the lower edges should be in line (diagrams top and bottom). Pictures hung higgledy-piggledy are confusing and create imbalance in a room. Avoid producing steps and always leave enough space between the individual pictures to allow them to "breathe," but not so much that the pictures look like randomly dispersed blotches on a wall. If you want to make a collection of pictures on one wall, try to balance the impact by placing lighter pictures over heavier pictures—a drawing with a few colors over an oil painting, or small pictures over large pictures (diagram center right). Etchings and woodcuts harmonize well in a room with a lot of books, but most paintings need more space to be appreciated properly.

The actual hanging of pictures depends on your walls. One of the best methods is a picture rail placed directly under the ceiling from which pictures can be hung from wires (usually nylon). These rails have sliding suspensions, meaning that you can easily alter the position of a picture. The rail is covered by a strip of wood that can be painted or wallpapered to blend into the room. Most carpenters will make these to size (see diagram center left).

Glossary

A

Acrylics
A synthetic resin painting material that is quick drying and water soluble.

B

Binder
Every type of paint consists of pigments held together by a binder. There are two main groups of binders: water soluble and non-water soluble. The binder determines the character of the paint.

C

Charcoal
Charred coal, usually in sticks, used for sketching and drawing.

China ink
Pine soot and bone glue compressed into blocks. Mixed with water on an ink stone, it will produce liquid ink. Also called sumi.

Cold-pressed paper
Handmade watercolor paper with a medium to rough grain.

Collage
A picture consisting of various glued-on elements.

Color pigments
Every color consists of pigments held together by a binder. It is the pigments that actually lend color. These are normally produced synthetically, but it is possible to get pigments taken from animal, vegetable, or mineral sources.

Complementary colors
Colors lying opposite each other on the color wheel. The colors that contrast most strongly to one another, such as red and green, orange and blue, violet and yellow.

Composition
The formal build-up of a drawing or painting, including arrangement of the individual picture elements and proportions.

Conté crayon
Crayons made from a mixture of clay and iron ochre. They can be red, black, white, or in the earth colors.

Crosshatching
See *hatching*.

Cubism
Phase of post-Impressionist art in which objects were reduced to cubic forms.

E

Earth colors
Natural white or colored pigments produced from minerals by purely mechanical means (grinding, sifting, screening, or washing) and used for making colors.

Easel
Frame to support a picture while the artist is working on it.

Expressionism
An art movement of the early twentieth century. Expressionism in painting is characterized by greatly simplified forms, strong color contrasts, and an estrangement from the colors of nature.

F

Figure drawing
Rendering of human models.

Fixative
A medium to prevent charcoal or pastel drawings from smudging. It is usually sprayed onto the drawings.

G

Gesso
A mixture of plaster of Paris and glue, used for white grounds.

Gouache
An opaque watercolor containing white pigments.

Graded wash
A color application running evenly from light to dark (and vice versa) or from one color into another.

Ground
A base coating applied to the painting surface to produce an even working surface.

H

Handmade paper
Characterized by rough, non-cut edges.

Hatching
A drawing technique involving numerous pen or pencil lines drawn in close proximity to one another. Should these lines cross horizontally and vertically this is referred to as crosshatching.

Highlights
Points of maximum light used to reinforce individual elements in a picture.

Hot-pressed paper
Watercolor paper with a fine grain.

Hue
Characteristic identification of a color, such as yellow, red, blue.

I

Impasto
Special painting technique implying an extra thick application of colors to give highly structured surfaces.

Impressionism
An art movement prevailing from the middle to the end of the nineteenth century. Impressionism in painting is characterized by the attempt of artists to capture light, atmosphere, and motion rather than form and structure.

Imprints
Colors transferred from one surface to another while wet.

Ingres paper
Structured paper, mainly used for pen-and-ink drawings. Named after the French classical painter, Jean Auguste Ingres.

Ink stone
A special black stone for mixing China ink with water.

Intensity
The brightness of a color.

J

Japanese knife
A knife that is sharpened by breaking off the end of the blade.

Japanese paper
Handmade, silk-fine paper that is very strong and durable. It is made from the pith of maple bushes.

K

Kneaded eraser
An eraser that can be kneaded, especially useful for erasing lines in charcoal drawings and for removing charcoal dust.

M

Mahlstick
A stick ending in a round knob used for supporting the painting hand while working at an easel.

Mat
Framework, usually made of card or paper, for setting off drawings or paintings.

O

Oils
Slow-drying colors. Linseed oil is added to the color pigments as a binder.

Oil pastels
Crayons consisting of color pigments in a wax mixture.

P

Painting knife
A small spatula for mixing, applying, and scraping colors.

Painting surface
Classic surfaces are made of wood or canvas. Today card, materials, walls are also utilized. These surfaces are usually primed and treated prior to painting.

Palette
A surface for mixing colors.

Palette knife
See *painting knife*.

Pantograph
An instrument for manual reproduction of pictures on a larger scale.

Pastels
Crayons made from a mixture of finely ground color pigments and substances such as clay. Very little binder is added. Pastels are applied in a dry state and must be treated with fixative.

Perspective
Technique for rendering three-dimensional motifs on two-dimensional surface.

Pigments
See *color pigments*.

Pointillism
An art movement related to Impressionism. Pointillism relies on the juxtapositioning of spots of pure color to produce the optical illusion of mixed colors.

Poster color
A water-soluble opaque color, which becomes water resistant after drying. Also called poster paint.

Primary color
Any color that cannot be made by mixing other colors. There are three primary colors: yellow, red, and blue.

Prime
To prepare a surface for painting by covering it with a material such as gesso. This prevents the paint from soaking through.

R

Reed pen
A pen made from bamboo or reed, with its ends cut at an oblique angle.

Ruling pen
A ruling pen can be filled with ink or colors for drawing straight, even lines. The width of the line is adjustable. Sometimes called a pen liner.

S

Secondary colors
These are produced by mixing two primary colors. There are three secondary colors: orange, green, and violet.

Sketch
A draft for a picture. A quick drawing to capture momentary situations or atmospheres.

Spray adhesive
Liquid adhesive, available in aerosol cans and applied by spraying.

Stencil
A shape usually cut out of paper or cardboard, often used in splattering.

Still life
A rendering of lifeless or motionless objects arranged into a composition by the artist.

Sumi
See *China ink*.

Surrealism
An art movement of the twenties and thirties characterized by representations of dreams, visions, and altered states of consciousness.

T

Tempera
Color pigments mixed with either natural emulsions (egg yolk) or artificial emulsions (oil or gum). The character of the tempera alters according to the emulsion used.

Transparent color
A thin layer of color which allows the underlying color to penetrate.

V

Value
Lightness or darkness of a hue.

W

Wash
Application of color with large quantities of water.

Watercolors
Water-soluble colors, consisting of finely ground pigments, mainly bound with a natural gum material.

Wedged frames
Frames for stretching canvases. The wedges are used to restretch the canvas while painting.

Wet in wet
A painting technique using wet colors in wet colors to make them run, as in washes. This technique is mainly used in watercolor painting.

Index

Acknowledgments

I should like to heartily thank the following companies for providing materials: Akachmie, Artcolor, Bahr, Binney & Smith, Brause, Elco, Eberhard Faber, Habico, Hahnenmuhle, Japico, Koh-i-noor, Krauss (Hoesch), Kreul, Kreuzer, Letraset, Lukas, Lyra, Marabu, Pelikan, PWA, Wolfgang Rayher, Schleicher & Schuell, Schmincke, Schoellershammer, Staedtler, Stotz, Trident Toy, Vangerow, Zahn, Zanders.

My special thanks go to the following companies for their generous help and collaboration: Hermann Bodecker (Caran D'Ache), Faber Castell, Rotring, A. Schutzmann, Schwann-Stabilo.

Illustration sources

Bagnall, Sue Copyright of the artist, 9, 11

Bagnall, Ursula Copyright of the artist, 16, 26 (bottom), 52 (top), 62, 63 (bottom), 83, 85 (top left), 136 (top), 187 (bottom), 189, 222, 241 (bottom left), 258 (top left), 262, 320, 321 (top left)

Beardsley, Aubrey, 17

Blake, Peter Copyright by Daler-Rowney Ltd., Bracknell, 260

Blank, Hartmut Copyright of the artist, 263, 325 (bottom)

Borsche, Peter Copyright of the artist, 40, 41, 66, 67, 88, 89, 96, 138, 139, 197 (bottom left), 200, 201, 226, 227, 246, 247, 264, 265, 292, 293

Brabazon, Hercules, 224

Cèzanne, Paul National Museum of Wales, Cardiff, 289

Constable, John Victoria and Albert Museum, London; photo: Sally Chapell, London, 287

Dürer, Albrecht, 86

Gauguin, Paul, 135

Giacometti, Alberto Copyright by A.D.A.G.P., Paris/1985; Cosmopress, Geneva; Museum Ludwig, Cologne, 100

Girtin, Thomas The Tate Gallery, London, 221 (section)

Gogh, Vincent van Museum of Art, Rhode Island, School of Design, 87; Kunst and Geschichte Archive, Berlin, 289

Greco, Giovanni Copyright of the artist, 65, 119

Holzach, Erika Copyright of the artist, 241 (top), 248, 322 (bottom)

Hornberger, Jörg Copyright of the artist, 199

Itten, Johannes Otto Maier, Ravensburg, 127

Kaüt, Ellis Copyright of the artist, 44 (bottom), 47, 48, 49, 57, 58, 73, 75, 160 (bottom), 161 (top left), 175 (top left), 214 (top right), 219, 223, 240 (bottom right), 242, 245, 282 (top), 283 (top), 322 (top), 323 (top, center, and bottom left)

Klee, Herbert Copyright of the artist, 261

Klee, Paul Paul Klee Stiftung, Kunstmuseum, Berne; copyright by Cosmopress, Geneva, 10; private collection, Berne; copyright by Cosmopress, Geneva, 225

Klimt, Gustave Copyright by Welz Gallery, Salzburg; Graphische Sammlung Albertina, Vienna, 100

Krahwinkel, Rudolf Copyright of the artist, 26 (top and bottom right)

Kraus, Karla Copyright of the artist, 63 (top), 85 (right and bottom), 194, 195, 196 (bottom)

Léger, Fernand Copyright by Spadem, Paris; Bild-Kunst, Bonn/1985; Museum Moderne Kunst des 20. Jahrhunderts, Vienna; permanent loan of the Kunsthistorischen Museum, Vienna, 285 (bottom right)

Magritte, René Copyright by G. Magritte, Brussels; Cosmopress, Geneva; private collection, Brussels, 286

Matisse, Henri Copyright by Spadem, Paris; Bild-Kunst, Bonn/1985, 285

Milligan, Terence Copyright by Phaedon Press Ltd., Oxford, 261

Neuhaus, Uwe Copyright of the artist, 288, 312, 316, 317

Palmer, Samuel Victoria and Albert Museum, London, 243

Picasso, Pablo Spadem, Paris; Bild-Kunst, Bonn/1985; Musée National d'Art Moderne, Paris, 301

Preis, Kurt Copyright of the artist, 223

Reese, Jens Copyright of the artist, 298

Reese-Heim, Dorothea Copyright of the artist, 299

Rummonds, Tom Copyright of the artist, 190, 244, 245, 253 (in collaboration with Brian Bagnall), 308, 309, 312

Sajtinac, Borislav Copyright of the artist, 17

Santi, Raphael Graphische Sammlung Albertina, Vienna, 100

Seurat, Georges Courtould Institute Galleries, Courtould Collection, London, 27 (top); Kunst and Geshichte Archives, Berlin, 27 (bottom); National Galleries of Scotland, Edinburgh, 284

Smith, Stan Copyright by QED Publishing, London, 304

Stark, Ewald From *Das Schöne als Ziel*, Falken-Verlag, 175 (bottom), 182 (top), 186 (top right), 187 (right)

Steinberg, Saul From "The Inspector" by Saul Steinberg, copyright by Rowohlt Verlag GmbH, Reinbeck 1965, 221

Steinherr, Carl Copyright of the artist, 303

Stumpp, Ute Copyright on the artist, 5, 119, 191, 199, 223, 225, 307, 324, 325 (top center), 326 (center)

Sutherland, Graham Copyright by Cosmopress, Geneva; Marlborough Fine Art, London, 242 (section)

Titze, Heidi Copyright of the artist, 69 (top left, in collaboration with Brian Bagnall)

Turner, William Copyright of the Trustees of the British Museum, London, 220

Unknown, 37, 119 (top left and bottom right)

All other illustrations by Brian Bagnall.

Art and cover: Bagnall Studios, Munich, West Germany
Printed and bound in West Germany.

Originally published in German under the title *Zeichnen und Malen.* Copyright © 1985 by Falken-Verlag GmbH Niedernhausen/Ts., West Germany. German text by Brian Bagnall and Ursula Bagnall. ISBN 3 8068 4167 5

English translation copyright © 1986 by North Light, an imprint of Writer's Digest Books, 9933 Alliance Road, Cincinnati, Ohio, 45242. English translation by Wendy Lees, Munich, West Germany. ISBN 0 89134 177 3

Although all recommendations in this book have been carefully contemplated and tested by both the author and its German publisher, no guarantee can be given. The author, publishing company, and those working under contract for the publishing company can accept no liability for any injury to persons, materials, or property.